Intimate Encounters

Intimate

LOVE AND DOMESTICITY

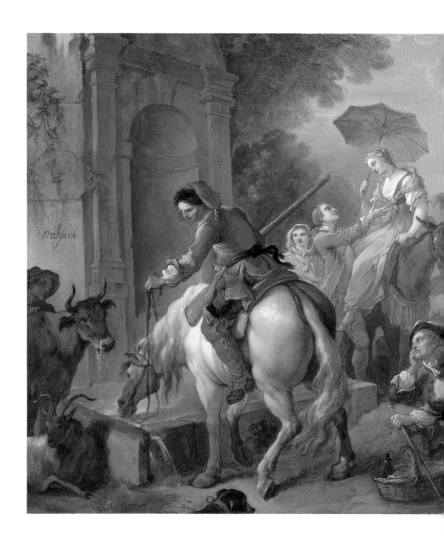

Encounters

IN EIGHTEENTH-CENTURY FRANCE

RICHARD RAND
with the assistance of Juliette M. Bianco

and contributions by
MARK LEDBURY
SARAH MAZA
ANNE L. SCHRODER
VIRGINIA E. SWAIN

Hood Museum of Art, Dartmouth College
Princeton University Press, Princeton, New Jersey
1997

Copyright © 1997 by The Trustees of Dartmouth College
ALL RIGHTS RESERVED
Hood Museum of Art, Dartmouth College, Hanover, NH 03755
Copublished and distributed by Princeton University Press,
41 William Street, Princeton, New Jersey 08540–5237

This exhibition was organized by the Hood Museum of Art,
Dartmouth College, and supported in part by grants from the
National Endowment for the Arts and the National Endowment
for the Humanities, federal agencies. Its presentation at the Hood
Museum of Art was made possible through the generous support
of The Philip Fowler 1927 Memorial Fund, The Marie-Louise
and Samuel R. Rosenthal Fund, and The William B. Jaffe and
Evelyn A. J. Hall Fund.

Exhibition schedule:
Hood Museum of Art, Dartmouth College, Hanover,
New Hampshire, October 4, 1997–January 4, 1998
The Toledo Museum of Art, Toledo, Ohio, February 15–May 10, 1998
The Museum of Fine Arts, Houston, Texas, May 31–August 23, 1998

Exhibition committee:
Colin B. Bailey, National Gallery of Canada, Ottawa
Edgar Peters Bowron, The Museum of Fine Arts, Houston
Philip Conisbee, National Gallery of Art, Washington, D.C.
Sarah Maza, Northwestern University
Lawrence W. Nichols, The Toledo Museum of Art
Donald Posner, Institute of Fine Arts, New York University
Richard Rand, Hood Museum of Art
Virginia E. Swain, Dartmouth College

Designed by Bruce Campbell
Printed in Singapore

LIBRARY OF CONGRESS
CATALOGING-IN-PUBLICATION DATA

Rand, Richard.
 Intimate encounters : love and domesticity in eighteenth-century
France / Richard Rand with the assistance of Juliette M. Bianco and
contributions by Mark Ledbury . . . [et al.].
 p. cm.
 Includes bibliographical references and index.
 ISBN 0-691-01663-1 (cloth : alk. paper).— ISBN 0-691-01662-3
(pbk. : alk. paper)
 1. Genre painting, French—Exhibitions. 2. Genre painting—
18th century—France—Exhibitions. 3. Prints, French—
Exhibitions. 4. Prints—18th century—France—Exhibitions.
I. Rand, Richard. II. Title.
ND1452.F84R36 1997
754´.0944´07473—DC21 97-172
 CIP

Frontispiece: Charles-Joseph Natoire, *The Rest by a Fountain*
(detail), c. 1737, oil on canvas, Hood Museum of Art, Dartmouth
College, Hanover, New Hampshire

Jacket/cover illustrations: (*front*) Jean-Honoré Fragonard,
Blindman's Buff, c. 1753–56, The Toledo Museum of Art, Edward
Drummond Libbey Gift; (*back*) Jean-Siméon Chardin, *The Good
Education*, c. 1753, The Museum of Fine Arts, Houston

Princeton University Press books are printed on acid-free paper
and meet the guidelines for permanence and durability of the
Committee on Production Guidelines for Book Longevity
of the Council on Library Resources

10 9 8 7 6 5 4 3 2 1

10 9 8 7 6 5 4 3 2 1 (pbk.)

Contents

Lenders to the Exhibition

Art Gallery of Ontario, Toronto

The Art Institute of Chicago

Ball State University Museum of Art, Muncie,
Indiana

The Cleveland Museum of Art

Colnaghi, London

The Detroit Institute of Arts

The Fine Arts Museums of San Francisco

Fundación Colección Thyssen-Bornemisza, Madrid

Harvard University Art Museums, Cambridge,
Massachusetts

Hood Museum of Art, Dartmouth College, Hanover,
New Hampshire

Indianapolis Museum of Art

Kimbell Art Museum, Fort Worth

Krannert Art Museum and Kinkead Pavilion,
Champaign, Illinois

Los Angeles County Museum of Art

The Metropolitan Museum of Art, New York

The Minneapolis Institute of Arts

Musée du Louvre, Paris

Museum of Fine Arts, Boston

The Museum of Fine Arts, Houston

Museum of Fine Arts, Springfield, Massachusetts

National Gallery of Art, Washington, D.C.

National Gallery of Canada, Ottawa

Nationalmuseum, Stockholm

The Nelson-Atkins Museum of Art, Kansas City

New Orleans Museum of Art

Private Collection, courtesy of Rosenberg and Stiebel

Private Collections

Portland Art Museum, Oregon

Sterling and Francine Clark Art Institute,
Williamstown, Massachusetts

Collection of Mr. and Mrs. Stewart Resnick

The Toledo Museum of Art

David Tunick, New York

Virginia Museum of Fine Arts, Richmond

Wadsworth Atheneum, Hartford, Connecticut

Williams College Museum of Art, Williamstown,
Massachusetts

Worcester Art Museum

Foreword

This catalogue and the exhibition it accompanies examine several significant aspects of eighteenth-century French art: the development of genre painting during a period of remarkable social and political change, and, within this increasingly important artistic category, the growing prominence of themes related to matters of the heart and the home. Indeed, as Richard Rand, the organizer of *Intimate Encounters: Love and Domesticity in Eighteenth-Century France* and the museum's curator of European art, has clearly demonstrated, these two phenomena—both the medium and its message—were closely linked and need to be understood in relation to each other and as products of a society in transition.

The nature of that transition and the ways in which the arts contributed to and reflected the profound changes that occurred during the last decades of the Old Regime are still being debated, perhaps because they have so much to tell us about ourselves and the formation of contemporary culture. How can we define the family, in ideal terms, as a social unit, and to what extent can it serve as a means for representing (and promoting) certain moral values? Furthermore, how do we understand gender differences and—a complex phenomenon—the expression of these differences in the various roles assigned to men and women in the public and private realms? Such questions, although first articulated in eighteenth-century France, sound very familiar, and are, of course, still with us today.

What is perhaps most fascinating about this exhibition are the issues that arise from a reconsideration of genre itself, a category of painting that, not surprisingly, changed in many notable ways during the period under review in response to shifting tastes and expectations regarding the proper function of the arts. In this regard, it is of particular interest to trace the contentious process by which genre painting—a popular type of art and one that, by definition, concerned itself with ostensibly frivolous subject matter or scenes of everyday life—began to lay claim to certain functions that had once been the exclusive domain of history painting: the capacity to excite our nobler passions, to be morally uplifting, to instruct, and to edify. This was a significant encounter, for in the growing popularity of genre painting in the middle decades of the eighteenth century, the efforts of Greuze and his apologists to reposition genre

within the hierarchy of categories of painting established by the Royal Academy, and the subsequent reaction led by David and his contemporaries in the 1780s, we can discern the beginnings of the spirited dialogue between the constantly shifting modes of popular culture and established forms of artistic expression that is fundamental to our understanding of modern art.

It should not go unremarked that many of the works presented in this exhibition—by artists such as Watteau, Chardin, Boucher, Greuze, and Fragonard—rank among the greatest achievements of European painting and are as appealing to audiences today as they were to connoisseurs and visitors to the Salon in eighteenth-century France. Thus, our greatest debt of gratitude is owed to those individuals and institutions, both in this country and abroad, who so generously agreed to make important objects from their collections available to us. The success of this project is due in large measure to their good will and collegiality. Special mention should also be made of the several grants awarded by the National Endowment for the Arts and the National Endowment for the Humanities to support the planning and production of the exhibition, catalogue, and related programs. The presentation of this exhibition at the Hood Museum of Art has been made possible through the support of several endowments: The Philip Fowler 1927 Memorial Fund; The Marie-Louise and Samuel R. Rosenthal Fund; and The William B. Jaffe and Evelyn A. J. Hall Fund.

I would also like to offer my thanks to David Steadman, Director of The Toledo Museum of Art, and Peter Marzio, Director of The Museum of Fine Arts, Houston, to whose institutions the exhibition will travel after it closes at the Hood Museum of Art, and to the many colleagues, named in Richard Rand's preface, who gave so freely of their time and provided invaluable advice and assistance at every turn. Finally, I would like to express my sincere appreciation for all of the time and energy that Dr. Rand has devoted to this project over the past four years. Its successful realization is eloquent testimony to his intelligence, enthusiasm for the subject, and curatorial skills.

Timothy Rub
Director, Hood Museum of Art
Dartmouth College

Preface and Acknowledgments

R I C H A R D R A N D

*When Louis XV succeeded Louis XIV, when a gay, amorous so-
ciety emerged from a ceremonious one, and when, in the more
human atmosphere of the new court, the stature of persons and
things diminished, the prevailing artistic ideal remained facti-
tious and conventional; but it was an ideal that had descended
from the majestic to the charming. There was everywhere dif-
fused a refined elegance, a delicate voluptuousness, what the
epoch itself specified as "the quintessence of the agreeable, the
complexion of grace and charm, the adornments of pleasure and
love."*[1]

With these general remarks about Old Regime society,
Edmond and Jules de Goncourt began their essay on
Boucher in their celebrated account of eighteenth-
century French art, first published in 1860. To begin this
catalogue with a quote from the Goncourts might seem
hopelessly passé. In recent years it has become custom-
ary to critique their view of the art of the Old Regime
as effusive and ahistorical, one that takes a nostalgic
look back to an elegant age that was supposedly free
from the turmoil of their own time. The Goncourts
gave scant attention to the many accomplished if less
celebrated masters who worked in the public sphere,
who continued the grand tradition of Charles Le Brun
in creating important and serious paintings for the
crown, the church, and the château.[2] Their provocative
analyses of paintings—intelligent and readable as they
are—depended as much on their personal reactions and
desires as they did on an effort to produce a rigorous
history of eighteenth-century culture. Without a doubt
their reductive view has had a strong influence even in
recent accounts of the period, perhaps because it is such
a seductive one.[3] But their sometimes hyperbolic dis-
cussions still have resonance for much of eighteenth-
century French art. This is especially true in regard to
the genre paintings and prints that are the focus of *In-
timate Encounters*; while many of these works of art were
exhibited in public and often occasioned comment
from critics, they were primarily aimed at the connois-
seur and amateur, who in the eighteenth century played
an active role in the cultural life of Paris. Small in scale
and delicately finished, these works invite close inspec-
tion by the viewer, who must enter into a dialogue with
them to appreciate fully their artistic value and subtlety

of meaning. Certain artists—Jean-Baptiste Greuze is
the principal example—appealed to a broad spectrum
of the art-loving public, but few of the genre paintings
produced during this period are declamatory and di-
dactic: this was the prerogative of history painting, with
its mandate to edify the mind and move the passions.

Intimate Encounters presents works of art that, on the
whole, undoubtedly would have appealed to the
Goncourt brothers. The exhibition explores images of
love and domesticity in eighteenth-century French
genre paintings and prints through their principal man-
ifestations: the *fête galante*, the pastoral, the *tableau de
mode*, the "middle-class" interior, moralizing and senti-
mental scenes of family life, and the *goût hollandais*.
These scenes are populated by the haughty aristocrat,
the vain seductress, the easygoing swain, the tired ser-
vant, the attentive mother, and the impish child: in
short, characters that would seem to justify the Gon-
courts' claim that the eighteenth century was a period
in which the graceful and delicate cabinet picture won
out over the didactic canvas painted in the grand man-
ner. While at different times certain types predomi-
nated—*fêtes galantes* and pastorals at the beginning of
the century, *scènes familières* and images influenced by
Dutch and Flemish painting in the second half—there
was no simple progression of themes over the course of
the century, and at any moment a variety of styles and
subjects was employed by genre painters. *Intimate En-
counters* concentrates on images of love and domestic-
ity, but it also offers a sense of the development of genre
as a whole, demonstrating the remarkable diversity of
styles, purposes, and meanings that is characteristic of
all French painting of the Old Regime.

The "intimate encounters" in the title of the exhibi-
tion is meant to suggest several distinguishing qualities
of the works of art it features, as well as its organizing
principle. For a start, most of the imagery depicted
in genre paintings is drawn from the private sphere
of eighteenth-century experience, which in the Old
Regime was indeed often conceived in intimate terms:
a suitor declaring his devotion in a salon, young lovers
playing in a garden retreat, a woman daydreaming over
the pages of an erotic novel, a working-class family

gathered together in a humble room, a servant pausing in her labors in a basement kitchen. It may seem paradoxical that, during a period when the role of the public sphere was undergoing a profound expansion in French social and artistic life, many genre painters concentrated on the familiar and commonplace, leaving the grand themes of public art to the history painters. Yet it was the very familiarity of this imagery that captured the imagination of spectators, and that placed genre paintings, for a time, in the center of artistic discourse. These works are the focus of the present exhibition, which concentrates on representations of private life at the expense of the occasional, although not unimportant, depictions of public spectacle—the boulevards of Etienne Jeaurat or the marketplaces of Nicholas-Bernard Lépicié, for example—that were produced in far fewer numbers during this period.

In many of the images presented here, the persons depicted—men and women, women and children, and sometimes all three—"encounter" one another in a variety of situations, from the carefully orchestrated aristocratic social rituals in a *fête galante* by Jean-Antoine Watteau (cats. 2 and 3), to an erotically charged confrontation by François Boucher (cat. 11), to—striking a very different note—a quiet discussion between a governess and her charge by Jean-Siméon Chardin (cat. 17) or the hushed adoration of a child by its parents in a painting by Jean-Honoré Fragonard (cat. 25). But there is also the encounter—more elusive but no less important—between the work of art and the viewer. The subtle dynamics of viewing were concepts that greatly interested eighteenth-century critics, and many of the pictures included in *Intimate Encounters* demand from the spectator engagement in a careful and protracted visual dialogue.[4] It is hoped that this dialogue—between the viewer and the works of art but also between the images themselves—will be among the chief enjoyments of this exhibition and catalogue.

We have sought to exhibit works produced by the leading artists of the period, many of whom remain in the pantheon of the great painters of European art history: Watteau, Boucher, Chardin, Fragonard, and Greuze, to cite the most famous. Eighteenth-century France produced an enormous number of capable, well-schooled, and interesting artists, the result of an efficient and rigorous training program introduced by the Royal Academy of Painting and Sculpture. Several of these less celebrated, if still engaging, *petits maîtres*— Jean-Baptiste Pater, Etienne Aubry, Martin Drolling, among others—are included not only for their own aesthetic merit but also to demonstrate the broad range of talent in Old Regime France. Nevertheless, the

major masters predominate. This may seem unusual in an exhibition that takes a thematic approach, one that focuses on ideas and issues as much as on the celebration of individual talents. Yet too often thematic exhibitions overly depend the marginal or peripheral example, perhaps with the thought that the works of less lofty artists are better reflections of social practice, whereas the "universal" values of great art transcend connection to a specific time and place. According to this point of view, only "bad art" mirrors society.[5] In this exhibition, by contrast, it is assumed that the major work of art has the most to reveal and best embodies the complexities and richness of cultural ideas and social practice, thereby offering the greatest reward to the interpreter.

Genre painting (in the modern sense of the term— that is, pictures of everyday life) encompassed a wide range of subjects, but during the Old Regime genre artists focused much of their attention on depictions of courtship, family life, and the routines of the household. Sometimes anecdotal, sometimes idealistic, these pictures often record with great accuracy the look and feel of eighteenth-century life across a wide spectrum of social classes. The degree to which these works of art represent reality or embody cultural ideals and aspirations is a vexing problem, however, and that question is explored in the essays and the catalogue entries that follow. The great French critic Thoré-Burger, writing in 1858 about Dutch art, referred to genre painting as "a kind of photograph,"[6] but a direct equation between any depicted scene and reality, however defined, is obviously far too simplistic. Although many of the works in the exhibition, from Jean-François de Troy's *Declaration of Love* (cat. 9) to Chardin's *Saying Grace* (cat. 18) to Louis-Léopold Boilly's *Portrait of the Artist's Wife in His Studio* (cat. 51), do indeed appear true to nature, as "transcriptions" of everyday life, others, such as Boucher's *Les Sabots* (cat. 14) or Fragonard's *Blindman's Buff* (cat. 21), unmistakably fall into the realm of pure fantasy. This is not to deny that many of the pictures in the exhibition can inform the viewer about French life in the eighteenth century—its manners, styles of dress, and physical environments. Nevertheless, one of the principal messages of *Intimate Encounters* is that all genre pictures—like all works of art—are to varying degrees idealizations, cultural constructions that embody meanings about the social world from which they spring. In their inclusions, exclusions, combinations of motifs, and approaches to their subjects, they may express complex ideas and beliefs but they do not straightforwardly mirror social realities. And through extraordinary artistry, these homespun and inauspicious

scenes retain a force and beauty that make their subjects memorable and enduring.

Indeed, apart from celebrating the remarkable quality and visual appeal of the paintings and prints, which are considerable, the exhibition and catalogue aim to explore the meanings of these works within the broader context of eighteenth-century French culture and history. The explosion of scholarship in French eighteenth-century studies in the past twenty-odd years has been remarkable, and this has been no less true in the history of art. Where once *dix-huitièmistes* might have worked on the margins of art history's mainstream, now the study of Old Regime art, culture, and politics has witnessed a reinvigoration comparable, perhaps, to the period's first rediscovery by the Goncourt brothers and their fellow critics more than a hundred years ago. Moreover, much recent scholarship has drawn fruitful connections between art and other aspects of social and cultural practice, taking advantage of the exciting and provocative work being carried out in social and political history, literary criticism, and gender and women's studies, to name only a handful.

The current catalogue seeks to draw together some of these new lines of historical inquiry. The interdisciplinary nature of the issues raised by the images in *Intimate Encounters* is reflected in the essays in this catalogue, which investigate the themes of love and domesticity and of genre from a variety of points of view and methodological approaches. The introductory chapter surveys the evolution of the concept of genre painting in France, discussing its changing status as the century progressed, the criticism of genre by reform-minded critics in midcentury, and the strategies artists adopted to combat this critique. Virginia Swain's essay analyzes several of the paintings in the exhibition within the context of the eighteenth-century debate over the rights of women, particularly as it was expressed in the literature of the Old Regime. Sarah Maza's provocative discussion seeks to provide a new framework in which to understand properly this period's fascination with sentimental themes—in art, literature, and even the politically charged causes célèbres that marked the prerevolutionary period. Her analysis provides an excellent foil to Mark Ledbury's ground-breaking study of the relationship between genre painting and contemporary theater, particularly as it sheds light on the innovative character of the art of Greuze. Anne Schroder explores the world of genre prints, the relationships between painters and printmakers, the changing meanings that images underwent, and the evolving market for high-quality prints. Finally, the individual catalogue entries on the paintings explore the varied, sometimes amusing, and always provocative images that make up the heart of the exhibition.

The organization and realization of this exhibition and catalogue have involved the assistance of many people, without whose help the project would have been immeasurably more difficult, if not impossible, to complete. From the time of the first proposal four years ago, I have had the unflagging support of Timothy Rub, the director, whose guidance and encouragement have seen the project over many hurdles and difficulties. Juliette M. Bianco, the exhibitions coordinator, has contributed to all aspects of the exhibition, and her name justly appears on the title page of the catalogue. Suzanne Gandell, the associate director, has ably overseen all facets of the exhibition and catalogue, while Kellen Haak, the registrar, and his staff have coordinated the complex details attendant on a traveling exhibition with characteristic good humor and professionalism; Evelyn Marcus, curator of exhibitions, and her department designed the graceful installation at the Hood Museum of Art. I am also pleased to acknowledge the help of Christine Crabb, Theresa Delemarre, Katherine Hart, Barbara J. MacAdam, Mary McKenna, and, especially, Nancy McLain. At Dartmouth College I have benefited from the expertise of Margaret Darrow, Stephanie Hull, Margaret Lawrence, Bill Pence, and Margaret Spicer. In writing the catalogue I have relied greatly on the capable assistance of Barbara Reed and her staff at the Sherman Art Library.

The planning of the exhibition was greatly facilitated by the generosity of the National Endowment for the Arts and the National Endowment for the Humanities, which provided the resources to assemble an exhibition committee composed of some of the leading scholars in eighteenth-century studies: Colin B. Bailey, Philip Conisbee, Sarah Maza, Donald Posner, and Virginia Swain all deserve thanks and credit for bringing their knowledge, ideas, and enthusiasm to this project. I would like to acknowledge in particular Edgar Munhall, who helped in a variety of ways, not least by hosting an important planning meeting in the elegant rooms of the Frick Collection in New York. I am most grateful to the contributors to the catalogue, each of whom wrote a probing and insightful essay: Mark Ledbury, Sarah Maza, Anne Schroder, and Virginia Swain. At Princeton University Press, Patricia J. Fidler, the art history editor, expertly guided the manuscript to its final form, and Bruce Campbell designed a catalogue that is every bit as beautiful as the works of art it features. My warm thanks go as well to Lawrence W. Nichols and David Steadman at The Toledo Museum of Art and Edgar

Peters Bowron and Peter Marzio at The Museum of Fine Arts, Houston, who have been ideal colleagues with whom to share this exhibition.

There would have been no exhibition at all without the support of the many institutions and private collections that agreed to lend their precious works, and I am deeply grateful for their generosity. For help in various and important ways, I am also pleased to thank Joseph Baillio, Raphael Bernstein, Görel Cavalli-Björkman, Thomas Crow, Jean-Pierre Cuzin, Robert Dance, Marianne Roland Michel, Pierre Rosenberg, David Tunick, and Alan Wintermute. A special acknowledgment is due to Donald Rosenthal, whose own plans to mount an exhibition of French genre painting unfortunately were not realized. Conversations with Dr. Rosenthal were extremely helpful to me in working out my own ideas for the present exhibition, and while ultimately it took its own form, I benefited from the research and materials he had already assembled. I also wish to thank David Acton, Lynne Ambrosini, Katharine Baetjer, Emma Barker, Tony Boring, John Buchanan, John Bullard, Victor Carlson, Alan Chong, Michael Conforti, Malcolm Cormack, Bruce Davis, Diane De Grazia, Everett Fahy, Ivan Gaskell, Dave Green, Tim Hardacre, Heather Haskell, Robert Haywood, Jennifer Helvey, Mary Tavener Holmes, Penelope Hunter-Stiebel, Patricia Ivinski, Bernard Jazzar, Alain Joyaux, J. Richard Judson, Rhonda Kasl, Martha Kelleher, Steven Kern, George Keyes, Sylvain Laveissière, Tomás Llorens, J. Patrice Marandel, Olivier Meslay, Steven Nash, Jeffrey Nintzel, Michael Parke-Taylor, Vivian Patterson, Edmund Pillsbury, Joachim Pissarro, Alan Salz, Maurice Segoura, George

T. M. Shackelford, Andrew Shelton, Susan Siegfried, Steven Spiro, Guy Stair-Sainty, Perrin Stein, Peter Sutton, Carol Togneri, Mary Vidal, Roger Ward, Sarah Wells-Robertson, James Welu, Gloria Williams, Humphrey Wine, Martha Wolff, and Valerie Zell.

Finally, two people deserve special recognition for their crucial support and the confidence they have had in this project since its inception. Over the years Philip Conisbee has remained a perfect colleague and good friend, and I have benefited immeasurably from his wise counsel and sound advice. My wife, Kelly Pask, has been in proper measure encouraging and critical, and always an ideal collaborator and companion.

1. Edmond and Jules de Goncourt, *French Eighteenth-Century Painters*, trans. Robin Ironside (London, 1948), 55.
2. For one of the first serious attempts to evaluate eighteenth-century painting within the context of its own artistic values, see Philip Conisbee, *Painting in Eighteenth-Century France* (Ithaca, N.Y., 1981). The exhibition catalogue by Pierre Rosenberg, *The Age of Louis XV: French Painting, 1710–1774*, exh. cat. (Toledo, Chicago, and Paris, 1976), gives a more inclusive view of the French art of the Old Regime. For a discussion of the impact of the Goncourt model on recent art history, see Mary D. Sheriff, *Fragonard: Art and Eroticism* (Chicago, 1990), 16–29.
3. David Wakefield, *French Eighteenth-Century Painting* (London, 1984).
4. Influential studies of these phenomena include Michael Fried, *Absorption and Theatricality: Painting and Beholder in the Age of Diderot* (Berkeley and Los Angeles, 1980); Norman Bryson, *Word and Image: French Painting of the Ancien Régime* (Cambridge, 1981); and Marion Hobson, *The Object of Art: The Theory of Illusion in Eighteenth-Century France* (Cambridge, 1982).
5. Robert L. Herbert, *Barbizon Revisited*, exh. cat. (Museum of Fine Arts, Boston, 1962), 37.
6. T.E.J. Thoré [W. Bürger], *Musées de la Hollande* (Brussels, 1858), 1:322–24.

Intimate Encounters

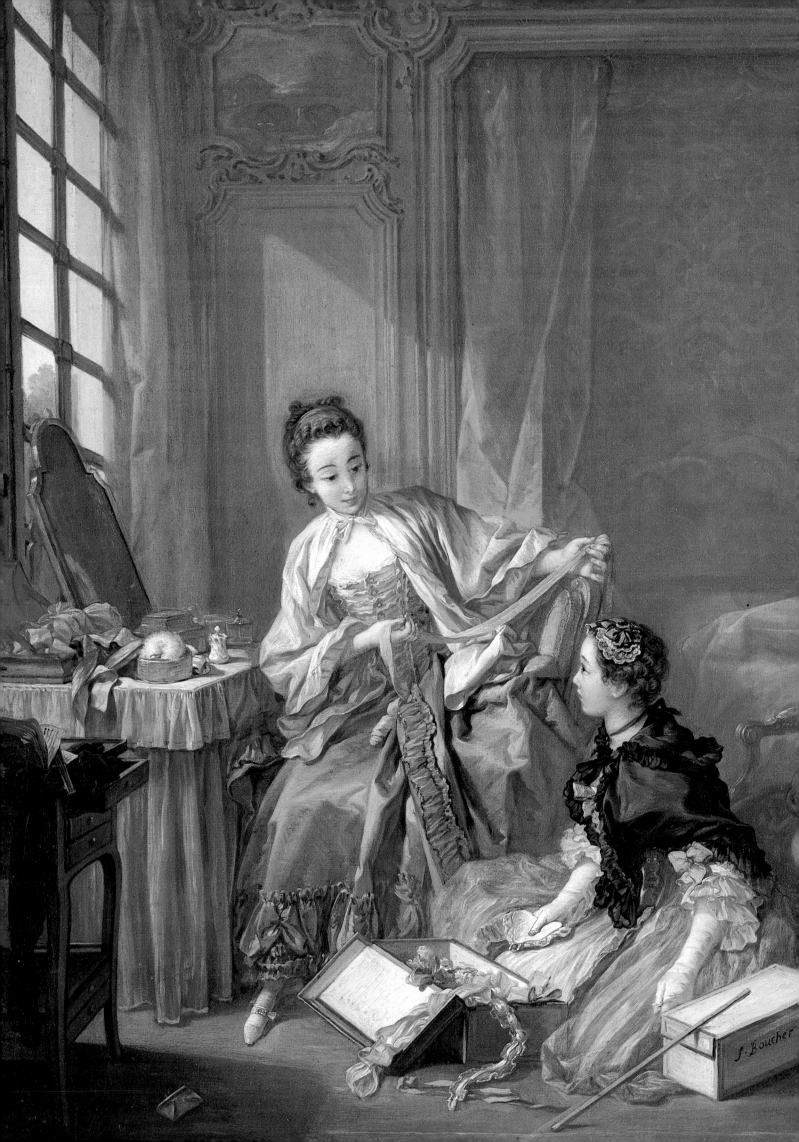

Love, Domesticity, and the Evolution of Genre Painting in Eighteenth-Century France

RICHARD RAND

The nature of the term *genre* in the language of eighteenth-century French art is complex and elusive. Literally translated as "kind" or "type," the word had numerous meanings and associations, from categories of subject matter to modes of painting.[1] What we now consider a genre painting—defined not long ago as "a scene of everyday life wherein human figures, being treated as types, are anonymously depicted"[2]—reflects a restrictive meaning that won widespread use only at the end of the Old Regime. For much of the eighteenth century, when used as a category of art the term was understood more broadly and was able to accommodate a far greater repertory of subjects than we would acknowledge today. As the Enlightenment philosopher and critic Denis Diderot acknowledged in his "Notes on Painting," written about 1765:

> The appellation "genre painter" is indiscriminately applied to painters of flowers, fruit, animals, woods, forests, and mountains, as well as to those borrowing their scenes from everyday domestic life. Teniers, Wouvermans, Greuze, Chardin, Loutherbourg, and even Vernet are all considered genre painters.[3]

In the official ranking of subject categories—the hierarchy of genres as promulgated by the Royal Academy of Painting and Sculpture—history painting stood unchallenged as the pinnacle of artistic endeavor, followed by portraiture and then *genre,* loosely defined to include all the types of art enumerated by Diderot. But throughout the eighteenth century the academy was not always doctrinaire in imposing the hierarchy; there existed in practice a certain fluidity among categories of subject matter that can sometimes further cloud the already muddy waters of genre painting. This is especially true of pictures that represent domestic subjects—for example, the group portrait by François-Hubert Drouais in the National Gallery of Art (fig. 1).[4] This monumental work—indeed, its sheer size places it in the exalted realm of history painting—is unusually anecdotal for a group portrait. The mother, seated before her dressing table, weaves flowers into the hair of her daughter while the father leans over the back of her chair, holding a letter. The painting is dated April 1, 1756, a date known in France as *poisson d'Avril,* a reference to the astrological sign Pisces and a day usually reserved for practical jokes (a tradition that has survived as April Fool's Day) and gift giving. Drouais sought to enliven the conventions of group portraiture by creating a setting and purpose for the gathering; he used Boucher's *Milliner (Morning)* (cat. 13) as a model. That work is a pure genre scene representing one of the times of day, from which Drouais borrowed the arrangement of figures and setting. By conceiving of his portrait group on such a grand scale and by giving it an intriguing storytelling aspect, Drouais created a surprising meld of genres, even to the extent of incorporating—in the details of the vanity table, the flowers fallen to the floor, and the open box—what was considered the lowest category of art, still life.

Although Drouais's innovative portrait was not altogether new in conception—painters such as Watteau and Nicolas Lancret (see cat. 6) had previously created "genre portraits" that were in turn related to the vogue in England for conversation pieces—the emphasis he placed on the warm family feeling among the sitters represented a developing trend in genre painting and portraiture in the 1750s.[5] Like Boucher's *Milliner,* which offers an intimate peek into the daily routine of an aristocratic lady, Drouais's painting celebrates domestic life, and both pictures clearly distinguish the roles of the protagonists. Boucher's young milliner kneels before her social better, at whom she gazes with a mixture of awe and even slight apprehension. Despite the obvious love shared by the family members in Drouais's portrait, their roles are subtly differentiated according to gender: the mother sits in the middle before her vanity table, attending to her daughter's costume and teaching her the importance of appearances; the man of the house, by contrast, stands at the side, as if he has just entered this "feminine" sphere, and gazes down admiringly and with a hint of proprietary satis-

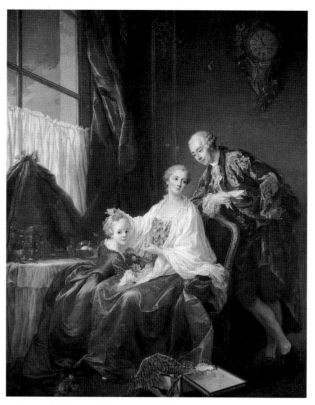

1. François-Hubert Drouais, *Family Portrait (April Fool's Day, 1756)*, 1756, oil on canvas, Samuel H. Kress Collection, © Board of Trustees, National Gallery of Art, Washington, D.C.

faction. This emphasis on the specific roles within the family would become a common feature of French portraiture in the second half of the eighteenth century, as the examples by Louis-Michel Van Loo (cat. 33) and François-André Vincent (cat. 39) demonstrate. Yet Drouais, like Van Loo, is not heavy-handed with such distinctions, and we are left with the sense that this is a model of conjugality, one that would increasingly come to dominate the ideology of the family in prerevolutionary France.

As a group portrait, Drouais's picture would have been easily classified, yet its incorporation of the forms and even the meanings of genre painting underscores the tendency of painters to shift among or bring together various subject categories. If nothing else it exemplifies the increasing recognition of genre painting in the middle of the eighteenth century.[6] This changing status had much to do with the evolving definition of the term *genre* itself, from a meaning that was at first indicative of a diverse range of subjects, as Diderot noted, to one that specifically referred to images of domestic or common life. In their important article on the subject, Wolfgang Stechow and Christopher Comer demonstrate how, after various permutations, the modern conception of *genre painting* was established at the end of the eighteenth century.[7] The increasingly narrow meaning of the term was in large measure a response to the new seriousness with which scenes of everyday life were regarded in the second half of the century. By the 1760s and 1770s, *genre* was beginning to acquire its restrictive definition, as commentators came to recognize the essential differences between scenes of daily life and such subjects as landscape and still life. A critic at the Salon of 1775 described the most common subject matter of genre painters in terms that are easily reconcilable with modern usage: "[A genre painter depicts] all that various scenes of life present most picturesquely to his eyes or imagination: water carriers, fighting Savoyards, the interior of a household, a painter packing up, a father of the family surrounded by his children, a woman cooking."[8] The important phrase here is "scenes of life," which distinguished genre from landscape and still life. In 1791, Quatremère de Quincy would define genre painting as "a scene of common or domestic life."[9]

THE CRITIQUE OF GENRE

Genre painting in its broad sense—still life, landscape, and scenes from daily life—was historically undervalued by the Royal Academy of Painting and Sculpture. The academy was founded in 1648 with several goals, not the least of which was to monopolize the most talented artists in the service of the king, whose ultimate glory it was their mandate to celebrate; as compensation, painters were recognized as practitioners of a liberal art, one that was distinguished from the craft-based tradition of the guild system. Thus the highest goal of painting, like that of poetry, was to treat subjects of "universal" significance. Such art was the product of the painter's creative imagination, in which the hallowed themes of ancient mythology and classical and biblical history could be translated into compelling narrative works; only such paintings, it was felt, had the capacity to stir the viewer's emotions and soul—in short, to provide moral exemplars. Most scenes of everyday life failed to reach these lofty goals simply because their subject matter was of a lower order: anonymous folk in their daily rounds, the drudge work of the servant class, the frivolous intrigues of high society. These were not themes to edify the French people.

Correspondingly, in its pedagogic role the Royal Academy privileged history painting; there, artistic training focused on the representation of the human body, the copying of works of antiquity and recognized masters, and the study of classical and biblical texts. The Prix de Rome, the annual student competition whose winner was sent to the academy's branch in

Rome for several years of intensive study, was granted during the Old Regime only to history painters. Likewise, the academy's professors could be elected only from the ranks of *peintres d'histoire*. Artists who wished to pursue careers as still-life painters or landscapists had little recourse other than to gain practical experience from an established master. The genre painter's art was one based in craft. It was a mere reflection of reality; thus its skills—so the argument went—could easily be assimilated in the studio.

The power and appeal of genre painting was rarely in doubt, however, and its most celebrated practitioners were praised in sometimes lavish terms. The Abbé Gougenot's comment that "the genre of M. Chardin [an artist who never once painted a mythological god or Christian saint] comes very near to history painting"[10] was no doubt an enthusiastic overstatement, but it was not unique. As early as 1706, André Félibien, the theorist who formulated the hierarchy of genres, wrote that the genre paintings of the Le Nain brothers (see fig. 4) could be admired for their visual beauty and even considered histories of a "less noble kind."[11] But he quickly added that such pictures could never elevate the mind or move the passions in the manner of historical and religious painting: "That is why these kinds of paintings can only be of interest for a moment or small interval, and we see few knowing people who give them much notice."[12] These sentiments were repeated by the Abbé du Bos in his seminal *Réflexions sur la poésie et sur la peinture*, first published in 1719: "The imitation therefore of those objects [country feasts and guardhouses] may possibly amuse us for some moments, may even draw from us an applause of the artist's abilities in imitating, but can never raise any emotion or concern."[13] Despite the increasing respect won by genre painting in the eighteenth century, for many observers genre remained the inferior stepchild of history painting; as a critic in 1775 put it rather caustically, "Genre painters are those who do not have the talent to be history painters, or who have abandoned [history painting] to treat minor subjects."[14]

Yet throughout the eighteenth century many critics and theorists recognized not only the difficulty of producing a successful genre painting but also the transforming effects that art could have on any subject, no matter how lowly. Roger de Piles remarked that it was better to excel at a minor genre than to paint historical subjects ineptly, and Watteau was alleged to have considered genre as difficult to succeed in as history painting.[15] Attitudes such as these underscore the increasing importance given in the early eighteenth century to the pictorial properties of art, regardless of its subject matter. Later in the century, Charles-Nicolas Cochin, the academician and champion of Chardin, would tell the academy: "The artists who were working in this highest genre were easily persuaded that if one were a successful history painter one could easily succeed in the so-called minor genres, which are only minor if they are handled in a minor way. How difficult these are is proven when one considers how difficult it is to achieve such a degree of perfection."[16] Cochin's comment that works of art are only minor if they are handled "in a minor way" stemmed from a tradition in eighteenth-century critical theory that valued a well-conceived work of art regardless of where it fell in the hierarchy. The Abbé du Bos had indeed stated, "'Tis not so much the object, as the artist's abilities, that draws our curiosity," yet he steadfastly maintained that noble subjects such as Poussin's *Seven Sacraments* "would engage our attention much more than the guard-house."[17] It was the first half of Du Bos's formulation, however, that would come to be emphasized. Later in the century Baron Melchior Grimm—the editor of the *Correspondance littéraire*, which circulated Diderot's famous exhibition reviews—would articulate the question this way: "It is not the object itself that one wishes to see, but the truest and most felicitous imitation of it. . . . In a work of art we look for the skillful, the fine, delicate lie that establishes between us and the imitation a secret exchange of feelings and ideas."[18] It was sentiments such as these that allowed for the critical and popular success of artists such as Chardin and the landscapist and marine painter Joseph Vernet in the middle decades of the eighteenth century.

THE POPULARITY OF GENRE: SALONS AND COLLECTORS

The recognition of painting's unique pictorial properties was one way for the academy to acknowledge the increasing influence of connoisseurs and amateurs in the artistic life of early-eighteenth-century Paris. Although history painting's preeminent position would never be challenged, the academy was willing to accommodate genre painters of great talent. This was most tellingly demonstrated in the case of Watteau, whose innovative works provoked the academicians to expand the hierarchical categories to incorporate his unique art. In 1717 he was accepted into the academy as a painter of *fêtes galantes*, an elusive term usually understood to refer to a gathering of men and women in the open air engaged in conversation, playacting, and flirtation (see cats. 2 and 3). Watteau's interweaving of nature and fantasy lends to many of his *fêtes* a lyricism

and poetic beauty that seem far removed from the quotidian world, yet such works could not be considered history painting.

Throughout the century genre paintings enjoyed a prominent place outside the realm of official stricture and academic dogma. Aside from such genre practitioners as Chardin and Greuze, for example, many artists, even history painters such as Boucher, who would be named First Painter to the King, and Charles-Joseph Natoire, eventually appointed director of the French Academy in Rome, produced genre works on numerous occasions. In doing so they were following the market as much as satisfying a personal whim, for history paintings on a large scale were expensive and intellectually demanding to produce, and clients—for the most part reduced to church and crown, along with the rare private collector—hard to come by. As late as 1796, at the height of the resurgence of history painting, the critic Polyscope could lament:

> But despite the circumstances and the current taste, a grand and beautiful history painting that has cost great sums for the canvas, the models, etc., still can hardly find a buyer, while a painter can much more easily pass off a few little genre pictures that were produced at hardly any cost. One prefers work that makes a living over work that procures nothing but honor.[19]

In 1796 there was little in the way of public funds to spend on grand historical paintings, unlike in the last decade of the monarchy. Yet this critic's complaint was one of long standing; since the middle of the century, the sight of eminent artists painting genre pictures was often blamed on the influence of connoisseurs, who were accused of being more likely to purchase high-end luxury items to decorate their *hôtels* than to commission noble works that would inspire the nation. Claude-Henri Watelet, writing in the *Encyclopédie*, the great mouthpiece of the Enlightenment, derided artists who wasted their talent painting genre subjects: "It cannot be repeated enough today, that all those men who misplace the use of their talent by letting whimsy, fashion, or bad taste control it, are not only completely useless citizens, but furthermore are extremely detrimental to society."[20]

Several of the paintings exhibited in *Intimate Encounters* were commissioned or purchased directly from artists and reflect the proclivity for beautiful, decorative, and refined works; these were especially sought in the middle decades of the eighteenth century, often by the most socially elevated clients. This was particularly the case for those works intended as decorations for specific settings, such as the large group of pictures

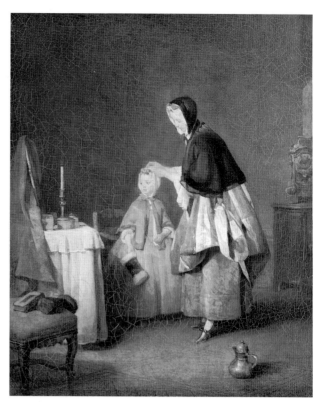

2. Jean-Siméon Chardin, *The Morning Toilet*, Salon of 1741, oil on canvas, Nationalmuseum, SKM, Stockholm.

commissioned from a variety of painters for the new royal apartments at the Château of Fontainebleau (see the painting by Natoire, cat. 15). It was not unusual for genre scenes to be painted for specific prestigious clients; Boucher's *Milliner* (cat. 13) was commissioned by Count Tessin, Swedish envoy to France, for Crown Princess Louisa Ulrica, who also acquired several of the greatest masterpieces by Chardin (fig. 2).[21] Greuze's career had been launched with the help of the Marquis de Marigny, who would become *directeur-général des bâtiments*—the king's minister responsible for all matters relating to art—and by the prominent collector Ange-Laurent de La Live de Jully, an *associé libre* (honorary member) of the Royal Academy.[22] During his trip to Italy in 1755–1757, Greuze was asked by Marigny to paint a pair of genre scenes for the private rooms of his sister, Madame de Pompadour, the king's *maîtresse en titre*, at Versailles. Greuze responded with two pastoral paintings in the fluent style of Pompadour's favorite artist, Boucher (cat. 28 and fig. 60). Such cultivated clients put the lie to the traditional equation between genre's "humble" subject matter and the so-called rise of the bourgeoisie in eighteenth-century France.

Interested art lovers and prospective buyers could enjoy all types of paintings at the public displays of art in Paris. The most spendid were the exhibitions organized by the Royal Academy, held on a regular basis

(every two years between 1748 and 1795) in the Salon Carré of the Palais du Louvre. Instituted as a means of displaying and validating the works produced by the academy's artists, these "Salons," as they were called, brought an unprecedented number of people from all classes into contact with works of art of the highest quality.[23] The academician Cochin credited the establishment of regular Salon exhibitions with "reviv[ing] painting by making known new talents and by inspiring the taste for art in a number of people who would otherwise never have thought of it."[24] He might have added that the exhibitions specifically served to elevate the status of genre painting by giving it a public venue that it did not have previously. Although history paintings were usually accorded the most prominent positions in the installation of the exhibitions, for many visitors they were not the chief attraction. As one critic wrote in his review of the exhibition in 1775: "I turn with pleasure to genre painting; it is the triumph of the French School in our century. I do not say that as a criticism, as might those many people who think that only historical painting is worthy of their attention. Those lesser genres, as they like to call them, have been and still are the glory of the Flemish School, our admiration of which is well demonstrated by the prices we sacrifice to it."[25]

Although the official Salons were unquestionably the most important vehicles for presenting art to the public, they were by no means the only forums. Paintings of all kinds, but especially genre paintings, were also exhibited in alternative venues, where the academic hierarchy was less of an issue. Chardin, for one, first came to prominence at the Exposition de la Jeunesse (exhibition of youth), held nearly every year in the Place Dauphine on the Ile Saint-Louis; genre paintings were prominent among the works exhibited at the artists' guild, the Académie de Saint-Luc, until its suppression in 1776; and independent spaces such as the Colisée and the Salon de la Correspondance, as well as celebrated private collections—many of which were made available to artists, interested amateurs, or visiting dignitaries—provided additional ways of making works of art available to a growing audience.[26]

Although there was an active network of dealers and auction houses in Paris, particularly in the second half of the century, many works of art, especially genre paintings, were sold at or shortly after the Salon exhibitions, which served as a kind of informal salesroom. Chardin and Greuze especially were extremely adept at selling work at the Salons. Indeed, one of the purposes of Diderot's celebrated Salon reviews, which were circulated privately to the exclusive and international circle of readers of Baron Grimm's *Correspondance littéraire*, was to help distinguish those works that foreign clients might acquire for their own collections.[27] As Anne Schroder discusses in her essay in this catalogue, genre painters also manipulated the print trade to disseminate their compositions and advertise their paintings. By the middle of the eighteenth century, genre painting, with its heightened visibility and consequently burgeoning market, came to play a prominent role in the critical debate concerning the current state of French painting.[28]

Concurrent with the increasing attention given to genre painting was the rise of art criticism. Following the publication in 1747 of La Font de Saint-Yenne's influential *Réflexions sur quelques causes de l'état présent de la peinture en France*—arguably the first influential work of modern art criticism[29]—a new chorus of voices, sometimes representing official opinion, often espousing independent and controversial ideas, was added to a growing public dialogue on the practice and purpose of art. Genre painting was particularly well positioned to benefit from this phenomenon. Because it drew its imagery from everyday life—from the familiar world of the present—genre could be more easily judged and evaluated by ordinary viewers. An appreciation of history painting, by contrast, depended at least to a degree on a working knowledge of classical and biblical subjects (which, admittedly, would have included a good percentage of Salon visitors during this period), but also an understanding of academic principles, inherited from the canon of admired Old Masters, concerning composition, the representation of gestures and facial expressions, and the proper presentation of narrative. One of the driving forces behind genre's ascendancy in the second half of the eighteenth century was precisely its ability to galvanize the imagination and enthusiasm of the public and independent critics.

GENRE AND FEMININITY

With the emergence of art criticism in the late 1740s, however, the critique of genre took on a new dimension, particularly in regard to those pictures produced by such rococo artists as de Troy, Boucher, and Chardin. This critique was part of a larger condemnation by critics in the middle of the century, who accused even the most honored history painters of failing to live up to their public responsibilities, of too often painting works with an eye to decorating the lavish *hôtels* of rich collectors than to ennobling the public.[30] The subjects they so often chose—Diana at the bath, Venus and Adonis, or Cupid and Psyche—might technically have

come under the rubric of "history painting"—*histoire galante* was the phrase often employed—but they were hardly enriching and uplifting narratives.

A concentrated focus on themes of domesticity and sexual intrigue exposed genre painting to even greater criticism from the "antirococo" critics than did mythological painting. For some writers, many genre pictures—because of both their subject matter and the style in which they were usually painted—represented a problematic relationship between art and femininity. Writing in 1747, La Font de Saint-Yenne set the tone by renouncing artists who waste their talent painting in the lower genres, rather than concentrating on history painting. Like writers who vainly attempt to treat all kinds of subjects, these artists are "seduced by a jealousy" described by La Font as "this odious daughter of pride and, too often, sister of mediocrity." By couching his criticism in these terms, speaking of genre painting's "seductive" qualities, and how it leads to vanity and jealousy (clearly feminine traits for La Font) he sought to distinguish it from the higher calling of history painting. "The history painter," he famously wrote, "is the only painter of the soul, others paint for the eyes."[31]

La Font's formulation essentially would be repeated by the influential critic Claude-Henri Watelet, under "Expression" in the *Encyclopédie*: "The word expression applies to action and the passions, just as the word imitation refers to forms and colors: one is the art of rendering intangible qualities, like movement and the affectations of the soul; the other is the art of reproducing the forms that our eyes distinguish between one and another object and the colors that produce the parts that compose their surface."[32] Similarly, another writer in the *Encyclopédie* distinguished between "beautiful" (*beau*) and "pretty" (*joli*): "The beautiful is grand, noble, and regular—we admire it; that which is pretty is fine and delicate: it pleases."[33] History painting—the representation of physical action—engages the spectator in a narrative, creating a dialogue between the beholder and the image for the purpose of improving the spirit and stirring the passions; genre painting—relying as it does on pleasing coloristic effects and a re-creation of the materiality of things—conjures up a world of appearances that is presented merely for one's superficial delectation. History painting and the minor genres were thus described in gendered terms. The opposition to genre painting and the rococo can be understood as part of a more general cultural and political critique of the influence and social pretensions of women in eighteenth-century France.[34]

Despite the wide range of everyday subjects available to artists, the majority of genre painters in the early and mid-eighteenth century focused on what would have been termed the "woman's sphere": morning toilets, housework, child care, preparations for the ball, intimate rendezvous, and so on. Such subjects far outweigh the representation of men in their daily rounds or the kinds of boorish scenes that make up a significant percentage of seventeenth-century Dutch and Flemish genre painting. In 1753 the Abbé Raynal praised Chardin, who "has always avoided these images humiliating for humanity."[35] Yet for many critics the focus on domestic subjects was almost equally problematic. For a woman painter such as Marguerite Gérard (cats. 41–43), it seemed "natural," as a critic implied in 1804: "How Mlle. Gérard is seductive in her pretty pictures! What charm! What suavity, what happy choice of subjects! They could only have been conceived by an amiable woman, soft and sensible."[36] As a woman artist, of course, Gérard was barred from studying the male nude, a practice essential to the history painter. Thus she turned to subject matter that was readily available to her and to a style of painting based on direct observation. Male artists, it was felt, should direct their brushes toward ends that were more noble. Those words of praise for Gérard's art—seductive, pretty, charming—had been epithets hurled in the antirococo campaign. Of the rococo painters, François Boucher came to epitomize the degradation of taste that critics associated with the "feminization" of the arts. Diderot, an early champion of the artist, came to detest what he saw as the corruption of pictures such as *Les Sabots* (cat. 14). Boucher's "elegance," Diderot wrote, "his affectation, romantic gallantry, coquetry, facility, variety, brilliance, rouged flesh tones, and debauchery will captivate dandies, society women, young people, men of the world, and the whole crowd of those who are strangers to true taste, to truth, to right thinking, to the gravity of art."[37]

An art that privileged detail, tactility, and coloristic effects was inevitably derided as "feminine," as opposed to a "masculine" art like history painting that foregrounded strong draftsmanship rather than distracting color, that abstracted and idealized its imagery rather than glorified the quotidian details of the everyday world. The exquisite surface effects and manual dexterity associated with many genre paintings could be likened to traditionally feminine pursuits such as sewing and needlework: "[Chardin]," wrote the Abbé Raynal, "applies color in layers, one on top of the other, hardly mixing them so that his work somewhat resembles a mosaic of juxtaposed pieces, similar to *point carré* in embroidery."[38]

This clarifies the relationship between seventeenth-

century Dutch and eighteenth-century French genre painting. Svetlana Alpers has argued that Dutch artists sought an alternative to the Italian humanistic tradition, one that placed description and fidelity to nature above narrative and invention. Following from this theory, Whitney Chadwick has argued that this distinction "transform[ed] the relationship between the artist as male observer and the woman observed," resulting in an art that privileged intimate observation over grandiose conception, in contrast to the Italian model in which art sought the intellectual possession of the world.[39] This might account for the impression that many French genre pictures, particularly those by Chardin (cats. 16–20), but also those by Boucher (cat. 13) and even Fragonard (cat. 23), are presented almost from a "woman's point of view," in which the artist is fully immersed in the domestic sphere, so that the scenes seem to emerge on their own terms rather than being constructed from outside by a mastering hand. One anonymous critic, writing in 1741 of Chardin's *Morning Toilet* (see fig. 2), implies as much: "We observe a deep understanding of nature, first in his figures and the easy, accurate movements of their bodies, and secondly in the workings of their inner lives."[40]

This equation of genre painting and women's "inner lives" became a familiar refrain in much art criticism of the second half of the eighteenth century. Genre painting was deemed problematic for two primary, if conflicting, reasons. As an objective or naive rendering of everyday life it was an uncomfortable reminder of painting's roots in craft, and as such it conflicted with the essentially ennobling task of ambitious painting. Conversely, its captivating play on the visual attraction of bright colors and resplendent surface effects was viewed as distracting or even dangerously seductive, appealing to the eyes rather than enriching the mind and moving the spirit of the viewer. This dual aspect of genre painting paralleled the way women were described in much of the mainstream writing of the period. The *Encyclopédie*'s article "Femme," for example, contrasts the woman of simple virtue, who attends to her family and domestic life, with the woman of the world, whose affectations and charms exaggerate her "natural" desire to please: "This art of pleasing, this desire to be pleasing to everyone, this longing to please better than one's rival, this silence of the heart, this dissoluteness of the spirit, this continual lie called coquetry, seems to be a primitive trait of women." On the contrary, the good, natural woman's "happiness lies in her ignorance of what the world calls pleasure, her glory is in living unaware. . . . She has a reserved and dignified character that earns her respect."[41] If the first

woman is embodied in Boucher's paintings, as Diderot's words suggest, the simple, honest woman is Chardin's subject in *Morning Toilet* (fig. 2), as reflected in the comments of the anonymous critic at the Salon of 1741: "There is not a woman of the Third Estate who, passing by, does not think that she is seeing an image of herself, her domestic life, her straightforward ways, her bearing, the caprices of her children, her furnishings and wardrobe."[42]

In the middle decades of the eighteenth century, Chardin's genre scenes were spared much of the searching criticism that befell those of Boucher. The enigmatic quality of Chardin's works, the sense of sobriety and quiet rectitude that pervades even his humblest subjects, such as *The Kitchen Maid* (cat. 16), elevated his paintings above the lowlife tradition of the *bambochade* that was typical of northern artists. A painting such as *The Bird-Song Organ* (cat. 19) presumably would have been even more acceptable in terms of its subject matter than *The Kitchen Maid*, not simply because of the distinction in social class between the two women depicted in these works, but because of the greater ambition of meaning—of art-historical reference and iconographic complexity—in the former picture.

More important, however, with Chardin artistic value was displaced by many critics from the "inconsequential" subject matter to a celebration of technique and painterly virtuosity. Diderot, while always ready to comment on the subject matter of Boucher's pastorals or Greuze's moralizing scenes, perceived Chardin—both in his still lifes and in his genre scenes—as essentially a technical "magician," from whose pictures pleasure was to be found exclusively in his manipulation of paint.[43] Other writers responded in similar ways, singling out Chardin's technique as essentially inimitable. Writing in 1747 about *The Amusements of Private Life* (see fig. 62), La Font drew a clear distinction between subject matter and form, praising Chardin's "talent for rendering with a truth that is his alone, and that is uniquely naive, certain moments in life that are not in the least interesting and that do not attract attention in themselves, and some of which are not worthy of the artist's choice or of the beauties that one admires in them."[44] In 1753 Jacques Lacombe praised Chardin's ability to engage the eye of the beholder: "His handling is seductive, but it surely demands much patience and time."[45] The characterization of Chardin's brushwork as seductive—a critic reviewing the Salon of 1757 remarked on his "simple and unvarnished truth that seduces the connoisseurs"[46]—places his enterprise within the more general response to the rococo, which emphasized its "feminine" character. Chardin himself is

said to have remarked to a fellow artist, "Who told you that one paints with colors. . . . One uses colors, but one paints with feeling."[47] This may seem a strange assertion coming from an artist whose paintings appear so deliberately made and lacking in emotion, but the claim of feeling was often made with regard to his work. In one sense it is a rebuttal to the basic premise of an academic system of artistic instruction: that it is a shared enterprise based on certain rational principles that can be learned (i.e., a reasonable, therefore traditionally "masculine," endeavor); Chardin's comment about painting with "feeling"—something unquantifiable and impossible to teach—could well have been understood as a quintessentially "feminine," emotional manner of making art. Reading the critics' opinions of Chardin, we recognize how his works appealed to such a wide spectrum of people. On the one hand, his familiar subjects were recognizable to anyone—even "women of the Third Estate," as one critic observed—who cared to focus on them; at the same time, for those who found his humble scenes inconsequential, there was the magic of his technique, which only the most sensitive connoisseurs could fully appreciate.

The lure of the surface—in which the succulent passages of paint, the creamy folds of drapery, the glowing tones of the flesh continually appeal to the eye of the beholder—is a defining characteristic of much rococo art. It is what attracted the same connoisseurs, such as Louisa Ulrica of Sweden, to such distinct artists as Boucher and Chardin. The "seductive" quality of art is a concept that one encounters frequently in discussions of painting during the eighteenth century, especially in regard to the so-called minor genres. Writing in 1754, La Font de Saint-Yenne spoke of genre in a manner that admitted admiration for its pleasing qualities while recognizing its superficial aspects: "a seductive imitation, a freshness and marvelous fountain of colors, a sweetness of brushwork, etc. All these objects presented to our eyes with such artifice and picturesque magic must necessarily amuse our vision and has a place in our cabinets. But it is not the same as history painting."[48] Fragonard's *Useless Resistance* (cat. 24) epitomizes the stunning visual effects such cabinet pictures often brought to bear on what were—if we follow La Font and like-minded critics—essentially superficial diversions. For those advocating reform, formal brilliance alone could not be painting's justification; art had to serve useful, preferably moralizing, themes. The problem is complicated for, as we have seen, critics were willing to ignore this question in the case of Chardin. Chardin's purported naiveté, his generally humble or modest subjects, and his scrupulous devotion

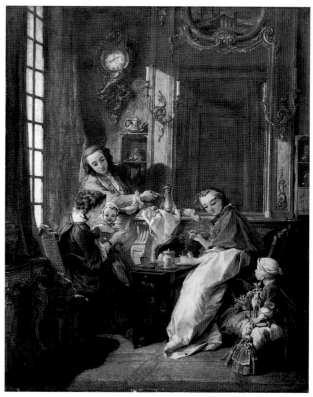

3. François Boucher, *Le Déjeuner,* 1739, oil on canvas, Musée du Louvre, Paris, photo R.M.N.

to nature are perhaps among the reasons for this exception. For such painters as Boucher and Fragonard, whose works are usually characterized by a high degree of artifice, brilliant colors, and sensuous passages of paint, the specter of femininity was more potent. Sketchy, seemingly unfinished works such as *The Useless Resistance* were sometimes equated with moral laxity, a kind of painterly *libertinage,* as one scholar has recently termed it.[49]

Jacqueline Lichtenstein's analysis of the relationship between women's adornment and color theory in seventeenth- and eighteenth-century French aesthetics is relevant here.[50] The triumph of the Rubeniste school in the academic debates at the end of the seventeenth century reestablished the importance of color and painterly brushwork—with their alluring beauty and fugitive sensuality—as a means of rescuing painting from the dry pedantry into which it had lapsed in the time of Charles Le Brun. Yet, like women's makeup, color had its dangers as well; in its quest for pleasing and seductive effects, it risked obscuring the natural beauty and integrity of its subject. This was essentially the interpretation given to René Gaillard's engraving after Boucher's *Milliner* (see the discussion under cat. 13), in which the woman is gently criticized for covering her natural beauty with makeup and ornament. Indeed, even the homey virtues that Chardin's *Morning*

Toilet (see fig. 2) apparently celebrates were understood by some critics as a subtle gloss on the young girl's awakening vanity, as she catches a glimpse of her reflection in the mirror.[51]

This seductive art, it was argued, could distract the beholder through its superficial surface effects, often rendering its message ambiguous or open-ended. The allure of color concealed the underlying form that was deemed essential to the transmission of meaning. *Papillotage* (a dazzling or glittering style, like the transient brilliance of a butterfly [*papillon*]), a term often used to describe the work of Boucher and rococo art generally, counteracted the principle of pictorial unity considered central to academic doctrine.[52] It seemed to parallel the "feminine" trait of dissimulation—the enemy of truth and virtue—characteristic of both the aristocracy and women, a construct summed up during the prerevolutionary decades in the character of influential female patrons such as Madame de Pompadour and Marie Antoinette.[53]

Indeed, one of the concerns of the antirococo critics was that the fundamental support system of painting, the academy, was being undermined by "feminine" tastes and a proclivity for interior decoration that was distracting painters from their important public roles. La Font complained that the contemporary rococo interior, with its pervasive mirrors and boiseries, left no room for large independent paintings, but only decorative works—overdoors, chimneypieces, and so on—which invariably led painters to represent such "insipid" subjects as the four seasons, the elements, or the muses; such taste provoked artists to create delicate paintings for the private collector rather than noble creations for the good of the public. In La Font's words, "Vanity, whose control is even more powerful than that of fashion, has produced an art that appeals to the eyes, especially the eyes of women, mirrors of themselves, the more enchanting the less they are true."[54]

This equation between female vanity and the denigration of the arts was most forcefully articulated by Jean-Jacques Rousseau, who derided art that appealed to feminine tastes: "These throngs of ephemeral works which come to light every day, made only to amuse women and having neither strength nor depth, fly from the dressing table to the counter."[55] For Rousseau the influence of women patrons represented a broader danger in which the natural hierarchy of the sexes was upset; surrounded by such women, men were losing their inherent masculine characteristics. "Every woman at Paris gathers in her apartment a harem of men more womanish than she."[56] Maintaining strict gender differences was essential to good social order, and the moralizing imperative of great art necessitated representing the sexes in terms appropriate to what were considered their "natural" characteristics and roles. In Boucher's famous *Le Déjeuner* (fig. 3), the women are confined to

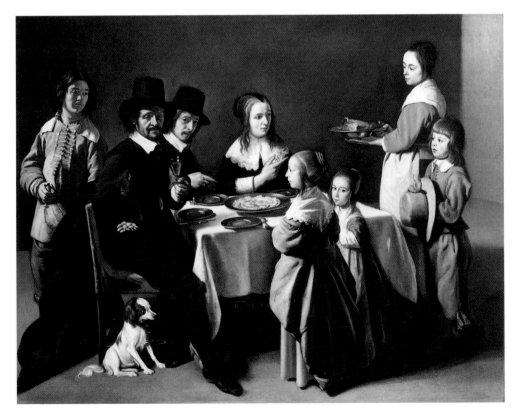

4. Mattieu Le Nain, *The Family Dinner*, c. 1645–48, oil on canvas, The Toledo Museum of Art; purchased with funds from the Libbey Endowment, Gift of Edward Drummond Libbey.

the domestic sphere where they tend to their children, a visual formulation that undoubtedly would have met with Rousseau's approval, although the subservience of the male figure—who has been identified as either a servant or the husband—could be seen as undermining the traditional male role. Boucher's representation of the family, it could be argued, inverts the conventions of such seventeenth-century precedents as Mattieu Le Nain's *Family Dinner* (fig. 4), in which the paterfamilias, raising his glass to the viewer, is given pride of place, surrounded by his respectful and deferential offspring. Boucher's later works, particularly such pastoral scenes as *Les Sabots* (cat. 14), seemingly defined a world where gender distinctions were ambiguous or, worse, women reigned over men.[57] If genre painting was to elevate its status in the hierarchy of subjects, it had by necessity to detach itself from its disparaging association with femininity.

GREUZE AND MORALIZING GENRE

Critics and academicians alike came to recognize that incorporating everything from scenes of everyday life to landscapes and still lifes into "genre painting" was arbitrary and ultimately meaningless. Painters of everyday life often depicted human beings in complex ways; unlike landscapists and still-life painters, they had to consider problems of expression, gesture, and sometimes even narrative, the same concerns that occupied history painters. It stood to reason that their subjects should be considered in a separate category, as Diderot recognized: "It seems to me that the distinction between genre painting and history painting is intelligent, but I'd like to see a little more attention paid to nature in the way it's formulated." Suggesting that a better differentiation would be between painters of "non-living, non-sentient, non-reflective [entities] and others living, sentient, and reflective," Diderot concluded that

> genre painting has almost all the difficulties of history painting; that it calls for just as much intelligence, imagination, and even poetry; a like competence in drawing, perspective, coloring, chiaroscuro, character, feeling, expression, drapery, and composition; a stricter adherence to nature, with details that are more carefully finished; and that, because it depicts the things that are most familiar and the best known to us, there are more judges of it, and better ones.[58]

Diderot's last point—that a wide audience was able to appreciate genre because it was closer to lived experience—was a significant one, and it accounts for the increasing attention given to genre in the Salon criticism of the second half of the century. Moreover, his opinion was by no means unique; many commentators at the Salons of the 1770s, the heyday of genre painting in France, understood that the artist's imaginative powers played an important role in the making of genre pictures. Scenes of everyday life may be modest and familiar, but they are not without relevance to cultural ideals, social practices, and philosophical, or even political, concerns.

For Diderot as for other critics, there seemed no reason why genre painting could not fulfill the same morally improving role as history painting. It is with this in mind that we should understand the famous quip in his "Notes on Painting" that the genre scenes of Greuze and the landscapes of Vernet were as much history paintings as Poussin's *Seven Sacraments* or Le Brun's *Alexander and the Wife of Darius*. Such a statement rested on the assumption that serious genre paintings—like the most ambitious landscapes—were more than direct transcriptions of everyday life; they might embody important moral truths that could benefit society.

In fact, visitors to the Salons recognized not only the great appeal of genre painting but also the degree to which its best and most ambitious examples served an important didactic function. These sentiments were neatly summed up by a critic reflecting on the strength of the genre scenes by Etienne Aubry and Jean-Baptiste Le Prince at the Salon of 1777: "Witness all these pretty pictures, so fashionable for the past few years, where we see represented little moral scenes that are very interesting to the greatest number of spectators. . . . In this way these artists also contribute to the reform of morals, because their compositions—not content with flattering the eyes—offer useful lessons that leave at least in the back of the heart the wholesome seeds of virtue."[59] These comments are fully in the tradition of La Font de Saint-Yenne, with their approval of a virtuous art that does more than simply "flatter the eyes." Here, however, it was not only history painting but "little moral scenes" that were perceived as capable of moving and instructing the viewer. Like others, this writer recognized Jean-Baptiste Greuze as the fountainhead for this new and improved model of genre painting.

During the 1750s and 1760s Greuze emerged as a genre painter of sufficient talent and appeal that he attracted the support of the Marquis de Marigny, *directeur-général des bâtiments,* along with Diderot and the important collector La Live de Jully. That these eminent men of the arts chose to promote the career of a painter of domestic subjects testifies to the new prominence given genre painting. Although Greuze some-

5. Jean-Baptiste Greuze, *The Village Bride*, Salon of 1761, oil on canvas, Musée du Louvre, Paris, photo R.M.N.

times painted ribald scenes such as *The Neapolitan Gesture* (cat. 27) or Boucher-inspired pastorals such as *Simplicity* (cat. 28), his reputation came to rest primarily on a series of homespun domestic dramas that combined a careful study of nature with exemplary subject matter. *The Village Bride* (fig. 5), painted for Marigny's personal collection and exhibited at the Salon of 1761, has remained the artist's signature work.[60] It shows the country wedding of a young bride and groom, surrounded by her family, as the aged father gives his blessing (and hands over the dowry) and the local notary signs the legal documents. Although of only modest dimensions, the picture drew a crowd at the Salon; the anticipation was no doubt enhanced by the artist's calculated withholding of the painting until the last two weeks of the exhibition. The critics were uniformly enthusiastic, with the Abbé de la Porte remarking that Greuze's "brush knows how to ennoble the rustic genre, without altering its truth"; another commentator went so far as to claim that in its treatment of gesture it surpassed Le Brun.[61]

What we might call the gendering of genre reached its apogee in *The Village Bride*, which reinforces in a memorable way the traditional familial roles that social reformers such as Rousseau saw as essential for the moral health of the nation. The groom stands firmly in the center as he listens intently to the wisdom proffered by the aged father; the women, by contrast, are placed to the side and represented as overcome with emotion. The bride's procreative responsibilities are symbolized in the hen and chicks in the foreground of the painting. Diderot felt that the painting showed signs of "good order," and it is clear that he was referring to more than the picture's composition.[62] In fact, the painting gives striking visual form to Rousseau's prescription, articulated most forcefully in *Emile* (1762), that in the best of families, as in the most stable societies, the wife defers to the husband.[63] Paintings such as Boucher's *Les Sabots* (cat. 14), in which the man assumes a subordinate position with regard to the woman (occasioned by the subject, an opéra comique by Sedaine, in which role reversal is part of the game of love), undoubtedly would

6. Jean-Michel Moreau le Jeune after Baudouin, *The Marriage Bed*, 1770, engraving, cat. P21.

What interest could this husband, this wife, these chambermaids, the whole of this scene possibly hold for us? Doubtless our former friend Greuze would have selected the preceding moment, in which the father and mother send their daughter to her husband. What tenderness! What decency! What delicacy! What a range of action and expression in the brothers, sisters, parents, and friends; how moving would be such a scene! A man who in such circumstances can imagine only a troop of chambermaids is wretched indeed![66]

Diderot's comparison of *The Marriage Bed* to *The Village Bride* was a provocative one, since Baudouin's gouache was also owned by Marigny. His caustic words went to the heart of the traditional critique of genre painting: that its subject matter was unimportant, that its technique was often superficially attractive, and that it was directed at a private clientele rather than the public good. Baudouin, Boucher's son-in-law, made his reputation as a painter of erotic *sujets galants,* often centered on aristocrats engaged in a variety of sexual intrigues: "Always little pictures, little ideas, frivolous compositions, appropriate for the bedroom of a little mistress, in the little house of a little master; just the things for little Abbés, little lawyers, substantial financiers and other persons without scruples and with a taste for the trivial."[67] Nor was this a minority opinion. Louis-Sébastien Mercier was just as damning in the *Tableau de Paris:* "Baudouin, that cynical painter, has surpassed [Boucher] in licentiousness, and has hardly produced anything that is not against good morals."[68] By contrast, *The Village Bride* was a moving and convincing scene that presented an important message about familial bonds, the "natural" roles of women and men, and respect for tradition, building blocks of the "good order" not only of the family but of society as a whole.

With the appointment in 1775 of the Comte d'Angiviller as *directeur des bâtiments,* a concerted effort was made to reestablish history painting as the leading and most innovative aspect of French art and to discourage works of questionable moral value.[69] Yet given the lack of serious and capable historical painters—Fragonard had long before abandoned the public arena, and Jacques-Louis David was still six years away from his first public exhibition—and the interests of the Salon audience and collectors, much of the attention fell on genre painting. The Salon of 1775, the first under d'Angiviller's administration, counted among the most successful, in terms of numbers and critical acclaim, for moralizing genre painting.[70] This was true even though Greuze was no longer the dominating presence he had

have struck exactly the wrong note. By contrast, when employed by Greuze in a painting such as *The Drunken Cobbler* (cat. 31), the transfer of traditional gender roles serves to underscore a world turned upside down: the angry wife becomes the forceful moral, indeed rational, voice, and the inebriated husband assumes the pliant, whimsical, irrational attitude.[64] Indeed, in Greuze's later work a new ideal of femininity emerges, one only hinted at by Chardin in such paintings as *The Morning Toilet* (see fig. 2) or *The Good Education* (cat. 20), in which the woman assumes a more active role in the domestic sphere. The stern wife in *The Drunken Cobbler* is but one example of a new construct of woman as a moral center, manifested in such pictures as *The Father's Curse* (see figs. 18 and 19), *The Woman of Charity* (c. 1772, Musée des Beaux-Arts, Lyon), or *The Widow and Her Priest* (c. 1785, Hermitage, St. Petersburg).[65]

The larger significance of Greuze's approach to genre is reflected in Diderot's comments in his review of the Salon of 1767, where he assailed Pierre-Antoine Baudouin's *The Marriage Bed,* a small gouache popularized by Jean-Michel Moreau le Jeune's engraving (cat. P21, fig. 6):

been in the 1760s. Since 1769 he had refused to participate in the Salons. That year he had sought to win acceptance into the academy as a history painter, submitting a precociously neoclassical painting on the subject of *Septimius Severus Reproaching Caracalla* (see fig. 17), but his bold strategy failed, and he was accepted "only" as a genre painter.[71] At the Salon of 1775 Greuze was conspicuous by his absence, although he continued to exhibit at his studio in the Louvre, timing his displays to coincide with the biennial Salons.[72] Moreover, d'Angiviller made sure that when *The Village Bride* came on the market in 1782 it was acquired for the crown.

At the Salon of 1775 itself, it was left to Aubry to carry on the cause of moralizing genre. As with Greuze, Aubry's scenes of domestic life (see, for example, *Farewell to the Nurse* [cat. 37]) spoke to contemporary concerns about family life and were perceived to have been formulated with the same ambition as history painting. The artist's obituary spoke of his paintings in just these terms: "M. Aubry, imitating M. Greuze, devoted himself to ennobling genre. This he succeeded in making interesting by the pathos of his scenes, the moving predicaments of the actors, and virtuous subjects—all the more attractive in painting given their increasing rarity in reality—and by a pleasing contrast of passions, feelings, and characters."[73] Even more important, Aubry had the ear of d'Angiviller, who, in an ironic twist on Greuze's failed ambitions, encouraged Aubry to make the leap from genre to history painting. Aubry dutifully traveled to Italy from 1777 to 1780, but his premature death in 1781 put an end to his efforts. Only one historical picture of note resulted from this experiment, *Coriolanus Saying Farewell to His Wife* (location unknown), a picture that, like Greuze's *Septimius Severus*, was an essentially familial subject in historical costume. Aubry's painting was exhibited posthumously at the Salon of 1781; admired for its composition, color, and appropriation of the antique, it was nonetheless thought to lack power.[74]

Greuze's rejection and Aubry's perceived failure proved that ultimately the boundaries dividing history painting and genre remained intact and resilient. With the public debut of David in 1781, history painting on a

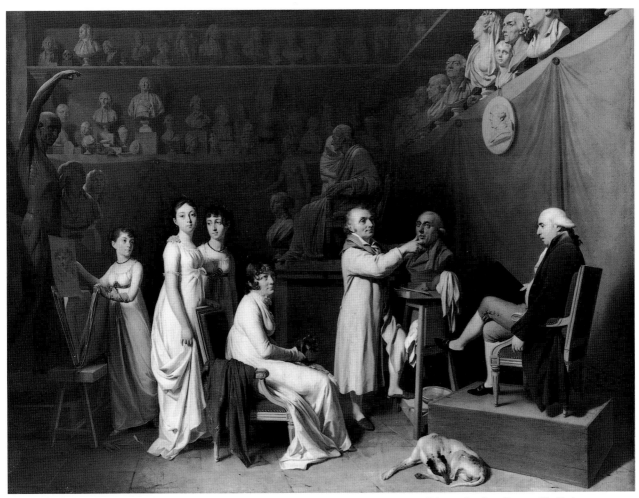

7. Louis-Léopold Boilly, *Sculptor's Studio, Picture of a Family*, Salon of 1804, oil on canvas, Musée des Arts Décoratifs, Paris.

grand scale reemerged as the vehicle for the most ambitious and innovative art. History painting, particularly with subjects drawn from ancient history, became the focus of critical and theoretical discourse. The Revolution only enhanced its prestige. The critic Polyscope, whose acknowledgment that genre painting was easier to produce and readily marketable was quoted earlier, went on to say in 1796: "But if the republic takes root, if public education improves, I assure you that despite the efforts of certain men who always want us to restore our old habits, this taste for the pretty will be replaced by a taste for the beautiful."[75]

Yet the opening of the Salon exhibitions in 1791 to all artists meant that even more genre paintings would be displayed. Works by such *petits maîtres* as Jean-Frédéric Schall (cat. 40), Henri-Nicolas Van Gorp (cat. 48), or—at a much higher artistic level—Louis-Léopold Boilly (cats. 49–51) reflect the continuing market for and interest in genre paintings of all types, a phenomenon that would last well into the nineteenth century. Boilly's *Sculptor's Studio, Picture of a Family* (fig. 7), exhibited in 1804, exemplifies the continuing impact of Greuze's *Village Bride* more than four decades after its first appearance. In the center stands the head of the family, the celebrated sculptor Houdon, accompanied by his wife and daughters. Houdon's creative act—modeling a bust—contrasts with the posed leisure of the women, and the picture emphasizes the conjugal ties that ideally bind all families. In this regard Boilly's *Sculptor's Studio* continues the strategy of combining group portraiture with domestic genre that made Drouais's painting, discussed at the begining of this essay (fig. 1), so innovative.

Genre painting, however, was no longer the energizing force it had been during the 1760s and 1770s. Boilly was reportedly even censored by the Committee on Public Safety for producing works that were deemed bad for public morals, beautifully realized yet ultimately trifling cabinet pictures such as *The Electric Spark* (cat. 49). The rapidly developing events of the Revolution made most genre paintings seem decidedly beside the point. Even had Greuze remained a painter to be reckoned with in the 1790s, it is unlikely that his domestic dramas would have been viewed as adequate visual manifestations of republican ideals. Indeed, as early as 1773 one precocious critic made this very point, predicting that history painting would eventually reclaim its preeminent position in French art. "The good family man, the return of the nurse, the bride [fig. 5], are charming scenes; but transform these actors into consuls and Roman matrons, instead of that paralytic [see fig. 16] imagine a dying emperor, and you will see that

the malady of a hero, like his good health, is not the same as those of a common man."[76] This challenge would be most convincingly taken up, of course, by David, whose remarkable series of history paintings produced in the 1780s—the *Belisarius Receiving Alms* (see fig. 65) is but one example—would recast the private and domestic dramas of Greuze in classical guise whereby they could most forcefully enter the public and political realms.

1. For example, Jacques-Louis David's *Paris and Helen* (1788–89; Louvre, Paris) was described as being in "an opposed genre" to that artist's *Death of Socrates* (1787; The Metropolitan Museum of Art, New York), even though both pictures would have been categorized as history paintings (see Thomas E. Crow, *Painters and Public Life in Eighteenth-Century Paris* [New Haven, 1985], 245).

2. Gordon Bailey Washburn, in *Pictures of Everyday Life: Genre Painting in Europe, 1500–1900*, exh. cat. (Pittsburgh, Carnegie Institute, 1954), unpaginated.

3. Diderot, "Notes on Painting," in *Diderot on Art*, ed. and trans. John Goodman (New Haven, 1995), 1:230. In his *Encyclopédie* article, "Genre (Peinture)," Claude-Henri Watelet also included in this category a diverse range of subjects "ainsi l'artiste qui ne choisit pour sujet de ses tableaux que des animaux, des fruits, des fleurs ou des paysages, est nommé *peintre de genre*" (*Encyclopédie; ou, Dictionnaire raisonné des sciences, des arts, et des métiers* [Paris, 1757], 7:597).

4. For full accounts of this enigmatic painting, see Colin Eisler, *Paintings from the Samuel H. Kress Collection: European Schools Excluding Italian* (Oxford, 1977), 322–23, and George T. M. Shackelford, in *A Gift to America: Masterpieces of European Painting from the Samuel H. Kress Collection*, exh. cat. (Raleigh, North Carolina Museum of Art, and elsewhere, 1994–95), 268–71, no. 53. My interpretation of this portrait is indebted to the discussion by Carol Duncan, "Happy Mothers and Other New Ideas in French Art," *Art Bulletin* 55, no. 4 (December 1973): 579.

5. Indeed, Drouais's reputation was made on such intimate and domestic portraits; among his most famous is the full-scale portrait of Madame de Pompadour working at her tapestry frame (1763–64; National Gallery, London).

6. In terms of portraiture itself, Drouais's appropriation of Boucher's *tableau de mode* represents a dramatic shift from the predominant portrait style of the 1730s and 1740s, exemplified by Jean-Marc Nattier, which often borrowed themes from history painting to ennoble its subjects.

7. Wolfgang Stechow and Christopher Comer, "The History of the Term *Genre*," *Bulletin of the Allen Memorial Art Museum* 33, no. 2 (1975–76): 89–94.

8. "Tout ce que les différentes scènes de la vie offrent de plus pittoresque à leurs yeux ou à leur imagination; des Porteurs d'eau, des luttes de Savoyards, l'intérieur d'un ménage, le déménagement d'un Peintre, un père de famille entouré de ses enfans, une Cuisinière" (*La lanterne magique aux Champs-Elysées ou entretien des grands peintres dur le Sallon de 1775* [Paris, 1775], 31 [Del. 163; McW. 0244]).

9. Quoted in Stechow and Comer, "History of the Term *Genre*," 90.

10. Quoted in Anita Brookner, *Greuze: The Rise and Fall of an Eighteenth-Century Phenomenon* (London, 1972), 46.

11. Barry Wind, *Genre in the Age of the Baroque: A Resource Guide* (New York, 1991), xx.

12. "C'est pourquoi comme ces sortes de peintures ne peuvent divertir qu'un moment et peu intervale, on voit peu de personnes con-

noissantes qui s'y attachent beaucoup." André Félibien, *Entretiens sur les vies et sur les ouvrages des plus excellens peintres . . .* (Amsterdam, 1706), 4:144.

13. Abbé Du Bos, *Critical Reflections on Poetry, Painting, and Music*, trans. Thomas Nugent (London, 1748), 1:44.

14. "Les Peintres de genre sont ceux qui n'ont pas le talent d'être Peintres d'Histoire, ou qui l'ont abandonné pour traiter de petits sujets" (*La Lanterne magique aux Champs-Elysées, ou entretien des grands peintres dur le Sallon de 1775* [Paris, 1775], 30–31 [Del. 163; McW. 0244]).

15. See Christian Michel, "Les Fêtes galantes: peintures de genre ou peintures d'histoire?" in François Moureau and Margaret Morgan Grasselli, *Antoine Watteau (1684–1721): Le peintre, son temps et sa légende* (Paris, 1987), iii.

16. Charles-Nicolas Cochin, *Essai sur la vie de M. Chardin* (1780), quoted in Marianne Roland Michel, *Chardin* (New York, 1996), 269.

17. Abbé Du Bos, *Critical Reflections*, 1:57; see also Brookner, *Greuze*, 48–51.

18. June 15, 1765, quoted by Marianne Roland Michel in *Claude to Corot: The Development of Landscape Painting in France*, exh. cat. (New York, Colnaghi, 1990), 108.

19. "Mais n'en accusés que les circonstances et le gout qui regne un grand et beau tableau d'histoire qui a couté d'assés fortes sommes pour la toile, les modèles, etc., ne trouve presque aucun acheteur, tandis qu'un peintre se defait bien plus facilement de quelque petit tableau de genre qu'il a produit presque sans frais. On préfère le travail qui fait vivre au travail qui ne procure que de l'honneur" (Polyscope [Amaury-Pineu Duval, called Amaury-Duval], "Observations de Polyscope sur le Salon de peinture, sculpture, etc. de l'an V," *La Décade philosophique* 11 [October 11, 1796]: 91–95 [Del. 493; McW. 0526]).

20. "On ne sauroit trop le répéter aujourd'hui, toute homme qui déplace l'exercice de ses talens en les laissent diriger par sa fantaisie, par la mode, our par le mauvais goût, est un citoyen non-seulement très-inutile, mais encore très-nuisible à la société" ("Genre [Peinture]," in *Encylopédie*, 7:598).

21. For the commission, see Alastair Laing in *François Boucher 1703–1770*, exh. cat. (New York, Detroit, and Paris, 1986–87), 224–29.

22. On La Live de Jully, see Colin B. Bailey, ed., *Ange-Laurent de La Live de Jully: A Facsimile Reprint of the Catalogue Historique (1764) and the Catalogue Raisonné des Tableaux (March 5, 1770)* (New York, 1988), and Barbara Scott, "La Live de Jully, Pioneer of Neoclassicism," *Apollo* 97 (January 1973): 72–77.

23. Two recent studies are essential to understanding the history and impact of the Salon exhibitions: Crow, *Painters and Public Life*, and Richard Wrigley, *The Origins of French Art Criticism from the Ancien Régime to the Restoration* (Oxford, 1993).

24. Charles-Nicolas Cochin, "Essai sur la vie de M. Chardin" (1780), quoted in Roland Michel, *Chardin*, 267.

25. "Je viens avec plaisir aux Tableaux de genre; c'est le triomphe de l'Ecole Françoise dans notre siècle. Je ne le dis point comme un reproche, ainsi que pourroient le penser beaucoup de personnes qui croient qu'il n'y a que le genre de l'histoire qui soit digne de leur attention. Ces genres, qu'il leur plaît d'appeler petits, ont fait et font encore la gloire de l'Ecole de Flandre, l'estime qu'on leur accorde est assez bien démontrée par les prix qu'on y sacrifie" (*Observations sur les ouvrages exposés au Sallon du Louvre, ou lettre à M. le Comte * * * * [Paris, 1775], 34–35 [Del. 160; McW. 0247]).

26. Wrigley, *Origins*, 11–39. On the popularity of genre at the Exposition de la Jeunesse, see Crow, *Painters and Public Life*, 86–88.

27. This important observation is made by Thomas Crow in his introduction to *Diderot on Art*, 1:xiv.

28. The changing fortunes of genre painting throughout this period are surveyed by Heather Ann McPherson, *Some Aspects of Genre Painting and Its Popularity in Eighteenth-Century France* (Ph.D. diss., University of Washington, 1982).

29. Crow (*Painters and Public Life*, 92) points out, however, that critical and satirical appraisals of art emerged in 1737, that is, coincidentally with the regular establishment of the Salon exhibitions that year. For a recent evaluation of the impact of La Font's work, see Ellen Munro, "La Font de Saint-Yenne: A Reassessment," *Gazette des beaux-arts* 126 (September 1995): 65–78; on art criticism generally during this period see Wrigley, *Origins*.

30. See Katie Scott, *The Rococo Interior: Decoration and Social Spaces in Early Eighteenth-Century Paris* (New Haven, 1996). On gender and the rococo, see the excellent discussion by Madelyn Gutwirth, *The Twilight of the Goddesses: Women and Representation in the French Revolutionary Era* (New Brunswick, N.J., 1992), esp. 3–22.

31. "Cette fille adieuse de l'orguëil, et souvent soeur de la médiocrité." "Le Peintre Historien est seul le Peintre de l'ame, les autres ne peignent que pour les ïeux" (La Font de Saint-Yenne, *Réflexions sur quelques causes de l'état présent de la peinture en France* [The Hague, 1747; reprint, Geneva, 1970], 5, 8).

32. "Le mot expression s'applique aux actions & aux passions, comme le mot imitation s'adapte aux formes & aux couleurs: l'un est l'art de rendre des qualités incorporelles, telles que le mouvement & l'affections de l'âme: l'autre est l'art d'imiter les formes qui distingent à nos yeux les corps des uns des autres, & les couleurs que produit l'arrangement des parties qui composent leurs surface" (*Encyclopédie*, 6:319).

33. "Le beau opposé à joli, est grand, noble & régulier; on l'admire: le joli est fin, délicat; il plaît" ("Beau, joli," in *Encyclopédie*, 2:181).

34. Joan B. Landes, *Women and the Public Sphere in the Age of the French Revolution* (Ithaca, N.Y., 1988), 17–38; Lynn Hunt, *The Family Romance of the French Revolution* (Berkeley and Los Angeles, 1992). See the essay by Virginia Swain in this catalogue.

35. Quoted by Pierre Rosenberg in *Chardin*, exh. cat. (Paris, Cleveland, Boston, 1979), 289.

36. "Comme Mlle. Gérard est séduisante dans ses jolis tableaux! Quel charme! Quelle suavité, quel heureux choix de sujets! Ils ne peuvent être composés que par une femme aimable, douce et sensible" ("Premier coup d'oeil au Salon du Louvre de 1804," *Journal des Spectacles* [1804]: 130; Del. 981; McW. 0826); for a discussion of Gérard's "femininity" and Salon critics, see Sally Wells-Robertson, *Marguerite Gérard, 1761–1837* (Ph.D. diss., New York University, 1978), 16–19.

37. "Son élégance, sa mignardise, sa galanterie romanesque, sa coquetterie, son goût, sa facilité, sa variété, son éclat, ses carnation fardées, sa débauche, doivent captiver les petits-maîtres, les petites femmes, les jeunes gens, les gens du monde, la foule de ceux qui sont étrangers au vrai goût, à la vérité, aux idées justes, à la sévérité de l'art" (Diderot, "Salon of 1761," Jean Seznec and Jean Adhémar, eds., *Diderot Salons* [Oxford, 1957], 1:112). On Boucher and the "feminization" of the arts, see Melissa Hyde, "Confounding Conventions: Gender Ambiguity and François Boucher's Painted Pastorals," *Eighteenth-Century Studies* 30, no. 1 (Fall 1996): 25–57. Diderot's observation recalls the condescending words about Flemish art attributed to Michelangelo, who—according to Francisco de Hollanda—criticized Flemish painting for emphasizing the "external exactness of things," for lacking "reason or art" and "substance," and saying that it therefore "appeals to women and certain noblemen who have no sense of true harmony" (quoted in James Snyder, *Northern Renaissance Art* [New York, 1985], 88). Whether or not Diderot was familiar with Michelangelo's comments is less important than that, across the divide of two centuries, these two eminent men of the arts articulated an association between what they saw as superficial, imitative, painting and women, who—according to this view—by their very nature were judged incapable of appreciating true artistic quality and meaning.

38. Roland Michel, *Chardin*, 134, quoting Abbé Raynal, *Correspondance littéraire*, 1750.

39. Whitney Chadwick, *Women, Art, and Society* (New York, 1990), 108. Svetlana Alpers, *The Art of Describing* (Chicago, 1983).

40. "On remarque une grande connaissance de la nature d'abor dans ses figures, et dans l'action corporele qui est aisée et vraie, ensuite dans le mouvement intérieur." "Lettre à M. de Poiresson-Chamarande . . . , au sujet des tableaux exposés au Salon du Louvre," in *Nouveaux amusemens du coeur et de l'esprit* II (1741): 34 (Del. 14; McW. 0022); see Norman Bryson's provocative discussion of Chardin in *Looking at the Overlooked* (Cambridge, Mass., 1990), 165–74. Without a doubt, most of the genre pictures in *Intimate Encounters* present a more traditional, "male" perspective.

41. "Cet art de plaire, ce désir de plaire à tous, cette envie de plaire plus qu'une autre, ce silence de coeur, ce déréglement de l'esprit, ce mensonge continuel appelé coquelterie, semble être dans les femmes un caractère primitif. . . . son bonheur est d'ignorer ce que le monde appelle les plaisirs, sa glorie est de vivre ignorée. . . . Elle a un caractère de reserve et de dignité qui la fait respecter." "Femme (Morale)," in *Encyclopédie* [1761], 6:472–75.

42. "Il ne vient pas là une Femme du Tiers-Etat, qui ne croye que c'est une idée de sa figure, qui n'y voye son train domestique, ses manières rondes, sa morale, l'humeur de ses enfans, son ameublement, sa garde-robe" ("Lettre à M. de Poiresson-Chamarande," *Nouveaux amusemens du coeur et d'esprit* II (1741): 33 [Del. 14; McW. 0022]).

43. See the discussion by Else Marie Bukdahl, *Diderot critique d'art* (Copenhagen, 1980), 190–94; and Marion Hobson, *The Object of Art: The Theory of Illusion in Eighteenth-Century France* (Cambridge, 1982), 69.

44. "Le talent de rendre avec un vrai qui lui est propre, & singulièrement naïf, certains momens dans les actions de la vie nullement intéressans, qui ne méritent par eux-mêmes aucune attention, & dont quelques-uns n'étoient dignes ni du choix de l'Auteur, ni des beautés qu'on y admire" (La Font, *Reflexions*, 109).

45. "Cette pratique est séduisante, mais elle demande surement beaucoup de patience et de tems" (quoted in Hobson, *Object of Art*, 77).

46. "Ce vrai simple & sans fard, qui séduit les connoisseurs" ([Anon.], "Expositions des ouvrages de peinture, sculpture et de gravure," *L'Année littéraire* 5 [August 31, 1757]: 347, letter 15 [Del. 88; McW. 0103]).

47. Quoted in Roland Michel, *Chardin*, 270.

48. "Une séduisante imitation, une fraîcheur et une fonte merveilleuse de couleurs, une suavité de pinceau, etc. Tous ces objets présentés à nos yeux avec l'artifice et la magie pittoresque doivent nécessairement amuser nos regards et avoir place dans nos cabinets. Mais il n'en pa de même des tableaux d'Histoire" (La Font, *Sentimens sur quelques ouvrages de peinture, sculpture, et gravure* [1754], quoted in Hobson, *Object of Art*, 69).

49. Wrigley, *Origins*, 275–76.

50. Jacqueline Lichtenstein, "Making Up Representation: The Risks of Femininity," *Representations* 20 (Fall 1987): 77–87.

51. See the comments in the *Mercure de France* (October 1741) quoted by Pierre Rosenberg in *Chardin* (exh. cat.), 274. This reading of the painting, which has been repeated by most art historians, has recently been challenged by Dorothy Johnson ("Picturing Pedagogy: Education and the Child in the Paintings of Chardin," *Eighteenth-Century Studies* 24, no. 1 [Fall 1990], 63–64), who suggests that the picture "should be understood as an emblem of instruction and the acquisition of social values . . . rather than of vanity."

52. Hobson, *Object of Art*, 51–56; Michael Fried, *Absorption and Theatricality: Painting and Beholder in the Age of Diderot* (Berkeley and Los Angeles, 1980), 82–92.

53. See Hunt, *Family Romance of the French Revolution*, 89–123, esp. 96–98; Gutwirth, *Twilight of the Goddesses*, 76–100.

54. "L'amour propre, dont l'empire est encore plus puissant que celui de la mode, a eu l'art de présenter aux ïeux & sur tout à ceux des Dames, des miroirs d'elles-mêmes d'autant plus enchanteurs qu'ils sont moins vrais" (La Font, *Réflexions*, 23–24). The critique of rococo interior decoration is analyzed in Scott, *Rococo Interior*, 252–65.

55. Jean-Jacques Rousseau, *Politics and the Arts: Letter to M. d'Alembert on the Theater*, trans. Allan Bloom (Glencoe, Ill., 1960), 103; see also Arthur Wilson, "'Treated Like Imbecile Children' (Diderot): The Enlightenment and the Status of Women," in *Woman in the Eighteenth Century and Other Essays*, ed. Paul Fritz and Richard Morton (Toronto, 1976), 97.

56. Rousseau, *Politics and the Arts*, 101. See Joel Schwartz, *The Sexual Politics of Jean-Jacques Rousseau* (Chicago, 1984), 67–68; see also Wrigley, *Origins*, 307–8; and Linda Walsh, "'Arms to Be Kissed a Thousand Times': Reservations about Lust in Diderot's Art Criticism," in *Femininity and Masculinity in Eighteenth-Century Art and Culture*, ed. Gill Perry and Michael Rossington (Manchester, 1994), 162–83.

57. On the suppression of gender difference in many works by Boucher, see Eunice Lipton, "Women, Pleasure, and Painting (e.g. Boucher)," *Genders* 7 (March 1990): 69–86; Hyde, "Confounding Conventions." See also Gutwirth, *Twilight of the Goddesses*, 104–6.

58. Diderot, "Notes on Painting," 230.

59. "Témoins tous ces jolis Tableaux, fort à la mode depuis quelques années, où l'on représente de petites scenes morales, très-intéressantes pour le plus grand nombre des Spectateurs. . . . Par-là ces Artistes contribuent aussi à la réformation des moeurs. Car leurs composition, non contentes de flatter des yeux, offrent d'utiles leçons, qui laissent au moins dans le fond des coeurs des germes salutaires de vertu" (*Lettres pittoresques à l'occasion des Tableaux exposés au Sallon en 1777* [Paris, 1777], 19 [Del. 190; McW. 0267]).

60. The literature on this painting is immense, but see the recent accounts by Edgar Munhall in *Jean-Baptiste Greuze*, exh. cat. (Hartford, San Francisco, and Dijon, 1976–77), no. 34; and *Diderot et l'art*, exh. cat. (Paris, 1984), 222–27, no. 59; Crow, *Painters and Public Life*, 142–51; Richard Rand, "Civil and Natural Contract in Greuze's *L'Accordée de Village*," *Gazette des Beaux-Arts* 127 (May–June 1996), 221–34.

61. See Edgar Munhall's excellent summary of critical opinion in *Jean-Baptiste Greuze*, 84–86, and *Diderot et l'art*, 226–27. Also see Linda Walsh, "The Expressive Face: Manifestations of Sensibility in Eighteenth-Century French Art," *Art History* 19, no. 4 (December 1996): 523–50.

62. Diderot, "Une bonne ordonnance" (Salon of 1761, in Seznec and Adhémar, *Diderot Salons*, 1:143).

63. See Rand, "Civil and Natural Contract," 227–29.

64. An even clearer example of Greuze's use of role reversal as a metaphor for domestic turmoil is his drawing *The Angry Wife* (c. 1785, The Metropolitan Museum of Art, New York), engraved by Gaillard; see Rand, "Civil and Natural Contract," 229–31. On the depiction of ideals of masculinity in late-eighteenth-century French painting, see Dorothy Johnson, "Corporality and Communication: The Gestural Revolution of Diderot, David, and *The Oath of the Horatii*," *Art Bulletin* 71 (March 1989): 92–113.

65. See Brookner, *Greuze*, 119–21, fig. 59, and 127–28, fig. 74. On this point, see the important forthcoming study by Emma Barker, *Greuze and the Painting of Sentiment: The Family in French Art, 1755–1785* (Cambridge). I am grateful to Dr. Barker for sharing with me the text of her lecture "The Transformation of Domesticity: From Chardin to Greuze," delivered at the College Art Association annual conference in Boston in February 1996.

66. Diderot, "Salon of 1767," in Goodman, *Diderot on Art*, 2:164–65.

67. Ibid., 2:164. On Marigny's ownership of *The Marriage Bed*, see the discussion by Marie-Catherine Sahut in *Diderot et l'art*, 129–30.

68. "Baudouin, peintre cynique, l'a surpassé en licence, et n'a presque rien fait qui ne soit contraire aux bonnes moeurs" (Jean-Claude

Bonnet, ed., *Tableau de Paris* [1782–88; reprint, Paris, 1994], 1, chap. 485, 1323).

69. Wrigley, *Origins,* 44; Jean Locquin, *La Peinture d'histoire en France de 1747 à 1785* (Paris, 1912), 50-52.

70. McPherson, *Some Aspects of Genre Painting,* 216–22; Wrigley, *Origins,* 297–98.

71. See Jean Seznec, "Diderot et l'affaire Greuze," *Gazette des Beaux-Arts* (May–June 1966), 339–56; Crow, *Painters and Public Life,* 163–68; and Mark Ledbury's discussion in this catalogue.

72. Hartford, San Francisco, and Dijon, 1976–77, 12–13.

73. "M. Aubry, a l'imitation de M. Greuze, s'attachait à ennoblir ce genre. Ce dernier y etait parvenu, en intéressant par le pathétique des scènes, par la situation touchante du acteurs, par des sujets vertueux, d'autant plus séduisants en peinture, qu'ils deviennent tous les jours plus rare dans la réalité, par une opposition heureusement contrastées des passions, de sentimens et de caractères" ("Notice sur M. Aubry" [1781]; Del. 1903, 2–3).

74. Ibid., 4–5.

75. "Mais que la république se consolide, que l'instruction publique se perfectionné et je vous assure que malgré les efforts de certains hommes qui voudraient toujours nous ramener a nos anciennes habitudes, ce gout pour le joli fera place au gout pour le beau" (Polyscope, *La Décade philosophique* 11 [October 11, 1796]: 91–95).

76. "Le bon père de famille, le retour de nourrice, la mariée, sont des scènes charmantes; mais transformez ces acteurs en Consuls et en Dames Romaines, au lieu de ce paralytique, supposez encore un Empereur expirant, et vous verrez que la maladie d'un héros et d'un homme du peuple, comme leurs santés, ne doivent être la même chose" (*Dialogues sur la peinture, seconde édition enrichie de notes,* Paris [1773], 42–43 [Del. 147; McW. 0227]). The status of genre during the Revolution is explored by Udolpho van de Sandt, "'Grandissima opera del pittore sara l'istoria.' Notes sur la hierarchie des genres sous la Revolution," *Revue de l'art* 83 (1989), 71-76.

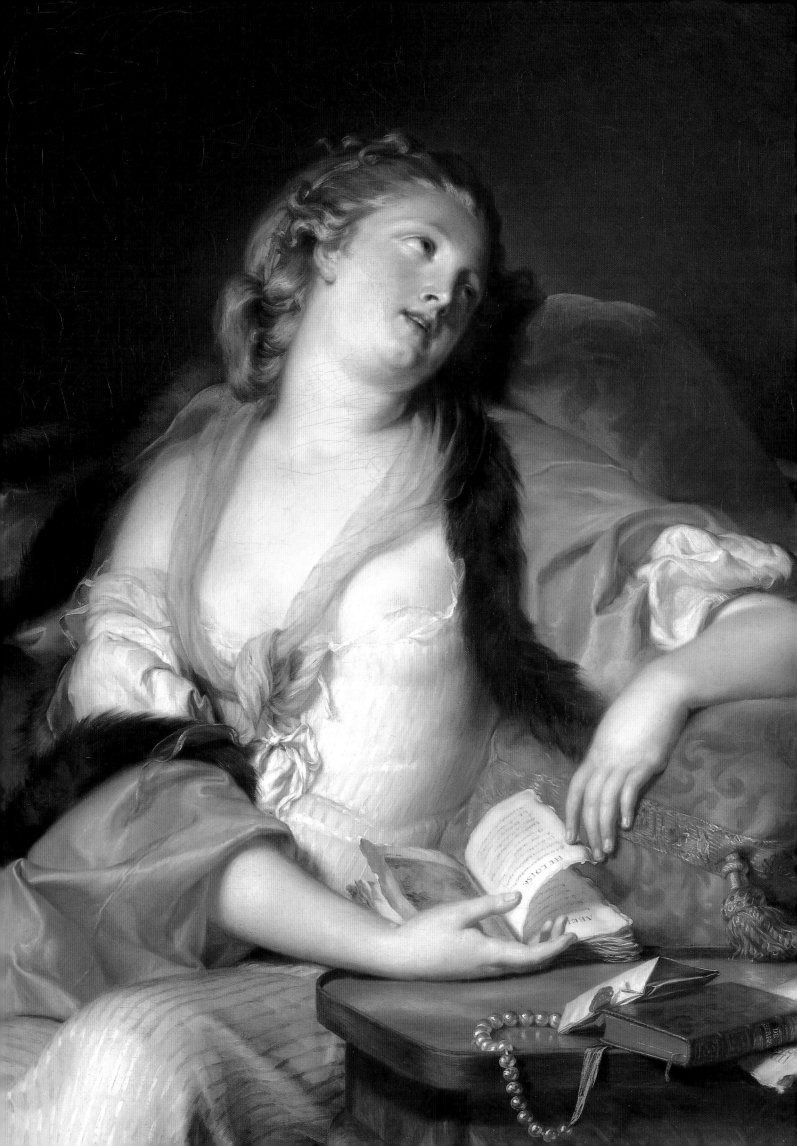

Hidden from View: French Women Authors and the Language of Rights, 1727–1792

VIRGINIA E. SWAIN

The sophisticated woman living in the late twentieth century has become accustomed to deciphering the images that assault and address her in magazines, on billboards, on television, and in the cinema. Seduced though we may be by the glamour, luxury, or leisure that these images portray, we have learned to demystify them and recognize the mobilization of envy and self-deprecation on which they depend. The image of woman that anchors so much advertising is airbrushed and unreal, a "perfect" body on which to write messages of desire. We know this and we try to resist. Sophisticated French women of the eighteenth century were similarly aware of the ways in which they were positioned and portrayed by their own society. Although they were not the primary addressees of the paintings that undertook to represent them, they too protested the limited number and limiting character of the roles into which their male contemporaries attempted to cast them. In their essays and novels, women authors challenged the shifting attitudes toward "woman" that this exhibition makes visible. They asserted a woman's right to define her own life, many decades before activists pursued the cause during the social reordering of the French Revolution.

MALE FANTASY AND IMAGES OF WOMEN

Two images in this exhibition help us take note of the way women were portrayed in genre paintings for the appreciation and pleasure of the male viewer. Jean-François de Troy's *The Declaration of Love* and *The Garter* (c. 1724–25; cats. 9 and 10) juxtapose depictions of upper-class life with works of art that complement and comment on both the subject and the function of the paintings as a whole. The embedded commentary reveals the "contract" between artist and viewer that governs the paintings.

Each painting depicts a nobleman making an amorous proposal to an attractive young woman in the sumptuous interior of an elegant home. The men are fashionable *petits maitres* (in red-heeled shoes),[1] whose emblems of nobility—their swords—are clearly visible. In *The Declaration,* the man holds the woman's hand while gesturing toward his heart; she leans away but listens complacently, looking down on him with a not unfriendly gaze. In the wall painting above, bold colors mark a pair of lovers against a landscape background: Venus leans her partially clothed body against the fully clad Mars, who fondles her bare breast. The red upholstery of the love seat in the drawing room, the heavy red curtain draped over one end of it, and the red coat and shoes of the gentleman echo the red cloth covering the ground where Venus and Mars make love and evoke the passion underlying the suitor's declaration. Although the lover does not look directly at the allegorical figures, the angle of his torso leads the viewer's eye upward to the half-nude Venus, while his own vision is focused on the true object of his desire, the young woman below. The painting that decorates the wall serves several purposes. Not only does it depict female surrender to the conquering hero, thus making apparent the suitor's goal, it also reveals the disparity (denoted by the varying states of undress of the two gods) between the male and female roles. Whereas the suitor's artistic double, Mars, serves to reinforce his social standing (the nobleman's sword is a sign of his class connection to military honor), the woman's double, Venus, reveals how much her place in the world is bound up with her sexuality.

In the second painting, *The Garter,* the suitor bends toward the lady, pointing to the garter she holds next to her exposed leg. Once again the woman leans away from her suitor, but in contrast to the woman receiving the declaration of love, she looks uneasy and resists the man with her outstretched left arm. Yet the potential for a sexual encounter is announced by the bared calf and suggested more obliquely in the folds of her dress, which come together between her spread limbs. To one side of this couple a small statue of a female nude decorates the tabletop and is reflected in the mirror. The young woman turns her head toward her lover and away from the table, but the man has both the woman and

the nude sculpture directly in his line of sight. Although the nude's head is turned modestly away, echoing the young woman's attempt to keep her lover at arm's length, her torso twists toward the center of the painting, giving the man a clear view. The sculpture not only embodies the male desire to see the woman unclothed, it also connotes the fulfillment of the man's sexual longing. The woman's head and body do not necessarily collaborate, the statue suggests; the man may still get his way. In this painting, only the woman is doubled, which effectively negates any possible reading of the reciprocity of their relationship and underscores the inequality between the male spectator and the female object of his desire.

De Troy's representations of art-within-art throw into relief the gender bias built into much of the painting of his time. Like the *fêtes galantes* of Antoine Watteau, de Troy uses the "innocence" of an embedded work of art to "allude to the erotic obsessiveness which was an inescapable part of his subject." But his female nudes do much more than "serve as living figures of the desire hidden beneath stylized costume and restrained gesture," as Thomas Crow says about Watteau's similar use of represented art.[2] These nudes play with the idea of "hidden" desire, yet by laying it open on the surface of the painting, they transform the "apparent" subject. Once the subtext of male fantasy is laid bare, so to speak, the art that inscribes it becomes erotic. What is more, by positioning the men in the compositions as viewers in relation to the two sets of female images, these paintings define the spectator as male and require that he—or she—take up the male gaze.[3] De Troy's paintings gender the viewer by playing upon male and female ways of seeing: "Men look at women. Women watch themselves being looked at. This determines not only most relations between men and women but also the relation of women to themselves. . . . Thus she turns herself into an object—and most particularly an object of vision: a sight."[4] A woman viewing de Troy's paintings necessarily sees them "objectively" (as a man seeing the female object[s]) and reflexively (as a woman seeing herself being seen). What she cannot fail to see is how a woman's individuality is collapsed into the figure of the generic nude.[5]

The tendency represented in these paintings for men to think about women in terms of their own (often sexual) desires and to represent women as types or allegories was widespread in the eighteenth century, not only in paintings and drawings, but in works of fiction as well.[6] More important, this tendency had real consequences for women's place in civil society. The male point of view predominated in the laws and conven-

tions of the time, just as it did in art. But whereas a career in art was open only to a handful of women and a career in the law was off-limits to them altogether, many took up the pen to represent themselves in essays and fiction. They supplied a female point of view that was all too often missing in the productions of men. As we trace the discussion of rights in women's writing, we can begin to see why these sophisticated women might be incensed by the way men represented them to each other in art, in letters, and in the law.

WOMEN WRITERS AND SEXUAL POLITICS

The tradition of French women thinking about sexual politics has its origins in the early fifteenth century, when the modern European state began to consolidate power in the hands of men and transformed the role and image of women. The "Querelle des Femmes," or "Women's Quarrel"—a series of rebuttals by literate women of works that portrayed them negatively—continued off and on over the next 400 years. Originating in and unfolding alongside the process of state formation and a developing republican ethos, it came to an end with the abolition of the absolute monarchy and the creation of the French republic in 1792.[7] The eighteenth century was the penultimate moment in the elaboration of the new republican ideal: it was the period that theorized the contractual basis of civil society and secured the individual rights of men. But women did not benefit from this new theory, and the Declaration of the Rights of Man that emerged from the Revolution made no mention of women. Indeed, it has been argued that "the Republic was constructed against women, not just without them."[8]

Although it is important to distinguish between the abstract idea of natural rights, which some theorists extended equally to women and men, and the legal situation of women in eighteenth-century France, it is the weight of the real judicial inequities that makes itself felt in women's writing of this period. Natural rights were much debated throughout the century, while women's legal status evolved very little. The articles on women and wives in the *Encyclopédie* (1756) succinctly defined the legal constraints on women's lives: in marriage, the woman was subordinate to the man, just as Eve was made to submit to Adam as punishment for her sins. Thus, "according to the old and new laws, the married woman is submitted to her husband, that is, she is in his power, so that she must obey him, and if she does not fulfill the duties of her state, he can correct her with moderation."[9] It was legally true that the hus-

band's right to "correct" his wife was limited in that she could sue her husband for a separation if he beat or abused her. However, the process of pursuing her rights in a court of law was so tortuous and subjected a woman to such public humiliation that in practice many women were deterred from taking action.[10] Furthermore, the husband could have recourse to the law to punish his wife for any real or suspected infraction of her sexual duties, while she was powerless to act against his infidelities.[11] The most important consequence of this subordination of the wife to the husband was, as the *Encyclopédie* acknowledged, that she could not freely enter into any obligations regarding herself or her real effects without her husband's consent and authorization.[12] In eighteenth-century France men not only had property, but they owned themselves as property and could enter freely into contracts on that basis.[13] In a century that laid the foundations for the contractual basis of civil society (what was to become the Republic), the marriage contract established a different set of rules for women.

If it is true that "political right originates in sex-right or conjugal right," as Carole Pateman claims,[14] then women's attempt to secure civil rights for themselves will begin not in the public arena, but at home. In the era that established civil rights for men, many literate women understood the need to assert their own rights in the family and in their marriages. When they spoke out in essays about their domestic rights or illustrated through their fiction the social or personal injustices done to them by men, they were advocates for much more than better intimate relations. At a time when women "represent[ed] all that men must master to bring civil society into being,"[15] their efforts to resist male mastery where they felt it most—in their everyday lives—constituted the only means readily available to them of contending for an equal share in all aspects of civil life. It is important to bear in mind the much larger stakes as we read these women's attempts to assert their will. These women were not seeking legal redress of the injustices done to them; instead they called on their fathers, husbands, sons, and male peers to grant them the right to develop their minds, to establish and live by their own principles, and to decide whom they would marry. But what was striking and bold for the time was less the particular, limited rights that these authors claimed than that they articulated this discourse of rights at all. Although there is no sustained philosophical or legal discussion of rights in the texts I will examine, this should not mislead us into minimizing their worth. Women's representations of the "contracts" that subjected them may be read as their attempt to in-

fluence for their benefit the "social contract" promoted by (and for) men of the Enlightenment.

LAMBERT, WATTEAU, AND "LA SOCIÉTÉ GALANTE"

Anne Thérèse de Marguenat de Courcelles, marquise de Lambert (1647–1733), was one of the most distinguished women in France in the early eighteenth century. Her salon, which met from 1698 until the end of her life, drew the most prestigious male authors of her time: Fénelon, Fontenelle, Houdar de la Motte, Montesquieu, and Marivaux.[16] Because her life spanned a good part of two centuries, she could compare with authority the most vigorous years of the seventeenth-century salons and their transformation in the early years of the eighteenth century. Furthermore, her ideas continued to find a receptive audience long after her death, as the publication history of her *Collected Works* amply demonstrates.[17]

Lambert's works appeared only a few years after Watteau's major paintings, and they address some of the same subjects. Thomas Crow argues that "Watteau found a means to represent, for the first time in visual terms, that set of contemporary aristocratic values and modes of behavior which together fell under the category of *honnêteté*. . . . The *fête galante* was . . . a tardy visual realization of an ideal form of life which had always existed apart from and even in opposition to the demands of the court."[18] But where Watteau's paintings seem to revel in "an eroticism that tests the limits of the permitted," Madame de Lambert's outrage at the degradation of "honnêteté" and "galanterie" in regency society and its negative consequences for the status of women gives her work a reformist or moralizing tone. Rather than "memorialize" a way of life that was under extreme stress, Lambert strove to rejuvenate its moral values for a new generation. In the face of "the libertine cynicism for which the Regency period is noted,"[19] she wanted to reestablish the links among distinction, virtue, and refinement. In this era when extraordinary fortunes were being made by men of no particular class, her concern was to establish nobility—and noble women—on a different footing. Nobility is not a matter of money, but of good breeding: "When luxury and money are in favor, true honor loses its value."[20]

Of the three Lambert texts I will consider, *New Reflections on Women* is the most direct and indignant: addressed to women and men alike, it condemns the mores of the time (debauchery, gaming, licentiousness, and the love of spectacle), holding men particularly responsible for this "disorder." Because men have mocked

women's interest in learning, as if it were as scandalous as vice, women have responded by turning to pleasure. They have become like men, she writes, adopting men's vices and giving up the virtue and propriety ("les bien-séances") that form the basis for their own rights in society. Hoping to reform these libertine mores, Lambert urges men to relent and allow women to cultivate their minds: "Women could say: 'How tyrannical men are! They do not want us to make any use of our mind or our sentiments. . . . They extend their rights too far.' Can women not say to men: 'What right have you to prohibit our studying the sciences and the arts?'"[21] Lambert's question points to one of the central issues for women in the Enlightenment. In a time when the right use of reason, the ability to subject the world to radical analysis or criticism, was the defining characteristic of humanity and the basis for participation in civil society, any attempt to depict women as all heart or emotion excluded them from the polis.[22] Lambert had firsthand knowledge of the salon culture of the seventeenth century, and her memory of a time when women were able to display and enjoy their intellectual capacities drives both her condemnation of contemporary society and her energetic argument in favor of women. She recognizes the errors of both sexes and seeks to convince both parties that women have the same rational capacity as men and should not be prevented from developing it. Women should be seen—and should see themselves—as having more to offer than beauty and superficial charm. Value depends on intrinsic merit, not on ephemeral physical qualities. Lambert notes: "To give things the rank and worth they deserve, let us distinguish between estimable qualities and agreeable ones. Estimable qualities are real and are intrinsic to things, and, by the law of justice, they have a natural right to our esteem."[23] In men and women alike, reason and virtue are the qualities that claim respect and deserve to be promoted.

Lambert does not use the language of rights lightly. She is aware of the force of her critique, and in those moments when it is most pointed she takes refuge behind the generalized, imagined speech of "women" ("Women could say . . . ," "Can women not say . . . ?"). Her own voice is more tempered and it exemplifies the evenhanded rationality she wants to encourage. In general, hers is a discourse of responsibilities. Reason and virtue have their rights by the natural laws of justice, because they are intrinsically self-governing and responsible. Rights operate within closed spheres and lose their legitimacy when they exceed those bounds: thus, men's rights over others require the scrupulous observation of those limits. Men whose behavior is less than

admirable, for example, have no right to attack women's actions as impure.[24] Men have usurped authority over women; their so-called rights derive more from illegitimate force than from natural law.[25] Lambert would re-center relations between the sexes around an *honnête* code of love, which would elevate and ennoble pleasure as it raises the mind. She refuses the elaborate sensual gratification and the ideal of artifice that predominate in Watteau's depiction of *honnêteté*. The only *honnête* relationships between the sexes, she argues, depend on and value women's self-respect (*fierté*).

In "Advice from a Mother to Her Son," Lambert makes it clear that she holds him—and, by extension, all men—to the highest standard of *honnêteté*, which she defines as "setting aside one's own rights and respecting the rights of others."[26] It is not enough to have acquired "military virtues" or the manly arts, she tells her son; they do not give a man permission to be unjust, *mal-honnête,* or impolite.[27] The "right of the sword" that accrues to the nobility does not free a man from carrying out his other obligations. Evidently, in Lambert's opinion, there are few real *honnêtes hommes* in regency society. The *société galante* depicted by Watteau and de Troy, with its emphasis on eroticism, is precisely what she decries. Lambert distrusts men "who make a career of gallantry": not only are they the antithesis of the real *honnêtes hommes,* who exhibit "that fine gallantry of mind and manners," but it is because of these coarse and callous men that women themselves become corrupt.[28]

In the corresponding epistle to her daughter ("Avis d'une mère à sa fille"), Lambert takes the same broad view of virtue that she set out for her son. She does not understand virtue in a woman to be synonymous with modesty (*la pudeur*) alone, although many women mistakenly cleave to this narrow interpretation. These are the women who derive from their "virtue" not only a haughty pride but also many illegitimate "rights," in particular the "right" not to carry out their duties in society.[29] Lambert takes aim at a society based on vanity when she urges her daughter to resist such feelings of superiority. Nor does she want her daughter to "take away from the rights of reason" by becoming too docile; instead, she encourages her to have confidence in her own ideas and not to be limited by what others think or say.[30] Clearly, Lambert wants her daughter to keep her own counsel and give greater weight to her own judgment than to the dictates of public opinion or fashion.

Because Lambert regards rights as operating within specific constraints and entailing corresponding responsibilities, she exhorts both her daughter and her son to take a limited view of them. But her appreciation

of the circumscribed nature of most rights does not prevent her from asserting categorically the injustices done to women in the first third of the eighteenth century. Reading the *Réflexions nouvelles sur les femmes* in the context of her letters to her children throws into relief the outrage expressed there. When Madame de Lambert exclaims, in the name of all women, "How tyrannical men are!" her words convey the full force of her conviction and distress. Although Lambert imagines a society governed by reason, in which (implicitly) the sexes would be equal and virtue alone would be singled out for esteem, she addresses a society in which men have usurped women's rights and discredited women by maligning their lack of virtue and minimizing their capacity for reasoned judgment. The care with which she expounds her philosophy to her children suggests that, for Lambert, the only hope for social reform lies with the next generation. By helping women bring up sons and daughters who recognize and live by the standards of honor, reason, and virtue, she aimed to secure for women a central and respected place in eighteenth-century French society.

The extent to which Madame de Lambert's thinking was revolutionary for a woman in her time may be appreciated by measuring her work against a contemporaneous novel by another famous *salonnière* and friend of Montesquieu, Claudine-Alexandrine Guérin de Tencin (1682–1749). In her *Memoirs of the Count of Comminges* (*Mémoires du Comte de Comminges*) (1735),[31] rights are at the center of the plot, but they belong only to the men. The count's father disputes his rights to the family inheritance with his cousin (the marquis de Lussan), enlisting his son in the feud. The count takes possession of the papers that establish his father's rights but then destroys them when he falls in love with the marquis's daughter, Adelaide. His actions precipitate the separation of the two young lovers and the imprisonment of the count. Only when Adelaide marries a tyrannical suitor whom she does not love is the count freed, since by then it is presumably too late for the two to consummate their passion. Adelaide and the count are ultimately reunited when, unbeknown to each other, they take refuge in the same monastery. It is only on her deathbed, however, that Adelaide reveals her true identity and confesses why she has been masquerading as a monk. The count recognizes his beloved too late. Withdrawing from the society of monks to live as a hermit, he writes his tragic story.

In this tale, property rights take precedence over all others. The son who usurps his father's authority and deprives him of his inheritance is punished in a not too subtle version of castration. Women never speak of rights and none are attributed to them. Not only are they expected to submit entirely to their parents' will as children—and in this they are no different from boys—but they are subordinate to men throughout their lives. The mothers of the count and Adelaide stand by helplessly and sympathetically while their children's fates are decided by their husbands. Whereas the young count tries out the language of rights in emulation of his father ("I thought I had the right to dispose of these papers"),[32] the women scarcely have the right to speak at all, let alone the right to articulate their own will. It is only when Adelaide is on her deathbed that—dressed as a man—she is finally able to make a long statement about her desires. But at this point she has already accepted the ascetic life and become reconciled to the "illegitimacy" of her love. Her death only seals her resolution to renounce the count.

Adelaide's fictional plight makes clear, by contrast, why Madame de Lambert's correlation of rights and duties is so important: the woman who has only duties and no rights is not free. Although Adelaide has been submissive to paternal authority from beginning to end, always evoking her duty as an explanation for her actions, the interdiction of her desire is so strong that she takes over and applies to herself the language of criminality that the fathers use to condemn her love. Crime in this novel is not the fathers' transgression, negation, or denial of the young woman's rights, but the daughter's aspiration to a freely chosen love. By depicting a young woman who has no rights and asks for none but is criminalized anyway, Tencin makes abundantly clear how patriarchy works. Men's right to property and their exercise of power depend on keeping women confined to their duty by attaching the language of crime to their desire for freedom.[33]

WOMEN AND THE REPUBLIC OF LETTERS

Tencin, like many female novelists of the eighteenth century, used plot and structure, rather than overt criticism, to denounce authoritarian fathers and husbands and their abuse of women.[34] Few female novelists addressed the issue of rights as directly and forcefully as Lambert did in her essays. Although Diderot claimed in his important *Encyclopédie* article "Droit naturel" ("Natural Right," 1755), that "the use of this word is so familiar, there is almost no one who is not deeply convinced that he obviously knows the thing itself,"[35] the word is not familiar in women's fiction, and perhaps not in women's diction generally. However, the ongoing publication of the *Encyclopédie* in the middle of the cen-

tury and the shift in gender politics it helped bring about may have provided an impetus for literate women to take the issue of rights more seriously.[36]

The *Encyclopédie*, published at intervals between 1751 and 1772, contributed crucially to the consolidation of the "republic of letters" and through it to the creation of a new "public sphere" that ultimately excluded women. As Dena Goodman argues, "By providing a 'center of unity' the *Encyclopédie* contributed to the establishment of the Republic of Letters as an association—a real society of men of letters—with Paris as its capital."[37] The editors created the egalitarian foundations of a new republic by extending citizenship in the Republic of Letters to "all who had a contribution to make to the *Encyclopédie* . . . [and] because the center of the encyclopedic association was a book, the Republic of Letters so conceived could expand further to include the readership of the *Encyclopédie* as well."[38] Although the philosophes who took part in the creation of the encyclopedia and derived their ideal of reciprocal exchange among equals from the "politics of sociability" practiced in the female-governed salons,[39] the citizens of the Republic of Letters that grew out of this woman-centered milieu tended to be men. Indeed, according to Goodman, the consolidation of the Republic of Letters eventuated in the formation of predominantly male assemblies (*musées* and clubs) that gradually supplanted the salons presided over by women such as Lambert and Tencin and their successors.[40] Women, who as *salonnières* had governed Enlightenment discourse, were being moved aside even as a new—theoretically egalitarian—public sphere was being established.[41]

Since the new public that the *Encyclopédie* helped fashion was "first a reading public," it is fitting that the letter should be the chosen form of communication that allowed "the philosophes, from their base in the salons, [to] reach out to (create) that public discursively." The letter and its avatars (essays and novels in letter form) "brought writers and readers together to interact on a footing of equality" and created "an active and interactive reading public."[42] But if the epistle was the philosophes' principal form of community building, there was a parallel trend in women's writing as well. Women, too, were reaching out through epistolary novels to create a public of readers beyond the salons. Not only were they creating a like-minded public for themselves, but they were educating this public to read (male) letters critically. Women of letters used the letter-novel to assert their own autonomy against the emerging male-dominated Republic.[43]

In particular, the 1750s saw the rise to fame of the novelist Marie-Jeanne Riccoboni, a prolific and widely admired author, whose woman-centered fiction was praised by Diderot, Choderlos de Laclos, and Restif de la Bretonne, and who excelled in the fashionable genre of the epistolary novel. So great was her popularity that her second novel, *Lettres de Milady Juliette Catesby* (1759), was second only to Jean-Jacques Rousseau's phenomenally successful novel *Julie, ou la Nouvelle Héloïse* (1761) in the number of editions and printings during a three-year period and between 1780 and 1790 there were seven editions of her complete works.[44] In *Juliette Catesby*, Riccoboni's story of a woman using critical reading to resist male domination provided a telling model for women readers and writers of her time.

LOVE LETTERS DEMYSTIFIED: RICCOBONI AND GREUZE

Greuze's sensual painting *A Lady Reading the Letters of Heloise and Abelard* (1758–59) (cat. 29) represents clearly some of the commonplace notions concerning female readers that women novelists such as Riccoboni and Françoise de Graffigny would implicitly call into question. The dreamy (or ecstatic) lady in Greuze's picture is reading one of the fashionable texts of the period, the letters exchanged by the twelfth-century lovers Héloïse and Abélard. These letters, in Latin, went through many editions in the seventeenth century and, from 1700 on, more than a dozen further editions were published in French.[45] The story is well known: the brilliant and controversial theologian Pierre Abélard was engaged as a tutor for the talented young Héloïse, and the two became lovers, apparently inflamed by the excitement of reading and studying together. When Héloïse's uncle discovered their intimacy he had the scholar castrated, and the two lovers were forever separated. She became the learned abbess of a convent, and he the abbot of a monastery, where he continued to write theological tracts. From their seclusion, the couple exchanged letters in which they revisited their love. In the history of literature, Héloïse and Abélard's extraordinary passion stands as lasting testimony to the effects of reading. Their letters also serve to replicate these effects, as other loves are sparked by reading them in turn. It is this allusion to the effects of reading that underlies Rousseau's best-selling and highly influential *Julie, ou la Nouvelle Héloïse* (*Julie, or the New Heloise*). The novel circulated in manuscript form for several years before it appeared in print in 1761, and may have come to Greuze's attention through private intermediaries during this time.[46] If so, Greuze would have been familiar with Rousseau's warning to the reader of his novel: "No chaste girl has ever read novels, and I gave a

title to this one definitive enough that anyone would know what it was about before opening it. She who, despite this title, dares read but one page is a fallen girl; but she should not blame the book; the evil was done [when she opened it]. Since she has already begun it, she should finish it; she has nothing left to lose."[47]

Although Greuze's painting portrays the powerful effects of passionate letters on the female reader and might be (counterintuitively) interpreted as a negative example to women, it is patently not addressed to a female viewer to warn her. The book of erotic poetry and the unsealed letter on the table beside her suggest that this woman reader is already "a fallen girl," while the seductiveness of her pose and her dishabille point up the availability of her desire. The woman is depicted as absorbed in her reverie and unaware of any viewer; she is not shown as deliberately enticing the spectator. Yet the painting plays a game with its public and private contents. As the woman moves from reading the lover's private letter to reading published letters by and about other lovers, she becomes associated with women whose desire is public knowledge—and certainly the passionate subject and sexual character of her own thoughts cannot be in doubt. The transfer of the woman's attention from the individual story of love to the archetypical story of passion is rendered in the painting by the transformation of the solitary activity of reading into a semipublic invitation to the male viewer.[48] Reading, Greuze suggests, is initiated by the man in order to produce the desire he wants to see and consume.

This male manipulation of the woman reader is both confirmed and contested by Riccoboni. Of the five epistolary novels she wrote, *Lettres de Milady Juliette Catesby* (1759) most clearly dramatizes and critiques the male strategy that Greuze depicts. The heroine of the novel is a young widow who is high-spirited, proud, intelligent—and an astute reader. Her story, in fact, recapitulates some of the reading effects we have already seen: midway through the novel, Juliette remembers how she and Count d'Ossery acknowledged their love while reading a story that sounds suspiciously like that of Héloïse and Abélard:

> *The Count was helping me perfect my French and I was teaching him Spanish: our readings led us to reflections for which our feelings supplied the principle. At every moment the secret of our love seemed ready to escape us; our eyes had already said it, when, reading one day a touching story of two tender lovers who were being cruelly separated, the book fell from our hands, our tears flowed together and equally overtaken by an*

unknown fear, we looked at each other. He slipped his arm around me, as if to hold me tight; I leaned toward him; and breaking the silence at the same moment, we cried out together: Oh how unhappy they were! A total confession of our secret followed this tender moment.[49]

However, because she is writing these letters after the sudden, inexplicable marriage of d'Ossery to someone else, Juliette's attitude as a reader and especially her reaction to declarations of love are no longer so unguarded. She has become acutely critical. Corresponding with her closest friend and confidante, Henriette, and occasionally with her best male friend, Lord Carlile, Juliette reveals her determination to operate by her own principles and resist further damage at the hands of men. In particular, she refuses any direct or mediated contact with her former suitor, and this includes sending his letters back to him intact. But when Juliette opens an envelope addressed by an unknown hand and finds a letter from the count, her resistance is effectively overcome; she gives in to reading and is caught. D'Ossery is able to play on her pride and goad her into responding, which allows him to press his case further. Although the intercalated letters from d'Ossery are not overtly sexual, they do derive their effectiveness from their appeal to Juliette's desire. Reading her lover's letters brings out her suppressed passion, unsettles her, and precipitates the story's denouement—her marriage to the man who had betrayed her.

Yet Juliette does not simply capitulate by any means. Throughout her correspondence she has maintained a running commentary on male/female relations. She is particularly critical of the idea that men set the rules that govern women's behavior and that these rules are not the same ones the men themselves observe. In the absence of d'Ossery, it is her friend Carlile who occasions her remarks and bears the brunt of her displeasure. She frequently comments on letters she has received from him or views he has asked Henriette to convey, displaying her talents as an insightful reader: "Milord Carlile claims that all resentment should yield to a true repentance: a beautiful maxim! In truth, I will use it with my inferiors but never with my friends. Trust doesn't take two hits; he thinks that, just as I do. But, my dear [Henriette], a useful point worth noting is that men only establish a principle in the hope of gaining some advantage from it." At one point, she responds angrily to Carlile's castigations: "Determined in my resolutions and guided by sure principles, I am capable of all the efforts that honor requires and what I think I owe myself will always decide my conduct and my ideas of happiness." Comparing her steadfast refusal of

d'Ossery's pleas to Carlile's own behavior with his friend Sternhill, whom Carlile killed in a duel, she turns Carlile's words against him, exclaiming: "Did anyone blame your *inflexibility*? Why would I pardon . . . ? And what right does one sex have to toy with the sweet temper and goodness of the other?" She goes on: "Once again, what are your rights to insult or to punish? What pride persuades you that you can punish when you believe that I must pardon?" Juliette believes in the equality of the sexes and does not "admit of any distinctions between creatures who feel, think, and act alike." She repeatedly questions why one sex should have the right to dictate rules of behavior to the other, and she makes it clear that she does not intend to be guided by standards she has not chosen herself. Summing up her feelings on the matter, she insists: "Do not give me prejudices for laws, my lord, nor usurpation for a title; time and possession may strengthen the power of the unjust, but do not make it legitimate."[50]

Given Juliette's rebellious spirit and her acute awareness of the way men usurp power over women, she responds with expected indignation to d'Ossery's duplicitous maneuver and the manipulative language of his first letter. Juliette's incorporation of textual elements from d'Ossery's letter in her missives to Henriette, accompanied by her own pointed commentary about his vocabulary, tone, and underlying philosophy, doubles his words and underscores his tactics. What d'Ossery sends is a distorted (verbal) portrait of Juliette as "an ordinary woman," the very opposite of all she aspires to be.[51] Her sarcasm reaches a new intensity as she picks out expressions in d'Ossery's letter that particularly offend her:

> *The more I reread the letter of Milord d'Ossery, the more I revolt against him; . . . my base condescension would better suit his ideas than an* inhuman pride [*or self-respect:* une inhumaine fierté]. *Oh my dear Henriette, men look upon us as beings placed in the Universe for the amusement of their eyes, to serve as playthings for . . . the fury of their passions, the impetuosity of their desires and [their] impudent freedom. . . . The object of their feigned adoration never wins their esteem and if we show them some strength of mind, some greatness of soul, we are* inhuman *creatures; we overstep the limits that they have dared to prescribe for us, and we become* unjust *without knowing it.*[52]

Nevertheless, Juliette's scathing assessment of the double standard that structures sexual relations does not prevent her from succumbing to her lover's strategy. The very trait that has stiffened her resolve becomes the means of her undoing. Because she is determined to be recognized as "a noble soul" who lives by her own high standards, Juliette feels compelled to rewrite the hurtful portrait d'Ossery has painted, to make it more faithful. She is drawn into his plot by the deliberately distorted image he has drawn of her. First in her letter to Henriette, then in a letter to d'Ossery himself, Juliette complains bitterly of his wrongful attack and tries to counter it. But the very act of writing back engages her. The passion that d'Ossery so skillfully mobilizes is not Juliette's lust, as in Greuze's model, but her pride.

Juliette's valiant struggle to reject men's rules and resist men's power ends in a certain failure. Although her marriage to Count d'Ossery is portrayed as a happy event, it also results in her (somewhat ambiguous) submission to her husband. Not surprisingly, it is an act of reading that embodies this ambivalence. Writing to Henriette, d'Ossery protests in mock horror that Juliette has taken the "liberty" of opening a letter addressed to "Milady Catesby," who no longer exists: "You write, beautiful Henriette, to Milady Catesby . . . but to whom should I give your letter? Is there still in the world a Milady Catesby? . . . If in place of this friend so dear to your heart, you want to accept a new friend, Milady d'Ossery is ready to respond to your tender congratulations. She opened your letter with a freedom that will perhaps astonish you, but what rights does not this charming woman, this Juliette have!"[53] The ironies in this letter are multiple. At the end of this spirited correspondence in which Juliette has resisted so adamantly the imposition of male power, it is her new husband who takes over writing in her stead. D'Ossery announces their marriage by claiming that Juliette Catesby no longer exists. In her newly married state, Juliette has lost not only her voice but her own subjectivity. The rights to self-determination for which Juliette so ardently campaigned have been reduced to a trivial "right" to read her friend's letter. D'Ossery's playful concession points up the shift that has occurred. The very imbalance of rights that Juliette so often emphasized is now the condition of her own existence. It is d'Ossery who will determine henceforth which "rights" are hers. Juliette has become her husband's property. Indeed, d'Ossery's triumphal exclamation, "She is mine, forever mine! No more Milady Catesby," is backed by the full literal weight of eighteenth-century French law.[54]

Although Riccoboni's ambiguous "happy ending" surprises some modern readers, who expect the novel to end as it began—with the critical reflections of a proud, independent heroine[55]—Juliette's sudden transformation illustrates a central dilemma for eighteenth-

century women as writers and readers. Riccoboni's novel is about the double bind in which strong, proud women find themselves: they cannot let men dictate their (self-)image, especially a distorted one; but they cannot substitute a better likeness for the one they abhor unless they take up the pen in their own self-defense, and then they have effectively submitted to the men's control. Although Juliette's pointed and protracted commentary in her letters to Henriette comes to an abrupt end, it nonetheless provides a model for critical double reading that the reader can apply to the novel itself. When Juliette's "feminist" discourse is allowed to echo beyond its foreclosure in the plot, the novel becomes a peculiarly female warning about the dangers of reading men's letters—and an act of resistance itself. Whereas men—Rousseau and Greuze, for example—may view reading as a dangerously sexual act that brings women (as readers and sexual beings) into the public sphere, Riccoboni locates the danger in men's ability to control how women see themselves. Her novel itself is a demonstration of how women writers can successfully retain control over their positive self-images and resist the distorted portraits men make of them—by writing their own fiction.[56]

WOMEN'S RIGHTS AND REPUBLICAN MOTHERHOOD

The view of the woman reader put forward by men of letters and artists in the mid-eighteenth century trades on the notion that women typically read novels, in preference to other writing, and are seduced and corrupted by their messages of desire. In the light of the philosophes' project to create a "republican" readership, their message to women about the unsuitability of their reading habits appears for what it was: one prong of a multipronged effort to remove women from their positions of influence in the public sphere and convince them that they belong at home, raising their sons for republican citizenship. Although the men focus on the deleterious effects novel reading has on women's virtue, behind this moral argument lies another fear—the fear of women's seductive effects on the (male) public. Rousseau is the principal spokesman for the attack on women's public role. As Joan Landes correctly observes, "Rousseau fears the infectious taint of women's company."[57] In his Letter to D'Alembert (1758), Rousseau decries the emasculation of Parisian men who frequent the female-run salons, and relates this degradation to the state: "Unable to make themselves men, the women make us into women. This disadvantageous result

which degrades man is very important everywhere; but it is especially so in states like ours [the Republic of Geneva], whose interest it is to prevent it. Whether a monarch governs men or women ought to be rather indifferent to him, provided that he be obeyed; but in a republic, men are needed." Rousseau regards the salons as "harems," where men pay homage to "a [female] idol, stretched out motionlessly on her couch, only her eyes and her tongue active."[58]

Opposed to this image of the seductive public woman (the "fallen girl" or the salonnière) is the mother, whose central role in reforming society Rousseau posits in Letter to D'Alembert and touts in book 1 of Emile (1762). If women return home and make raising a family their priority, he asserts, men will devote more time to their wives; children raised by their mothers and not by wet nurses will love and be loyal to their parents; and society as a whole will benefit.[59] The new iconography of the mother is pervasive in paintings and prints from the 1750s onward. As Emma Barker points out, although earlier in the century Chardin painted women in domestic scenes such as Saying Grace (c. 1740–42; cat. 18) or The Diligent Mother (1740; see fig. 26), his pictures present an image of woman's "wifely duty," not her "maternal destiny."[60] In the 1760s, Greuze depicted a new model of femininity in works such as The Well-Beloved Mother (fig. 8). Here, "the mother's voluptuous attitude contravenes all the rules of modesty . . . she appears to be almost overwhelmed by her own procreativity."[61] This mother's explicit role is to bear and rear healthy children at home, under the proud gaze of her husband; she embodies the new republican ideal for women "formulated and imposed by men." That the painting was understood by male critics as encouraging men to enter into marriage and become fathers is entirely consonant, moreover, with Rousseau's reasoning in book 1 of Emile. Even as a mother the woman continues to be seductive, but now she entices men back into the family, where they will rule over their wives and educate their sons to be citizens.[62]

This ideology proved difficult for women to resist, and its effects are felt on novels that otherwise emphasize women's rights to be educated and to speak their minds.[63] A forgotten but once popular novel by Madame Elie de Beaumont testifies to the pressures that the republican ideology of motherhood exerted on women, especially after Rousseau's Emile and Julie, ou la Nouvelle Héloïse appeared back-to-back in the early 1760s.[64] As early as 1764, Elie de Beaumont's novel Lettres du Marquis de Roselle put into play the maternal iconography that would become common currency during the French Revolution.[65]

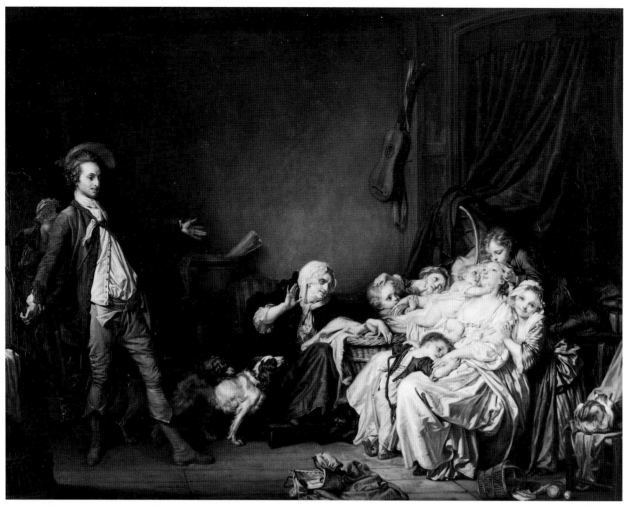

8. Jean-Baptiste Greuze, *The Well-Beloved Mother,* 1769, oil on canvas, Marquis de Laborde Collection, Madrid.

Anne-Louise Elie de Beaumont (1729–83) was the wife of the "avocat au Parlement" Jean-Baptiste Elie de Beaumont (1732–86), whom Dena Goodman considers one of "the two most prominent and enlightened lawyers in France at the time."[66] A wealthy seigneur who entertained members of the court at his estate at Canon, Elie de Beaumont was also one of the lawyers known as "patriotes," who advocated vesting power in the will of the people and elevating the public good over private concerns. Their ideology drew from several contemporary oppositional traditions: not only constitutionalism but also "the 'High Enlightenment' of the philosophes and the radical Enlightenment represented by thinkers like Rousseau and Mably."[67] In other words, Madame Elie de Beaumont kept company with the enlightened elite who supported the developing republican ethos and helped promote the new public sphere. Elements of this progressive political thought make their way into her epistolary novel and underlie

the author's position on relations between the social classes and the rights and responsibilities of the aristocrat as citizen. This is a woman-centered novel, however, featuring overtly political language attributed to a female character. If the philosophes, whose work inspired her husband, were plumping for the exclusion of women from the public sphere, Madame Elie de Beaumont's views were evidently divided.

Lettres du Marquis de Roselle revolves around the dilemma of a young married woman, the Comtesse de Saint-Sever, who is acting *in loco parentis* to raise her younger brother, the marquis of the novel's title. The countess steers a difficult course between being a stern disciplinarian and an overly indulgent friend, as she tries to dissuade her brother from marrying inappropriately. She wants to teach her brother the rights and responsibilities of an aristocrat without alienating him and driving him into the arms of his beloved Léonor, a "fille d'opéra." Refusing the harsh stance recommended,

the sister turns for advice to an older, more experienced friend, Madame de Narton, who helps her bring about the desired result.

The novel applauds the two women's rational and sensitive approach while showing up the husband as passionate and hasty, and thereby reverses the usual gender and marital roles in the male-authored literature of the time. Furthermore, by featuring a sweet but level-headed young woman who articulates directly and at length a discourse of rights, it promotes a model of female behavior that rebels against contemporary conventions. The countess takes note of legal rights in many different situations. For example, after her husband's confrontational approach has caused her brother to break off relations with them, she writes to Madame de Narton in despair: "Now only violent means are left to us; unfortunate and feeble resource! Is my brother not his own master? If his mind is made up, what we prevent today will happen in a month, in a year. Moreover, what right do we have to diminish in any way a [female] citizen's freedom? Am I wiser, or more powerful than the law?"[68] The countess uses a language of female citizenship and civil rights that is highly unusual in women's novels at any time in the century. But it is when she upbraids her brother that her language is particularly striking:

> You are a citizen, decorated with prerogatives and honors. What right do you have to invert the order of society, which has made distinctions between the classes for the good of the State and rightfully assumed that those it placed in an honorable rank would be neither cowardly enough nor ungrateful enough to trouble the harmony by their own vile acts? Society has attached duties to distinction, and you want to violate these laws boldly, which conform to religion and virtue, and which have chosen your delicacy for their guarantee . . . !
> What right do you have, you who are specially charged by virtue of your rank with the sacred trust of public mores, to degrade the Nation by robbing it . . . of these precious mores, which your ancestors transmitted to you by their example? . . . What will you say, when your country [la patrie] reproaches you for having used her purest blood to nurture the unworthy and denatured child you have become?[69]

Although we can hear in these words some of the ideas of man's limited rights and corresponding responsibilities articulated forty years before by Madame de Lambert, they appear here in a very new context.[70] Elie de Beaumont, through her countess, wants to expound on the values that any honnête homme of the nobility must uphold. But these values cannot be reduced to a code of honor that would govern male-female relations; rather, it is the marquis's failure to understand the importance of marriage *for the nation* that is at the center of the plot.

The countess has imbibed the republican ideology of motherhood in its most allegorical form: in her impassioned speech the mother is not the literal mother, but *la patrie*. The context collapses the idea of "fatherland" into the maternal imagery and implies that the marquis is both a "child" of this nurturing parent and himself a father-to-be. The result is a picture of the husband as citizen, responsible to his mother country for the upbringing and future destiny of her children. The countess's dense imagery makes clear what Greuze's painting *The Well-Beloved Mother* only insinuates: while the mother may require her children to behave appropriately, the central role in the family/state is not that of the mother, but that of the husband. The husband has the obligation to family and country to marry a proper wife and raise his children (as he should have been raised) to be loyal, responsible citizens. His blood is synonymous with—and replaces—the mother's milk that nurtures the posterity of the nation.

The figures of mother, husband, and child are brought together in this condensed image of the nation as a family, but the literal mother is absent. In a sense, the countess herself plays this role. Standing in for their parents, she gives advice to her brother/son and, in the name of both their family and their nation, exhorts him to change his ways. When she calms down after this diatribe, however, the countess fears the effects of her too-direct words. Her patriotic speech could scare her brother away and cause him to run into Léonor's clutches. Regretting her rash outburst, the countess gives up the rhetoric of the public sphere and returns to her role as sensitive listener and friend. Shortly after this moment, the events of the story pass out of the control of the countess, as Roselle comes to terms with the discovery that his Léonor has deceived him. Going to recover in the country from the sequellae of a duel, he comes under the watchful gaze of Madame de Narton, who has an estate near the baths where he will recuperate, and Madame de Ferval, the mother of the woman he will eventually marry. The responsibility for the young man's fate is now in the hands of two other women, one of whom is the "real" mother figure in this novel.

If the first part of the story revolves around the question of how to guide a young man in making the right choices in life, the second half concerns the proper education of a young woman. It is here that Madame de Ferval explains the educational philosophy that has enabled her to raise such outstanding daughters. The most

fascinating aspect of this section, however, is a dialogue between the young Mademoiselle Ferval and her brother, with Roselle looking on. The siblings discuss the daughter's belief that a woman cannot properly fulfill her duties "if she hasn't formed her mind by instruction, that is, by reading and reflection."[71] A dispute ensues. When the young woman argues that preparing herself to educate her children, administer a household, and affect "the general moral tone" of society requires her to read most works that a man would read, her brother reacts angrily. She will never have to lead an army or run a government, he retorts, so she has no need for such learning. No, she replies, but will you? But his sister will not be dismissed. Women are not men's "slaves" or their "playthings," and she expects to hold her own in men's company: "If I find myself among educated and reasonable people, I will not have the meanness to feign shameful ignorance," she declares (204).

The siblings' debate encapsulates the tension between women novelists and *salonnières,* on the one hand, and certain philosophes on the other, over women's right to an education, their right to read what they choose, and their right to take an active role in society commensurate with their knowledge and their intelligence.[72] The discussion ends, however, on an attenuated note. When the young man finally declares "you want us to treat you like men" (204) his sister backs down: "I am only asking you to have more just and noble ideas of our sex, I am not at all trying to trample on the rights of yours; that would be a total reversal of society."[73] Still, she has said enough to convince the marquis, who happily accepts this opinionated young lady as his bride.

The novel ends, more or less, with the happy conclusion of the marquis's marriage, but there is a small coda. Roselle writes to Madame de Narton to ask a last favor: he despairs because his new wife has adopted "an air of reserve and submission that humiliates [him]." Taking his wife's side, he asks: "You know her, Madame, and I know myself; is it not up to me to follow her advice and her desires in everything? Can there be men so barbaric that they do not realize that the superiority of talents, mind, reason, and virtue gives those women who are thus endowed [the same] rights that men demand for themselves, often with harshness and injustice?"[74] Ultimately, Elie de Beaumont's novel walks a fine line between the positions of the *salonnière* and the philosophe, between arguing for women's right to educate themselves for participation in the public sphere and adopting the philosophic discourse that would confine them to their domestic role as mothers of the Re-

public. If the first part of the novel sets out the father's responsibilities to his family and to the nation and subordinates the mother to her husband, the second part shows him bowing to his wife's superiority and yielding to her his rights.

The novel has a contradictory message for women. Although the countess speaks a language of rights unusual for a woman, it is aimed at a man: the person who ultimately has rights and responsibilities is not the countess but the marquis. And it is Madame de Narton, as the countess's liaison to Madame de Ferval, who supplants the countess and brings the drama to its ideal end. The unprecedented example of a woman speaking the "male" language of rights is thus contained and even superseded by the motherly discourse of her friends. Women may be well versed in the discourse of rights and even on the verge of obtaining male rights for themselves, the novel seems to say, but their function as mothers will inevitably win out. Rousseau's ideology of motherhood may be felt as an unfortunate subtext in this novel, which points to the final shift for women's rights in the century, when women accepted the maternal image of themselves made fashionable by Rousseau and became increasingly ambivalent on the subject of their *droits.*

Between the late 1750s and the Revolution, prominent authors such as Marie Le Prince de Beaumont (1711–1780) and Stéphanie Félicité de Genlis (1746–1830) began to target a new public of mothers and children. Although Le Prince de Beaumont wrote a number of feminist tracts and other works aimed at worldly readers,[75] she was best known for her moral tales for children, published in her *Magasin des enfants* (1757) and *Magasin des adolescentes* (1760), and in particular for her abridged—and now classic—version of "Beauty and the Beast," which teaches the lesson of female obedience and self-sacrifice. Similarly Genlis, the tutor of the royal princes, drew on her pedagogical experience in her books for children and on education—among them *Théâtre à l'usage des jeunes personnes* (1779), *Adèle et Théodore, ou Lettres sur l'éducation* (1782), and *Les Veillées du château, ou Cours de morale à l'usage des enfants* (1784). The issues of courtship, marriage, betrayal, separation, and oppression, which preoccupied the *salonnières* and their successors among the women novelists, are here condensed—if discussed at all—and reduced to lessons. The concern of these works is female duty and obedience, not women's rights. The problems women of the world might encounter in trying to negotiate a more egalitarian "sexual contract" have been replaced by the problems mothers face in educating their young. These works of and on pedagogy attest to—and encourage—

women's widespread acceptance of their role as mothers and educators in the home.[76]

THE RIGHTS OF WOMAN DENIED

It would take the "public women" of the French Revolution—and Olympe de Gouges in particular—to bring out forcefully and explicitly the relation between the "sexual contract" and the new Republic. The culmination of the republican project in the revolutionary period brought with it a number of positive changes for women—including a law granting women the right to inherit and another allowing divorce by mutual consent—but equal rights eluded them. The Declaration of the Rights of Man was intended not for humanity in general but for men in particular. In her "Declaration of the Rights of Woman" (1791), de Gouges pointedly reproaches men for their hypocrisy: "[Man] wants to command as a despot a sex which is in full possession of its intellectual faculties; he pretends to enjoy the Revolution and to claim his rights to equality in order to say nothing more about it." Calling on women to be "aware of their deplorable fate, and of the rights they have lost in society," she exclaims: "Oh women, women! When will you cease to be blind? What advantage have you received from the Revolution? A more pronounced scorn, a more marked disdain."[77]

De Gouges attempted to remedy this loss by amending the male declaration to take women into account. She inserted women in each of the declaration's seventeen articles, sometimes merely changing "citoyens" to "citoyennes," sometimes substantially rewriting an article to make women's particular needs known. But she innovated as well. In fact, she added in a postscript a new "Form for a Social Contract between Man and Woman," which "redefines marriage as a limited and renewable social contract between two free and willing parties."[78] By attaching this marriage contract to her demand for women's political equality, de Gouges made it clear that she understood and intended to revise the link between "conjugal rights" and civil rights so that women, as equal and freely contracting partners in marriage, could be equal and politically active citizens of the nation. Although the female authors earlier in the century may not have conceived of their projects in such radical terms, de Gouges's text makes explicit, nonetheless, what was at stake in the protests of Lambert, Tencin, Riccoboni, and Elie de Beaumont.

De Gouges's attempt to insert an image of woman in a male-authored text from which it was absent and to create a public of women readers who would rally to form a constituency for her demands was unsuccessful,

and de Gouges was ultimately executed for her political activity. In the same month that her fate was decided, the Committee of General Security debated the question of women's political rights, their role in government, and their right to found and participate in political associations such as clubs, and concluded that women belonged at home. Women's claim to political rights was rejected and women's clubs were banned.[79] Olympe de Gouges's tragic struggle points to the evanescence of women's rights in the nascent Republic and underscores the difficulty women encountered as they tried to wrest control of their own image from the men who would shape or even efface it.

1. Diderot makes fun of these courtiers in *La Religieuse (The Nun)* when his heroine calls them "that sort of scatterbrained man that you call *talons rouges* and that I soon sent packing" ("cette sorte d'étourdis que vous appelez des *talons rouges* et que j'eus bientôt congédiés"). *Oeuvres romanesques* (Paris, 1962), 282. Unless otherwise noted, translations are mine.

2. Thomas E. Crow, *Painters and Public Life in Eighteenth-Century Paris* (New Haven, 1985), 63.

3. As John Berger says, "The 'ideal' spectator is always assumed to be male and the image of the woman is designed to flatter him" (*Ways of Seeing* [London, 1972], 64).

4. Ibid., 46–47.

5. Berger identifies the contradiction that nude paintings embody: between, on the one hand, "the individualism of the artist, the thinker, the patron, the owner [and] on the other hand the person who is the object of their activities—the woman—treated as a thing or an abstraction. . . . [Paintings of the nude displayed] a remarkable indifference to who any one person really was" (ibid., 62).

6. L'Abbé Prevost's *Manon Lescaut* (1731), an influential novel contemporaneous with de Troy's art, comes immediately to mind. The woman's story is told by her lover to another man, who repeats it in turn to the (presumably male) reader. Furthermore, the narrator adds the story of his own baffling encounter with Manon, whom he saw in a group of prostitutes being transported to America. Manon's exceptional beauty, dignity, and modesty confound his expectations, and he remarks, "Such is the inscrutable nature of woman." This "inscrutability" leads to, or results from (it is impossible to say which), Manon's allegorical status—and her silencing—in the text.

7. Joan Kelly, "Early Feminist Theory and the Querelle des Femmes, 1400–1789," *Signs* 8 (1982): 4–28.

8. Joan B. Landes, *Women and the Public Sphere in the Age of the French Revolution* (Ithaca, 1988), 12.

9. "Ainsi, suivant les lois anciennes et nouvelles, la femme mariée est soumise à son mari; . . . c'est-à-dire en sa puissance, de sorte qu'elle doit lui obéir; et si elle manque aux devoirs de son état, il peut la corriger modérément" ("Femme, mariée," in *Encyclopédie; ou, Dictionnaire raisonné des sciences, des arts, et des métiers* [Paris, 1756], 6:476–78. The articles on women run from pp. 468 to 481 of this volume.).

10. See Nadine Bérenguier, "Victorious Victims: Women and Publicity in *Mémoires Judiciaires*," in *Going Public: Women and Publishing in Early Modern France*, ed. Elizabeth C. Goldsmith and Dean Goodman (Ithaca, 1995), 62–78.

11. An adulteress, for example, legally could be punished by being whipped and then locked up in a monastery for two years. During

that time her husband could come and take his wife back, but once the two years elapsed or if the husband died, the woman had to take the veil and live cloistered for the rest of her life.

12. "Le principal effet de la puissance que le mari a sur sa femme, est qu'elle ne peut s'obliger, elle ni ses biens, sans le consentement et l'autorisation de son mari, si ce n'est pour ses biens paraphernaux dont elle est maîtresse" ("Femme, mariée," *Encyclopédie*, 6:478).

13. See, for instance, John Locke's statement that "every Man has a Property in his own Person" (*Two Treatises of Government*, ed. P. Laslett, 2nd ed. [Cambridge, 1967], treatise 2, 627).

14. Carole Pateman, *The Sexual Contract* (Stanford, 1988), 3.

15. Ibid., 102.

16. The authoritative reference for Lambert is Roger Marchal, "Madame de Lambert et son milieu," *Studies on Voltaire and the Eighteenth Century*, no. 289 (1991). Fontenelle said about her salon, "C'était la seule, à un petit nombre d'exceptions près, qui se fût préservée de la maladie épidémique du jeu; la seule où l'on se trouvât pour se parler raisonnablement les uns les autres, et même avec esprit, selon l'occasion" (quoted in Joseph François Michaud and Louis Gabriel Michaud, *Biographie universelle, ancienne et moderne* [Paris, 1811–62], 23:44).

17. Her *Collected Works* went through thirteen editions in French between 1747 and 1785. In addition to *Réflexions nouvelles sur les femmes* (*New Reflections on Women* [1727]), "Avis d'une mère à son fils" ("Advice from a Mother to Her Son" [1728]), "Avis d'une mère à sa fille" ("Advice from a Mother to Her Daughter" [1732]), and the various editions of her *Collected Works* in French, Lambert's works were regularly issued in England between 1749 and 1781 and were also published in German and Spanish. (Although Lambert's letters to her children were composed as many as thirty years before they were published, I have followed custom in giving the dates of their first publication.)

18. Crow, *Painters and Public Life*, 66.

19. Ibid., 65, 72.

20. Lambert, *Oeuvres*, ed. Robert Granderoute (Paris, 1990), 4218: "Quand le luxe et l'argent sont en crédit, le véritable honneur perd le sien."

21. Ibid., 217–18: "Les femmes pourraient dire: 'Quelle est la tyrannie des hommes! Ils veulent que nous ne fassions aucun usage de notre esprit ni de nos sentiments. . . . C'est étendre trop loin leurs droits.' . . . Les femmes ne peuvent-elles pas dire aux hommes: 'Quel droit avez-vous de nous défendre l'étude des sciences et des beaux arts?'"

22. For example, see Immanuel Kant, "What Is Enlightenment?" (1784), in *Philosophical Writings*, ed. Ernst Behler (New York, 1986).

23. Lambert, *Oeuvres*, 223: "Pour donner aux choses le rang et le prix qu'elles méritent, distinguons les qualités estimables et les agréables. Les estimables sont réelles et sont intrinsèques aux choses; et, par les lois de la justice, ont un droit naturel sur notre estime."

24. Ibid., 225: "Les hommes se sont-ils acquis, par la pureté de leurs moeurs, le droit d'attaquer celles des femmes?"

25. Ibid., 215: "Les hommes, plutôt par la force que par le droit naturel, ont usurpé l'autorité sur les femmes."

26. "Avis d'une mère à son fils," in ibid., 61: "L'honnêteté consiste à se dépouiller de ses droits et à respecter ceux des autres."

27. Ibid., 46.

28. Ibid., 63: "Cette fine galanterie de l'esprit et des manières," and 64: "en examinant de près ceux qui se font un métier de la galanterie, on les trouve souvent de malhonnêtes gens. . . . Les hommes ne sont pas en droit de tant blâmer les femmes; c'est par eux qu'elles perdent l'innocence."

29. Ibid., 101.

30. Ibid., 113: "En donnant trop d'étendue à la docilité, vous prenez sur les droits de la raison, vous ne faites plus d'usage de vos propres lu-

mières, qui s'affaiblissent. C'est donner des bornes trop étroites à vos idées que de les renfermer dans celles d'autrui."

31. L'Abbé Prévost, best known as the author of *Manon Lescaut*, reviewed the novel in the year of its publication and announced: "Les Mémoires de Comminges se sont fait lire de tout le monde avec goût, et passent tout d'une voix pour un livre bien écrit" ("The *Memoirs of Comminges* have been read and enjoyed by everyone with taste and are unanimously acclaimed as a well-written book"). (The relevant article from *Le Pour et contre* is partially reprinted in Prévost, *Oeuvres*, ed. Jean Sgard [Grenoble, 1985], 7:499.) There were many subsequent editions of the novel in French, published not only in France but in London and Berlin; an English translation appeared in 1774. The novel continued to be published rather regularly until 1908. I refer to the edition published in Paris by Desjonquères in 1985 as *Comte*. Tencin also wrote *Le Siège de Calais* (1739) and *Les Malheurs de l'amour* (1747, translated as *The Female Adventurers*); another unfinished novel, *Anecdotes de la cour et du règne d'Edouard II, roi d'Angleterre*, was completed by Madame Elie de Beaumont, whose work I discuss below.

32. *Comte*, 30: "Je crus avoir droit de disposer de ces papiers."

33. Tencin's novel relates convincingly to her own life: sent to a convent at the age of eight and forced to become a nun when her appeals to her father for release went unanswered, she spent more than twenty years trying to free herself from her father's orders. Seven years after he died, she finally succeeded in obtaining an annulment of the vows that she had taken against her will and that resulted in a depression so profound as to be life-threatening.

34. Eva Martin Sartori, "Claudine-Alexandrine Guérin de Tencin (1682–1749)," in *French Women Writers: A Biobibliographical Sourcebook*, ed. Eva Martin Sartori and Dorothy Wynne Zimmerman (New York, 1991), 481.

35. "L'usage de ce mot est si familier, qu'il n'y a presque personne qui ne soit convaincu au dedans de soi-même que la chose lui est évidemment connue" ("Droit naturel," *Encyclopédie*, 5:131–34).

36. One apparent sign of heightened interest in the "woman question" during this period is the flurry of misogynist and feminist tracts published between 1750 and 1759. See Maïté Albistur and Daniel Armogathe, *Histoire du féminisme français* (Paris, c. 1977), 1:266–68.

37. Dena Goodman, *The Republic of Letters: A Cultural History of the French Enlightenment* (Ithaca, N.Y., 1994), 31.

38. Ibid., 32.

39. Ibid., 5.

40. Ibid., chap. 6.

41. Goodman suggests that women's legitimacy in the governing role stemmed in part from their position outside the male discourse they governed. She also notes that this legitimacy "was both tenuous and temporary, for it was undermined by a masculinist assumption of the illegitimacy of female power and authority, especially over men" (ibid., 6).

42. Ibid., 136–37. Some prominent examples of philosophic writing in this genre are Montesquieu's novel *Lettres persanes* (*Persian Letters*) (1721); Diderot's essay "Lettre sur les aveugles" ("Letter on the Blind") (1749); and Rousseau's public reply to D'Alembert's article on Geneva in the *Encyclopédie*, "Lettre à D'Alembert" (1758).

43. Some epistolary novels by women that foreground women as serious and critical readers and show them creating their own publics are: Françoise de Graffigny's *Lettres d'une Péruvienne* (1747, revised 1752), in which the heroine retires from "the world" to her country estate where she will ensconce herself in her library to read the philosophes and edit her own correspondence for the edification of her readers; Marie-Jeanne Riccoboni's several epistolary novels, including the first, *Lettres de Mistriss Fanni Butlerd* (1757), which ends with the heroine announcing that she will publicize her fickle lover's deeds in the newspaper, and for which Riccoboni created a public by publishing in the *Mercure de France* a (fictional) letter

from Fanni that did indeed denounce him; and Anne-Louise Elie de Beaumont's *Lettres du Marquis de Roselle* (1764), discussed below. For the story of Riccoboni's savvy creation of her reading public by playing with public and private reading effects, see Joan Hinde Stewart's introduction to *Lettres de Mistriss Fanni Butlerd* (Geneva, 1979).

44. Ruth P. Thomas, "Marie Jeanne Riccoboni (1713–1792)," in Sartori and Zimmerman, *French Women Writers*, 357.

45. I have checked only the National Union Catalogue listings, which show that a version might go through several editions.

46. Martha Wolff, in her entry on Greuze in Susan Wise et al., *French and British Paintings from 1600 to 1800 in the Art Institute of Chicago* (Chicago, 1996), 70–74, points out that "it is not impossible that Greuze knew of Rousseau's novel, since his patrons and champions, including La Live de Jully and Diderot, were connected to those friends of Rousseau who had access to the manuscript."

47. Rousseau, *Julie, ou la Nouvelle Héloïse*, in *Oeuvres Complètes* (Paris, 1964), 2:6: "Jamais fille chaste n'a lu de Romans; et j'ai mis à celuice un titre assés décidé pour qu'en l'ouvrant on sut à quoi s'en tenir. Celle qui, malgré ce titre en osera lire une seule page, est une fille perdue: mais qu'elle n'impute point sa perte à ce livre; le mal étoit fait d'avance. Puisqu'elle a commencé, qu'elle achève de lire: elle n'a plus rien à risquer." I have used Nancy Miller's translation of this passage from *A New History of French Literature*, Denis Hollier (Cambridge, Mass., 1989), 485. Although his formulation was extreme, Rousseau was by no means the only one to hold this point of view. Already in the early part of the century, Madame de Lambert had her reservations about recommending novel-reading to her daughter, even though she admired and wanted to encourage the novelistic production of women authors. She, like Rousseau, believed that novels transmitted to young female readers the wrong idea about relations between the sexes and inflamed their imaginations.

48. In her entry on this painting, Martha Wolff recalls Diderot's observation that Greuze was able "to paint women as occupying a border region between decency and lasciviousness." She quotes Diderot as saying about another of Greuze's works that it depicts "a paroxysm more sweet to experience than it is decent to paint" ("un paroxisme plus doux à éprouver que honnête à peindre") (70–74, n. 13).

49. "Le Comte me perfectionnait dans le Français et je lui enseignais l'Espagnol: nos lectures nous conduisaient à des réflexions dont nos sentiments étaient le principe. A chaque instant le secret de notre coeur paraissait prêt à nous échapper; nos yeux se l'étaient déjà dit, lorsque, lisant un jour une histoire touchante de deux tendres amants qu'on séparait cruellement, le livre tomba de nos mains, nos larmes se mêlèrent et saisis tous deux de je ne sais quelle crainte, nous nous regardâmes. Il passa un bras autour de moi, comme pour me retenir; je me penchai vers lui et rompant le silence en même temps, nous nous écriâmes ensemble: *Ah qu'ils étaient malheureux!* Une entière confiance suivit cet attendrissement" (*Lettres de Milady Juliette Catesby à Milady Henriette Campley, Son Amie* [Paris, 1983], 55–56). Riccoboni signaled her intent to rewrite the traditional story of the tutor and his female pupil when she made Juliette the count's Spanish teacher and introduced the possibility of the reciprocal (and equal) education of the sexes.

50. "Milord Carlile prétend que tout ressentiment doit céder à un vrai repentir: belle maxime! en vérité, je m'en servirai avec mes inférieurs mais jamais avec mes amis. La confiance ne reçoit pas deux atteintes; il le pense comme moi. Mais, ma chère, une remarque utile à faire, c'est que les hommes n'établissent un principe que dans l'espoir d'en tirer avantage" (ibid., letter 7, 22–23); "Déterminée dans mes résolutions par des principes sûrs, je suis capable de tous les efforts que l'honneur exige et ce que je croirai me de-

voir, décidera toujours de mes projets de condite et de mes idées de bonheur" (ibid., 44); "Quelqu'un blâma-t-il votre *inflexibilité*? Pourquoi pardonnerais-je . . . ? Et quel droit un sexe a-t-il de se jouer de la douceur et de la bonté de l'autre?" (45); "Encore une fois, quels sont vos droits pour insulter ou pour punir? Quel orgueil vous persuade que vous pouvez punir quand vous croyez que je dois pardonner?" (45); "Je n'admets point de distinctions entre des créatures qui sentent, pensent et agissent de même" (46); "Ne me donnez point des préjugés pour des lois, Milord, ni l'usurpation comme un titre; le temps et la possession affermissent le pouvoir de l'injuste, mais ne le rendent jamais légitime" (45–46).

51. Letter 21.

52. Ibid., 22, 96–97.

53. "Vous écrivez, belle Henriette, à Milady Catesby; . . . mais à qui remettre votre lettre? Est-il encore au monde une Milady Catesby? . . . Si la place de cette amie si chère à votre coeur, vous voulez en accepter une nouvelle, Milady d'Ossery est prête à répondre à vos tendres félicitations. Elle a ouvert votre lettre avec une liberté dont vous serez peut-être étonnée, mais quels droits n'a pas cette femme charmante, cette Juliette!" (ibid., note following letter 37, 172–73).

54. "Elle est à moi, pour jamais à moi! Plus de Milady Catesby" (ibid., note following letter 37, 172–173).

55. One critic, Susan S. Lanser, in *Fictions of Authority: Women Writers and Narrative Voice* (Ithaca, N.Y., 1992), has suggested that the novel's counterplot leads to a second ending that brackets and subordinates the conventional male-dominated ending: in a kind of postscript to the story, after d'Ossery's note, Juliette writes a last letter to Henriette asking her to come and join the festivities. Lanser reads Juliette's last words as extending the story beyond the conventional ending and suggesting that Juliette's relationship with her confidante is still primordial.

56. Riccoboni's vigilance and her resistance are exemplified in her correspondence with Choderlos de Laclos, the author of *Les Liaisons dangereuses* (Dangerous Liaisons). In April 1782, shortly after the publication of Laclos's shocking novel, she wrote to him to protest his depiction of the villainous Madame de Merteuil: "C'est en qualité de femme, Monsieur, de Française, de patriote zélée pour l'honneur de ma nation, que j'ai senti mon coeur blessé du caractère de Madame de Merteuil" (Laclos, *Oeuvres complètes* [Paris, 1979], 759). Unfortunately, her correspondence with Laclos also proves my other point: once she writes to him, he controls the correspondence (sending her a copy of his book, writing two letters to her one, for example) until she finally begs off, saying, "Dire ce que je ne pense pas me paraît une trahison, et je vous tromperais en feignant de me rendre à vos sentiments" (768).

57. Landes, *Women and the Public Sphere*, 87.

58. Rousseau, *Politics and the Arts: Letter to M. d'Alembert on the Theatre*, trans. Alan Bloom (Ithaca, N.Y., 1960), 100–102. See *Oeuvres Complètes* (Paris, 1995), 5:92–93.

59. Rousseau says, for example: "Do you wish to bring everyone back to his first duties? Begin with mothers. . . . Let mothers deign to nurse their children, morals will reform themselves, nature's sentiments will be awakened in every heart, the state will be repeopled. . . . Let women once again become mothers, men will soon become fathers and husbands again" (Rousseau, *Emile*, trans. Alan Bloom [New York, 1979], 46). For a discussion of Rousseau's influence, see Jean H. Bloch, "Women and the Reform of the Nation," in *Woman and Society in Eighteenth-Century France*, ed. Eva Jacobs et al. (London, 1979), 3–18.

60. Emma Barker, "The Transformation of Domesticity: From Chardin to Greuze," paper read at the annual conference of the College Art Association, Boston, 1996. See also Carol Duncan, "Happy Mothers and Other New Ideas in Eighteenth-Century French Art," in *Feminism and Art History*, ed. Norma Broude and Mary D. Garrard (New York, 1982), 200–219.

61. Barker, "Transformation of Domesticity." It is fascinating to notice the links among three Greuze paintings that seem to depict the same woman (Greuze's wife?) in more or less the same pose (reclining against a pillow, her head tilted back) as *Philosophy Asleep/La Philosophie endormie* (suggesting that women are *not* philosophers, since they fall asleep over weighty tomes), *Lady Reading the Letters of Heloise and Abelard*, and *The Well-Beloved Mother/ La mère Bien-aimée*. The similarities among the women in these three different works point up not only the aura of seductiveness that seems to cling to women no matter what their role, but also, and more to the point, the propaganda against the *salonnière* or the learned woman (whose reason is deemed to be "asleep") and in favor of the "beloved" mother. The woman reading novels could be said to mediate between the two.

62. Regarding the father's role in the family, Rousseau does not mince words: "A father, when he engenders and feeds children, does with that only a third of his task. He owes to his species men; he owes to society sociable men; he owes to the state citizens. Every man who can pay this triple debt and does not do so is culpable, and more culpable perhaps when he pays it halfway. He who cannot fulfill the duties of a father has no right to become one" (*Emile*, 49). And in a note to this discussion, Rousseau reminds his reader that both Cato the Censor, "who governed Rome so gloriously," and Augustus, "master of the world that he had conquered and that he himself ruled," raised and taught their sons or grandsons. For the husband's "rule" over the wife, see *Emile*, book 5.

63. As P. D. Jimack explains, while Rousseau's ideology of republican motherhood won the assent of many women, his plan for women's education, set out in book 5 of *Emile*, was not so well received. Many were the critics, both male and female, who found his ideas in favor of a very limited education for women and his views on the wife's complete submission to her husband far too extreme. See "The Paradox of Sophie and Julie: Contemporary Response to Rousseau's Ideal Wife and Ideal Mother," in Jacobs, *Woman and Society*, 152–65.

64. According to Joan Hinde Stewart, who cites the bibliographical work of Angus Martin, Vivienne G. Mylne, and Richard Frautschi, thirteen reeditions of the *Lettres du Marquis de Roselle* appeared in the fifteen years after its original publication in 1764. (See "A Wife for the Marquis," in *Dilemmes du roman: Essays in Honor of Georges May*, ed. Catherine LaFarge [Saratoga, Calif., 1989], 61.) The National Union Catalog lists several editions published simultaneously in London and Paris—anonymously in 1764, then under the author's name or initials in 1764, 1767, 1771, and 1775. English translations appeared in 1765 and 1766. According to Michaud and Michaud, *Biographie universelle*, "Ce roman a eu assez de succès pour que M. Desfontaines de la Vallée donnât au public les *Lettres de Sophie au Chevalier de* * * *, pour servir de Supplément aux Lettres du marquis de Roselle*, 1765, 2 parties in-12" (11:358).

65. See Lynn Hunt, *The Family Romance of the French Revolution* (Berkeley and Los Angeles, 1992), and Madelyn Gutwirth, *The Twilight of the Goddesses: Women and Representation in the French Revolutionary Era* (New Brunswick, N.J., 1992).

66. Goodman, *Republic of Letters*, 262: "In the 1770s and 1780s [he and his friend Target] had among their clients two of the king's brothers, his nephew, and the University of Paris." Together they would help found, in 1779, the Société Libre d'Emulation, "an association of persons of all ranks and conditions" (ibid., quoting the *Mémoires* of J.-P. Lenoir), which was the first "assembly of private persons in a public space whose purpose was utility" (262–63).

67. Sara Maza, *Private Lives and Public Affairs* (Berkeley and Los Angeles, 1993), 55, 97.

68. "Nous n'avons plus que les moyens violents à employer; malheureuse et faible ressource! Mon frère n'est-il pas son maître? Si sa résolution est prise, ce que nous empêcherons aujourd'hui se fera

dans un mois, dans un an. D'ailleurs, quel droit avons-nous d'attenter à la liberté d'une citoyenne [Léonor]? Suis-je plus sage, ou plus puissante que la loi?" (Madame * * * [Madame Elie de Beaumont, like so many other women, first published her novel anonymously], *Lettres du Marquis de Roselle* [Amsterdam, 1764], 116).

69. Ibid., letter 58; 102–3: "De quel droit, vous citoyen, vous décoré de prérogatives et d'honneurs; de quel droit intervertiriez-vous l'ordre de la société, qui, en distinguant les conditions pour le bien de l'Etat, s'est promis à juste titre, que ceux qu'elle plaçait dans un rang honorable, ne seraient ni assez lâches, ni assez ingrats pour en troubler l'harmonie par leur propre avilissement? Elle a attaché des devoirs aux distinctions, et vous en violerez audacieusement les lois, qui s'accordent avec la religion et la vertu, ne se sont choisi . . . pour garans que votre délicatesse . . . ! De quel droit vous, plus particulièrement chargé par votre rang au dépôt auguste des moeurs publiques, dégradez-vous la Nation, en lui ravissant, autant qu'il est en vous, ces moeurs précieuses, dont vos aïeux vous avaient transmis l'exemple? Il faut donc que vous cessiez d'être citoyen, et que vous vous déclariez l'ennemi de l'ordre, et cet ordre vous ne l'aurez pas seulement enfreint pour vous-même, vous l'aurez aussi troublé dans les autres: la contagion de votre exemple entraînera une foule de jeunes insensés, séduits par ces malheureuses, qu'un tel succès aura rendu plus entreprenantes. Que répondrez-vous à votre patrie, qui vous reprochera de n'avoir nourri en vous de son plus pur sang, qu'un enfant indigne et dénaturé?"

70. Indeed, Elie de Beaumont recognizes her debt to her predecessors when she has one of her male characters—the unsavory "galante" or libertine, Valville—mock Roselle's sister and her friends. Valville claims their virtues are those of their "old grandmothers" (ibid., 23) and he ridicules "a woman who reasons" (190). Valville, of course, will be proven wrong and cast out of the marquis's life in the end. In her life as an author, moreover, Elie de Beaumont had a direct connection to the *salonnières* of the previous generation: she completed the novel, *Anecdotes de la cour et du règne d'Edouard II, roi d'Angleterre* (1776), that Madame de Tencin left unfinished at her death in 1749.

71. Beaumont, *Lettres du Marquis de Roselle*, 198: "Le premier objet d'une femme est de plaire, non au monde en général . . . [mais] à son mari"; nonetheless, "son état lui impose, ainsi qu'à l'homme, des devoirs importants qu'elle ne peut bien remplir, si elle ne s'est formé l'esprit par l'instruction, c'est à dire, par la lecture et par la réflexion."

72. In fact, at one point the brother says in desperation: "If you only knew where I've gotten my ideas and in what author" (ibid., 205), to which his sister replies: "Let us pay homage to the talents of famous writers; but we should be allowed to discuss their opinions, and to yield only to reason" ("rendons hommage aux talents des écrivains célèbres; mais qu'il nous soit permis de discute leurs opinions, et de ne céder qu'à la raison").

73. Ibid.: "Je ne cherche qu'à vous faire prendre des idées plus justes et plus nobles de notre sexe, et point du tout à empiéter sur les droits du vôtre; ce serait un renversement total dans la société."

74. Ibid., 283–84: "Vous la connaissez, Madame, et je me connais; n'est-ce pas à moi à suivre en tout ses conseils et ses volontés? Y a-t-il des hommes assez barbares pour ne pas sentir que la supériorité des talents, de l'esprit, de la raison, et des vertus, donne aux femmes qui l'ont reçue du ciel, des droits qu'ils réclament si souvent avec autant de dureté que d'injustice?"

75. Le Prince de Beaumont wrote *L'Apologie des femmes* (1751) and *Les Femmes illustres* (which features the Roman and Spartan mothers so frequently cited and painted by republican writers and artists), as well as *Le Pour et le contre: Dissertation sur l'éducation des personnes du sexe*. These pieces were collected in the multivolume *Oeuvres mêlées de Madame Le Prince de Beaumont* (Maestricht, 1775), which is a reprint of *Le Nouveau Magasin français, ou Biblio-*

thèque instructive, published in London in 1750, 1751, and 1755, according to Michaud, *Biographie universelle.*

76. For an excellent discussion of the complexity of these two authors' work, and the ways in which they may also subtly subvert the didactic lessons they seem to put forward, see Joan Hinde Stewart, *Gynographs: French Novels by Women of the Late Eighteenth Century* (Lincoln, Neb., 1993).

77. *The Declaration of the Rights of Woman and Citizen (Déclaration des droits de la femme et la citoyenne),* in *Women in Revolutionary Paris, 1789–1795,* ed. Darline Gay Levy et al. (Urbana, Ill., 1979), 88–89, 92.

78. Janie Vanpée, *"La Déclaration des Droits de la Femme et de la citoyenne*: Olympe De Gouges's Re-Writing of *La Déclaration des Droits de l'homme,"* in *Literate Women and the French Revolution of 1789,* ed. Catherine R. Montfort (Birmingham, 1994), 74.

79. Ibid., 57.

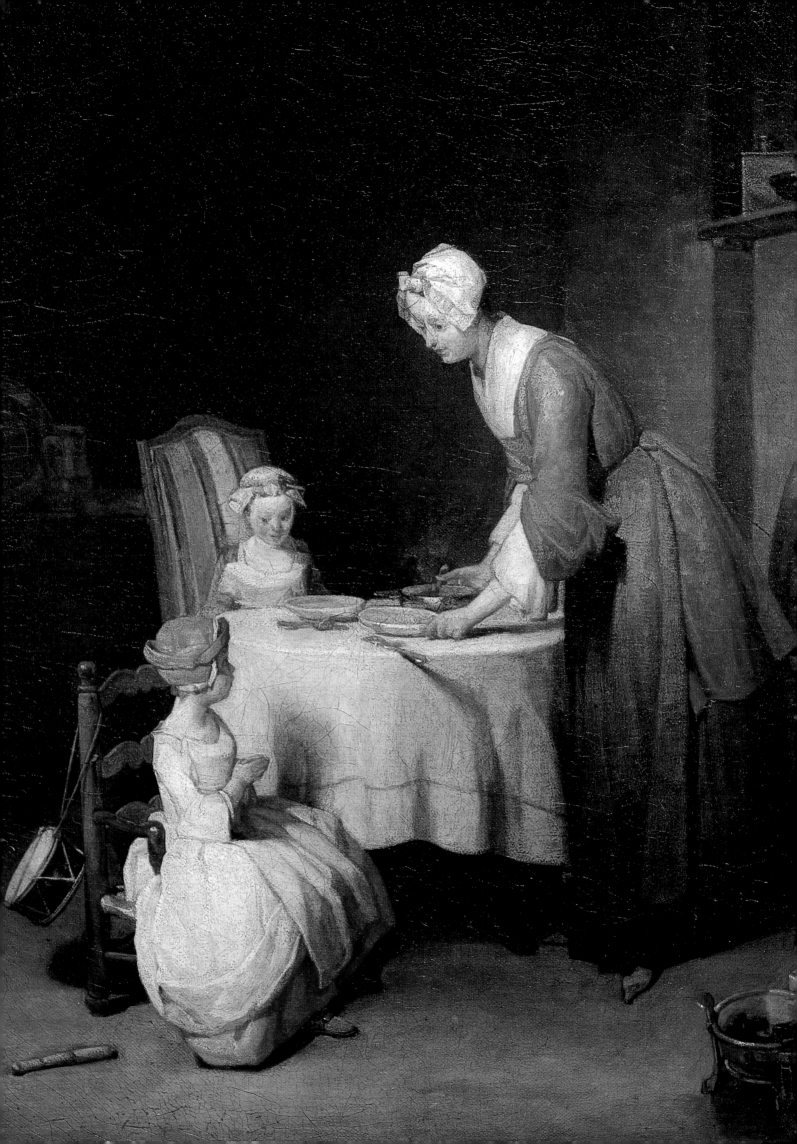

The "Bourgeois" Family Revisited: Sentimentalism and Social Class in Prerevolutionary French Culture

SARAH MAZA

The link between "family values" and what we call the middle class is one of the most tenacious myths in our culture. The rich have too many resources, we assume, and are therefore prey to too many temptations. They delude themselves into thinking they can buy their way into love or happiness; the poor are vulnerable for the opposite reason, their families shattered by penury and self-destructive despair. The mythical middle, those with enough money to nurture their loved ones and enough prudence to know that one has to work at loving them, will inherit a world of rewarding domesticity. Such assumptions are easy to project onto the past. One look at the quiet intensity between adult and child in a Chardin (cat. 18), or at the histrionic family affect in a Greuze (cat. 31), and we know we have found it: the prototype of bourgeois domesticity, the upstanding answer to all of those fleshy nudes and frilly "swingers" (exemplified in this exhibition by Boucher [cat. 11] and Fragonard [cat. 24]) that seem to epitomize the aristocratic culture of the Old Regime.

There is no question that representations of family life, and especially of happy families, were central to the culture of eighteenth-century France, at least among the literate elites. But is there any reason to assume that such images in art and literature had anything to do with the middle classes, or for that matter with class at all? I believe that the material conditions of family life changed significantly in eighteenth-century France, as did representations of, and ideological discourse about, the family. Not only was the family (usually parents and children only) routinely idealized, it was also often represented—especially in the second half of the century—in hyperbolically sentimental terms. Although sentimental images of family life did have a class content (mainly in their explicit rejection of perceived "aristocratic" family values), they cannot be taken as symptomatic of the rise of a bourgeoisie or middle class. Rather, this heavy investment in the idealized family reflected other aspects of cultural change.

New understandings of human nature, foremost among them John Locke's theories of individual cognition and development, posited that each person was the product of a unique succession of individual experiences; human society, Locke and other contractual thinkers argued, was the result of a rational decision on the part of individuals to bond by means of the so-called social contract. A society based on the rational contracting of isolated individuals lacked, however, the emotional glue theretofore provided by king, church, or ingrained social deference. In the eighteenth century the sentimental family became crucial as a model and ideal of social cohesion in reaction to the dilemmas posed by individualistic and rationalistic thinking; society could only cohere if the overwhelming power of family love was recognized, portrayed, and extended from the domestic sphere outward. In this context, the family bore the burden not of shoring up a particular class but, on the contrary, of negating or transcending social divisions.

The nuclear family familiar to our society (father, mother, a couple of children) did not appear with the modern world. In preindustrial Europe a family made up of four to six persons and comprising only two generations was the norm, and this was as true of Hungary and Scotland as it was of England and North America.[1] In France, this small family unit was typical of the largest class in the realm, the peasantry, and prevailed especially in the north of the country, where inheritances were divided equally among heirs. Shorter life expectancies and limited resources meant that children and their grandparents rarely got to know each other: a couple typically wed late, in their middle or even late twenties, since many waited for their parents' death to take over the shop or the farm.[2]

There were exceptions to this pattern of small families. In the south of France one heir was favored by law or custom, which sometimes forced less fortunate siblings to live with them. In times of dearth, or in poorer areas such as Corsica, one could find households known as *frérèches,* made up of married siblings living together in order to maximize their resources. Large households

comprising unrelated persons also remained typical of richer folk of different sorts: the "rural bourgeoisie" of well-to-do peasants often included in their households a number of live-in farmhands and maids, and aristocratic households even in provincial towns could boast a dozen or more personal servants.[3]

Nevertheless, the smaller family remained the norm, not because of ideology or contraception, but because of the staggering mortality rate of infants. In eighteenth-century Lyon, for instance, lack of contraception combined with relatively good nutrition made for high levels of fertility among the working and middle classes. But although a woman might give birth to six or eight children, these modest families resorted to the practice, in this context quite murderous, of putting out infants to nurse—the result being that half or more of their children never reached adulthood.[4] It would be quite wrong to associate the restricted nuclear family with either modernity or the rise of the middle class. Economic and demographic conditions in the age of Enlightenment were such that for a majority of the French population no other sort of family was possible.

The small, two-generation family had been around long before the eighteenth century and it was not especially typical of the urban middle classes. But the century did witness some fundamental developments affecting the experience of family life. To begin with, more and more people lived in towns. Better economic conditions made for a growing population, but peasant holdings remained small, and large numbers of people were forced to leave the land for the nearest town, either temporarily or permanently. Over the course of the century the number of people living in towns of more than two thousand inhabitants grew from four to five million and from 15 percent to 20 percent of the total population.[5]

The most striking developments in the way people lived in these towns have to do with changes in concrete living conditions. Historians such as Annick Pardailhé-Galabrun and Daniel Roche, working on rich collections of after-death inventories, have established that in Paris at least, for the middle sections of the population, nearly every aspect of material life changed in the decades after 1730.[6] In the seventeenth century, a working-class or middle-class family would live in cramped rooms on two floors of a tall, narrow building; the eighteenth century saw the rise of larger edifices, in which a family occupied a roomier apartment located on a single story. Traditionally, rooms were ill differentiated, and household members spent much of their time cooking, eating, keeping warm, and sleeping in the main *salle*, around the huge hearth with its high man-

tel and sloping hood. In eighteenth-century buildings, chimneys were smaller and more numerous, scattered throughout the apartment, and more efficient and economical heating stoves began to appear. This was connected to an increased differentiation of living spaces, as rooms for entertaining—living and dining rooms—were separated from cooking and sleeping rooms in more and more households.[7]

What changed was not merely the structure of domestic space but, just as dramatically, its contents. Furniture went through its own revolution, for instance. Besides one or two beds (always the most costly and prized pieces of furniture), a seventeenth-century family might own a table and a few chairs; possessions such as clothing were stashed in the ubiquitous and indispensable trunks. In the following century most of the distinct items of furniture with which we are familiar made their appearance in middle-class households: cupboards, chests of drawers, sideboards, and even desks. Not only were these items aesthetically pleasing, they also made life easier by doing away with bending and crouching.[8]

Finally, the aspect of domestic interiors changed significantly again in the decades after 1730. Katie Scott has recently surveyed the evolution of the aristocratic interior, but middle-class households also experienced great change during this period.[9] Objects, materials, and colors went through striking transformations. With heating more efficient and widespread, it became possible to replace the heavy, drab Bergamo tapestries that had commonly hung on walls, keeping out drafts and humidity, with lighter fabric or wallpaper. These new wall coverings came in brighter colors and more-varied patterns, airy blues and lemon yellows edging out the traditional dark reds and greens.[10] New objects, both functional and decorative, were increasingly numerous in modest or middling homes. Mirrors became common, suspended or propped above the new lower mantelpieces, as did framed pictures and all manner of decorative knickknacks. Instead of eating off pewter dishes, families now had matching sets of colored crockery, including items such as salad bowls and soup tureens; they were also likely to own a range of personal objects such as umbrellas, watches, fans, and game boards.[11] In short, thanks to economic growth and increased commercialism, modest homes, once mostly utilitarian sources of food, warmth, and company, became places of aesthetic pleasure and self-expression. The genre paintings of Jean-Siméon Chardin executed in the 1740s and 1750s reflect aspects of this consumer revolution: while an image such as *Saying Grace* (cat. 18) suggests the traditional aspect of middle-class interiors

(dark red and green hues, bare walls, mostly utilitarian objects), other paintings such as *The Governess* (cat. 17) and *The Bird-Song Organ* (cat. 19) feature carpets, pictures on the walls, games and toys, and even a pet bird.

Historians of private life in Old Regime France have noted a marked trend toward greater individual and familial privacy, surely related to the changes in material life. (No one can say which came first: did increased domestic space and possessions encourage people to seek and enjoy privacy, or did the taste for seclusion prompt a pursuit of greater comfort and pleasure at home?) In the households of wealthier peasants and the upper working classes, a sharper distinction between public and private life appeared as beds were gradually banished from the main room.[12] Higher up the social scale, among merchants and professionals, privacy was achieved through the proliferation of small rooms where one or two people could remove themselves from public exposure, or at least from exposure to servants' eyes. One historian lists twenty different terms for such spaces: *cabinet, antichambre, garde-robe, office, boudoir, réduit,* and so on;[13] such rooms provide the setting for many genre paintings, especially de Troy's *tableaux de mode,* in which the intimacy of the tête-à-têtes between a woman and her suitor is reinforced by the intimacy of the environments (cats. 9 and 10).

A telling sign of the growing sense of both individual and family privacy is the gradual change, over the course of the eighteenth century, in domestic habits governing relations between masters and servants. In the seventeenth century it was common for servants in wealthier households to sleep on the floor, either in their masters' and mistresses' bedrooms, or just outside the door in the antechamber, ready to get up if called upon during the night.[14] (In the seventeenth century Madame de Sévigné, concerned for her daughter's health, advised her to move a servant into her bedroom to discourage her husband from coming in and getting her pregnant again.)[15] In the poorer households of peasants and working people, the maid or valet often shared a bed with one or more members of the master's family.[16]

Over the course of the eighteenth century, such promiscuity gradually became unacceptable. In upper-class homes (those of the aristocracy, but also those of comfortably-off rentiers and professionals), domestic architecture began to feature hallways and corridors to ensure privacy, and servants were gradually confined to waiting rooms or their own quarters. Dressing, undressing, and appearing naked before servants had once been a sign of confidence in one's own status: that was the point of the king's public *levers* and *couchers* in front of his courtier-servants. By the eighteenth century it had become indecent to expose one's body to the eyes of menials, and parents were warned to exercise caution about the contact their children had with domestics.[17] Much of the eighteenth-century movement against wet-nursing, famously initiated by Jean-Jacques Rousseau, derived from the same impulse: fear that infants would become corrupted if they suckled the milk of a "mercenary" woman.[18] (The growing sensitivity to the presence of servants in middle- and upper-class households is reflected in some of the paintings gathered here. Images from the 1720s or 1730s, such as Pater's *The Picnic* [cat. 7] show masters utterly oblivious to the presence of the menials who serve them. Half a century later, genre paintings either omit servants altogether, or conversely—as in Marguerite Gérard's *The First Step* [cat. 41] or Michel Garnier's *The Letter* [cat. 45]—feature a single trusted maid or nurse sharing the mistress's secrets or the family's happiness.)

Urban households made up of two parents, two to four children, sometimes a maid or two; cheerful, comfortably furnished homes; a rejection of outsiders and a quest for intimacy and privacy: surely, one is drawn to conclude, what we are witnessing here is the rise of the middle-class family. I would argue, however, that we should not jump to such conclusions. The "middle class," as Dror Wahrman points out, is a labile, arbitrary category, invoked with special force only in certain times and places, such as England and France in the early 1800s, often by historical actors with specific social or political agendas.[19]

Not only do we tend to impose the idea of the middle class onto times and places to which it may be less relevant, we also pack a host of related ideas into our concept of the bourgeoisie or middle class: capitalism, individualism, selfishness, philistinism, moralism, hypocrisy, and certain domestic ideals such as separate spheres for men and women and the pursuit of family happiness. Any of these elements, however, may exist in isolation from the others; nor does the conspicuousness of any item on this list in a given culture necessarily entail the presence of a hegemonic middle class. As both the paintings in this exhibition and the essays in this catalogue suggest, eighteenth-century France saw the emergence of a strong cult of domestic life and family happiness; but how much does this have to do with the appearance, or the recognition, of a middle class? The cult of domestic happiness at the end of the Old Regime certainly included a class dimension, in that social critics usually assumed that most of the aristocracy did *not* enjoy rewarding family lives. One could draw examples of this belief from some of the best-known

works of fiction of the prerevolutionary decades: Count Almaviva's philandering and domestic bullying in Beaumarchais's *Le mariage de Figaro* (1784), or the conspicuous absence of family ties and sentiment in novels featuring the libertine aristocracy, such as Choderlos de Laclos's *Les Liaisons dangereuses* (1782). A famous court case and a play, both dating from the early 1770s, provide good illustrations of this point.

The Véron-Morangiès affair, which unfolded from 1771 to 1773, was one of the most sensational and eagerly followed court cases of the century.[20] There was nothing particularly dramatic about the central issue of the case: the count of Morangiès, a well-connected, aristocratic spendthrift, had borrowed a very large sum, three hundred thousand *livres,* from the Vérons, a family of modest standing but comfortable means. (Each side accused the other of lying about the loan, and the truth was never fully established.) What made the case sensational, aside from the explosive political context of the early 1770s, was the way in which the Vérons' lawyers skillfully portrayed the contrast between, on the one hand, the solitary count and his corrupt agent, the police agent Desbrunières, and on the other, a loving family, made up of helpless women and one gullible young man.[21]

The public learned of the Véron case mostly through the trial briefs written by lawyers; the most successful one by far was the first brief written by François Vermeil on behalf of the Véron family, entitled *Mémoire pour la demoiselle Geneviève Gaillard.*[22] In this text, the Véron family appears mostly as a group, a "natural" and loving unit, in stark contrast with the odd pair of the count and his evil agent Desbrunières. The story begins with the death of the eighty-eight-year-old matriarch, Dame Véron, and then gives a short family history punctuated with sentimental vignettes. Véron was the widow of a banker of modest means, who, after her husband's death, lived with her daughter and son-in-law: "The union of these spouses was a happy one, and the constant sight of their felicity was enough to ensure that of a virtuous and sensitive mother. Her happiness only increased with the birth of two grandchildren."[23]

The narrative dramatizes the contrast between the parties in the scene in which the grandson, François, a young man in his early twenties, is introduced to the count through whom he seeks to invest his family's money. On the one hand a grandee "born into high society and used to cutting a figure there . . . with that ingratiating tone, those seductive words, those easy promises . . . opposite him a young man with no experience, equipped only with the inclination to artlessness and candor he had acquired in the bosom of his fam-

ily."[24] Soon the count has borrowed the money, denied the loan, and had François and his mother arrested when they protested to the authorities.

In this narrative, which had wide appeal, family love signals innocence, while evil takes the shape of isolated men who try to sever or distort family ties. Young François and his mother are arrested and separately tormented by Desbrunières and his thugs in the hope that they will falsely incriminate themselves, which the mother does. She and her son are reunited, in a pathetic scene: "Ah, my son, she said, dissolving into tears." François is arrested and dragged off in chains: "What a sight, for a mother! She tries to rush towards her son, and one of the guards makes a gesture with his sword which stops her. Ah my son!"[25] In another scene, Desbrunières, who is clearly a stand-in for the count, seeks out the two teenage daughters of the family as they walk in the Luxembourg Garden. He convinces them, under the guise of trying to help their kin, to write an incriminating letter to the police chief, Sartine. How can one doubt, asks Vermeil, the villainy of "a man capable of despising nature's sacred duties, to the extent of having children accuse their mother, sisters their brother?"[26]

Vermeil's narrative articulates the demonstration of guilt and innocence around two radically different definitions of what family means. At the end of the trial brief, in response to charges that he was attacking the nobility in the person of Morangiès, the lawyer produced a rather lame rationale for respecting hereditary status. The prince, he said, rewards the most useful of his subjects, and especially military heroes, with honorific distinctions. "Thus are the great names established, the glory of a great man courses with his blood, and passes through the ages to his posterity."[27] This profession of respect for lineage is no match, however, for what most of the text insistently seeks to demonstrate, namely that "it is in mediocre conditions, where one lives without need or ambition, that modest virtue often seeks asylum."[28] Like so many other texts of the prerevolutionary decades, Vermeil's *Mémoire* contrasts the family as lineage, embodied by the pride, greed, and solitude of the count and his (unrelated) subordinates, with the family (represented by the Véron group) as companionship, support, and happiness.

The new definition of the family was about life and love, instead of lineage; it was "horizontal" rather than "vertical"; and it frequently took the form of a rejection of aristocratic values. Among a multitude of possible examples, I will single out plays written in the new genre known as *drame* or *genre sérieux.* Best represented by the plays of Diderot in the 1750s, Sedaine in the

1760s, and especially Sébastien Mercier in the 1770s, this highly expressive sentimental genre has been of special interest to social historians because of its emphasis on tensions between different groups in society and because it was later known as the *drame bourgeois*.[29] In *drames* contemporaneous with the Véron case, a similar pattern contrasts the lone (and lonely) aristocrat with the happily clustered family of commoners.

Mercier's *Le Juge* (1774) offers a typical example of the genre's social imagery. The main characters represent three distinct social strata: the wealthy count de Monrevel, the principled and hardworking judge de Leurye, and the impoverished peasant Girau. Monrevel has been Leurye's patron and surrogate father, but a crisis between the two men is brewing when the play opens. The count has decided, on the basis of a recent and spurious land charter, to claim Girau's land and evict him, along with his wife and many children. After wrestling with his conscience the judge decides to take on Girau's defense; the angry count threatens in response to disown and ruin the magistrate.

The three men embody different conceptions of family. De Leurye's ideal family life is prominently portrayed, as he is shown conversing with his loving, sensitive wife and equally delightful young daughter. The upstanding Girau is described as "a perfect *honnête-homme*, a good father to his family,"[30] and he appears on stage surrounded by his brood of children. He turns down the count's bribes, explaining that the land he inherited from his own father cannot be alienated, since it represents family sentiment: "I am told that great seigneurs like yourself fear having a big family, but for the likes of us it is our fulfillment and our wealth."[31] As for the count, a solipsistic bachelor, he cannot see the cruel irony in his desire to evict a family so he can build a temple "to Friendship" visible from his drawing room. The crisis is resolved when a comment by Girau to the judge, "Happy he who can call himself your father,"[32] causes the count to break down and reveal that the judge is in fact his own unrecognized son from an early, clandestine marriage. The play ends, as do so many in this sort of "recognition-and-reversal" plot, with tearful embraces between newly reunited family members.

Does this play glorify the middle-class family? It may be tempting to read this into the judge's loving nuclear unit (he and his wife tutoyer each other), but there is a great deal in the play to suggest that family sentiment is not class specific. The poor peasant Girau is every bit as family oriented as are his social superiors. Conversely, the play suggests that the "right" family sentiment is possible among the aristocracy, since the count does succumb to it, and at the end of the play the family-oriented judge rejoins the robe nobility: now that Leurye knows his real "condition," the count points out, "another rank calls you to the magistrature."[33]

In other plays family sentiment is located decisively among the poor. Mercier's *L'Indigent* (1774) features a family of destitute spinners right out of Greuze: the implausibly aged Rémi and his children, Charlotte and Joseph, are dressed in rags and live in a hovel, but they are rich in their love for one another. The threat to this family unit comes from their landlord, a grasping and philandering nobleman named De Lys, who tries to evict the family after he fails to seduce Charlotte. A good thing too, since Charlotte turns out to be De Lys's lost sister and not Rémi's daughter; but she decides to marry her (former) brother Joseph, which means they all will be related. De Lys succumbs to family sentiment. As in *Le Juge*, the lonely, selfish aristocrat is redeemed when he recognizes his emotional bond to his kin: "This is the first real delight of my life, I have felt it in your embraces," De Lys concludes.[34]

In Mercier's plays, family sentiment seems to flower naturally in a broad spectrum of society roughly equivalent to the Third Estate—people who enjoy no privilege, do not command vast fortunes, but are otherwise quite disparate in status and wealth, ranging from the laboring poor to comfortable professionals. Furthermore, even nobles could participate in the delights and rewards of family life if they adopted the right system of values. One of the most famous instances of this occurs in Rousseau's *Julie, ou la Nouvelle Héloise*, the most popular French novel of the eighteenth century.[35]

In book 4 of the novel, the protagonist, Saint-Preux, returns to the Clarens estate in Switzerland to visit his former lover and pupil, Julie, who is now married to the kind and highly rational (if not especially thrilling) Monsieur de Wolmar. The long letter Saint-Preux writes to his English friend Milord Edouard describes in detail the domestic economy of Clarens. Saint-Preux's portrayal of life at Clarens is remarkable in that it depicts a highly inegalitarian domestic economy as a familial utopia. The letter centers on the relations between the masters and their employees, who are both house servants and agricultural workers. The Wolmars employ farm and field hands, and a small staff of eight household servants; they treat all of their employees with equal measures of fairness, severity, and loving concern. Although Rousseau (via Saint-Preux) is sharply aware that at bottom all employees are "mercenaries," he nonetheless presents Clarens as a utopian vision of an aristocratic household functioning as a sentimental family.

To the modern reader, the domestic arrangements at Clarens will no doubt seem grimly coercive. The masters control every aspect of their servants' lives, allegedly for the servants' own good: employees are chosen locally and hired young, kept constantly busy, and manipulated by means of financial threats and incentives; male and female employees are kept separate (even married couples are allowed together only at night) and "decent" entertainment is provided at scheduled times by the masters. All signs of independence are frowned on and soon lead to dismissal.

Rousseau's attitude appears on the face of it incoherent. He frankly acknowledges the irreducibly venal, contractual nature of the relationship between master and servant: "How can one contain servants, who are mercenary creatures, other than by restraint and coercion? The very art of the master lies in concealing that coercion under a veil of pleasure or self-interest."[36] But the burden of Saint-Preux's description lies in the demonstration that "good" masters can and should create bonds with their menials analogous to those between parents and children: "The servants are not looked upon as mercenaries, of whom a specific service is demanded, but as members of the family." Once hired and tried out for a while, they are taken on as "part of the staff, that is, of the children of the household," and Saint-Preux tells the story of an elderly retainer who, when offered a comfortable retirement elsewhere, begs the masters, with tears in his eyes, to keep him on. "Am I wrong, Milord, in comparing such beloved masters to parents, and their servants to their children?"[37]

Rousseau's novel shows that the ideal of the sentimental family, though most often construed as the antithesis of aristocratic isolation and pride, could be adapted to a wealthy land-holding establishment such as the Wolmars'; this would happen, the author suggested, if the emotional charge of the parent-child relationship were replicated, at least to *some* degree, in the master-servant relationship. (Naturally, the Wolmars are also exemplary parents.)

But it is the apparent contradictions in Rousseau's text that are, in the end, the most illuminating. The description of the Clarens community is premised on a clear acknowledgment of venal, contractual relationships. The letter prominently discusses salary scales and the masters' use of financial threats and incentives, but it also asserts that the domestic contract can, indeed must, be transformed through the alchemy of family love. Speaking of the wise and happy *père de famille,* Saint-Preux concludes: "His servant was a stranger; he makes him into a child, he appropriates him. He had rights only over actions; now he rules over wills. He had

mastery only through money; he now attains it through respect and kindness."[38] Family love cleanses the servant, as well as the master, of the taint of money. At Clarens, "everything works through attachment: it seems as if these venal souls are purified when they enter this dwelling of wisdom and unity."[39]

Rousseau's concerns were those of his contemporaries—at least, of the educated elites of the eighteenth century. Clarens is a fantasy of community that speaks to a dilemma and suggests its resolution. Rousseau, and his followers in later generations, believed that basic family ties such as marriage were man-made and contractual rather than religious in nature; but if that was so, how was one to prevent the reckless breaking of contracts and the social atomization that would result? Family love, a feeling rooted in "nature," was the glue that would ensure the long-term cohesion of most such relationships. In order for humankind to continue functioning, the family had to become, in Francis Ronsin's telling oxymoron, a "sentimental contract."[40] Hence Rousseau's description of Clarens as a "family" in which love counterbalances and conceals the adamantine fact of wage labor.

In France, most of the late-eighteenth-century debate about the family centered on the institution of marriage. In many ways, the struggle on the part of progressive jurists and writers of the eighteenth century to define marriage as a civil contract was an extension of the French monarchy's centuries-long effort to claim jurisdiction over matrimony in opposition to the post-Tridentine Catholic Church. This rivalry had its roots in the sixteenth century, when the church vigorously reaffirmed marriage as a religious sacrament; the royal bureaucracy, meanwhile, bloated by the creation of venal offices, sought to increase its own hold over marriage.[41] The tug-of-war between church and state over marriage was still spirited in the eighteenth century; in 1753 the jurist Pierre Le Ridant published an influential treatise arguing that marriage was in essence a secular contract, only later sanctified by the church.[42]

In the later eighteenth century, such arguments were taken up by the philosophes and their peers in connection with demands for specific judicial reforms such as the granting of civil rights to Protestants and the establishment of divorce. They also became more pointedly anticlerical, antiaristocratic, and contractual.[43] In 1781, for instance, Jacques Le Scène Desmaisons published a long essay significantly entitled *Le Contrat conjugal.* In it, he insisted that marriage was a civil contract, a *contrat d'association* that should fall entirely under "the legislative power of the state."[44]

Le Scène's argument, obviously inspired by classic

contract theory, marches humankind out of the state of nature and into association and private property, both of which are reflected in the marriage contract. The institution of marriage arose from the need to associate in order to survive, from the natural attraction between the sexes, and from the "property instinct"; it legalized the spouses' property in one another, which was in turn enforced by the state.[45] The state had the greatest interest in encouraging marriage to increase the population, a nation's greatest resource. The clear villain in this story was the clergy, who had sought from time immemorial to control matrimony, making laws against interfaith marriage, declaring unions indissoluble, and coercing its servants into celibacy.[46]

Le Scène belonged to a large and distinguished group of eighteenth-century French intellectuals and professionals who argued in favor of divorce. The list includes, besides a host of eminent jurists, such men of letters as Voltaire, Linguet, Morelly, Helvétius, and d'Holbach.[47] These writers claimed that the legal termination of marriage would promote both the individual and the collective good: it would end loveless marriages, boost morality by removing most of the rationale for infidelity, and most of all contribute to population growth, because happy couples were more likely to procreate than unhappy ones. Marriage, like any other contract, should be freely entered into and, if necessary, lawfully broken.

To argue for marriage as a civil contract, and in favor of divorce, was a liberal, enlightened stance. Those such as Le Scène who embraced this position often contrasted the good morals that would result from this increased freedom to the immoral situations created by indissoluble marriage. A marriage that could not be broken would become a breeding ground for all sorts of objectionable behavior; writers frequently made this point by describing the manners and morals of the upper classes. Le Scène, for instance, depicts the trajectory of an upper-class marriage: a young girl educated in a convent by women who have renounced "the most cherished and sacred duties of nature"; an arranged marriage and hasty couplings in the interests of "ambition" and "succession"; both spouses turning then to serial infidelity. These are mostly upper-class vices, the author agrees, but they cascade down the social scale, so eager are all groups to imitate their "betters."[48]

Once again, as in Mercier's plays, conjugal and familial misery and emptiness are decisively associated with the wealthy upper classes—if not always the aristocracy strictly speaking, then the more loosely defined group known as *les grands* or *le grand monde*. Good family morals involved free choice in marriage, loving

unions, fidelity, numerous children, and "natural" child-rearing habits such as maternal breast-feeding. This positive family model was not, however, class specific. Mercier's plays and Greuze's paintings, for instance, suggested that these ideals could be imagined to exist among the poor, and Marie Antoinette's public adoption of a sentimental, Rousseauian style of motherhood is proof that they could also be popular among the very rich.[49] Aubry's painting *Farewell to the Nurse* (cat. 37) may serve to illustrate the point, showing as it does the emotional tug of war between a plebeian nurse and a patrician mother who compete for the love of an infant.

At the core of progressive ideas about marriage, however, lay an apparent contradiction: how was it possible to sing the praises of marital and family love, to portray that love in hyperbolically sentimental terms, while at the same time reducing marriage to a contract and campaigning for divorce? The answer is that far from being contradictory, these two modes of thinking, the contractual and the sentimental, were profoundly linked. The conventional analysis of eighteenth- or early-nineteenth-century sentimentalism views the phenomenon as a compensation for the rise of capitalism and the market, and as essentially deceptive or hypocritical. Tears and family love were the means whereby *homo economicus* convinced himself and the world, with the help of his wife and children, that he was not such a bad fellow after all; sentiment was "icing on the materialist cake of capitalism."[50]

I would argue, with the help of several recent studies of the subject, that sentimentalism was not a "reflection" of bourgeois class interests but a means of understanding and coming to terms with the social implications of new ideological currents, including Lockean sensationalism and contractual ideologies. Sentimentalism is, first of all, as David Denby and Roddey Reid point out, a way of denying social hierarchies. The sentimental narrative, be it of Julie and Saint-Preux's impossible love, or of the exiled community on Mauritius in Bernardin de Saint-Pierre's *Paul et Virginie*, suggests the superiority of natural virtue and justice over conventional social divisions.[51] The sentimental text does not reflect the interests of a class; it tries to deny the reality of class.

For outdated social prejudices and divisions, the sentimental text substitutes not class but community: utopias such as Clarens, Mercier's tearful and celebratory families, and beyond the text the community of readers weeping over the same passages in *Julie* or *Paul et Virginie*.[52] Sentimentalism was represented as a binding, socially conjunctive force. As Denby and Julie Hayes have argued, it was Lockean individualism

turned inside out: if the individual was the product of a unique succession of particular experiences, how was she or he to connect with fellow human beings? In Denby's words, "one of the tasks of the sentimental text is to make visible the inner experience of subjects, as a first step in the construction and celebration of a social morality."[53]

Far from reflecting bourgeois individualism, sentimentalism "strives towards perfect harmony and the dissolution of barriers separating consciousness from nature and other consciousness."[54] Sentimentalism is not, in short, the other side of capitalism and the marketplace, but the necessary complement of Lockean individualism and contractual thought: the demonstration that in "natural" feelings, such as those arising among family members, lay the basis of a new social morality. It was not about class but about binding together a classless community.

Family life in the eighteenth century was not reshaped by capitalism or the bourgeoisie, but it was affected by significant demographic and material changes. Nostalgic myths notwithstanding, French society was largely made up of small, two-generation family units; in the eighteenth century more families began to live in towns, and this urban population had access to increasing amounts of privacy, material comfort, and consumer goods. I have argued, however, that representations and ideologies do not point to the rise of the archetypal modern middle-class family.

Novels, plays, pictures, and polemical works show the flowering of an ideology that emphatically rejected "aristocratic" definitions of family: the nobleman (or more generally the man of wealth and power) would remain in miserable solitude as long as he refused to acknowledge and rejoin his true "family." The eighteenth century redefined the family as *life*, as emotional and sensual gratification rather than abstract pride in lineage. In the later eighteenth century, artists represented families as emotional units, as in Nicolas-Bernard Lépicié's rendition of a working-class interior (cat. 38), or in Louis-Michel Van Loo's group portrait of the wealthy Devin family (cat. 33). In both pictures mother and father are engaged in separate, gender-specific activities, with a child or children providing the affective bond between them: family life, whether in work or in play, had superseded the family as simple display.

With the binding force of church and king on the wane, the sentimental family acquired central importance (as Rousseau clearly understood) as the means of making sure that the social contract would hold together. The family, far from being the prerogative of a particular class, became the basis for a dream of community. That dream was shattered by a revolution that forced upon the French nation the recognition of irreducible ideological and social differences. Only *after* the Revolution did the sentimental family become the exclusive property of a class, instead of the vehicle for the expression of an inclusive utopia of togetherness.

1. The work that first made this finding conspicuous is Peter Laslett, *The World We Have Lost: England before the Industrial Age,* 2d ed. (New York, 1971), esp. chap. 4. For France, see Jean-Louis Flandrin, *Familles: Parenté, maison, sexualité dans l'ancienne société* (Paris, 1976), chap. 2, and Alain Collomp, "Familles: Habitations et cohabitations," in *Histoire de la vie privée,* ed. Philippe Ariès and Georges Duby, vol. 3: *De la Renaissance aux Lumières* (Paris, 1986), 501–41.
2. Flandrin, *Familles,* 57–58; Collomp, "Familles," 532, 533.
3. Flandrin, *Familles,* 63, 73–75, 88–91; Collomp, "Familles," 522–28.
4. Maurice Garden, *Lyon et les lyonnais au XVIIIe siècle* (Paris, 1975), chap. 2.
5. Daniel Roche, *La France des Lumières* (Paris, 1993), 157–68. See also Georges Duby, ed. *Histoire de la France urbaine,* 4 vols. (Paris, 1981), 3:295–98.
6. Daniel Roche, *The People of Paris: An Essay on Popular Culture in the Eighteenth Century,* trans. Marie Evans (Berkeley and Los Angeles, 1987); Annick Pardailhé-Galabrun, *La Naissance de l'intime: Trois mille foyers parisiens, XVIIe–XVIIIe siècles* (Paris, 1988). Pardailhé-Galabrun and her team of researchers worked on 2,783 after-death inventories in the notarial records of Paris; of the total only 477 came from the period before 1700. These inventories spanned a wide spectrum of society, from nobles to salaried workers, with the heaviest concentration among categories that could be described as "middling": merchants and "bourgeois" (22.5 percent of the total), master artisans (27 percent), and skilled workers (15.5 percent); only 2.5 percent were from the nobility, while wealthy professionals such as doctors, lawyers, and high administrators add up to 13 percent, and domestic servants make up 7 percent (chap. 3). For other discussions of eighteenth-century French consumer culture, see Cissie Fairchilds, "The Production and Marketing of Populuxe Goods in Eighteenth-Century Paris," in *Consumption and the World of Goods,* ed. John Brewer and Roy Porter (London, 1993), 228–48; and Colin Jones, "The Great Chain of Buying: Medical Advertisement, the Bourgeois Public Sphere, and the Origins of the French Revolution," *American Historical Review* 101 (Feb. 1996): 13–40.
7. Pardailhé-Galabrun, *Naissance de l'intime,* chap. 6; Roche, *People of Paris,* chap. 4.
8. Pardailhé-Galabrun, *Naissance de l'intime,* 319–24; Roche, *People of Paris,* 147–50.
9. Katie Scott, *The Rococo Interior: Decoration and Social Spaces in Early Eighteenth-Century France* (New Haven, 1995).
10. Pardailhé-Galabrun, *Naissance de l'intime,* 368–76; Roche, *People of Paris,* 150–52.
11. Pardailhé-Galabrun, *Naissance de l'intime,* chaps. 8–10; Roche, *People of Paris,* 141–42, 153; Fairchilds, "Populuxe Goods."
12. Flandrin, *Familles,* 96.
13. Pardailhé-Galabrun, *Naissance de l'intime,* 243–44.
14. Flandrin, *Familles,* 92–93; Sarah Maza, *Servants and Masters in Eighteenth-Century France: The Uses of Loyalty* (Princeton, 1983), 183–90; Cissie Fairchilds, *Domestic Enemies: Servants and Their Masters in Old Regime France* (Baltimore, 1984), 40–41.
15. Maza, *Servants and Masters,* 185–86.
16. Flandrin, *Familles,* 99.

17. Ibid., 93–94; Maza, *Servants and Masters,* 254–55.

18. Madelyn Gutwirth, *The Twilight of the Goddesses: Women and Representation in the French Revolutionary Era* (New Brunswick, N.J, 1992), 57–60.

19. Dror Wahrman, *Imagining the Middle Class: The Political Representation of Class in Britain, c. 1780–1840* (Cambridge, England, 1995), esp. chap. 1.

20. I have discussed this case in detail in *Private Lives and Public Affairs: The Causes Célèbres of Prerevolutionary France* (Berkeley and Los Angeles, 1993), chap. 1.

21. For a discussion of the way the political struggles of the 1770s shaped the case, see ibid., 51–60.

22. François Vermeil, *Mémoire pour la demoiselle Geneviève Gaillard* (Paris, 1772). A chronicler reported that three thousand copies of the brief were printed and disseminated, a high figure for an ephemeral production at the time. For other figures and a general discussion of the importance of such briefs, see Maza, *Private Lives and Public Affairs,* 38–39, 120–25.

23. Ibid., 7.

24. Ibid., 17–18.

25. Ibid., 45–46.

26. Ibid., 51–54 (quotation on 54).

27. Ibid., 117.

28. Ibid., 3.

29. The classic work about this genre is Félix Gaiffe, *Le Drame en France au XVIIIe siècle* (Paris, 1910), which contains a good listing of plays in the genre. The most illuminating recent study I know of is Julie Hayes, *Identity and Ideology: Diderot, Sade, and the Serious Genre* (Amsterdam, 1991).

30. Sébastien Mercier, *Théâtre complet,* 4 vols. (Amsterdam, 1778–84), 2:28.

31. Ibid., 51.

32. Ibid., 95.

33. Ibid., 99.

34. Ibid., 3:105.

35. Jean-Jacques Rousseau, *Julie, ou la Nouvelle Héloise* (Paris, 1967), 329–52 (part 4, letter 10).

36. Ibid., 339.

37. Ibid., 333–35.

38. Ibid., 350.

39. Ibid., 352.

40. Francis Ronsin, *Le Contrat sentimental: Débats sur le mariage, l'amour, le divorce de l'Ancien Régime à la Restauration* (Paris, 1990).

41. James Traer, *Marriage and the Family in Eighteenth-Century France* (Ithaca, N.Y., 1982), chap. 1.

42. Ibid., 38.

43. Ibid., chap. 2.

44. Jacques Le Scène Desmaisons, *Le Contrat conjugal ou loix du mariage, de la répudiation et du divorce* (n.p., 1781), book 1, chaps. 1–5 (quotation on 15).

45. Ibid., 9–12.

46. Ibid., book 2, chap. 2, and book 3, chap. 5.

47. Traer, *Marriage and the Family,* chap. 2.

48. Le Scène Desmaisons, *Contrat conjugal,* 47–51.

49. On Marie Antoinette, see Gutwirth, *Twilight of the Goddesses,* 180–84.

50. This is David Denby's phrase characterizing the standard view of sentimentalism in *Sentimental Narrative and the Social Order in France, 1760–1820* (Cambridge, 1994), 88.

51. Ibid., 18–22.

52. Roddey Reid, *Families in Jeopardy: Regulating the Social Body in France, 1750–1910* (Stanford, 1993), 112.

53. Denby, *Sentimental Narrative,* 24.

54. Julie Hayes, "A Theater of Situations: Representation of the Self in the Bourgeois Drama of La Chaussée and Diderot," in *The Many Forms of Drama,* ed. Karelisa Hartigan (Lanham, Md., 1984), 71.

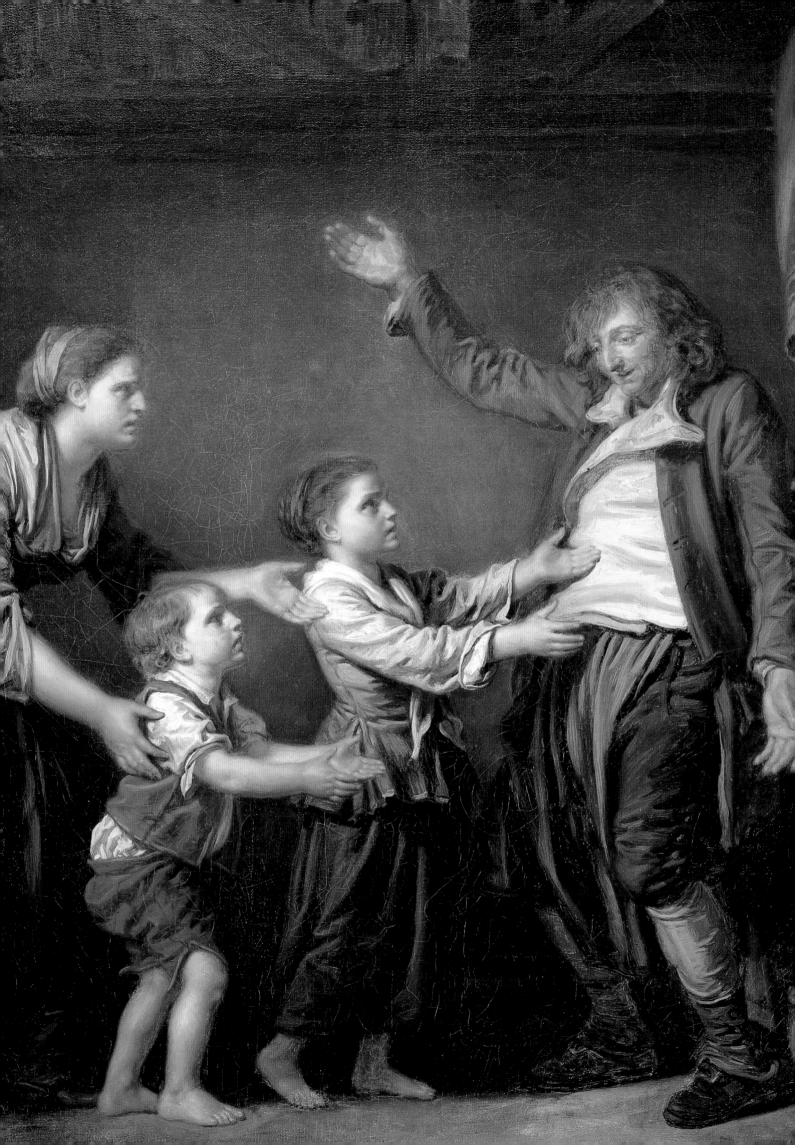

Intimate Dramas: Genre Painting and New Theater in Eighteenth-Century France

Mark Ledbury

The relationships between theater and painting in eighteenth-century France were profound and complex. Just as genre painting cannot simply be equated with the representation of "everyday life," painters cannot be expected to provide documents of eighteenth-century theater—any more than we can look to dramatic works for the key to the meanings of eighteenth-century painting. No single painter faithfully represented scenes from specific plays in any quantity, or recorded dramatic performances in any systematic way, and some of the well-known alliances between painters and dramatists were actually based on creative tensions and misreadings.

These alliances were significant, however, and I believe that cooperation and cross-fertilization of repertoire between artists and dramatists occurred not on the traditionally grand stages of French dramatic life or in the realms of the *grande machine* of academic history painting, but on alternative stages and in the lesser genres. These collaborations led to a significant challenge to powerfully held views on the nature and purpose of drama and painting.

If we were only to study the discourses of painting and drama in the period we might believe that doctrine and decorum dominated both playwriting and the visual arts throughout the eighteenth century. The legacy of both the theory and practice of drama in seventeenth-century France (*la doctrine classique*) was a series of oppositions structuring the way in which drama was understood.[1] The most important of these oppositions was that between tragedy and comedy.[2] There was a series of subsidiary oppositions, however, chief among which was the divide between the high theaters—officially sanctioned and state sponsored since the reorganizations of the seventeenth century—and alternative theaters, dedicated to comic entertainment and established by traveling and temporary troupes, which often performed in the popular fairs held regularly in Paris. Parallel to this dual opposition of tragedy and comedy, official and unofficial, was a deep fear and abhorrence of mixing the two and a fostering of enmity and divi-

sion between official and unofficial theaters. Although mixtures of genre, especially tragicomedy, had historically been popular in France, they had entirely disappeared by the end of the seventeenth century under the pressure of doctrine strongly advocating fundamental, natural barriers between tragedy and comedy.[3] Throughout the eighteenth century this principle was accompanied by a fear of the contamination of tragedy by experimentation and of the perceived threat to the balance of the natural order posed by the public's love of alternative spectacle. These fears were exploited in the rather gloating prologues to plays performed at the fairs,[4] but were also present in many of the pamphlets condemning the fair theaters and denouncing the desertion of the Comédie-Française and the corruption of taste that the popularity of alternative sites entailed.[5]

These well-documented theatrical oppositions were mirrored to a surprising degree in contemporaneous discourse on painting. In the French context, anonymous multifigure paintings, now known as genre paintings, never enjoyed a fixed position in the much-discussed hierarchy of genres. André Félibien's famous founding statement of genre theory, which established a distinct hierarchy of types of painting, created no distinct place for it.[6] As the century progressed, it remained undefined except in opposition to history painting. Claude-Henri Watelet's discussion of genre in the *Encyclopédie* reconstituted the hierarchy of categories of painting into a fundamental opposition between history painting, regarded as the higher, nobler genre, and all other types of painting, defined as inferior and artisanal.[7] The equivalence between these two oppositions, genre/history and comedy/tragedy, was acknowledged by influential contemporary theorists from the Abbé du Bos to Roger de Piles and Voltaire.

From the beginning of the century, however, critical perceptions of the division of genres in painting and drama were transferred uneasily into practice because of the sheer variety and volume of both theatrical and artistic production. The dramatic spectrum encompassed the highest official theaters (the Opéra and the

Comédie-Française), the floating Théâtre Italien, the fair theaters at Saint Laurent and Saint Germain, the boulevard theaters that sprang up at the end of the century, private theaters, puppet theaters and other entertainments staged inside the enclosed spaces of bourgeois and aristocratic society, and improvised entertainments in masons' yards. The century was an essentially theatrical one, but its practical models were not necessarily Pierre Corneille, Jean Racine, and Molière.

The two officially sanctioned high theaters were the Comédie-Française, firmly established since 1680 as the guardian of the French dramatic tradition, and the Opéra, where large-scale *tragédies lyriques* and ambitious ballets were staged. The story of the expulsion of the Italian players from France because of offense taken at *La Fausse prude* in 1697 is well known, but the players were to return in 1716 to a permanent and officially sanctioned home.[8] The gap left by the absence of these troupes between 1697 and 1716 was filled by the developing theaters based at the two main fairs of Paris, the Foire Saint-Germain and the Foire Saint-Laurent.[9] These theaters took over and adapted the Italian theater repertory, combined it with ingredients drawn from the indigenous *chansonnier* tradition, and pioneered a flexible parodic dramatic form—at once experimental, controversial, and enormously popular—known as opéra comique.[10] The fair theaters were incorporated into the Théâtre Italien in 1762, where opéra comique dominated the programs, all but displacing the more traditional Italian repertoire.

Dramatists were as flexible as the spectrum was diverse. Many tried their hands at different forms of drama, moving from one genre and stage to another. Jean-François Regnard, one of the more successful comic authors of the early part of the century, moved among theaters, and many of the key writers of the later years of the century, notably Denis Diderot, Michel-Jean Sedaine, and Pierre-Augustin Caron de Beaumarchais, graduated from writing opéras comiques to other forms of drama and subsequently returned to their earlier forms. Even Voltaire, remembered for his tragedies and his steadfast reinforcement of the genre oppositions, also wrote sentimental comedy, satire, and opéra comique, and Alexis Piron, the staple of the fair theaters, had tragedy in his portfolio.

Moreover, there existed a certain interdependence between the fair theaters and theatrical institutions, which were perhaps not such deadly rivals as has often been claimed. The expulsion of the Italian theaters and the repressive measures taken by the jealous Comédie-Française to curb the activities of the fair theaters have

formed the background of many of the major accounts of the history of theatrical institutions in the early eighteenth century and have featured prominently in accounts of Watteau's work.[11] Although these events certainly did take place, they must be set against the appropriation and sharing of repertoire and audience among institutions. The parodic opéras comiques fed off a diet of tragedies and high operas. The nourishment was mutual: Florent Carton Dancourt and Boindin incorporated much of the spectacular appeal of the fair theaters and the comedic energy of the Italian traditions into plays performed at the Comédie-Française, and Pierre Marivaux used the Théâtre Italien as a base for the crafting of dialogue and poetic language that more properly belonged to the Comédie-Française. There is also a case for arguing that Diderot's *genre sérieux* was inspired by its inventor's thorough knowledge of the fair theaters.

A similar situation prevailed in painting. Although the Royal Academy held a position of dominance over artistic production that no one institution in drama could match, it was, as Thomas Crow has shown, far from a monolith.[12] The academy was structured to privilege history painting, but it was adaptable enough to sponsor artists working in nonhistorical genres. Portraitists such as Nicolas de Largilliere, expert still-life painters such as Jean-Siméon Chardin, and animal painters such as Jean-Baptiste Oudry were given encouragement, and their works hung alongside those of history painters in the exhibition spaces. Salon critics were strict in their preservation of the opposing structures by which they categorized and judged painting, but the experience of the ordinary Salon visitor would have been one of variety. Heather McPherson's studies have shown that genre painting was highly popular and visible not just in the Salons but in the private market, at alternative exhibition sites, and on the walls of numerous influential collectors.[13] There was also a certain flexibility among artists: almost all dabbled in portraiture, while some moved from historical painting to other genres. Claude Gillot and Antoine Watteau started their careers as history painters, and François Boucher and Etienne Jeaurat, while officially regarded as history painters, relished the production of nonhistorical work.

Thus, while classical doctrine and critical discourse in both arts stipulated the clear demarcation and opposition of genres, in practice these distinctions were blurred in the work of many creative artists, and this practical flexibility was tolerated, up to a point, by the institutions that governed them. The artists and dramatists who feature in the history of genre painting and al-

9. Antoine Watteau, *The French Comedians*, 1720–21, oil on canvas, The Metropolitan Museum of Art, New York, the Jules Bache Collection, 1949 (49.7.54).

ternative theater in this period were aware of both the subordinate status of their work and the inadequacy of these oppositions. The most sophisticated of them tried to subvert and challenge these assumptions, sometimes in direct association, often by mutual inspiration. The major innovations in eighteenth-century French drama, from Alain-René Lesage to Sedaine to Beaumarchais, occurred in comedy, just as the most significant developments in painting, at least until the 1770s, occurred in the realm of genre painting, as artists such as Watteau, Boucher, and Greuze exploited the freedoms of this ill-defined, lesser category to experiment in a manner that threatened central critical oppositions and created new possibilities for artistic practice.

Although Gillot can in many ways be credited with being the first eighteenth-century artist to be profoundly involved with the culture of alternative theater, it is with Antoine Watteau that the story truly begins. As A. P. de Miramonde, François Moreau, and others have ably demonstrated, the world of the fairs and of the burgeoning musical theater served as Watteau's apprenticeship and gave him the opportunity to become thoroughly acquainted with the repertoire of all parts of the dramatic spectrum.[14] His use of the theater as source material was part of the reason that his work is a watershed in the development of French painting.

Watteau made a point of including stock figures from the commedia dell'arte, wrenched from their context, the boards on which they traditionally played and mingled—always slightly uncomfortably—with their

public. Watteau's procedure made theatrical characters part of different, much less predictable and more complex, narratives with disturbing autobiographical, political, or erotic undertones, whose mystery and suggestion differed from the predictable and often salacious repeated patterns of both Italian theater and the newly developing fair theaters. Pierrot and Harlequin are removed from the comforting confinement of the fair theaters, then recast as inappropriate presences in a very different environment, haunting the intimacy of lovers and commenting on social spectacle.[15]

Part of Watteau's subtlety was to blur the distinctions between stage and audience; a further innovation was to imagine theatrical scenes that combined elements from different theaters and genres and challenged oppositions. Watteau's work might be seen as a meditation not on a timeless, eternal theater but on changes in the theatrical world in France in the first two decades of the eighteenth century. André Blanc's recent analysis of *The French Comedians* (fig. 9), for example, explains the central tension in this obviously parodic picture by suggesting that it attempts to incorporate the representation of both a tragedy and its afterpiece.[16] One might further suggest that Watteau mixes tragedy and comedy, supposedly separated by an eternal and immutable barrier, on one tragicomic canvas. Furthermore, he presents us simultaneously with a play and its parody, thus merging official and unofficial stage in an imaginary hybrid that mirrors the public's experience of the stage. Not only were the audiences at the Comédie-

Française accustomed to a juxtaposition of tragic play and comic afterpiece, but often the same audience would attend a tragedy and subsequently laugh heartily at its parody at the Foire Saint-Laurent.[17] The irony of the strict separation of genres and theaters in theatrical discourse on the one hand and a practical mixture on the other lends these pictures their central satiric energy.

Through this mix the alternative, lesser traditions of the stage were beginning to create a powerful decentering of the dramatic world. Watteau performed some of the same maneuvers in painting by reveling in the operation of confusion, making complex, hybrid compositions out of material that was viewed as inferior. The academy's desperate desire to accommodate him, well chronicled by Crow, led to his being received into the invented category of *peintres des fêtes gallantes*. This reflected an attempt to corral his experiments in order to avoid the awkward questions that his work asked about the relevance of traditional hierarchies and oppositions. It was essential for the academy to see Watteau as a painter of comic entertainments, even though modern critics and scholars have been quick to realize that the enduring value of his work might lie in its noncomic qualities.

The exploitation of the materials of comic and lesser theater for new, ambitious ends was to increase near the middle of the century with changes that moved fair theaters from the periphery to the center of French theatrical life. Painters not only participated in these transformations but drew inspiration from them for their own continuing experiments in genre painting. In March 1743 the right to manage the fair theaters was sold to Jean Monnet, an entrepreneur whose contributions to the new-style opéra comique are only now being acknowledged.[18] Monnet was an expert assembler of talent and demanded high standards of performance from his actors and musicians. His troupe included the musician Rameau,[19] and the young and promising Charles-Siméon Favart, paid handsomely as the director of artistic operations. Favart had already established his credentials with the immensely popular *La Chercheuse d'esprit* (1741), which showed the author working toward the relaxed and self-consciously charming vernacular within which the sexual innuendo and vibrant wordplay of traditional fair entertainment were not expunged but sublimated. Favart was beginning to reinvigorate the pastoral idiom and exploit its decorative and ironic possibilities on the stage. Monnet also attracted such major artistic talents as the painter François Boucher and the dancer Jean-Georges Noverre to his enterprise, mixing them with untried and provin-

cial talents, including the actor Préville and (later) Sedaine.

Monnet's enterprise was one of considerable innovation in every aspect of performance, and a triumph of discipline and self-regulation.[20] He organized what had been improvised and chaotic and adopted a serious approach to marginal comic material, giving new scope and ambition to what was regarded as a low and hybrid form. The first period of Monnet's direction of the opéra comique was actually too successful, and he was closed down by order of the Académie Royale de Musique on June 1, 1745, when his lease was terminated. He then went to Lyon and later London, where the opportunity had arisen to establish a French theater. Despite the disastrous bad fortune and Francophobia that wrecked this project, Monnet's English experience brought him into close and friendly contact with David Garrick and his troupe.[21] He became aware of the theatrical potential of the English repertoire and new styles of acting, and of the importance of innovation and reform. He was ideally placed to pass on this newly acquired expertise to the young generation of authors in his employ.[22]

Monnet returned to the direction of the opéra comique in 1751, gaining permission to run the enterprise on December 20 of that year, which gave him less than two months to prepare his troupe for the Foire Saint-Germain. In the same year he designed and constructed the Salle Saint-Laurent with considerable help from Arnoult, a *machiniste ingénieur du Roi*, and from Boucher. According to Monnet's memoirs, the painter "took pleasure in composing the ceiling designs, the decorations, even the ornaments, and in overseeing all aspects of the painting that were undertaken in the theater."[23] From the swift preparation of the theater, which was acknowledged upon completion to be the most perfect venue in France,[24] it became clear that Monnet intended to pick up where he had been forced to leave off in 1745, the team spirit of close collaboration unbroken. Charles-Simon Favart, Noverre (the premier danseur, who was to be promoted to choreographer), and Boucher returned to his enterprise, and the playwright Jean-Joseph Vadé began to work for him in earnest.

Some of the aims of the Monnet enterprise were announced in the inaugural stage performance of the 1743 season; it was traditional for the first play performed at the fair theaters to be preceded by a prologue in which the actors would reflect on the opéra comique and on the entertainment that would be offered. Written by Favart, this prologue is revealing of the project that Monnet conceived.[25] It is set in Parnassus, where Pierrot, the commedia dell'arte figure here representing

the opéra comique, has come to seek advice on what direction his genre should take. He encounters four characters: La Muse Chansonnière, who represents the spirit of French popular song and entertainment; Thalie, the muse of comedy; Zoïle, the critic; and Le Goût, the god of taste, who has the final say. Thus the debates about the direction of comedy, opéra comique, and the French stage are played out before the fair audience. The nub of this short but significant prologue, with its revealing incidental details, is that the new opéra comique is licensed as a serious artistic form, and Zoïle is dismissed by Taste and Pierrot. Le Goût, the ultimate arbiter of taste, is personified as a nymph.[26] This is a self-conscious reference to the new guise of the gods in the decorative and visual scheme that Monnet's opéra comique was to employ, which Boucher must have helped create.[27] Given the strongly collective nature of the Monnet enterprise, it would be safe to assume that from the earliest days a close artistic collaboration was built up between Favart and Boucher.

A direct example of this collaboration derives from the sometimes difficult period of Favart's employment by the Maréchal de Saxe. Favart's *Les Nymphes de Diane* was written in 1748 to be performed on the marshal's military stage.[28] Boucher supplied designs for engravings by Pierre Quentin Chedel, which illustrated the published text of 1748 (fig. 10). More important, this play, written at a time of regular correspondence between Favart and Boucher, is an example of close, mutual inspiration.[29] It is part pastoral, part mythological travesty, grafting the world of desire and innocence of Favart's early pastorals onto one of Boucher's best-loved mythological sites—the enchanted forest of Diana and her nymphs. It is understandable that Favart should choose this theme for a play to be shown to soldiers, who would relish the opportunity to watch a largely young female cast. Beyond this, the play contains scenes intertwining the myth of Diana and her world of nymphs, satyrs, and cupids with the pastoral scenario and props. The play is designed to exploit the two iconographies, as the central female character is both nymph and shepherdess, and it is through an ironic combination of Boucher's treatment of mythology and Favart's reworking of pastoral that this play creates its effect. Alastair Laing has pointed out the extent of Favart's influence on the pastoral idiom that Boucher pioneered and in which he produced some of his most striking and commercially successful works.[30] It is important to remember, however, that this work developed in the context of interart collaboration in the milieu of the opéra comique.

It would, in fact, be a misrepresentation of the reper-

10. Pierre Quentin Chedel after Boucher, *The Nymphs of Diana*, 1748, engraving, by permission of the British Library, London.

toire of the opéra comique under Monnet's direction to claim that Favart's and Boucher's delicately sensual pastoral genre was the single dominant ingredient. Monnet came to rely on the talents of another prolific writer, Jean-Joseph Vadé, who worked in a very different mode. Vadé was particularly fond of genres developed more specifically out of a parody of high opera, and was more directly a descendant of the Lesage-Piron tradition. He was one of the most skilled practitioners of *poissard*, a genre of poems, dialogues, and plays mimicking the tones, language, and jargon of the marketplace and the fishwife. In Vadé's plays, most often set in the streets and markets of Paris,[31] the influence of genre painting, and particularly its Dutch antecedents, were powerfully evident. Monnet described Vadé's *Les Racoleurs* (premiered on March 11, 1756), as "tolerably a picture by Teniers set in action."[32]

Vadé was more sensitive even than Favart to the potential visual impact of his work, and often integrated large set-piece tableaux into his productions. This painterly inspiration was also vital to another genre that contributed to the originality and reputation of the theater: the ballet-pantomimes. These complex visual spectacles, designed in the first years by Dourdais and in the later years by Noverre, would often appear on the same program as the short opéra comique[33] and they became an integral part of performances in the period from 1752 to 1757.[34] Noverre's *Les Réjouissances Flamandes*, performed at the Foire Saint-Laurent on August 11, 1755, was described by a critic of the *Almanach des spectacles* as a *Teniers Dansé*.[35] Like Vadé, Noverre turned to the work of highly popular Dutch genre artists for inspiration in the construction of his piece.

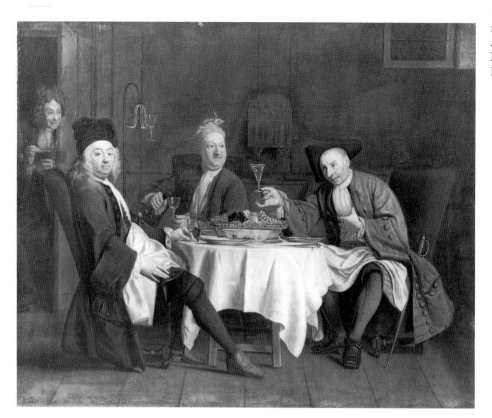

11. Etienne Jeaurat, *Piron and His Friends,* oil on canvas, Musée du Louvre, Paris, photo R.M.N.

Thus in the creation of stage spectacle in the mid-1750s, genre painting models provided a key element of stage aesthetics. This influence was mutual as well as ongoing. If Favart and Boucher collaborated on the forging of an idiom, so did Vadé's urban version of pastoral hold its own attractions for academic visual artists, particularly Etienne Jeaurat, who exhibited genre-blurring work at the Salons of the 1750s.[36]

It is well known that Jeaurat frequented the company of the opéra comique writers and bon vivants that included Vadé, Charles Pannard, and Charles Collé, as well as Alexis Piron, and that he celebrated his association with them in a painting now in the Louvre, *Piron and His Friends* (fig. 11). Although officially classed as a history painter, Jeaurat often departed from historical models to paint indoor genre scenes, portraits, and even still lifes, and was particularly fond of multifigure paintings showing scenes of street and market life in Paris. Jeaurat's theatrically constructed genre scenes feature the same cast of fishwives, street women, and market traders as did the alternative theater. His works are not realistic portrayals of the grim realities of life for Parisian artisans and urban peasants, but they manifest his absorption into the world of the *genre poissard*.

Between 1743 and 1757, the Monnet enterprise was the focus of major experiments and transitions in the opéra comique. Even usually skeptical critics acknowledged the change Monnet's direction had brought about. Opéra comique had come to represent innova-tion, renewal, and the raising of moral and aesthetic standards, and it prepared the ground for many later experiments in costume, decor, and acting style, and for the transformation of lowly and unregarded subject matter and genre within an artistically challenging and commercially successful operation.

By 1753, younger playwrights were realizing the power and flexibility of the opéra comique. Chief among these was Michel-Jean Sedaine, a writer of unusual background who, in a long, semi-ironic *ars poetica* had extolled the possibilities of opéra comique in its new sophisticated form. Sedaine, who was taken on by Monnet in the second period of his tenure, was a key figure in the history of French drama in the late eighteenth century.[37] He began by writing and adapting farces, often from the English repertoire. From his first play, *Le Diable à quatre* of 1755, he was a keen experimenter, constantly seeking a new repertoire. Throughout the late 1750s and in particular in the early 1760s, Sedaine created a series of plays that took the opéra comique techniques into increasingly complex dramatic productions. These productions not only revealed his ambition to integrate the energies of opéra comique into mainstream theater but also showed Sedaine drawing fair theaters into central social and political debates. His particular gift was for combining the appeal of Favartian pastoral with the knowing parodic edge of Vadé's more metropolitan work, to which he added the social critique and relish of contentiousness character-

istic of those English dramatists whom he had adapted. An enthusiastic disciple of the *Encyclopédie*, Sedaine incorporated not only knowing references to contemporary events into his plays—a staple since *La Fausse prude*—but also a wider moral and political program, involving the presentation on stage of moral dilemmas and criticism of court corruption.[38]

Sedaine's success was based precisely on his masterful disguise of a contentious political message within a structure of ironic laughter, visual spectacle, and stage business. Although uniformly praised for its use of the stage and its feel for drama, his work was almost universally criticized for its unpolished, rough language. In effect, Sedaine subordinated language—that essential ingredient of drama in the French classical tradition—to spectacle. There is some evidence that he went to artists of his acquaintance, including Boucher and members of the Saint-Aubin family, for inspiration.[39] Boucher used Sedaine's *Les Sabots* as the subject for one of his late pastoral paintings (cat. 14), and Gabriel de Saint-Aubin illustrated scenes from his plays, such as *Le Jardinier et son seigneur* (fig. 12). Sedaine's background in fair culture was combined with an acute visual sense and a love of innovation, making him a key figure in the establishment of opéra comique as a vehicle for serious and complex musical drama. He stated that his *Le Roi et le fermier* had marked a crucial step: "In 1762 I accomplished what I thought impossible, to elevate the tone of this genre and to place a king himself in the scene of a three-act play that lasted as long as a work in five acts at the Théâtre Français."[40] Sedaine's implied comparison here is with tragedy. He saw himself lending a new and unprecedented gravitas to opéra comique, and his comments strongly imply that he saw his play rivaling large-scale tragic productions in its interest and complexity. His preface to the printed libretto noted that he saw no reason why stage drama at the opéra comique should not be used as a vehicle for social and philosophical comment.[41]

While Sedaine was successfully molding the theatrical experiment of the opéra comique into ever more complex and challenging forms, Jean-Baptiste Greuze was performing a parallel operation in painting. Greuze's experiments with the traditions of genre painting and his awareness of the impact of new dramatic genres enabled him to develop a dense and complex practice at the center of painterly experiment and public success.[42] It is difficult to ascertain the extent to which Greuze was affected by the theater in his early years. It is evident that Boucher influenced him as a young man and that he was well placed in Lyon and Paris to appreciate Monnet and the opéra comique. Anita

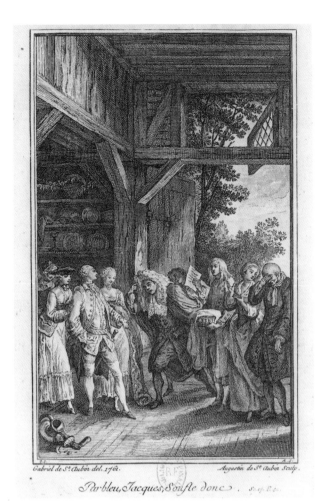

12. Augustin de Saint-Aubin, after Gabriel de Saint-Aubin, *Le Jardinier et son seigneur*, 1761, etching, Bibliothèque Nationale, Paris.

13. Jean-Baptiste Greuze, *Etienne Jeaurat*, Salon of 1769, oil on canvas, Musée du Louvre, Paris, photo R.M.N.

Brookner has pointed out how closely some of Greuze's early paintings imitate Boucher's style, which suggests that Boucher's luxurious, inventive, and morally suspect travesties held some appeal for the young Greuze.[43] It is also possible that Greuze came into contact with Jeaurat early in his career. His portrait of Jeaurat displayed at the 1769 Salon is proof of some contact between the two men (fig. 13), although whether they met in the early 1750s is uncertain. Jeaurat was a celebrated bon vivant, and he may have introduced Greuze to his theatrical friends.[44]

Aside from these contacts, there is the evidence of Greuze's early work to show how closely comparable his experiments in painting were with contemporaneous opéra comique. The two major paintings he exhibited in his début 1755 Salon display that same mixture of farce, morality, and irony that allowed Sedaine to explore moral issues while exploiting a thorough understanding of the comic appeal of fair theater tradition. Much has been made of the originality and impact of Greuze's *A Father Reading the Bible to His Family* (fig. 14), which is often thought to have molded genre painting prototypes to fit a new, encyclopedic, moral scenario.[45] The painting, however, is by no means clear in its moral message: inattention, furtiveness, reproach, and sulky culpability are expressed by Greuze's cast of characters. He creates a scene of awkward ambiguity that disturbingly suggests both Arcadian unity in the village foyer and the postlapsarian aftermath of the dis-

ruption of this unity. Even this apparently moral scenario is shot through with the drama of disobedience.

The picture cannot be seen in isolation from his other major Salon offering, *The Blind Man Deceived* (fig. 15). The two paintings suggest that Greuze's playfulness and irony were as notable as his penchant for the depiction of virtue. One creates an attentive, bonded family uncomfortably united by the patriarch; the other confronts us with a strikingly similar old man, this time portrayed as a blind dupe unable to exercise control over his young bride and her lover. This scenario would have been familiar not just to connoisseurs of genre painting but to any spectator familiar with popular theater. Perhaps more surprising to the public would have been the size and ambition of the work, which—with its elaborate geometric architecture of limbs—anticipated the artist's most structurally complex works of the 1760s.[46] There is a hint of a visual pun between the two images. In *A Father Reading the Bible*, the young boy makes a gesture at his dog (in French, "faire les cornes"; literally to make horns), a gesture indicating that one had been cuckolded. The same phrase could also refer to the adulterous action of the two younger participants in *The Blind Man Deceived*. Greuze seemed to enjoy the ironies and tensions established by the ever-developing opéra comique, balancing itself between morality and salaciousness.

The products of Greuze's Italian journey of 1755–56 indicate an ironic and sophisticated integration of as-

14. Jean-Baptiste Greuze, *A Father Reading the Bible to His Family*, Salon of 1755, oil on canvas, private collection, Paris.

15. Jean-Baptiste Greuze, *The Blind Man Deceived,* Salon of 1755, oil on canvas, Pushkin Museum, Moscow.

pects of alternative theater, but there are also new elements of opposition in his playfulness. The first fruits of the visit were four paintings displayed in the Salon of 1757. Two of these, *The Broken Eggs* (see fig. 59) and *The Neapolitan Gesture* (cat. 27), boldly present their viewers with a self-conscious mixture of genres and influences.[47] Like *The Blind Man Deceived,* they combine techniques and features borrowed from history painting with strong reminders of the work of Dutch genre painters (particularly Gabriel Metsu) and, most visibly, a tendency toward gallantry and a seeming determination to avoid the historical and heroic in favor of the anecdotal and theatrical.[48] The full title of *The Neapolitan Gesture* in the Salon *livret* was *Une Jeune italienne congédiant (avec le geste napolitain), un cavalier portugais travesti et reconnu par sa suivante* (*A Young Italian Woman Dismissing [with the Neapolitan Gesture] a Cavalier Disguised as a Portuguese But Recognized by Her Maid*). The narrative revolves around seduction and rejection, disguise and deception, and must have reminded viewers of the eternal disguises and seductions of Harlequin. Making a dubious gesture the central focus of the work lent a parodic gravitas to popular tradition. Greuze's displacement of references to classical antiquity to the rank of incidental detail further challenged the accepted purpose and outcome of his Roman visit.

Although the artist might have been expected to learn from the great artistic canon of antiquity and the Renaissance, it seems that Greuze's Italian journey was more of a voyage into Italian comedy than a profound encounter with the classical legacy. He appeared to parody the purpose of the visit, which Crow described as an "improvised version of the Rome prize."[49] Specific references to antiquity in the Italian pictures came not in any new seriousness or inspired invention but in irreverent allusions, such as the broken column fighting for space in the corner of *The Neapolitan Gesture* or the transfer of the pose of the Farnese Hercules to the young man in *The Broken Eggs*. Greuze's ironic assemblage of elements drawn from the classical canon and from popular tradition shows a talent for ironic, parodic visual representation. He also showed signs of increasing ambition. The cautious formal experiments of 1755 had been superseded by an ostentatious exploitation of the triangle and pyramidal compositions of Raphael and the Renaissance painting canon, and by confidence and boldness in the handling of color. Like Sedaine and the newly ambitious opéra comique, Greuze was exploiting traditions of parody while simultaneously lending his work new ambition and complexity.

The other main products of Greuze's Italian sojourn are even more telling in their exploitation of the repertoire of alternative theater. In 1755 he was commissioned by the Marquis de Marigny to produce a pair of paintings for the apartments of Madame de Pompadour at Versailles. Marigny made plain to Charles-Joseph Natoire, the director of the French academy in Rome, that Greuze should put effort into the work; if it were successful, he could expect greater favor and reward.[50] Marigny, keen to shift perceptions of the *bâtiments du roi,* was perhaps expecting a domestic *exemplum virtutis*. He received instead a lavishly painted but mysterious pair of ironic pastoral images (cat. 28 and fig. 60). The shepherd and his shepherdess are pictured as sexless and naive, but this naiveté is ironic—the Marigny/Pompadour dynasty is reduced to a pastoral parody. The completed paintings were greeted with a resounding silence by Greuze's previously enthusiastic patrons, who must have been stunned by the technical virtuosity and by the cheek of Greuze's response to their generosity.

The analogy between Greuze's painting and opéra comique, particularly the new, complex, and challenging type adopted by Sedaine and his contemporaries, is nowhere more visible than in *The Village Bride* (see fig. 5), exhibited at the Salon of 1761. Its phenomenal success was a fitting climax to the collaboration and

mutual inspiration of alternative theater and genre painting. In this ambitious painting, Greuze not only integrated elements from different genres of painting more comfortably than ever before; he also captured the complex theatricality of the opéra comique in its years of triumph. Here Greuze returned with confidence and sophistication to the techniques he had pioneered in his earlier work. He used the Farnese Hercules as a model for his bridegroom,[51] but his integration of classical models went far beyond the burlesque bricolage of his Italian travesties. On this occasion, the modern model of virtue (the central groom) and the classical model of ideal beauty were harmoniously mixed and mutually reinforcing.

The Village Bridge is founded on a happy union. There are central meetings—of the *villageois* and the bourgeois, of the private domestic sphere and the public sphere of commerce and law, of servant and family. The decor is also mixed: the cupboard door is refined on the outside and plain on the inside, indicating the hybrid, floating social status of the scene. In technical terms the painting revels in mixture. The complex orchestration of gestures, used to comic effect in *The Blind Man Deceived,* and the distinct undulating pyramid used in the Italian paintings are combined here with unprecedented confidence and dexterity. Just as Greuze compacted into one moment many aspects of one narrative—meeting, courtship, betrothal, civil and legal ceremonies—so he revisited many of the sites of genre painting and fair theater, specifically the family scene, the village wedding, the scene of exchange, and the theatrical performance, creating a complex composite.

There are striking parallels between Greuze's painting and those final scenes of operas comiques in which the characters gather for an intense set of vaudevilles that review the production and at the same time celebrate the almost inevitable union of the central protagonists. Greuze might have been familiar with Watteau's vaudeville scenes (see fig. 9), but he also may have drawn on the example of complex final scenes in popular opéras comiques of the day, such as those by Sedaine. In the conclusion of the farce *Blaise le Savetier,* Sedaine included an artisan's celebration at the end of the play that provided a pretext for a complex visual spectacle. More significantly, he had conceived elaborate scenes for *Le Jardinier et son seigneur* and *On ne s'avise jamais de tout,* his more ambitious works of the 1760s that combined social comment with lavish celebratory spectacle. It is well known that Greuze's picture provided the Théâtre Italien with a *tableau vivant.*[52] It is reasonable to suppose that the intense finales of mod-

ern opéra comique provided a model for Greuze's composition.

Despite the affinities of *The Village Bride* with opéra comique, the painting has become inseparable in modern scholarship from the theories and criticisms of Denis Diderot. The interventions of the philosophe, dramatic theorist, and art critic have shaped the way Greuze and Sedaine are now appraised. It has been easy to see both as disciples of Diderot, putting into painterly and dramatic practice the master's complex theories. However, the story of this triangular relationship is more complex than has sometimes been recognized, and it was central to the fate of genre painting and of new drama in the latter half of the century.

Diderot's intervention in the dramatic sphere in 1757 with his *Fils naturel* and the accompanying tract, the *Entretiens sur le fils naturel,* and one year later with the publication of *Le Père de famille* and *De la poésie dramatique,* represented the most complex and radical challenge to understanding the nature and purpose of drama in eighteenth-century France. Diderot saw that mainstream French drama had become stagnant, in part because of the oppositional structures that dominated theory but also because of the lack of practical innovation at the Comédie-Française. The dialogues spoken by Dorval, the hero of *Entretiens,* not only urged changes in the way plays were staged, acted, and viewed, but also attempted to tackle the issue of genre in a serious way.

Dorval's pleas for practical changes in the stage—reforms in acting style, and a new emphasis on pantomime, on the visual impact of theater and better integration of props and decor to create illusion, and on the production of stage pictures (tableaux)—while passionately expressed,[53] are not necessarily original. Theater practitioners such as Luigi Riccoboni and now-forgotten personalities such as Paul Landois had been attempting to reform theater for decades; experiment dominated the stages of fair theaters, and tableau scenes had long been the staple of the programs. Diderot, a keen theatergoer, had lived in proximity to the fairs at the time when Monnet's enterprise was in full swing, and even tried his hand at fair theater himself in the early 1750s while he was developing his theories on theater. He must have been aware that many of the reforms suggested by his passionate fictional interlocutor were already occurring on minor stages in comic genres. Diderot's aim was to mold the experiments taking place in the realm of travesty, pastoral, and parody into a powerful new theatrical idiom. His intention was to make travesty serious, and it is paradoxically out of the materials of some of the most antinaturalistic forms of the-

ater that he wished to shape his protorealist stage.

Diderot's fictional interlocutor Dorval also became the mouthpiece for an assault on the structure of genre. He dared to utter that which had been implicit in the experiments of the fair theaters and in the ambitions of genre painting since Watteau: the classifications of comedy and tragedy were inadequate and stifling. Dorval expressed a theory of how theater genres should be reformed, indicating that he wished to see the oppositions that structured dramatic thinking challenged by what he called the serious genre (*genre sérieux*). This he imagined as an intersection of dramatic genre, overlapping comedy and tragedy and taking elements from both. Nowhere had such a potentially revolutionary theory been so lucidly and eloquently stated, but in effect Diderot merely articulated an idea generated by experiments in painting and drama that had taken place over the previous forty years.

Equally important was the purpose Diderot believed this new genre would serve. His theater was a blueprint for a stage on which controversial contemporary subjects could be tackled directly in the intense laboratory of the domestic interior. Dorval wishes the stage to explore "all relationships, the father of the family, the spouses, the sister, the brothers. The father of the family! What a subject in a century such as ours, where it seems one has not the slightest notion what a father is."[54] Here Dorval implies that the network of familial relationships might form the center of interest, rather than *états* or professions. The private sphere (the salon) would become a mirror to reflect the public sphere, an enclosed arena where eminently political issues could be translated into the mechanics of family division and reconciliation.

Diderot's suggestions were as hotly disputed as his plays were clumsy and unsuccessful. Actors, critics, and satirists found the complexities of his theory threatening and the reality of his practice unimpressive, if not ludicrous. His theory provoked a reaction on the part of purists, who were fearful that Diderot's ideas might lead to an opening up not just of an aesthetic debate but a political one. Charles Palissot and Elie-Cathérine Fréron were quick to link Diderot's dramas to his wider philosophical and encyclopedic projects,[55] and censors recognized that they were potentially politically sensitive.[56] Critics were quick to seize on Diderot's deficiencies as a playwright to damn his theory. Frustrated, he turned to fair theater and genre painting again as an alternative place for his theatrical vision.

Sedaine and Greuze became acquainted with Diderot in the early 1760s,[57] and their experiments provided him with a golden opportunity. While Diderot was en-

during the failure of *Le Père de famille* at the Comédie-Française, he was beginning his regular reviews of the Salon exhibitions for Melchior Grimm's *Correspondance littéraire*. Diderot's reputed friendship with Greuze is little documented, but the central plank of his relationship with the artist was the long passages that appeared in his Salon reviews in which he creatively reconstructed the series of ambitious genre paintings that made Greuze famous in the 1760s.[58] In the passage on *The Village Bridge* in his Salon of 1761, Diderot not only re-created the space in front of the painting as a packed theatrical parterre but went on to mold Greuze's image to fit his ideal theater: "It is a father who is about to hand over his daughter's dowry. The subject is moving and in looking at it one is overcome by a sweet emotion."[59]

Essentially, *The Village Bride* was not a pathetic image; Greuze placed the groom rather than the father at the center. By contrast, Diderot's *Père de famille* was a pathetic drama of father-son relationships, and in his review of the Salon he seemed determined to remind readers of the perfect alliance between Greuze's painting and his own drama. He claimed that Greuze merely observed a scene rather than invented it—the same fiction that was vital to Diderot's *Fils naturel*. He even made up dialogue for the old father who is shown handing over the dowry. Diderot's ecstatic review appropriates Greuze's celebratory image as an extension of his own rather less successful theater.

It is not known whether Greuze and Diderot collaborated on the subject of *Filial Piety* (fig. 16), exhibited at the Salon of 1763, but this image provided Diderot with a solid base for comparison with his own blueprint in drama. It represented a shift from the celebratory to the serious; the finished picture differed substantially from the sketch displayed in 1761, and the changes indicated how an exuberant comic style had been harnessed to become compatible with the aesthetic and moral program of the philosophes. The new closure in the painting, created by the sealed, intense nature of the surroundings, together with the shift of attention from the celebration of transition to the drama of patriarchal pathos, corresponded better with Diderot's plans for drama. The painting performs the key operation of transforming the vicious triangle of Greuze's *The Blind Man Deceived* into a virtuous one. This time the young bride is almost shut out by the exchange of glances between the father and the son, thus making the father the unambiguous center of attention. Although there was no strict agreement among commentators on the exact meaning of the image, there was a consensus that it represented a shift from comedy to morality.[60]

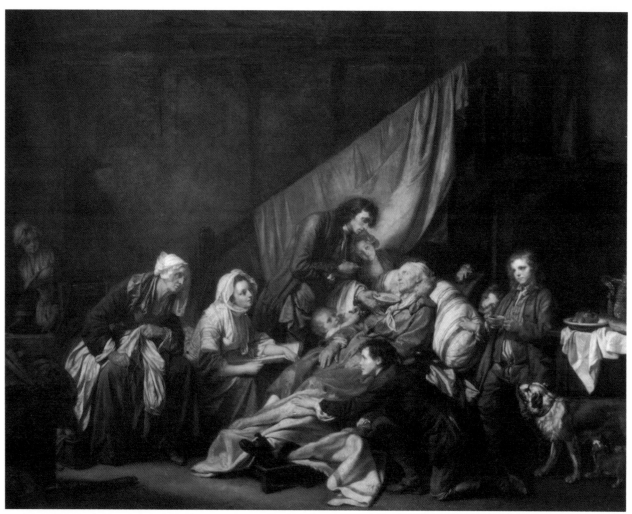

16. Jean-Baptiste Greuze, *Filial Piety,* Salon of 1763, oil on canvas, Hermitage, St. Petersburg/Bridgeman Art Library, London.

Diderot fully exploited the opportunity to make every possible link between the image and his own theater: "To begin with, the genre pleases me. It is moral painting. Do you not think that too often and for too long the brush has been dedicated to debauchery and vice? Would we not be satisfied to see it finally follow the path of dramatic poetry, for the purpose of moving us, instructing us, to reform us and lead us to virtue?"[61] Greuze's work was transformed into both example and model, and Diderot's complex and enthusiastic rhetoric succeeded in creating a powerful bond between his dramatic ideas and Greuze's painting.

The complex nature of the involvement of Sedaine with Diderot and his circle is not often recognized. Sedaine's major spoken drama *Le Philosophe sans le savoir* is viewed as the most successful attempt to apply Diderot's theories in practice.[62] Yet the play's success was a triumph of the integration of the resources of opéra comique in the creation of modern drama, rather than a vindication of the theories of Diderot. Sedaine

wrote the play in 1763, having been heavily involved with developing opéra comique as a serious vehicle and with the avant-garde of the theatrical parterre at the Comédie-Française.[63] He wrote the play as an intervention into the heated debate that followed the publication of Diderot's plays and tracts. He also sent it to Grimm, who invited him to supper to discuss the work. Diderot was present on this occasion and must have realized that fortune had brought him a powerful ally.[64] Sedaine possibly brought a draft to Diderot, who realized it suited his purposes well, although it seems unlikely that he made an active contribution to it.

Sedaine redeployed opéra comique techniques in a subtle, understated way to reinforce an unmistakable moral and political message, making his *Le Philosophe* directly comparable to Greuze's work of the 1760s. Like Greuze, Sedaine used hybrid space: the house of the noble turned *commerçant,* Vanderk, is simultaneously an intimate family sphere, a place of business, and a hive of celebratory activity as the family gears up for Van-

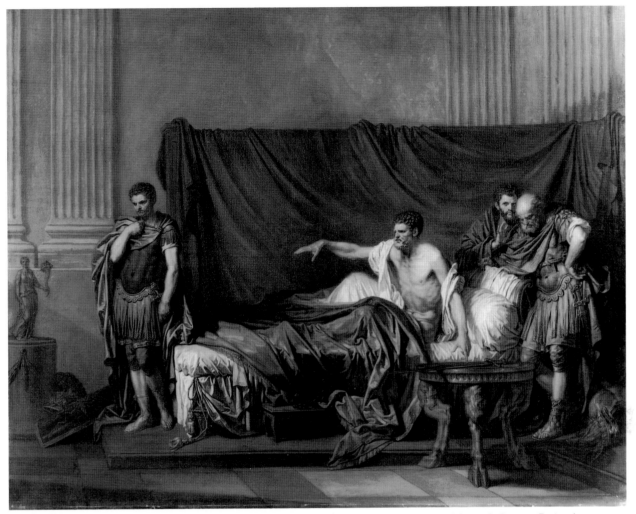

17. Jean-Baptiste Greuze, *Septimius Severus Reproaching Caracalla*, Salon of 1769, oil on canvas, Musée du Louvre, Paris, photo R.M.N.

derk's daughter's marriage. As with Greuze's painting, the world of the *Le Philosophe* is socially mixed, and the true identity of almost all the characters is confused. Furthermore, Sedaine's story ennobles his contemporary scene with classical allusion. In the preface to sections the censors forced him to cut, Sedaine hinted that Vanderk was a modern Brutus.[65] As Greuze adapted his classical sculptural model with new seriousness, so Sedaine translated a tragic model without parody.

Sedaine, like Greuze, drew on the techniques of his former parodic style, creating dialogue and spectacle that had been pioneered on lesser stages. His experience in manipulating short lines of dialogue for musical theater is evident in the most effective dialogue of *Le Philosophe*. So, too, is his grasp of visual techniques, wherein the entrances, costumes, and objects all carry emotional or political significance. There are spectacular entrances of characters—such as the appearance of the daughter in her wedding finery—that punctuate and structure the work that were indebted to the opéra

comique. In *Le Philosophe* Sedaine combined farce, sentimental comedy, intimate drama, and tragedy into a complex modern composite drama. After the performance, Diderot and Grimm disingenuously claimed not to know Sedaine, but were enthusiastic in their praise, expressing their belief that his play opened up new possibilities for the renewal of drama in France. Distinct parallels with Diderot's exhortations to Greuze are obvious.[66]

At a moment in the 1760s, then, both new theater and genre painting seemed to have reached unprecedented levels of sophistication and success. The combined talents of Diderot, Greuze, and Sedaine seemed set to form a new, virtuous triangle, a happy collaboration that would lead to a modern conception of art, one in which erosion of genre by progressive mixing would facilitate the representation of contemporary society for which the old order was inadequate. To some extent, Sedaine's and Greuze's work did indeed spur such activity. From 1765 to 1769 a variety of dramas loosely

classed as *drames* were developed, and new theories of drama explicitly called for an end to the oppositions of genre.[67] Greuze continued his experiments in genre in 1765 with the powerful pair of sketches known as *The Father's Curse*.

The new dawn of modern hybrid practice was a false one, however. Greuze and Sedaine were ambitious and wished to extend their genre-mixing practice and gain acknowledgment and status. Previous experiments, although rich and complex, had taken place within the realms of the lesser genres—Sedaine had labeled *Le Philosophe sans le savoir* a comedy, and Greuze had shown little inclination toward history painting. In 1769, however, each attempted to move his experimental zeal into the realms of higher genres, but both were to discover that the power of the old oppositions was still strong.

The circumstances surrounding the reception of Greuze's history painting *Septimius Severus Reproaching Caracalla* (fig. 17), his long-delayed reception piece for the academy, are well known.[68] After widespread and hyperbolic critical praise in the preceding decade, Greuze suffered vilification and ignominy in 1769 when his work was roundly criticized, and the artist was received into the academy only as a genre painter. Departure from his expected genre was the cause of the failure of the picture.[69] To fully comprehend the reasons why *Septimius* was unacceptable to critics across the political and academic spectrum, it is instructive to compare the painting with another work that also faced a barrage of outraged criticism and mockery: Sedaine's tragedy *Maillard, ou Paris sauvé*, also of 1769. This drama, accepted for performance at the Comédie-Française in 1771, was consistently prevented from reaching the public by a combination of official censorship, court obfuscation, and the biting assaults of Voltaire and the actor Le Kain.[70] The parallels between *Septimius* and *Maillard* and the responses to them are striking. Both painting and play were accused of being clumsy and ill constructed, but the main point of the criticism was generic rather than technical, and both were rejected as much for their aspirations as for their intrinsic qualities.

Sedaine and Greuze made surprising choices of subject matter for their works. *Maillard, ou Paris sauvé*, set in the murky and inglorious fourteenth century, focused on Etienne Marcel's plot to overthrow royal authority in 1358.[71] The subject of Greuze's picture was drawn from a troubled period of the fading Roman Empire and focused on a tense moment of family conflict between two of the cruelest Roman leaders.[72] Both subjects were based on complex narratives in which family loyalty clashes painfully with civic virtue. Sedaine's play mixed the historical with the contemporary in startling ways, containing discussions of breast-feeding and a battle for the sovereignty and possession of Paris. Greuze's *Septimius* also seemed to mix the domestic with the political in awkward ways, focusing on a political power struggle reduced to a moment of intimate father-son conflict, steeped in reminders of the wider bloody scenario of patricide and abuse of power that surrounded this episode in the historical account.

The prickly subjects of both the painting and the drama, however, were less provocative than their formal characteristics. Greuze's painting was widely criticized for its strange and inappropriate mixture of elements. His canvas juxtaposed the antique with the burlesque, the *bambocciade* tradition with the thorough study of Nicolas Poussin. The treatment of the figure of Caracalla, in whom Greuze combined the pose of the Belvedere Antinous with the expression of one of his hesitant and reproached adolescent females, epitomized this collision of repertoires. Sedaine's play was not only provocative in its abandonment of the alexandrine for prose, ostensibly the reason for Voltaire's aggressive condemnation of the work, but also because—as in Sedaine's earlier, comic works—it seemed to delight in a juxtaposition of highly contemporary language and deliberately archaic phrases, and in a mixture of the rhetoric of civic virtue, the intimate language of lovers, the proverbial language of friends, and the violent discourse of plotters. Its heavy emphasis on visual spectacle was the result of Sedaine's experience with opéra comique, the traces of which made the historical tragedy unacceptable.

These works by Greuze and Sedaine presented critics with the possibility of a hybrid form of history painting and tragedy, created out of radical formal experiment, a sometimes ironic treatment of antique sources, powerful political undercurrents, and the confusion of domestic psychological drama with public tragedy. The righteous indignation of the academicians who gathered to judge Greuze and of the critics and actors who opposed Sedaine can be read as a defensive reaction to this move. Artist and dramatist had attempted to graft their experiments onto the highest genre, bringing their complex hybrid practice into realms where it was unacceptable. Although this mixture might be tolerated, even celebrated in the realm of genre painting and comedy, it could only be construed as a dangerous tendency in history painting or tragic drama, a "monster to be stifled at birth," as Watelet phrased it.[73]

After their difficulties with these *oeuvres maudits*, Sedaine and Greuze nevertheless continued to be enor-

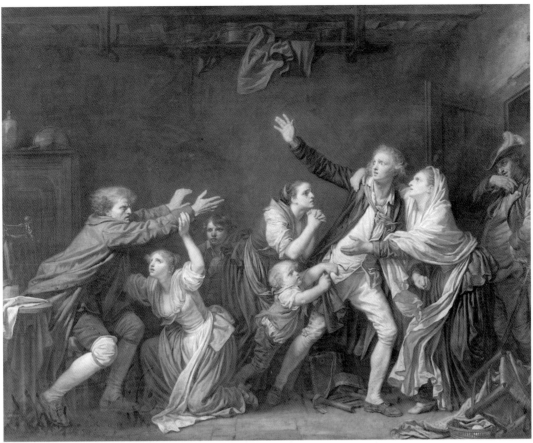

18. Jean-Baptiste Greuze, *The Father's Curse: The Ungrateful Son*, 1777–78, oil on canvas, Musée du Louvre, Paris, photo R.M.N.

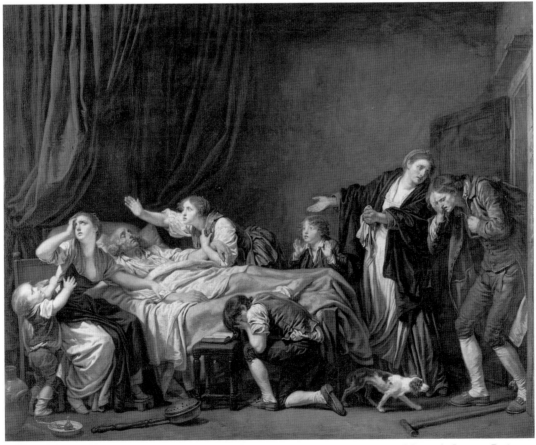

19. Jean-Baptiste Greuze, *The Father's Curse: The Punished Son*, 1777–78, oil on canvas, Musée du Louvre, Paris, photo R.M.N.

mously popular and successful. Sedaine was in demand as an author of operás comiques and wrote two plays for Catherine the Great of Russia. This same patron also proved a great sponsor of Greuze's work, and sales of prints after his work were as successful as his exhibitions of finished work in his studio. To some extent, however, both were successfully marginalized from the highest genre and from the institutions that continued to be at the center of French artistic life.

With the D'Angiviller regime came a determination to reimpose strict barriers between history painting and other genres. Sedaine never wrote another tragic drama, nor did he reconcile himself to the failure of *Maillard*. One of the plays he wrote for Catherine was a bitter satire on the problems of the playwright whose work is censored and finally wrecked by a corrupt court.[74] The other was a spiky comedy whose conclusion saw a literary journalist receive a good thrashing.[75] Sedaine's fortunes reflect a general decline of innovative drama in Paris, and—under the weight of parody and other forms of attack—Beaumarchais, Diderot, and other writers renounced their efforts at reform.

Greuze's work in the 1770s similarly displayed the signs of his bitterness and marginalization. His compositions retained their large scale but remained self-conscious, as he struggled uncomfortably to contain his ambitions as a history painter within the limits of his former genre. Recent commentators have praised *The Father's Curse* pendants (figs. 18 and 19) as perfect modern history paintings.[76] However, the integration of the techniques of history painters (particularly Poussin) are more accomplished and convincing in the 1765 sketches than in the finished works. The 1770s paintings, in their gothic classicism, show signs of strain and exhaustion in their hyperbole, chiaroscuro, and overly dramatic gesture.[77]

Other paintings reveal Greuze making his own dilemmas the subject of his work. One of these, *The Drunken Cobbler* (cat. 31), is painfully introspective and self-conscious. Its allusions to classical culture are again parodic and irreverent: the drunkard is given the characteristics of two famous versions of Bacchus.[78] The lurching, crude posture of the husband contrasts so strongly with the Poussinian features of the disappointed and discontented wife that it is difficult to read this image as anything but a tense and unsuccessful mélange of the ennobled peasant and the travestied classical figure, twin prongs of Greuze's former experiments, here in bitter conflict. The social message of this picture is entirely swamped by a self-conscious theatricality as Greuze struggled to maintain ambition while acknowledging the failure of his experiments. This startling and disturbing comic image might be taken to represent the punch-drunk artist's return to his genre.

Greuze's rather dispirited and confused *Drunken Cobbler* brings the history of the collaboration of artists and dramatists in the eighteenth century full circle. Watteau had examined the theater as a site for the mixing of genres and the blurring of boundaries and as an inspiration for his own creation of a sophisticated modern practice. Greuze's defeatist self-parody seems to admit the impossibility of mapping modernity onto the oppositional structures that dominated judgment of his art. Genre painting decreased in ambition as it increased in visibility in the 1770s and 1780s. Similarly, the ever more popular and well-frequented boulevard theaters that sprang up in these decades did not perform complex works but reverted to a familiar repertoire. The last point of comparison is thus one of defeat, as genre painting and new theater in France lost their uniquely exciting experimental edge and returned to a familiar and subordinate role.

This bleak conclusion is tempered by a surprising epilogue. Paradoxically, the rejection of Greuze's *Septimius* marked the start of the revival of history painting, and Sedaine's experiences proved part of the rejection of *drame*. Yet the work of both men was to exercise a powerful influence on the future of history painting through Sedaine's close links to Jacques-Louis David and the impact of *Septimius* on a new generation of history painters.[79] In this complex narrative, the ambitions of new theater and genre painting were sacrificed, to resurface as "influence." It was at the expense of the experimental developments in mixed genre that history painting was to flourish in the latter years of the century. The old order had triumphed over modernity, and it was not until the nineteenth century that the true heirs of Sedaine and Greuze were able to practice with success and acclaim.

1. The best analyses are René Bray, *La Doctrine classique en France* (Paris, 1963), and Jacques Scherer, *La Dramaturgie classique en France* (Paris, 1963).
2. The importance of this opposition is explicitly stated in L'Abbé d'Aubignac, *La Pratique du théâtre und Andere Schriften zur Doctrine Classique*, ed. Hans-Jorg Neuschäfer (Geneva, 1971), esp. 62–65, 128–31, and 313.
3. See the revealing chart of the disappearance of mixed genres prepared by Scherer in *La Dramaturgie classique*, 459.
4. Among many examples, one accessible prologue is that to *Le Forêt de Dodone* and *Arlequin Endymion* performed at the Foire Saint-Germain in 1721, reprinted in *Théâtre de foire au XVIIIe siècle*, ed. Dominique Lurcel (Paris, 1983), 170–81.
5. See for example, François-Thomas Marie de Baculard d'Arnaud, "Les Dégouts du théâtre," in *Oeuvres diverses* (Berlin, 1751).

6. André Félibien, *Conférences de l'Académie Royale de Peinture et de Sculpture pendant l'année 1667* (Paris, 1669), preface.

7. Claude-Henri Watelet, "Genre, peint.," in *Encyclopédie, ou dictionnaire raisonné des arts, des sciences, et des métiers* (Lausanne, 1781), 17:970–71.

8. On the commedia dell'arte in France, see Pierre Duchâtre, *La Commedia dell'arte et ses enfants* (Paris, 1955). More specifically on the relationship between the Italian comedians and the French court, and the *Fausse prude* incident, see François Moreau, "Les Comédiens Italiens et la cour de France, 1694–1697," *XVIIe Siècle* 130 (January–March 1981): 63–81.

9. A useful summary of the basic facts about the Parisian fairs can be found in Robert Isherwood, *Farce and Fantasy* (New York, 1989), 22–59. On the fair theaters, see Maurice Albert, *Les Théâtres de la foire* (Paris, 1900), and Martine de Rougemont, *La Vie théâtrale* (Paris, 1988).

10. On opéra comique, see esp. the recent volume edited by Philippe Vendrix, *L'Opéra-comique en France au XVIIIe siècle* (Liège, 1992). See especially Maurice Barthélémy, "L'Opéra-comique des origines à la querelle des bouffons," 9–77. Other useful works are Georges Cuceul, *Les Créateurs de l'opéra-comique français* (Paris, 1914), and Emile Campardon, *Les Spectacles de la foire*, 2 vols. (Paris, 1877). On the wrangling and disputes between the official and unofficial theaters, see esp. Isherwood, *Farce and Fantasy*.

11. Isherwood, *Farce and Fantasy*, 60–80, discusses the constrictions under which the fair theaters were forced to work in the early part of the century. The most famous account to tie Watteau's work to the history of the fair theater's development was A. P. de Miramonde, "Les Sujets musicaux chez Antoine Watteau," *Gazette des Beaux-Arts* 58 (November 1961): 249–88. See also François Moreau, "Watteau in His Time" in *Watteau, 1684–1721*, exh. cat. (Washington, D.C., 1984), 475–93.

12. Crow, *Painters and Public Life*, 134.

13. Heather McPherson, *Some Aspects of Genre Painting and Its Popularity in Eighteenth-Century France* (Ph.D. diss., University of Washington, 1983).

14. Among the most important of these studies are: Yvonne Boerlin-Brodbeck, *Antoine Watteau und Das Theater* (Basel, 1977); Miramonde, "Les Sujets musicaux chez Antoine Watteau"; Robert Tomlinson, *La Fête gallante: Watteau et Marivaux* (Geneva and Paris, 1980); Moreau, "Watteau in His Time" and "Theater Costumes in the Work of Watteau," in *Watteau, 1684–1721*, exh. cat. (Washington, D.C., 1984), 469–506 and 507–26; André Blanc, "Watteau et le théâtre français," in *Antoine Watteau (1684–1721): Le peintre, son temps, et sa légende*, ed. Margaret Morgan Grasselli and François Moreau (Paris, 1987), 197–202; Robert Tomlinson, "Fête galante et/ou foraine? Watteau et le théâtre," in *Colloque Watteau*, 203–11.

15. See, for example, Alain René Lesage, *Arlequin roi des Ogres, ou les bottes de sept lieues* (Foire Saint-Germain, 1720).

16. Blanc, "Watteau et le théâtre français," 200–201.

17. John Lough, *Paris Theatre Audiences of the Seventeenth and Eighteenth Centuries* (London, 1957).

18. The main source of information on Monnet is his autobiographical volume, *Supplément au roman comique, ou Mémoires de Jean Monnet*, 2 vols. (London, 1772). This work was republished with additional notes and an introduction as *Mémoires de Jean Monnet* (Paris, 1909). The major critical and biographical works on Monnet are J. Heulhard, *Jean Monnet: Vie et aventures d'un entrepreneur de spectacles aux XVIIIe siècle* (Paris, 1884); Rougemont, *La Vie théâtrale*, 183–86; and Isherwood, *Farce and Fantasy*, 101–7. Isherwood speculates that Monnet may have taken too much credit for reforms in the opéra comique.

19. Martine de Rougemont states that Monnet's 1743 orchestra was conducted by Jean-Phillipe Rameau and not his nephew, who was involved in Monnet's later projects; see Rougemont, *La Vie théâtrale*, 191. Most other commentators opt for the nephew. See A. Pougin, *Madame Favart: Étude théâtrale, 1727–1772* (Paris, 1912), 7, and Isherwood, *Farce and Fantasy*, 95.

20. See the appendix to Heulhard, *Jean Monnet*, which reprints an undated document stating in writing these tight regulations; among the rules for the dancers was this one: "Ceux qui négligeront la propreté dans leur chaussure payeront trente sols d'ammende" (98).

21. On Garrick and Monnet, see F. Hedgecock, *Garrick et ses amis français* (Paris, 1911).

22. Ibid., 1:116; Heulhard, *Jean Monnet*, 33–43.

23. "Se fit un plaisir de composer les dessins du plafond, les décorations, des ornemens même, et de présider à toutes les parties de la peinture qui fut employeé dans cette salle" (Monnet, *Supplément*, 2:38).

24. Ibid.

25. The play was never published, but it survives in manuscript form; see C. Favart, "Prologue pour l'ouverture du nouvel Opéra-comique," 1743, Bibliothèque Nationale, MS, fonds français 9325, fols. 405–14.

26. "Eh! Quoi! L'Opéra-comique s'étonne de me voir sous la figure d'une nimphe" (ibid., fol. 410).

27. Ibid., fols. 410–11.

28. Charles-Siméon Favart, *Les Nymphes de Diane* (Paris, 1748).

29. Apart from the evidence of the letters cited above, indications of the close collaboration between Boucher and Favart, and the musician de la Garde and the chief choreographer of opéra comique, Dourdais, can be found in the Favart papers in the Bibliothèque de L'Arsénal, Paris. See esp. Rondel MS 291, fol. 2 (Pierre de la Garde to Favart, March 8, 1746), and f. 3 (de la Garde to Favart, April 3, 1748—this letter contains a discussion of the arrangements for Boucher's engravings for *Les Nymphes de Diane*).

30. Alastair Laing, "Boucher et la pastorale peinte," *La Revue de l'art* 73 (1986): 55–64; Laing, "Boucher: The Search for an Idiom," in *François Boucher, 1703–1770*, exh. cat. (New York, Detroit, and Paris, 1986–87), 56–72.

31. On the *genre poissard*, see A. P. Moore, *The Genre Poissard and the French Stage* (New York, 1935). On Vadé, see G. Lecocq, *Poésies et lettres facétieuses de Joseph Vadé* (Paris, 1879), and the recent article by Pierre Frantz, "Travestis Poissards," *Revue des sciences humaines* 2 (1983): 7–20.

32. "Proprement un tableau de Tenière [*sic*] mis en action" (Monnet, *Supplément*, 2:47).

33. On Noverre's work for Monnet, see D. Lynham, *The Chevalier Noverre* (London, 1950), esp. 20–30.

34. See Heulhard, *Monnet*, appendix, 103–13.

35. See also Desboulmiers [J.-A. Julien], *Histoire du théâtre de l'opéra-comique* (Paris, 1769), 2:486, for a full description of the scene; see also *Mercure de France* (September 1755).

36. The most useful modern summary of Jeaurat's life and work is provided by Marie Cathérine Sahut, "Jeaurat," in *Diderot et l'art de Boucher à David*, exh. cat. (Paris, 1984), 280–81. See also Simon Puychevrier, "La famille Jeaurat à Vermonton: Le peintre Etienne Jeaurat," *Annuaire historique du département de L'Yonne* (1863): 159–88, and Paul Wescher, "Etienne Jeaurat and the French Eighteenth-Century *Genre de Moeurs*," *Art Quarterly* 32, no. 2 (Summer 1969): 153–65.

37. On Sedaine, see Mark Ledbury, "Greuze, Sedaine, and Hybrid Genre in Late Eighteenth-Century France" (Ph.D. diss., University of Sussex, 1996); Margaret Rayner, "The Social and Literary Aspects of Sedaine's Dramatic Work" (master's thesis, Westfield College, University of London, 1960); D. Charlton, *Grétry and the Growth of Opéra-comique* (Cambridge, 1988); and Louise Arnoldson, *Sedaine et les musiciens de son temps* (Paris, 1934).

38. See *Le Jardinier et son seigneur*, 1761, and *Le Roi et le fermier*, 1763. Some commentators, including Isherwood, have seen in the work of Sedaine and other librettists of the late 1750s and 1760s a "time

of loss," when the excitement and energy of popular culture was somehow appropriated by a bourgeois moral program. This ignores that Sedaine was exploiting the energies of a heritage he understood exceptionally well. It also underestimates the radical and politically daring nature of Sedaine's work. "Virtue" was a potent political concept in late-eighteenth-century France. See Marisa Lintern, "Concepts of Virtue in Eighteenth-Century France" (Ph.D. diss., University of Sussex, 1993).

39. Sedaine's links with artists and interest in painting have been little explored but are significant. He was in close contact with the Saint-Aubin family, and his poetry is replete with references to others, such as Boucher and Joseph-Marie Vien. On Sedaine and the Saint-Aubin family, see Emile Dacier, "Le 'Sedaine' du Musée Condé, ou Gabriel de Saint Aubin poète," *Revue de l'art ancien et moderne* 38 (1920): 5–18 and 65–76, and Dacier, *Gabriel de Saint Aubin* (Paris, 1929).

40. "En 1762, j'ai effectué ce que j'avais cru impossible, d'élever le ton de ce genre, et de mettre même un roi sur la scène dans un ouvrage en trois actes qui occupât la scène aussi longtemps qu'une pièce en cinq actes au Théâtre Français" (Michel-Jean Sedaine, "Quelques réflexions de Sedaine sur l'opéra-comique," in *Oeuvres*, ed. Guibert Pixericourt [Nancy, 1841–43], 507).

41. Michel-Jean Sedaine, *Le Roi et le fermier* (Paris, 1762), "Avertissement de l'Auteur."

42. On Greuze, see esp. Edgar Munhall, *Jean-Baptiste Greuze*, exh. cat. (Hartford, San Francisco, and Dijon, 1976–77); Anita Brookner, *Greuze: The Rise and Fall of an Eighteenth-Century Phenomenon* (London, 1973); and Crow, *Painters and Public Life*, 134–74.

43. Brookner, *Greuze*, 92–93.

44. Munhall's catalogue entry for the Jeaurat portrait in *Diderot et l'art*, 262–63, states: "Célibataire fortuné et aimant le plaisir, Jeaurat a peut-être connu son collègue de l'académie dans le monde."

45. On the formal borrowings in the picture, see Brookner, *Greuze*, 93–95. On Greuze and contemporary social thinking, see E. Barker, *Greuze and the Painting of Sentiment* (Ph.D. diss., Courtauld Institute, London, 1994). On the reception of Greuze and its political implications, see Crow, *Painters and Public Life*, 138–53.

46. *Lettre sur le Salon de 1755, adressée à ceux qui la liront* (Amsterdam, 1755), 44.

47. James Thompson, "Jean-Baptiste Greuze in the Collection of the Metropolitan Museum of Art," *Metropolitan Museum of Art Bulletin* 47 (Winter 1989): 4–52.

48. Willibald Sauerländer pointed out how much Greuze's post-Italian paintings owed to Italian history paintings, and particularly to the work of Michelangelo: "Pathosfiguren im Oeuvre des Jean Baptiste Greuze," in *Walter Friedländer Zum 90 Geburtstag*, ed. Georg Kauffman and Willibald Sauerländer (Berlin, 1965), 46–50. This article, which convincingly points to similarities between Greuze's Italian pictures and Michelangelo's Sistine frescoes and antique friezes and statues, is of fundamental importance in its revision of the prevailing wisdom that Greuze's Italian journey was of no benefit and in pointing to specific examples of Greuze's frequent integration of canonical history paintings and antique statues into his work. Sauerländer went as far as to suggest that there was a conscious humor in this technique.

49. Crow, *Painters and Public Life*, 141.

50. See Marigny's letter to Natoire, in *Correspondance des directeurs de l'Académie de France à Rome*, vol. 11, letter 5202, November 28, 1756.

51. See Richard Rand, "Civil and Natural Contract in Greuze's *L'Accordée de village*," *Gazette des Beaux-Arts* 127 (May–June 1996): 225.

52. See Edgar Munhall in *Diderot et l'art*, exh. cat. (Paris, 1984), 226.

53. For the most important exposition of these ideas, see Diderot, *Entretiens sur le Fils Naturel*, in *Diderot et le théâtre: Le drame*, ed. Alain Ménil (Paris, 1994), 79–84; on Diderots theories in general, see esp. Alain Ménil, *Diderot et le drame: Théâtre et politique* (Paris, 1994);

Robert Abirached, "Diderot et le théâtre," in *Oeuvres complètes de Diderot*, ed. R. Lewinter (Paris, 1970), 3:i–xvi; A. Guedj, "Les drames de Diderot," *Diderot Studies* 14 (1971): 15–95; Derek F. Connon, "Innovation and Renewal: A Study of the Theatrical Works of Diderot," *Studies on Voltaire and the Eighteenth Century*, no. 258 (1989).

54. "Toutes les relations, le père de famille, l'époux, la soeur, les frères. Le Père de famille! Quel sujet dans un siècle tel que le nôtre, où il ne paraît pas qu'on a la moindre idée de ce que c'est qu'un père de famille" (Diderot, *Entretiens*, 129).

55. Charles Palissot, *Petites lettres sur les grands philosophes* (Paris, 1757), esp. 17–73; *Année Litéraire*, April 1758, supp. 1–71, ascribed tentatively to Elie-Cathérine Fréron by A.-M. Chouillet, in "Dossier du *Fils Naturel* et du *Père de Famille*," *Studies on Voltaire and the Eighteenth Century* 208 (1982): 108.

56. See esp. Malesherbes letter of October 1758, published in Chouillet, "Dossier," 86.

57. The exact circumstances of Diderot's acquaintance with Sedaine and Greuze are still hazy. However, it is likely that the Abbé Lemonnier, a friend of all three, was involved in the introductions.

58. On the biographical links between Diderot and Greuze, see *Greuze et Diderot: vie familiale et éducation dans la seconde moitié du XVIIIème siècle*, exh. cat. (Clermont-Ferrand, 1984).

59. "C'est un père qui vient de faire payer le dot à sa fille. Le sujet est pathétique, et l'on se sent gagné par une émotion douce en la regardant" (Diderot, *Salon de 1761*, ed. Jacques Chouillet and Gita May [Paris, 1984], 164).

60. The Abbé de la Garde described the painting's relation to *The Village Bride* as "moins riante mais peut-être encore plus morale" (*Mercure de France* [November 1763], 193).

61. "D'abord le genre me plaît. C'est la peinture morale. Quoi donc, le pinceau n'a-t-il pas été assez et trop longtemps consacré à la débauche et au vice? Ne devons-nous pas être satisfaits de le voir concourir enfin avec la poésie dramatique à nous toucher, à nous instruire, à nous corriger et à nous inviter à la vertu" (Diderot, *Salon de 1763*, ed., Jacques Chouillet and Gita May [Paris, 1984], 234).

62. On *Le Philosophe sans le savoir* see esp. the modern editions of the play by John Dunkley (Egham, 1993), Graham Rodmell (Durham, 1990), and Robert Garapon (Paris, 1990). See also Félix Gaiffe, *Le Drame en France au XVIIIe siècle* (Paris, 1908), esp. 367–72, and Ledbury, *Greuze and Sedaine*, 107–34.

63. See the reference to Sedaine in the review of Voltaire's *L'Ecossaise*, in *Année littéraire* 5 (1761): 209. See also Sedaine's own account of the genesis of *Le Philosophe* in "Quelques réflexions," 509–10.

64. A letter from Grimm to Sedaine, dated December 10, 1763, inviting him to this dinner, was on the market through the thirty-fifth *Bulletin* of the Librarie de l'Abbaye, Paris.

65. Sedaine, *Le Philosophe sans le savoir*, ed. John Dunkley (Egham, Surrey, 1993), 186.

66. Diderot discusses his reaction to the play in his *Paradoxe sur le comédien*, in *Oeuvres esthétiques*, ed. Paul Vernière (Paris, 1958), 330–31. For Grimm's reaction, see *Correspondance littéraire* 6 (December 1765): 402.

67. The most famous of these were Beaumarchais' *Essai sur le genre dramatique sérieux* of 1767 and Louis-Sébastien Mercier's *Du Théâtre*, published anonymously in 1770, in which its author implored: "Tombez, tombez murailles qui séparaient les genres."

68. Among the most important accounts of the picture and its reception are Jean Seznec, "Diderot et l'affaire Greuze," *Gazette des beaux-arts*, 6th ser. 67 (May–June 1966): 339–56; Munhall, in *Jean-Baptiste Greuze*, 153–57; Munhall, in *Diderot et l'art*, 253–58; Crow, *Painters and Public Life*, 164–72; Daniel Arasse, "L'échec du Caracalla: Greuze et 'l'étiquette du regard'" in *Diderot et Greuze: Actes du Colloque de Clermont-Ferrand*, ed. Antoinette Ehrard and Jean

Ehrard (Clermont-Ferrand, 1986), 107–19; Regis Michel, "Diderot et la modernité," in *Diderot et l'art*, 110–21; and Brookner, *Greuze*, 67–9 and 109–10.

69. See Diderot, *Salon de 1769*, in *Héros et Martyrs* (Paris, 1995), 84–92; Anon. (Beaucousin), *Lettre sur le Salon de Peinture de 1769* (Paris, 1769), 22–26; and Anon., *Discours sur l'origine, les progrès et l'état actuel de la peinture en France* (Paris, 1785), 24.

70. Sedaine's own explanation of events surrounding the play is contained in his preface to *Maillard, ou Paris sauvé* (Paris, 1789). The most thorough discussion of Sedaine's play and its reception is contained in: L. Breitholz, *Le Théâtre historique en France jusqu'à la révolution* (Uppsala, 1957), 237–57; M. Rayner, "The Social and Literary Aspects of Sedaine's Dramatic Work" (master's thesis, Westfield College, London, 1960), 160–74.

71. Sedaine's most likely source was Froissart's *Chroniques*; see the Lettenhove edition (Paris, 1873), vol. 6.

72. Both Cassius Dio and Louis Moreri, Greuze's principal sources, discuss at length the bloody history of Septimius and the future cruelty of Caracalla. See Cassius Dio, *Roman Histories* (London,

1911), 270–71; and Moreri, *Grand dictionnaire historique* (Paris, 1759), vols. 3 and 9, s.v. "Caracalla" and "Septime Sévère."

73. Watelet, "Genre, peint.," 971.

74. Sedaine, "Raimond V, Comte de Toulouse," manuscript archives of the *Comédie Française*, MS 368.

75. Sedaine, "Hinckelmann ou les Journalistes," Bibliothèque de l'Arsénal, Rondel MS 747. See Ledbury, *Greuze and Sedaine*, for a discussion of this play, long thought lost.

76. See Munhall, *Greuze*, 170–81; Pierre Rosenberg, ed., *La Mort de Germanicus de Poussin du Musée de Minneapolis* (Paris, 1973), 58.

77. They resemble the *genre sombre* of his friend Baculard D'Arnaud rather than the subtle experiments of his own and Sedaine's work during the 1760s. For evidence of the friendship between Greuze and D'Arnaud, see the entry for the portrait of D'Arnaud's son in *Greuze and Diderot*, 48.

78. Munhall, *Greuze*, 188.

79. On Sedaine and David, see Ledbury, *Greuze and Sedaine*, 279–322; Thomas Crow, *Emulation: Making Artists for Revolutionary France* (New Haven, 1995), 5–31.

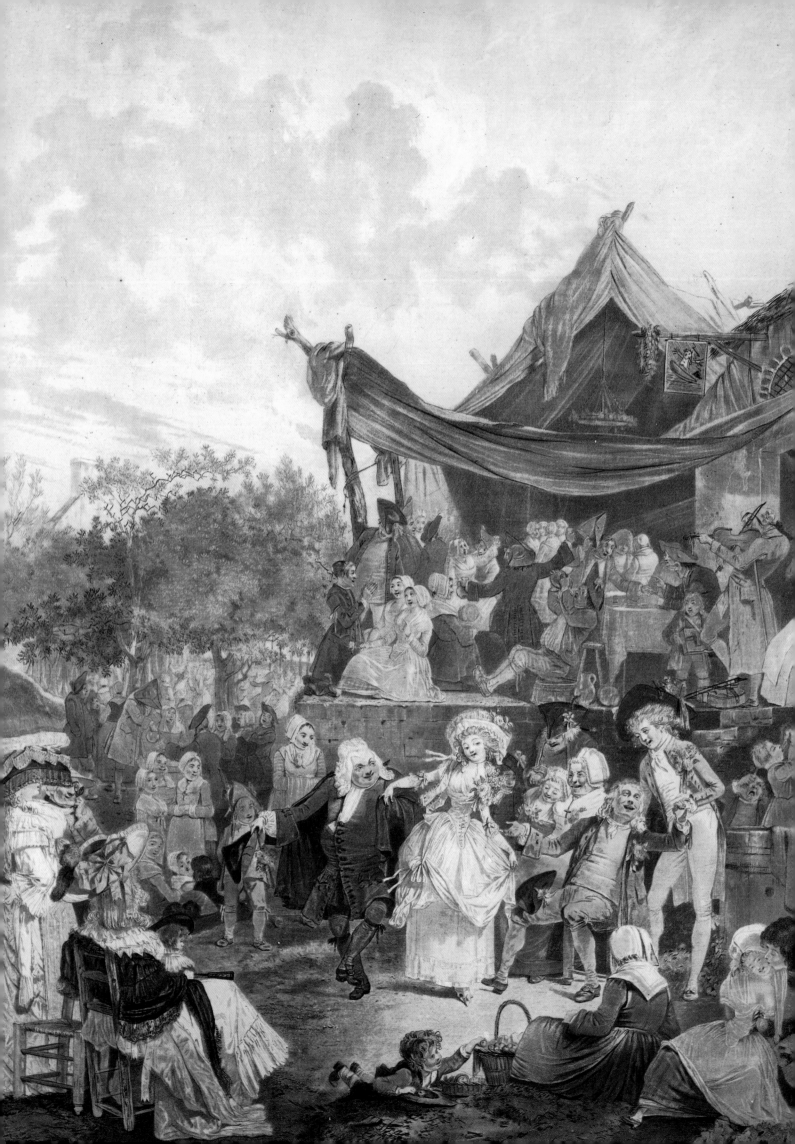

Genre Prints in Eighteenth-Century France: Production, Market, and Audience

ANNE L. SCHRODER

Genre rose to prominence in eighteenth-century France through the overlapping interests of painters, the print industry, and the commercial marketplace. Certainly the growth of an educated art public and a belief in Enlightenment ideals regarding the social necessity of art intensified the demand for images affirming contemporary values. Equally important however, were the expansion of the print industry and the development of new printmaking techniques, which enhanced mass production and allowed for better imitations of the appearance of paintings. The success of genre subjects was secured through the easy dissemination of engravings; produced in multiple copies on paper, prints were more affordable than paintings and therefore more accessible to a wide audience.

French painters embraced the opportunity to replicate their images for greater public impact. Engravings had long been used to reproduce paintings—think of Marcantonio's works after Raphael during the Renaissance and Michel Dorigny's prints after Simon Vouet in seventeenth-century France. Indeed, in 1732 Voltaire proclaimed the cultural significance of the reproductive print; it was "an undertaking, useful to humanity, which multiplies at little cost the achievements of the best painters, which gives eternal life, in all the print-rooms of Europe, to beautiful works which would perish without the help of printmaking, and which can give the knowledge of all the schools to a man who will never have the opportunity to see a painting."[1] Voltaire's assertion that the multiplied print offered "eternal life" to painters reflected a view held by many eighteenth-century philosophers, writers, and artists that fame lasting throughout posterity would be the "enlightened" man's equivalent of a Christian afterlife.[2] Denis Diderot also claimed in his Salon criticism of 1765 that prints would preserve a painter's legacy: "Paintings are destined to disappear. . . . Only through engraving can they be saved."[3]

Genre prints addressed a consumer desire for popular subjects with fashionable appeal. The public delighted in images that reflected their daily lives and they

eagerly responded to mass-produced prints of the subjects they had seen at the academy's biennial Salon exhibitions. Pierre-Jean Mariette noted this phenomenon in 1749 in his comments about the acclaim Chardin's subjects received:

> The prints which have been engraved after the paintings of M. Chardin . . . have become fashionable prints, which like those of Teniers, Wouwermans and Lancret, have dealt a fatal blow to serious prints such as those of Le Brun, Poussin, Le Sueur and even Coypel. The general public enjoys seeing the events which occur daily in their own homes, and do not hesitate to give these preference over more sophisticated subjects.[4]

Just who was this "public"? Precise sales records are scarce, but Pierre Casselle has analyzed a register kept by one Parisian print dealer during the late 1780s. A wide range of buyers—both men and women—are identified by social status and occupations; they range from a cashier and a fabric dyer to a police inspector and a baroness.[5] Throughout the eighteenth century the expansion of the print market paralleled the increased attendance at the academy's Salons, and indicated the growth of an educated art public.

At the turn of the eighteenth century, paintings reflecting the activities, amusements, customs, and values of French society received increased recognition in official circles, particularly from the Royal Academy of Painting and Sculpture. The genre print industry, however, had long existed in France. Etched, engraved, and woodcut images of contemporary life, ranging in quality from crude to elegant, had been produced in Paris for more than a hundred years. Local sellers and itinerant merchants, many of whom had ties to the international art trade, sold fine engravings and etchings alongside more ephemeral materials such as illustrated calendars, printed games, depictions of the artisan trades, and hand-colored representations of men and women wearing the latest fashions.[6]

The Parisian print trade had developed during the sixteenth century, first on the Left Bank near the Sor-

bonne and the Latin Quarter's booksellers, and then on the Right Bank near Les Halles. The district expanded to Saint-Germain-des-Prés, where a Flemish colony had been established after the sack of Antwerp in 1576; by the eighteenth century, the print trade was concentrated on the Left Bank around the rue Saint Jacques.[7] Dealers and hawkers sold their materials in shops and outdoor stalls along the Seine and on its bridges, at art fairs such as that at Saint-Germain, in estate sales, and at auctions. Although the subjects were monitored by government censors, there was great diversity in quality, format, and thematic material.[8]

Driven by commercial interests with a need for skilled labor and technical knowledge, the print industry had a different purpose than did the French Royal Academy of Painting. The academy's mission was threefold: to provide a combined liberal arts and studio education for young painters and sculptors, to sponsor official art projects for the state, and to promote the careers of its members. In the academy's view, art was a learned and humanistic enterprise that should inspire noble thoughts and bring glory to France. Indeed, academic theory since the Renaissance had privileged the artistic concept over its manual production. Painters and sculptors were recognized as intellectuals, whereas engravers were considered mere craftsmen and copyists of other artists' work.[9]

Printmakers generally lacked the elevated status granted to painters and sculptors. They were denied admission to the Royal Academy until Michel Dorigny was accepted in 1663. Throughout the eighteenth century only a handful of engravers was allowed membership. The academy offered the select few an improved social and artistic status, government pensions, exclusive publishing privileges, and the right to exhibit at the biennial Salons, but it also severely limited commercial dealing among its members.[10] By contrast, printmakers excluded from the academy were denied the superior standing and benefits but were free to be actively involved in the marketplace.

The increased interest in genre painting and popular imagery at the beginning of the eighteenth century reflected a broadening of official taste and the reassertion of private patronage, reversing the previous trend. In the last third of the seventeenth century, the academy had successfully promoted history painting and formal portraiture as the highest calling for artists, asserting its essentially classical ideals, to the detriment of French genre painting. Nevertheless, the popularity of scenes of everyday life was evident in the print market and in collectors' taste for works by Dutch and Flemish artists.[11] Northern art, especially works in the manner of Pieter Brueghel, Pieter Aertsen, and David Teniers, remained readily available on the Left Bank in Paris and at the fair at Saint-Germain. Lessons of virtuous behavior, festival celebrations, and scenes of rustic life and boisterous tavern drinking were common in such images.

One of the major French artists engraving scenes of fashionable Parisian society in the seventeenth century was Abraham Bosse (1602–1676). Born in Tours, he may have studied in Antwerp in the early 1620s and thus had firsthand access to northern genre subjects. He returned to Paris to become a professor of perspective and an honorary member of the academy; he was also the author of important manuals on the theory and techniques of printmaking.[12] Works such as his *Gallery in the Palace* (fig. 20), with its well-dressed Parisians examining books and fashion accessories for sale, and *The Ball* (fig. 21), with couples dancing, fused northern realism with a French subject matter and refinement, while reflecting the dress, manners, and social activities of the upper middle class. In another print, *The Schoolmistress* (fig. 22), Bosse employed a rigorously organized composition and a realistic style to illustrate a scene representing young girls being instructed in the basics of reading and writing. In *The Parable of Lazarus and the Rich Man* (fig. 23), the verses inscribed beneath the image convey the biblical message,[13] yet the figures wear contemporary dress, thus relating the story to modern society. Other artists who continued this trend of fashionable or moralizing subjects included Sebastien Le Clerc, Bernard Picart, and Henri Bonnart. A print by Bonnart entitled *January* (fig. 24) depicts an elegantly dressed woman seated at a vanity table as she selects a ribbon from a box held by a servant. It exemplifies the fusion of the fashion plate and calendar print with an everyday activity.

When eighteenth-century French painters turned to genre themes, they often drew on the existing French print tradition. Around 1710, Jean-Antoine Watteau etched his own series of fashion images, the *Figures de Mode* (fig. 25), which updated the earlier fashion-plate tradition.[14] Mary Tavener Holmes has demonstrated the impact of fashion-plate subjects on the genre paintings of Nicolas Lancret. A print such as Bonnart's *January* may have served as an inspiration for both Lancret's *Morning* (see fig. 40) and Boucher's *The Milliner* (cat. 13), the latter also identified as a morning scene for a series on the times of day.[15] In these eighteenth-century subjects, however, the emphasis has shifted away from costume design to the daily activities of fashionable Parisian women.

20. Abraham Bosse, *Gallery in the Palace*, engraving, The Metropolitan Museum of Art, New York, Rogers Fund, 1922 (22.67.16).

21. Abraham Bosse, *The Ball*, engraving, The Metropolitan Museum of Art, New York, Rogers Fund, 1922 (22.67.17).

22. Abraham Bosse, *The Schoolmistress*, engraving, The Metropolitan Museum of Art, New York, Harris Brisbane Dick Fund, 1926 (26.49.54).

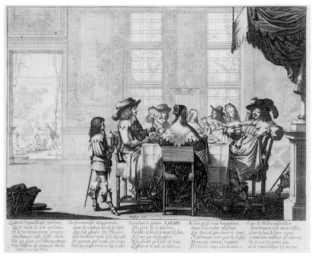

23. Abraham Bosse, *The Parable of Lazarus and the Rich Man*, engraving, Philadelphia Museum of Art; Purchased: Farrell Fund.

24. Henri Bonnart, *January*, engraving, Bibliothèque Nationale, Paris.

25. Antoine Watteau, *Figure de Mode*, c. 1710, etching, The Minneapolis Institute of Arts.

The Reproductive Print as Painting Criticism: Chardin and the Print Market

Scholars who study how engravings deviate from their original models recognize that the reproductive print often operates as a form of art criticism,[16] enhancing and diminishing certain elements of the original while "framing" the image in a new context. The use of verses in the legend beneath the engraved scene, as in Abraham Bosse's *Parable of Lazarus and the Rich Man*, was one of several strategies engravers developed to adapt a painted subject to a format desirable to print collectors. The combination of a graphic image with an inscription had been commonplace in sixteenth-century emblem books, where standard symbolic devices were accompanied by an explanatory text. Seventeenth-century moralized genre prints often combined scenes of everyday life with a short poem, usually of a cautionary nature, encouraging virtuous behavior to avoid harmful consequences.[17] Printmakers continued to append verses to engravings throughout the first half of the eighteenth century, generally to stimulate customers' interest but also to "explain" the images.[18] Verses were even added to reproductive prints after paintings for which there had never been a specified "text," with the result that the painter's intended meaning often became more narrowly circumscribed or was even significantly altered. A case in point is the modifications printmakers made to the works of Jean-Siméon Chardin, whose domestic scenes of women and children date primarily from the late 1730s to 1748. Twenty-seven prints after Chardin's genre subjects were produced from 1738 to 1761 and met with great success.[19]

Chardin's *The Diligent Mother* (fig. 26) exemplifies the subtle shifts in meaning that could occur when one of the artist's works was engraved for a broader audience, even when the painter and the printmaker worked closely together. Chardin exhibited *The Diligent Mother* at the Salon in August 1740, along with its pendant, *Saying Grace* (see fig. 51). Both were cited in a Salon review in the journal *Mercure de France* in October,[20] where the painter's "natural" style was admired.[21] Chardin offered the pair to Louis XV the following month.[22] *The Diligent Mother* was then engraved and published in December (cat. P20, fig. 27) by François Bernard Lépicié, secretary of the academy, and one of Chardin's preferred printmakers, who eventually produced engravings after ten of the artist's genre subjects. Lépicié wrote a poem explaining the subject, which he signed and included in the legend beneath the image.

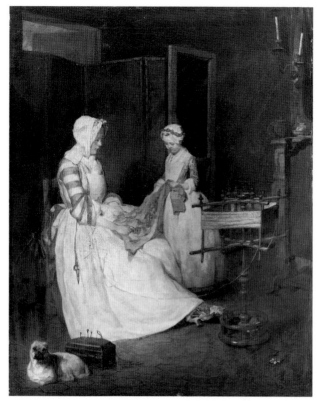

26. Jean-Siméon Chardin, *The Diligent Mother*, Salon of 1740, oil on canvas, Musée du Louvre, Paris, photo R.M.N.

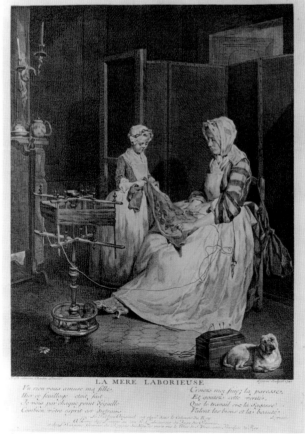

27. François Bernard Lépicié after Chardin, *The Diligent Mother*, 1740, engraving, cat. P20.

He also noted that the original painting was part of the royal collection; this would undoubtedly have enhanced the prestige of the engraving for collectors.

Lépicié announced the print's availability in an article in the December *Mercure*, which, at a full page, was unusually long; the advertisement was immediately followed by a two-page adulatory poem dedicated to Chardin and these two paintings by a "professeur du College du Plessis."[23] Lépicié then donated two proofs of the engraving of *The Diligent Mother* to the academy in January 1741 and exhibited the print at the Salon later that year.[24] It was cited under his own name in the *Mercure* Salon review in October 1741, where the reviewer proclaimed that this engraver "transmitted [Chardin's] glory to Posterity."[25] Although no formal documentation survives regarding the specific relationship between Chardin and Lépicié, it is evident that the painter and the printmaker coordinated a strategy to use the academy's exhibitions to display the works and the *Mercure* publicity to promote their success.

The juxtaposition of the two articles on *The Diligent Mother* in the December 1740 *Mercure* demonstrates that differing views could exist simultaneously on Chardin's characterization of childhood. In his advertisement Lépicié quoted his own poem, in which the mother scolds the daughter for not being attentive to her needlework:

A trifle distracts you my child:
This leaf work you did yesterday,
By each stitch I can see
How your mind often drifted away.
Believe me, that sloth you must shirk
To discover this truth, as you should:
That steadiness, prudence and work
Are more valued than beauty and goods.[26]

The advertisement continued: "These verses were made by M. Lépicié; they express very well the subject of the painting. Here are other verses to M. Chardin, whose praises are both true and well-turned." The next two pages, as noted, contained a poem by the "professeur du College du Plessis." The "professeur," in contrast to Lépicié, admired Chardin's positive, gentle interpretation of "lovable childhood," where "all is smiling and witty." The viewer, he says, "looks, admires, smiles at these children, and is charmed by them."[27] Whereas Lépicié's poem adopts a scolding tone, in which the mother warns her daughter to avoid laziness, the professor's poem reflects the view that childhood is a time of delightful innocence. Did Lépicié's poem appropriately reflect Chardin's intended message about the nature of childhood? Or did it exemplify a continuation

of conventional moralizing verses, such as had existed for over a century in the genre print tradition? The real issue is the distinction between the painter's original creation and the reception of the work, whether by printmakers or by print collectors, who might be accustomed to broader thematic traditions.

It has been common in the scholarly literature to interpret Chardin's paintings according to these inscribed verses,[28] but several writers (e.g., Philip Conisbee, Norman Bryson, and Thomas Crow) have also expressed reservations.[29] Dorothy Johnson has argued instead that Chardin's paintings present a positive message about childhood. She sees these works as reflecting Enlightenment ideas, particularly those that promote a mother's close involvement in her children's instruction. Johnson cites the eighteenth-century popularity of such works as François Fénelon's *Education of Young Girls*: "The mother is singled out as the crucial figure in the early education of the child, and her duties are specified in great detail. Fénelon even describes the appropriate demeanor, temperament, and attitude for the mother to assume as educator; she must be tender, kind, firm, confident, and sincere, and assert her authority through gentle example rather than harsh remonstrance."[30] Johnson also finds that Chardin often depicts the natural curiosity of children who learn through experimentation and play, citing *Soap Bubbles* as an example. Marianne Roland Michel has likewise rejected the conventional view that Chardin intended this painting, as well as *The Morning Toilet* (see fig. 2), as "references to coquetry, frivolity and idleness, which were considered to be female attributes."[31] Because Lépicié worked closely with Chardin on so many occasions, we must assume that the painter did not condemn the verses, particularly if they stimulated the interest of collectors. As Roland Michel adds, "their presence underneath a print would certainly have helped it sell better, by bringing it into line with the vast stock of images sought by the public."[32]

Indeed, Lépicié's scolding message more closely resembles the lines appended to Abraham Bosse's *The Schoolmistress* (fig. 22). There the text reads that a young girl should be taught only the basics of reading and writing to curb her natural inclinations to "wound and enflame." Thus the little "tyrant of affections" will have her "passions constrained" and her "thorns changed to roses."[33] Ironically, the images by Bosse and Chardin each reflects a willingness of little girls to learn, contradicting the text's warning about their naturally selfish characters. Bosse's students earnestly work together to help each other with their assignments, but also study quietly by themselves; in general, they are sociable

and naturally curious. Bosse thus presents an array of positive examples of female instruction, arranged in rhythmically placed groups across a stagelike setting. Chardin, by contrast, focuses on the symbiotic relationship between the mother and daughter, fused by their juxtaposed white aprons and the tapestry they hold.

Lépicié's engraved image alters Chardin's subject in significant ways. In Chardin's painting the faces of the mother and daughter are emotionally neutral, whereas in the engraving the mother's face is more harshly defined. Lépicié has increased the lighting on the mother so that the lines of her mouth, eyebrow, and nostrils are sharper than in the painting. Even more important, in the print the mother looks directly at the child's eyes, as if accusing her. In Chardin's original painting, however, she looks in the general direction of the child's hands or bodice; her stare is distant and unfocused, as if she were lost in thought. A similar distinction is also evident in the face of the child. In the painting Chardin highlighted her entire forehead, the seat of the imagination and learning. In the print Lépicié used more shadow and sharpened the line of her eyebrow, also shortening her lip, so the child has an expression of slight worry or sadness. Finally, Chardin privileged the figure of the child in his painting; her face is more clearly visible than that of her mother and she stands in the approximate center of the composition, reinforced by the highlighted vertical edge of a folding screen behind her. Lépicié, in contrast, gave equal emphasis to mother and daughter by considerably darkening two panels of the folding screen, one behind each figure, to isolate the figures. He eliminated their symbiosis by increasing the shadows on their skirts, thus interrupting the continuous flow of white in their juxtaposed aprons. Evidently, Lépicié felt compelled to alter the emotional expressions and interrelationship of Chardin's figures to correspond with the message of confrontation in his appended verses.[34]

Bosse and Chardin both created positive messages about female instruction with adult women as paragons for girls. The setting for each is the domestic environment, but there are distinctions. Bosse made his site of female learning an airy, upstairs room, integrated with the outdoors by the inclusion of a view out one window in the back and bright sunlight streaming in through another on the right. Chardin's interior space in *The Diligent Mother*, however, is closed off from the outside, with the folding screen blocking the doorway. The mother and daughter are fully domesticated in the enclosed room. In another painting, *The Governess* (cat. 17), also engraved by Lépicié (cat. P19, fig. 28), Chardin

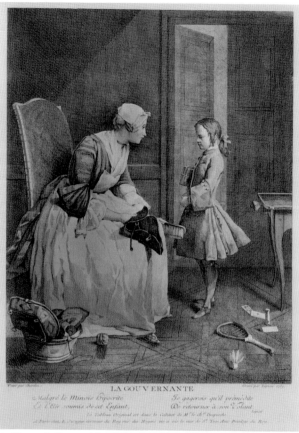

28. François Bernard Lépicié after Chardin, *The Governess*, 1739, engraving, cat. P19.

depicted a male pupil and his governess; here, the door in the background is open, and the child is free to depart and is prepared to do so. As with *The Diligent Mother*, Lépicié's poem appended to *The Governess* reverts to traditional allusions about moral character in the assertion of a child's selfish nature over the positive interaction with a teacher: "His pretty face dissembles well. / Obedience in all but name, / But I will bet his thoughts do dwell / On when he can resume his game."[35] In contrast to the verses attached to *The Diligent Mother*, this poem deems it acceptable for little boys to be mischievous and independent.[36]

Lépicié's engraving thus presents a critique of Chardin's domestic subject in the substitution of the painter's progressive views on children's instruction with more-traditional values about discipline. Chardin had depicted the warm relationship between a mother and her daughter in *The Diligent Mother* as symbiotic, quiet, and absorbed; the child would be nurtured and gently guided through what the "professeur" termed "lovable childhood," an Enlightenment concept. Lépicié's alterations to the image and his appended verses reflect pre-Enlightenment beliefs about the sinful nature of little girls, who must be constrained to preserve an orderly society. Print editors and engravers evidently believed that consumers would prefer traditional, cau-

tionary messages about gender and behavior, and consequently reframed these images according to the more familiar context of the moralizing print. Two and a half centuries later, we try to understand the "true" meaning of Chardin's paintings, but we must be aware that competing interpretations existed in the artist's own day and were conditioned by other visual and literary traditions.

THE REPRODUCTIVE PRINT AS THE PAINTER'S "ETERNAL LIFE": WATTEAU, BOUCHER, AND THE "ENGRAVED CATALOGUE RAISONNÉ"

Another example of how appended texts might recast an artist's oeuvre—and be used to enhance its commercial value—is found in the reproductive prints after the paintings and drawings of Jean-Antoine Watteau (1684–1721). Pierre Aveline's masterful engraving after Watteau's *Gersaint's Shopsign* (cat. P2, fig. 29) depicts fashionable Parisians visiting an art dealer's gallery (Bosse's *Gallery in a Palace* is a distant memory). The lines accompanying the print pay homage to Watteau, stating that, had he lived beyond the age of thirty-seven, the painter would certainly have surpassed the great masters whose works are displayed on the shop's walls.[37] As such, the verses are addressed to potential collectors, affirming Watteau's artistic status, but they do not interpret this particular painting.

The text for Aveline's print of *Gersaint's Shopsign* must have been composed by Jean de Jullienne, the print's publisher and the painting's owner. Jullienne, director of the Gobelins tapestry works and one of four inheritors of Watteau's estate when the painter died in

1721, instigated a project to make reproductive engravings after all of Watteau's known works. The publisher's prospectus of 1734 announced that Jullienne's purpose was to honor his beloved friend. Marianne Roland Michel has noted, however, that Jullienne owned many of Watteau's paintings at the time they were engraved and that, in general, the prints reproduced only the works available for purchase.[38] The verses thus served to promote the artist's reputation among print collectors but also among potential buyers for the painted originals. At the same time, Jullienne's engraved series, which Roland Michel has appropriately called a "tomb of Watteau" in the tradition of a memorial to the deceased artist, exemplifies Voltaire's assertion that the multiplied reproductive print offered "eternal life" to painters long after their deaths.

The *Recueil* Jullienne, as the engraving effort is generally known, and the earlier *Figures de Différents Caractères* series after Watteau's drawing oeuvre, constituted two of the major publishing enterprises of the first half of the eighteenth century. Around five hundred prints after Watteau's paintings and drawings were produced in four volumes between 1726 and 1735. Many printmakers contributed to the effort, including the young François Boucher, for whom the engraving project served as a "school" for rococo imagery and style.[39] Verse inscriptions, some signed by known minor poets, appeared on about forty prints.[40] Given that this was a posthumous project, these could not have reflected Watteau's intentions. Some prints have titles inscribed in both French and Latin. This has been explained as an effort by Jullienne to elevate the status of Watteau's genre subjects—to make them more "literary"—as well

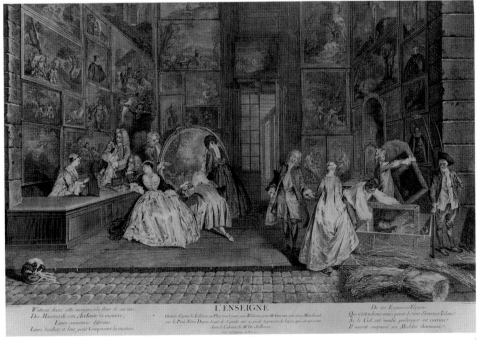

29. Pierre Alexandre Aveline after Watteau, *Gersaint's Shopsign*, c. 1732, engraving and etching, cat. P2.

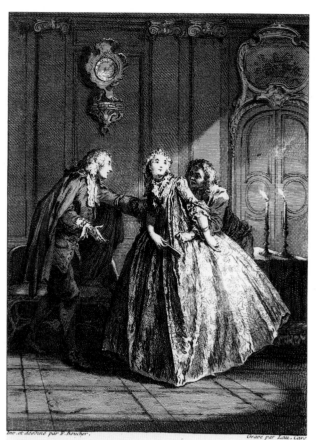

LE TARTUFFE
ou L'imposteur.

30. Laurent Cars after Boucher, *Le Tartuffe*, from *The Works of Molière*, 1734, etching and engraving, from the copy in the Rare Book Collection, Wilson Library, University of North Carolina at Chapel Hill.

as a translation for foreign buyers who might not read French.[41]

Jullienne's volumes are documented throughout the century in the collections of various dealers and private owners. Given the sheer number of these prints sold as a set, they did not fetch high prices at first—100 *livres* at the sale of Watteau's friend Antoine de La Roque in 1745, but then 199 *livres* at the Clairambault sale ten years later. Jullienne's venture was clearly not for profit; Roland Michel has stated that he experienced a financial loss.[42] The dealer François Chereau, who had a successful international trade that included Austria, Italy, Belgium, and the United States,[43] noted in his 1770 catalogue that prices for Watteau's individual prints were between fifteen *sols* for the smaller works and six *livres* for the larger items,[44] which is comparable to prices for other artists' genre prints. For example, prints after Chardin's subjects of domestic scenes and children, produced until 1761, cost one *livre* ten *sols* each, whereas the print of his *Bird-Song Organ* (see cat. 19) cost three *livres*. Boucher's prints likewise cost up to three *livres* into the 1780s.[45]

François Boucher could easily have observed first-hand how an artist's reputation could be enhanced through the reproductive print, given that he was responsible for etching more than a hundred of Watteau's drawings in Jullienne's *Recueil*. Boucher had been involved with the print industry from the beginning of his career. From 1729 to 1733 he created some of the finest book illustrations of the century for a publication of Molière's plays (fig. 30).[46] Although Molière's subject is seventeenth-century theatrical literature, Boucher's designs are set in contemporary rococo interiors and gardens with his characters wearing current fashions, acting in an up-to-date comedy of manners.

Reproductive engravings after Boucher's paintings (for example, *The Milliner* [cat. 13]) were quite popular. So too were prints based on his drawings of rustic scenes, children, young lovers, and street vendors. Writers such as Denis Diderot expressed a deep appreciation for original drawings, seeing them as the embodiment of an artist's spontaneity and creative genius. In the second half of the eighteenth century artists' drawings and sketches were highly collectible; it is ironic that reproductive prints of drawings, particularly those by Boucher, also became fashionable. New printmaking techniques such as "crayon manner," as seen in Gilles Demarteau's *The German Dance* (cat. P8; see fig. 81) and Gilles-Antoine Demarteau's *Mother and Child* (cat. P9), were developed in the 1750s; they successfully reproduced Boucher's chalk sketches. Crayon manner employed the use of spike-headed tools such as the *mattoir* and the roulette that were pressed or rolled against a prepared etching ground. When the plate was printed, the result gave the illusion of a grainy chalk stroke against rough paper. The number of prints made after Boucher's compositions is extraordinary. More than sixteen hundred subjects—a large proportion of which are genre themes—are catalogued in the Edmond de Rothschild collection in Paris.[47] Boucher's work was still being engraved in 1785, fifteen years after he had died,[48] which is a testament to how prints could perpetuate an artist's name.

OFFICIAL TASTE VERSUS MARKET SUCCESS: GREUZE, FRAGONARD, AND THE FRENCH ACADEMY

The reproductive print market certainly offered an artist the possibility of greater glory, but there was also a reasonable opportunity for financial gain. As public interest in art grew throughout the eighteenth century, paralleled by increased attendance at the academy's biennial Salon exhibitions, there was correspondingly

tremendous growth in the print market.[49] Although print production required an initial investment, financial return could be substantial. Jean-Baptiste Greuze, for example, claimed to have made more than three hundred thousand *livres* during his lifetime from the sale of prints after his paintings.[50]

Greuze's engravings fetched among the highest prices of the century for individual engravings—sixteen *livres* for *The Village Bride*; thirty-six *livres* for *Twelfth Night Cake*.[51] Given that print prices were generally much lower (averaging three to six *livres*) Greuze and his engravers were clearly targeting a luxury market and testing the limits of print industry conventions. Indeed, surviving documents reveal that Greuze was more closely involved in the supervision of the printmaking process, maintaining absolute editorial and financial control, than were most painters.[52] Most other artists sold their designs to a printmaker or a print editor who handled all aspects of the project.[53] Greuze, by contrast, stipulated in his contracts that he would be able to correct the printmaker's design during production and would receive 50 percent of the profits.[54] He earned a fortune through the sale of his engravings, as revealed in documents from his divorce proceedings; he accused his wife of embezzling much of the profits.[55]

Greuze's *Household Peace* (cat. P22; fig. 31) was based on a drawing that the artist had designed in 1766 for Jean-Georges Wille, who headed one of the most prominent print workshops in the second half of the eighteenth century. Wille had two of his assistants, the young Jean-Michel Moreau le Jeune, who would later achieve great renown in his own right, and Pierre-Charles Ingouf, prepare the plate for the final print. Wille's journal entry for August 2, 1766, documented the production: "I have given to M. Ingouf the plate which M. Moreau etched for me after a drawing of M. Greuze, and which [M. Ingouf] will engrave after it is retouched by M. Greuze, because the original drawing is no longer in Paris, but in Zurich." Nine months later, on May 18, 1767, the finished print was announced in the *Avant-Coureur*.[56] Greuze's subject combined high artistry with new ideas about family life, which had been popularized by Jean-Jacques Rousseau. Unlike Chardin, who rarely depicted adult men, Greuze emphasized the father of the family, placed at the apex of a pyramidal composition. Caressed by his wife, he smiles proudly at the baby sleeping in a crib. Greuze created a subtle, interlocking arrangement of the three figures, reinforced by the gendered emotional responses of the man and woman to establish the theme of domestic bliss. Such expressive artistic devices, traditionally employed by history painters, are here used

with great effect for a sentimental subject that would clearly resonate with the public.

Greuze's success with genre subjects and his personal involvement in the print market present an interesting case for a discussion on the divergence of public and official taste. His *Village Bride* (see fig. 5) received such acclaim at the Salon of 1761 that Diderot and Grimm called for it to be engraved for the public's pleasure. In 1767 he engaged Jean-Jacques Flipart, one of the reproductive engravers he used most often, to produce the plate, and announced that it would be part of a series on the stages of life, which would also include prints after his paintings of *Filial Piety* (see fig. 16), *The Well-Beloved Mother* (see fig. 8), *The Spoiled Child*, and *The Death of the Father*.[57] The print of *The Village Bride* itself was not published until 1770, when it was advertised at the relatively high price of sixteen *livres*. Flipart exhibited it at the Salon of 1771.[58]

The publication of *The Village Bride* may have been delayed by the humiliating failure Greuze had sustained at the Salon of 1769, when he submitted his long-delayed acceptance painting, *Septimius Severus Reproaching Caracalla* (see fig. 17). He had expected to be designated as a history painter, with all its attendant honors and privileges, but the academy instead admitted him at the lower rank of genre painter.[59] Thereafter

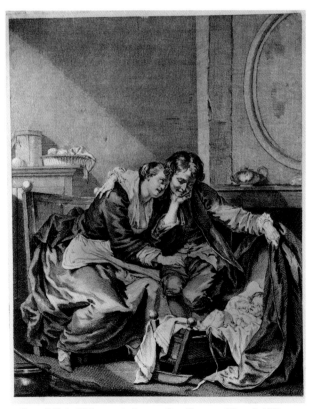

31. Jean-Michel Moreau le Jeune after Greuze, *Household Peace*, 1766, engraving, cat. P22.

ANNE L. SCHRODER

32. Jean-Honoré Fragonard, *The Armoire,* 1778, etching, cat. P11.

L'ARMOIRE

he refused to exhibit his paintings at the Salon until 1800, preferring to display them at his Louvre studio.[60] Nevertheless, some of Greuze's most famous subjects date from the 1770s and 1780s, including *The Ungrateful Son, The Punished Son* (see figs. 18 and 19), and *The Broken Pitcher.* His engravers, however, continued to show their reproductive prints at the Salons, where they were seen by the general art public, although there could be a delay of a year or more after a new painting had been completed. Prints were not given a prominent space at the Salon exhibitions.

Greuze's decision not to show his paintings at the Salon meant that he had to develop new strategies to attract public attention. Having his works engraved provided him with an opportunity to promote his sentimental and moralizing subjects directly to the public, bypassing the academic system. He wrote letters to the *Mercure de France* and the *Journal de Paris* describing his new works.[61] The *Mercure* article announcing the print after his *The Village Bride* and praising its effect was extraordinarily long, extending over three pages.[62] Greuze's signing his name to such examples of bold self-promotion surely must have piqued the academy, which disdained commerce. Official criticism of Greuze's prints was often negative, even during the years before his break with the academy. Diderot, for example, wrote in his *Salon of 1767* that the engraved lines of Greuze's *Filial Piety,* pendant to *The Village Bride,* were "dry, hard and black . . . [with] nothing of the effect of the painting."[63]

Despite the official criticism, prints after Greuze's works were cited more often in estate inventories of upper-middle-class private collections during the second half of the century than were those of other artists. They accounted for 6 percent of all framed engravings, which is remarkable for a single artist. That they were framed indicates that these prints were displayed in homes. The two most often listed were Flipart's *The Village Bride* and *Filial Piety,*[64] even though the latter had been severely criticized by Diderot. Pierre Casselle's study of the print dealer's register kept by Siméon-Charles Vallée from 1787 to 1789 records strong sales of the print after *A Widow and Her Curate,* produced in 1786. Vallée's register is a unique document, allowing us to determine the names, social status, and purchases of one dealer's clients on the eve of the Revolution.[65] Greuze's success with Vallée's clients affirms that the print audience embraced different aesthetic criteria than did the academy and its official arbiters of taste.

Another painter who broke with the academy and yet achieved great success outside its domain, especially through the print market, was Jean-Honoré Fragonard. Although Fragonard himself refused to participate directly in the Salons after 1767, his engravers regularly exhibited reproductive work after his paintings, often receiving favorable reviews. For example, Nicolas De Launay's *The Good Mother* was shown at the Salon of 1777, where Bachaumont admired the printmaker's ability to emulate the painter's distinctive brushwork: "One

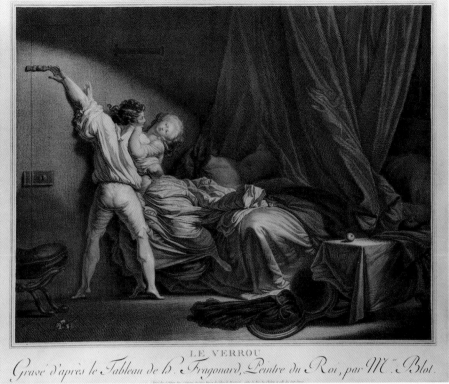

LE VERROU

Gravé d'après le Tableau de h.ˀ Fragonard, Peintre du Roi, par Mˀ. Blot.

finds an execution full of softness in his *Good Mother* after Fragonard."[66] Advertisements for the sale of these same prints, appearing in the *Mercure*, the *Journal de Paris*, the *Gazette de France*, and other journals, were timed to follow the exhibitions to stimulate sales and promote the prints to as broad an audience as possible. *The Good Mother* was listed in three different periodicals just weeks after the Salon closed.[67]

Fragonard was himself an accomplished etcher. This technique, which complemented his skills as a draftsman, was well suited to painters and other amateur printmakers. Etching, unlike engraving, did not require advanced metalworking ability, and it allowed the practitioner to draw a design directly onto a soft ground with a needle. Georges Wildenstein catalogued twenty-five etchings by Fragonard, along with five others made in some degree of collaboration with his sister-in-law and pupil Marguerite Gérard.[68]

Fragonard's etching *The Armoire* (cat. P11, fig. 32), dated 1778, was his largest and most complex effort. It is a tour de force in its subtle modulation of hatchings and cross-hatchings, rendering the effect of splashed sunlight across the four main figures. The scene depicts the discovery by two adults of an adolescent tryst. The enraged man and woman, faces glowering sternly, have thrown open the door to an armoire, exposing a sheepish young man hidden inside. To the left, a young girl sobs into her apron, knowing she will be severely punished. In the shadowed background to the right is the unmade bed. Fragonard has employed the type of emo-

tionalized facial expressions he learned in his youth when he studied to be a history painter and which he so superbly demonstrated in his academy reception piece, the *Coresus and Callirhoë*. Here, however, the scene is humorous rather than tragic. Given Fragonard's penchant for appropriating and transforming other painters' subjects into his own witty re-creations, *The Armoire* may reflect Fragonard's comic recasting of Greuze's more melodramatic and sentimental genre themes, such as *The Neapolitan Gesture* (cat. 27), *The Broken Eggs* (see fig. 59), and *The Father's Curse* (see figs. 18 and 19), the first two of which had already been successful in the print market. In *The Bolt* of about 1778,[69] engraved in 1784 by Blot (cat. P4, fig. 33), Fragonard likewise fused melodrama with wit in what is a variation on his popular "useless resistance" theme. Here a woman struggles—but not too hard—to stop her lover from locking the bedroom door.

The analysis of an artist's presence in the print market can shed light on his or her reception by the art-buying public. As in the case of Greuze, such information is especially useful given the strong biases and self-serving agenda of much official Salon criticism. Fragonard, for example, is widely believed to have fallen out of fashion after 1780,[70] and yet the success of prints after his work suggests otherwise. At a time when Jacques-Louis David and neoclassicism had a stronghold on painting style at the academy, genre subjects, such as those by Fragonard, continued to flourish in the print market.

ANNE L. SCHRODER | 79

Advertisements for engravings after Fragonard's genre paintings began to appear regularly in 1777, although earlier reproductive prints had been published sporadically since 1760.[71] For the six years from 1777 through 1782 there were five announcements in the *Mercure* for engravings after his work. For the ten years between 1783 and 1792, the period during which his reputation was supposedly in decline, the frequency of listings only intensified, with seventeen new prints advertised and seven other engravings cited in reference to other subjects.[72]

Fragonard was, for example, the featured artist for Nicolas De Launay, one of the most successful reproductive engravers in the last quarter of the century. De Launay specialized in linking previously unrelated works by different artists under a general theme. Between 1777 and 1786 he produced a series on the family—always a popular subject—with eight works after Fragonard, Le Prince, Aubry, and Sigmund Freudenberg.[73] Although the original paintings had little in common with each other beyond domestic genre, De Launay's intention was undoubtedly to create a rubric to entice buyers to acquire all eight prints. This is comparable to the strategy used by Chardin's engravers to reframe the artist's work according to the familiar context of the moralizing print, already well established in the print trade. Many of the paintings De Launay reproduced in his series, particularly those by Fragonard, had been painted at least ten years earlier. Nevertheless, as with other artists such as Watteau, Boucher, and even Chardin, reproductive prints represented an opportunity to disseminate an artist's corpus retrospectively to a broad audience and to transmit his or her accomplishments to posterity. Indeed, artists were concerned with their public reputations as much as their private clientele, if not their academic standing.

To enhance the cohesion of his family series, De Launay gave each work a similar border and sold them at attractive prices, three *livres* for each print. Individual works by the same artists often sold for more. De Launay's prints after Aubry's *Farewell to the Nurse* (see cat. 37) and Fragonard's *The Good Mother* sold for six *livres*. His 1789 price sheet listed Fragonard's *The Swing* (cat. P15) at nine *livres*,[74] whereas *The First Lesson of Fraternal Friendship* after Aubry cost sixteen *livres*.[75] The latter works seem to have been in high demand and were considered luxury items. Fragonard likewise fared particularly well among Vallée's clients in the late 1780s. Recurrent listings appeared in his register for sales of *The Bolt, The Fountain of Love, The Vow of Love, The Good Mother,* and *The Souvenir.* The buyers for these works were a diverse economic and social group, and included an *abbé,* a notary's clerk, an actor, a painter of miniatures, a count, a baron, and a baroness.[76]

Fragonard's presence in the print market was consistent throughout the 1780s and into the 1790s, despite the turbulence of the French economy in the final years of the ancien régime and during the Revolution. There were only fifty-two prints advertised in 1791, but De Launay listed two new reproductive engravings after Fragonard's paintings, *The Little Preacher* and *Education Is Everything,*[77] associating them with *The Joys of Motherhood* and *Say Please.*[78] The latter had just been exhibited at the Salon.[79] The *Journal de Paris* advertised two more prints after Fragonard's paintings that same year, one of which was for Antoine-Louis Romanet's engraving after a genre subject, *The Mother of the Family;* Fragonard's name was also mentioned in two additional announcements.[80]

The year 1792 was a difficult year for the print industry; sales were very low.[81] Pierre Casselle has demonstrated that trade with regions outside Paris had greatly diminished and the general economy was seriously weakened. Print publishing, a speculative venture requiring a large initial investment for labor and materials, was seriously affected. Many businesses went bankrupt that year.[82] The overall number of advertisements in the *Mercure* was reduced to just twelve listings for new prints. Two of these, however, were for engravings involving Fragonard's paintings: Maurice Blot's reproduction of *The Contract,* marketed as a pendant to *The Bolt,* and Géraud Vidal's engraving after a collaborative effort between Fragonard and his sister-in-law, Marguerite Gérard, for *The Beloved Child* (see fig. 71).[83] Indeed, the prints after Fragonard and Gérard were the only genre subjects advertised that year in the *Mercure*; they sold for nine and twelve *livres* respectively.[84] The other ten engravings that were announced in 1792 were seven portraits, one map, one historical event, and one allegory, with prices between two and six *livres*.[85]

Greuze and Fragonard successfully established reputations outside the academy by turning to the print market. Although both had been judged harshly in official circles for their commercial interests, and in Fragonard's case for having rejected a career as a history painter, they both appealed directly to a growing audience for sentimental genre subjects. Greuze's financial arrangements are known through the numerous contracts and notarial records that have survived, but almost no documentation exists for Fragonard and his engravers. Nevertheless, the number of real estate purchases and financial investments he made in the 1780s, 1790s, and beyond suggests that he greatly benefited from the success of his prints.

Original Print Production: Debucourt and Moreau le Jeune

The genre print market did not consist only of reproductions after celebrated paintings. There were also many successful prints that featured original subjects produced by engravers and etchers who designed their own work, among them some of the best-known printmakers of the century. Charles-Nicolas Cochin *fils* and Augustin de Saint-Aubin were prolific designers as well as etchers. Gabriel de Saint-Aubin, Jean-Michel Moreau le Jeune, and Philibert-Louis Debucourt had trained as painters, but are best known for their print work. Debucourt is one of a number of printmakers who achieved recognition in color printing at the end of the century. Among others, Jean-François Janinet specialized in color reproductive engravings after Fragonard, Lavreince, and Hubert Robert, and the Demarteaus used color chalk-manner etching and engraving to imitate the drawings of Boucher. Debucourt used combinations of etching, engraving, and aquatint in multiple plates with different inkings to suggest the soft washes of watercolor for his own designs.[86]

Debucourt made prints that delighted in the fashions and leisure pastimes of Parisian society. His subjects ranged from the sentimental to the domestic to the clever, depicting both family and libertine themes. Charles-Siméon Vallée sold more prints by Debucourt than by any other artist during the years 1787 to 1789. Four prints appeared in one year alone: *The Minuet of the Bride* (cat. P7, fig. 34); *Scaling the Wall, or Morning Goodbyes*; *Good and Bad Luck, or The Broken Pitcher*; and *The Compliment, or New Year's Morning* (cat. P6a, fig. 35). Buyers included Imbert, editor of the *Mercure*, two counts, a baron, an *abbé*, a comedian, a bookseller, a jeweler, a police inspector, a cashier, and a fabric-dyer.[87]

The Minuet of the Bride, a print combining etching and engraving printed in color using five plates, is a festive wedding dance, with the young bride dancing with an older, heavyset, bewigged curate.[88] *The Compliment, or New Year's Morning*, employing aquatint and etching in color, was the most popular of Debucourt's prints sold by Vallée. Dedicated to the "fathers of the world," it presents a young couple taking their two small children to visit their grandparents. Debucourt paid homage to the sentimental genre tradition of Greuze: on the walls of the grandparents' living room are framed prints of Greuze's *Filial Piety* and *The Well-Beloved Mother*.[89]

Debucourt's *The Casement* of 1791 (figs. 36 and 37) is especially intriguing because it exists in two states, revealing that the artist changed an amorous subject into a sentimental family scene. The first state, a proof be-

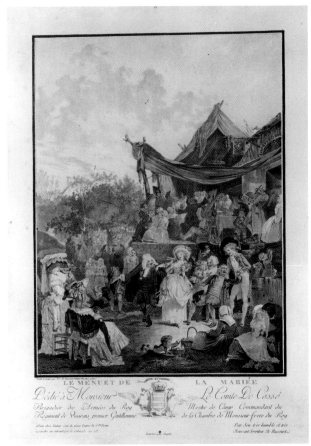

34. Philibert-Louis Debucourt, *The Minuet of the Bride*, 1786, color etching and engraving, cat. P7.

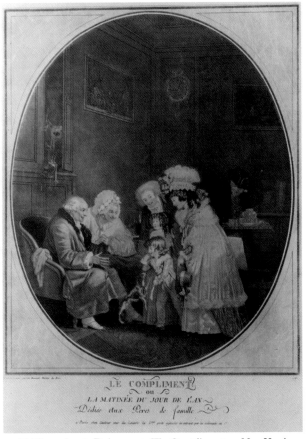

35. Philibert-Louis Debucourt, *The Compliment, or New Year's Morning*, 1787, color aquatint and etching, cat. P6a.

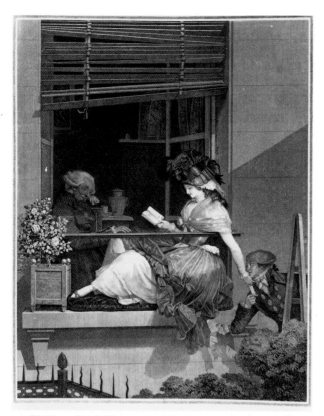

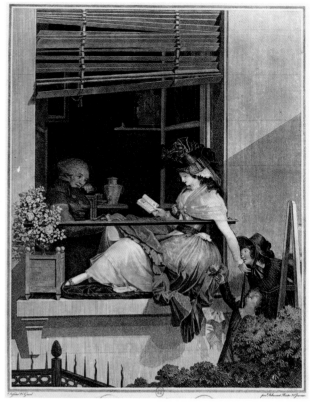

36. Philibert-Louis Debucourt, *The Casement*, first state, color etching, Cabinet des Estampes, Bibliothèque Nationale, Paris.

37. Philibert-Louis Debucourt, *The Casement*, second state, color etching, Cabinet des Estampes, Bibliothèque Nationale, Paris.

fore letters, shows a young woman seated on a windowsill reading aloud a book entitled *L'Art de rendre les femmes fidelles* (*The Art of Rendering Wives Faithful*). Inside the room her elderly husband sits listening to her, his hand on her knee. Unseen by him, but clearly visible to the spectator, is a young man outside the window on a ladder. He kisses the wife's hand as she discreetly passes to him what is presumably a love letter. In the second state, which was published, the young gallant has been eliminated and replaced by two young children who have climbed up the ladder to kiss their mother's hand and joyously present her with a rose.[90] The husband inside the room has been made more youthful with a loving look toward his wife. The title of the woman's book has been struck to render it illegible. Although "gallant" subjects continued to be produced into the early 1790s, as in works by Boilly and Garnier,[91] Debucourt had apparently decided that the presence of the children might make this particular print more marketable.

Among the most ambitious series of prints in the second half of the century was the *Monument du costume physique et moral de la fin du dix-huitième siècle* by Nicolas-Edme Restif de la Bretonne, with illustrations designed by Sigmund Freudenberg and Jean-Michel Moreau le Jeune, published in three volumes. The plates in the final two volumes, by such engravers as

Baquoy, Helman, and Patas, were ostensibly intended as a record of contemporary fashion and manners. But the series was organized as an unfolding narrative, depicting the lives and daily activities of a young wife and a young man pursuing their respective family and social routines. Set in an apparent chronology, the prints addressed the young woman's role as a wife and new mother and the man's life as a bachelor (cats. P23a–d; see fig. 85). As a reflection of the customs and values of the French upper middle class, the engravings have a vitality and social relevance far beyond the costume plates made by Bonnart and Watteau at the beginning of the century.[92]

Publishing Trends and Collecting Practices for Genre Prints in Eighteenth-Century France

The addition of popular verses, the linking of print announcements to exhibitions, the creation of engraved series, and the use of color printing and new techniques such as aquatint and crayon manner were only a few of the methods developed to attract buyers to the print market. Newspaper advertisements often tried to appeal to the potential buyer's vanity as a "sensitive" person with good taste. Generally such announcements

emphasized subject content, the artist's reputation, and even how the print might be displayed or used, perhaps inserted in a book or presented to a lady on her birthday.[93]

Collectors who bought prints stored them in boxes and portfolios or framed them for display in the home. Studies by Pierre Casselle, Olivier Bonfait, and Jean Chatelus on estate inventories throughout the century reveal how different social groups displayed their artworks and what subjects they preferred. One conclusion is evident: despite the relatively low cost of prints, they were not collected by the lower classes. Chatelus's research on the works of art (including prints) owned by merchants and artisans from 1726 to 1759 shows a strong preference for portraits and religious subjects, the latter presumably for devotional use. Genre subjects accounted for only 3 percent of merchants' and artisans' collections before 1760.[94]

Olivier Bonfait's study of the collecting habits of *parlementaires* throughout the entire eighteenth century indicates that prints and pastels were hung on the walls only after about 1750, particularly in bedrooms and reception rooms (as seen with Debucourt).[95] Indeed, the most intense market for genre prints did not begin until the second half of the century. Pierre Casselle has demonstrated that 30 percent of all prints exhibited at the Salon between 1751 and 1789 were of genre subjects, which corresponds with data that genre themes represented 36 percent of all print announcements in the *Mercure* between 1750 and 1790.[96] Finally, Casselle's study of Vallée's sales records indicates that in the final years before the Revolution, 50 percent of the print dealer's sales were for genre themes. His general clientele for all print subjects was both middle and upper class, with 29 percent nobility, 25 percent skilled artisans and merchants, and 15 percent clergy.[97]

Genre prints had wide distribution and appeal throughout the eighteenth century. Nevertheless, the output of genre prints began to decline after 1780. Casselle has put the peak of the genre print market as overlapping with the period in which Greuze was dominant—1765 to 1780.[98] I have studied the total number of print advertisements in the *Mercure* for this period as well as those for genre subjects. Both numbers decline during the 1780s. In 1785 there were 122 total listings, slightly more than half of which were for genre subjects. Of the 55 print listings in 1790, 13 were of genre themes. In 1795 the Terror had seriously affected the art print market, and the total number of prints advertised had fallen to five, with two being of genre themes. The category that remained strong during this time was portraiture, particularly of revolutionary heroes.

Many of the genre prints advertised in the journals, exhibited at the Salons, and sold by art dealers in the eighteenth century were fashionable luxury items. This market was seriously affected by the Revolution. The new interest in prints featuring portraits of famous individuals, recent political events, battle scenes, and even maps shifted the focus of contemporary issues away from the domestic realm to the national arena. Genre prints continued to be produced, but in the face of the dramatic political situation, they lost their novelty as prized collectibles.

Genre prints had flourished in French art long before scenes of everyday life became fashionable in paintings. Early eighteenth-century artists such as Watteau, Lancret, and Chardin borrowed from the existing print tradition in developing new themes reflecting contemporary life. However, the print market had a different purpose and audience than did painting. Indeed, reproductive engravings often served as a critique of painting, recasting an artist's work into a format that might be more familiar and appealing to a print audience. Painters nevertheless realized the advantages of having their works engraved; prints could give them wider recognition, even "eternal life," as Voltaire suggested. Artists such as Greuze and Fragonard, who operated outside the official protocols of the academy, found that commissioning prints after their paintings helped advertise their work and kept them in the public eye.

Throughout the eighteenth century, even during the Revolution, moralizing subjects coexisted with erotic themes; one did not supplant the other. Studies of collecting practices demonstrate that, despite their appealing themes and affordable prices, genre prints were not bought by the poor or lower middle class. Rather, the audience for subjects of everyday life was largely members of the bourgeoisie and aristocracy. For the most part, these were fashionable collectors who, in Mariette's words, enjoyed "seeing the events which occur daily in their own homes and [did] not hesitate to give these preference over more sophisticated subjects."

1. Voltaire, "Le Temple du goût," in *Mélanges* (Dijon, 1965), 1363, quoted by George Levitine, "French Eighteenth-Century Printmaking in Search of Cultural Association," *Regency to Empire: French Printmaking, 1715–1814,* ed. Victor I. Carlson and John W. Ittman, exh. cat. (Baltimore and Minneapolis, 1984–85), 13–14.

2. Carl Becker, *The Heavenly City of the Eighteenth-Century Philosophers* (New Haven, 1932), 119–68.

3. "Les tableaux sont destinés à périr. . . . C'est à la gravure à sauver ce qui peut en être conservé" (Denis Diderot, *Salons,* ed. Jean Seznec and Jean Adhémar [Oxford, 1979], 2:227).

4. Pierre-Jean Mariette, *Abecedario,* ed. P. de Chennevières and A. de

Montaiglon (Paris, 1851–53), 1:359; translation from Marianne Roland Michel, *Chardin* (New York, 1996), 238.

5. Pierre Casselle, *Le Commerce des estampes à Paris dans la seconde moitié du dix-huitième siècle* (Paris, 1976), 170–71.

6. François Courboin, *L'Estampe française: Graveurs et marchands* (Brussels, 1914), 95–98.

7. Marianne Grivel, "Printmakers in Sixteenth-Century France," in *The French Renaissance in Prints from the Bibliothèque Nationale de France*, exh. cat. (Los Angeles, 1994), 36.

8. Courboin, *L'Estampe française*, 95–98.

9. See, for example, Denis Diderot, *Salon de 1763* (Oxford, 1975), 200, in which he describes the engraver as a "prosateur" who renders poetry into another language.

10. Michel Melot, *Prints: History of an Art* (New York, 1981), 62–63.

11. Alain Mérot, *French Painting in the Seventeenth Century*, trans. Caroline Beamish (New Haven, 1995), 159; Oliver Banks, *Watteau and the North: Studies in the Dutch and Flemish Baroque Influence on French Rococo Painting* (Ph.D. diss., Princeton University, 1977), 18.

12. See *From Mannerism to Classicism: Printmaking in France, 1600–1660*, ed. Alvin L. Clark, Jr., exh. cat. (New Haven, 1987), 56, 58.

13. The verses read (in the original French with its ancient spellings): "Quittant l'orgueilleuse insolence, / Qui te vient de ton opulence, / Et de tes mouvemens pervers; / Aux Pauvres cesse d'estre chiche; / Toy qui dans ces Tableaux divers, / Vois l'Histoire du mauvais Riche. // Sa Gourmandise insupportable, / Dans les Desbauches de la Table, / Luy fait epuiser ses Thresors; / Des meilleurs mets il se degouste; / Et pourveu qu'il traitte son Corps, / Tout luy plaist et rien ne luy couste. // Sependant le pauvre LAZARE / A la porte de ce Barbare, / Tremble de froid, et meurt de faim; / Il se mocque de sa misere; / Et la pleinte qu'il fait en vain, / L'offence et le met en colere. // Au lieu que sa voix languissante, / Dans la nécessité pressante, / Luy devroit esmouvoir le cœur; / Cet inhumain veut qu'on le chasse, / Et par une extreme rigueur, / Il ioint les coups à la menace. // O que de Riches miserables, / Aux Pauvres sont inexorables, / Dans le lux de leurs repas; / Comme leur malheur est extreme, / Tu dois ne les imiter pas, / Si tu veux t'obliger toy mesme."

14. Watteau seems to have studied the works of Jacques Callot, Abraham Bosse, Sebastien Le Clerc, and Saint-Jean. See Emile Dacier and Albert Vuaflart, *Jean de Jullienne et les graveurs de Watteau au XVIIIe Siècle* (Paris, 1922), figs. 41–52; *Regency to Empire*, cat. 1.

15. See Mary Tavener Holmes, "Nicolas Lancret and Genre Themes of the Eighteenth Century" (Ph.D. diss., New York University, 1986), chap. 2, 32–33; chap. 5, 4–5, figs. 256, 257.

16. Sean J. Taylor, "Pendants and Commercial Ploys: Formal and Informal Relationships in the Work of Nicolas Delaunay," *Zeitschrift für Kunstgeschichte* 50 (1987): 509; Linda C. Hults, *The Print in the Western World: An Introductory History* (Madison, Wisc., 1996), 287.

17. See, for example, Wayne Franits, *Paragons of Virtue: Women and Domesticity in Seventeenth-Century Dutch Art* (Cambridge, 1993).

18. Courboin, *L'Estampe française*, 130–33.

19. Emile Dacier, *La Gravure de genre et de mœurs* (Paris, 1925), 14, gives 1757 as the date of the final print after Chardin's work. Roland Michel, *Chardin*, 281, reproduces an engraving by Louis Surugue of *L'Aveugle* (*The Blind Man*) with a date of 1761, as well as two portrait prints by Louis Le Grand and Simon Charles Miger of 1760 and 1766.

20. *Mercure de France* 884 (October 1740): 2274: "Chardin, Académicien. 1. *Le Singe qui peint.* 2. *Le Singe de la Philosophie.* 3. *La Mère Laborieuse.* 4. *Le Bénédicité.* 5. *La petite Maîtresse d'Ecole.* Les Tableaux de ce Peintre sont dans une réputation constante de plaire au Public & généralement à tous le monde, aux sçavans, aux ignorans, & aux gens de tous Etats; en effet, dans les Ouvrages de cet habile Artiste, la Nature est imitée avec tant de justesse & de naïveté, que cela a fait dire à quelques Connoisseurs que le Peintre avoit trouvé, par son application, les moyens de prendre la Nature sur le fait, & d'en enlever furtivement ce qu'elle a de plus naïf & de plus piquant."

21. For a discussion on the "natural style" of Chardin, see Mary D. Sheriff, "Reflecting on Chardin," *Eighteenth Century: Theory and Interpretation* 29, no. 1 (1988): 19–45.

22. *Mercure de France* 885 (November 1740): 2513.

23. *Mercure de France* 886 (December 1740): 2709–11.

24. Anatole de Montaiglon, ed., *Procès-verbaux de l'Académie royale de peinture et de sculpture*, 10 vols. (Paris, 1875–92): 5:290; Pierre Rosenberg, *Chardin 1699–1779*, exh. cat. (Cleveland, 1979), 263.

25. *Mercure de France* 894 (October 1741): 2295–96: "M. Lepicier, Sécretaire & Historiographe de l'Académie . . . 1. La *Mère Laborieuse*, d'après M. Chardin. . . . L'Auteur de la Vie de *Rubens* a remarqué que ce fameux Peintre des Pays Bas, étoit plus heureux que quantité d'autres fameux Peintres, en ce qu'il y avoit vécu dans un siècle, où il y avoit quantité d'habiles Graveurs qui ont transmis la gloire à la Posterité, tels que Paul Ponce, Bolswert, Soutmans, &c. qui ont gravé ses plus belles Compositions. On pourroit faire ici la même remarque au sujet de M. Chardin & des autres Maîtres de l'Académie, d'après lesquels M. Lepicier exerce son Burin."

26. *Mercure de France* 886 (December 1740): 2709: "Un rien vous amuse, ma Fille, / Hier ce Feuillage étoit fait, / Je vois par chaque point d'éguille / Combien votre esprit est distrait. / Croyez-moi, fuyez la paresse, / Et goûtez cette vérité, / Que le travail & la sagesse / Valent les biens & la beauté" (translation by Pierre Rosenberg in *Chardin*).

27. *Mercure de France* 886 (December 1740): 2710–11.

28. See Ella Snoep-Reitsma, "Chardin and the Bourgeois Ideals of His Time," *Nederlands Kunsthistorisch Jaarboek* 24 (1973): 147–243, and Rosenberg, *Chardin*, catalogue entries.

29. Philip Conisbee, *Chardin* (Lewisburg, N.J., 1985) 127, 133; Norman Bryson, *Word and Image: French Painting of the Ancien Régime* (Cambridge, 1981), 113–14; Thomas E. Crow, *Painters and Public Life in Eighteenth-Century Paris* (New Haven, 1985): 137–38.

30. Dorothy Johnson, "Picturing Pedagogy: Education and the Child in the Paintings of Chardin," *Eighteenth-Century Studies* 24, no. 1 (1990): 47–68. See also Roland Michel, *Chardin*, 213.

31. Roland Michel, *Chardin*, 242.

32. Ibid., 243.

33. "Ces Filles encore petites / En leur foibles commencemens, / Par cette bonne Vieille instruites, / N'aprennent que leurs rudimens. // Quand par l'accroisement de l'âge / Se renforcera leur Esprit, / Elles en scauront davantage / De viue voix et par escrit. // Alors l'Enfant, dont l'exercice / Est de blesser et d'enflammer, / Leur apprendra sans artifice, / Qu'on scait tout en scachant aimer. // Par d'estranges metamorphoses, / Ce Tyran des affections, / Changeant leurs espines en roses, / Contentera leurs passions."

34. Jay M. Fisher, in *Regency to Empire*, has also observed Lépicié's manipulation of lighting effects in the print after Chardin's *Le Bénédicité*, published in 1744 as the pendant to *La Mère laborieuse*: "Perhaps to reinforce the narrative, Lépicié deviated from Chardin's painting by exaggerating the strength of the directional light, thereby isolating the figures from their environment. He has given great attention to details, gestures, and expressions to illustrate the theme that he put forth in his quatrain" (102).

35. "Malgré le Minois hipocrite / Et l'Air soumis de cet Enfant, / Je gagerois qu'il prémédite / De retourner à son Volant." The English translation is quoted from Rosenberg, *Chardin*, 260.

36. Lépicié's engraving for *The Governess* makes fewer radical changes from the painting, but these include brighter highlights for the playthings on the floor, shuttlecock, racquet, and cards to draw our attention, and a brighter doorway.

37. The text reads: "Watteau, dans cette enseigne, à la fleur de ses ans, / Des Maistres de son Art Imite la manière; / Leurs caractères différens, / Leurs touches et leur goût Composent la matière; / De ces Esquisses Elegans. / Que n'attendons-nous point de tant d'heureux Talens! / Si le Ciel eut voulû prolonger sa carrière / Il auroit surpassé ses Modeles charmans."

38. Marianne Roland Michel, *Watteau: An Artist of the Eighteenth Century* (New York, 1984), 260, 265–77.

39. Victor Carlson, in *Regency to Empire*, 74.

40. Dacier and Vuaflart, *Jean de Jullienne*, 92.

41. Ibid., 94.

42. Roland Michel, *Watteau*, 267.

43. Casselle, *La Commerce des estampes*, 74.

44. Dacier and Vuaflart, *Jean de Jullienne*, 119–20, 130–32.

45. Dacier, *La Gravure de genre*, 40.

46. Per Bjurström, "Les illustrations de Boucher pour Molière," *Figura* (1959): 138–52; David P. Becker, in *Regency to Empire*, 84–85.

47. These are fully illustrated in Pierrette Jean-Richard, *L'Oeuvre gravé de François Boucher dans la collection Edmond de Rothschild* (Paris, 1978). For additional discussion of Boucher, see Dacier, *La Gravure de genre*, 14–16.

48. Dacier, *La Gravure de genre*, 14.

49. Casselle, *Le Commerce des estampes*, 74.

50. Edmond and Jules de Goncourt, *L'Art du dix-huitième siècle* (Paris, 1860), 40; Christian Michel, "La Diffusion des gravures d'après Greuze," in Ehrard and Ehrard, *Diderot et Greuze*, Actes du Colloque de Clermont-Ferrand (Clermont-Ferrand, France, 1986), 39, cautions that this figure might be exaggerated.

51. Casselle, *Le Commerce des estampes*, 67; Dacier, *La Gravure de genre*, 30.

52. F. Arquié-Bruley, "Documents notariés inédits sur Greuze," *Bulletin de la Société de l'histoire de l'art français* (1981 [1983]): 125–54.

53. Casselle, *Le Commerce des estampes*, 32–42.

54. Arquié-Bruley, "Documents notariés inédits sur Greuze," 127–28.

55. Anita Brookner, *Greuze: The Rise and Fall of an Eighteenth-Century Phenomenon* (Greenwich, Conn., 1972), 77–79.

56. *Graveurs français de la seconde moitié du XVIIIe siècle*, exh. cat. (Paris, 1985), cat. 61.

57. Michel, "La Diffusion des gravures," 42 n. 15.

58. Ibid., 40–43; Dacier, *La Gravure de genre*, 77–78.

59. Crow, *Painters and Public Life*, 163–74.

60. Michel, "La Diffusion des gravures," 40–43; Brookner, *Greuze*, 128.

61. *Journal de Paris*, no. 103 (April 13, 1781): 415–16; *Mercure de France* 1493 (April 1781): 187–88; *Journal de Paris*, no. 339 (December 5, 1786): 1412–13. For further discussion, see Michel, "La Diffusion des gravures," 46.

62. *Mercure de France* 1328 (April 1770): 187; Dacier, *La Gravure de genre*, 77–78.

63. Diderot, *Salon de 1767*, 333.

64. Casselle, *La Commerce des estampes*, 156.

65. Ibid., 171.

66. L. Petit de Bachaumont, *Mémoires secrets pour servir à l'histoire de la République des lettres en France depuis 1762 jusqu'à nos jours*, 31 vols. (London, 1777–89): "on trouve un faire dans le moêlleux dans . . . son heureuse fécondité d'après H. Fragonard" (11:58). Quoted by Pierre Rosenberg, *Fragonard*, exh. cat. (New York, 1987–88), 420.

67. *Mercure de France* 1449 (October 1777): 164; *Journal de Paris* no. 275 (October 1777): 3; *Affiches, annonces, et avis divers* (October 15, 1777): 167.

68. Georges Wildenstein, *Fragonard aquafortiste* (Paris, 1956).

69. This painting reworks the subject of an earlier drawing. See Jean-Pierre Cuzin, *Jean-Honoré Fragonard: Life and Work, Complete Catalogue of the Oil Paintings*, trans. Anthony Zielonka and Kim-Mai Mooney (New York, 1988), 179.

70. For example, see Rosenberg, *Fragonard*, 419.

71. Jacques-Firmin Beauvarlet's engravings of the Toledo Museum's *Blindman's Buff* (first state erroneously identified as Boucher, second state as Fragonard) and the Thyssen-Bornemisza collection's *The Seesaw* were the first to appear in the early 1760s. See Cuzin, *Jean-Honoré Fragonard*, 268.

72. The advertisements were: *Say Please* (by Robert De Launay) and *The Favorable Inspiration* (by Louis-Michel Halbou) in 1783; *The Bolt* (by Maurice Blot) in 1784; *The Armoire* (version engraved by De Launay, but called *The Discovered Hiding-Place*), *La Coquette Fixée*, and *The Fountain of Love* (engraved by Nicolas-François Regnault) in 1785; *The Sermon of Love* (by Jean Mathieu), *The Bolt*, and *The Victorious Lover*, along with references to *The Good Mother*, *Happy Fertility*, *Say Please*, *The Fritters*, and *The Beloved Child*, in 1786; *The Stolen Shift* in 1787 (by Guersant for Massard); *My Shirt Is on Fire*, *Ingenious Love*, and *Telemachus and Eucharis* (all by Augustin Le Grand) in 1789; *The Little Preacher* and *Education Does It All*, and references to *Happy Fertility* and *Say Please*, in 1791; and, finally, *The Contract* (by Blot) and *The Beloved Child* (by Gérard Vidal after Fragonard and Marguerite Gérard) in 1792.

73. The series included Fragonard's *L'Heureuse fécondité*, *Les Beignets*, *Dites donc s'il vous plaît*; Le Prince's *Le Bonheur du menage* and *L'Enfant chéri*; Aubry's *L'Abus de la crédulité*; and Freudenberg's *La Guide conjugale* and *La Félicité villageoise*. Each time De Launay added another print to the set, he recapitulated the list of the previously published items, undoubtedly to stimulate sales of existing prints along wih the new works. This series is analyzed by Taylor, "Pendants and Commercial Ploys," 519–27; *Mercure de France* 1619 (October 5, 1791).

74. Taylor, "Pendants and Commercial Ploys," 511.

75. Ibid., 521–22.

76. Casselle, *Le Commerce des estampes*, 170–71.

77. *Mercure de France* 1612 (March 12, 1791); see also *Journal de Paris* (January 1, 1791).

78. *Mercure de France* 1619 (October 5, 1791).

79. *Mercure de France* 1600 (March 3, 1790).

80. Regnault's engraving for *The Warrior's Dream of Love* was announced in *Journal de Paris* on April 19, 1791 as a pendant to *The Fountain of Love*; *La mère de famille* was advertised on July 25, 1791. Delaunay cited Fragonard's name when promoting his sister-in-law Marguerite Gérard's *Les Regrets mérités* on October 4, 1791.

81. Among Fragonard's circle, De Launay died that year at the age of fifty-seven.

82. Casselle, *Le Commerce des estampes*, 101–2.

83. *Mercure de France* 1623 (February 11, 1792): 60; *Mercure de France* 1626 (May 26, 1792): 103.

84. A price list of prints available from Nicolas De Launay in 1789 shows that Fragonard's prices could range from three to nine *livres*. This document is reproduced by Taylor, "Pendants and Commercial Ploys," 509. Taylor also found that at De Launay's death in 1792 the remaining stock of two prints after Lavreince was triple that of the other artists, including Fragonard (532). Presumably, Fragonard's work sold better than that of Lavreince.

85. *Mercure de France* 1622 (January 21, 1792): 84. The allegorical subject was *The Origin of Painting*, by "M. Tresca, en manière anglaise, d'après M. David-Allen."

86. *Graveurs français de la seconde moitié du XVIIIe siècle*, cats. 129–48; *Regency to Empire*, cats. 98, 99, 102, 103; Egbert Haverkamp-Begeman, ed., "Color in Prints," *Yale Art Gallery Bulletin* 27–28 (1962): 23–24.

87. Casselle, *Le Commerces des estampes*, 171.

88. *Regency to Empire*, cat. 98, illus.; *Graveurs français de la seconde moitié du XVIIIe siècle*, cat. 131.

89. *Graveurs français de la seconde moitié du XVIIIe siècle*, cat. 134, illus.

90. Maurice Fenaille, *L'Oeuvre gravé de P.-L. Debucourt (1755–1832)* (Paris, 1899), cat. 28; *Graveurs français de la seconde moitié du XVIII*

siècle, cat. 145.

91. See also Debucourt's *La Rose mal défendue* of 1791 in *Regency to Empire,* cat. 102, illus., as well as other examples in *Aimer en France, 1760–1860: Cent pièces tirées du Cabinet des Estampes de la Bibliothèque Nationale,* ed. Paul Viallaneix and Jean Ehrard, exh. cat. (Clermont-Ferrand, France, 1977).

92. *Regency to Empire,* cat. 85; *Graveurs français de la seconde moitié du XVIIe siècle,* cats. 65–83.

93. Casselle, *Le Commerce des Estampes,* 131.

94. Ibid., 163–64; Jean Chatelus, "Thèmes picturaux dans les appartements de marchands et artisans parisiens au XVIIIe siècle," *Dix-huitième siècle* (1974): 311, 315, 318–19.

95. Olivier Bonfait, "Les collections des parlementaires parisiens du XVIIIe siècle," *Revue de l'art* 73 (1986): 31.

96. Casselle, *Le Commerce des Estampes,* 120, 123. Casselle also noted that the *Mercure* advertised only what the editors believed would be of particular interest to their readers (115).

97. Ibid., 166–68.

98. Ibid., 119.

Catalogue of Paintings

Note to the Reader

The catalogue is arranged chronologically by date of execution, although works by a single artist spanning several decades are grouped together. Selected references and exhibitions in which the works are cited or have appeared are given in abbreviated form; complete citations may be found in the bibliography and list of exhibitions at the back of the book. Citations from eighteenth-century art criticism are catalogued according to the numbering systems established in the Deloynes Collection, Cabinet des Estampes, Bibliothèque Nationale, Paris (as Del.), and in Neil McWilliam, Vera Schuster, and Richard Wrigley, eds., *A Bibliography of Salon Criticism from the Ancien Régime to the Restoration, 1699–1827* (Cambridge, 1991) (as McW.).

Jean-Antoine Watteau *(Valenciennes 1684–1721 Nogent-sur-Marne)*

ittle is known about Watteau's first eighteen years in Valenciennes. After his move to Paris in 1702, he studied in the studios of Claude Gillot (1673–1722) and Claude Audran (1658–1734). He failed to win the Grand Prix in 1709 finishing second, but was enthusiastically agréé (made an associate member) at the Royal Academy three years later. During this time he painted decorative works as well as easel paintings depicting military subjects and lowlife scenes inspired by northern art. Probably around 1717–18, Watteau lived for a time in the house of the financier Pierre Crozat, whose great collection of paintings and drawings, particularly by Flemish and Venetian masters, would profoundly influence him. In 1717 Watteau was formally received into the academy with the presentation of his reception piece, Pilgrimage to the Island of Cythera *(Musée du Louvre, Paris). Having no classification in which this painting fit, the academicians created for him the new category of "painter of fêtes galantes." His work thereafter remained almost exclusively in that genre, for which he gained great renown. Near the end of his life, Watteau returned to the theatrical themes that he had studied under Gillot. After a journey to London to seek treatment for his tuberculosis, Watteau died at the age of thirty-seven. His final painting, the large* Shopsign *(Schloss Charlottenburg, Berlin), was done for his friend the art dealer Edme Gersaint. The nostalgic and dreamlike qualities of his paintings, as well as the ambitious suite of reproductive prints executed for his friend Jean de Jullienne, made Watteau one of the most influential and admired artists of the eighteenth century.*

1. The Country Dance

c. 1706–10
Oil on canvas, 19 1/2 × 23 5/8 in. (59.6 × 60.0 cm)
Indianapolis Museum of Art, gift of Mrs. Herman C. Krannert, 74.98

Provenance: Private collection, southern France; Wildenstein and Co., New York; Max Safron Galleries, New York; J. K. Lilly Collection, Indianapolis; Mr. and Mrs. Herman C. Krannert, Indianapolis; given in 1974.

Selected References: (Print by Dupin from the then-lost painting): Dargenty, 1891, ill.; Dacier and Vuaflart, 1922, no. 170; Adhémar, 1950, no. 4, pl. 3; Camesasca, 1968, no. 5, ill.; (painting): Janson and Fraser, 1980, 124–27, ill. 125; Roland Michel, 1984b, 211–12, 307, fig. 207, colorplate V; Posner, 1984, 15, 18, 20, 21, 160, ill. 16, colorplate I, 81; Vidal, 1992, 122, fig. 127.

Long known through Pierre Dupin's engraving, produced for Jean de Jullienne's *Recueil*—a compendium of prints reproducing most of the artist's oeuvre—Watteau's intriguing painting was only relatively recently brought to light. It must stand among the artist's earliest surviving works, painted after Watteau moved to Paris in 1702. The rather awkward drawing, most evident in the clumsy pose of the dancing man, and the crowding of the principal figures into the center of the composition suggest a painter still struggling to find his way. Yet the picture's less than ideal state of preservation—a common complaint with Watteau's paintings—and the possibility that the artist worked on the canvas for an extended period complicate any assessment of its precise date.[1]

The Country Dance reflects Watteau's northern heritage and his roots in Valenciennes on the Franco-Flemish border. During his first years in Paris, Watteau gravitated toward the active Flemish artist colony, where he eked out a living as a hack painter, producing quick copies of devotional paintings and northern genre works for the low end of the art market. *The Country Dance*, by contrast, represents one of the earliest surviving examples of his original work, even if it is still clearly influenced by Dutch and Flemish lowlife painters from the previous century. The theme of the country dance enjoyed a long tradition in northern genre painting, and here Watteau obviously was responding to works by such painters as Adriaen van Ostade and David Teniers. As Donald Posner adroitly observes, however, Watteau rejected the northern tendency to show peasants as boorish and crude.[2] In a forest clearing, just outside a cottage, a gaily dressed young woman and man dance to the music of an informal quartet consisting of a tambourine, musettes, and shawn (a form of bagpipe). A little girl interrupts the proceedings, as if asking to join in. In the left background, half-hidden among the trees, a man and woman embrace. The painting is already typically French in the bright coloring, the pretty faces of its figures, and the poised and calibrated attitude of the dancers. Its view of country life is an ideal one of cheerful and vivacious peasants enjoying themselves in nature.

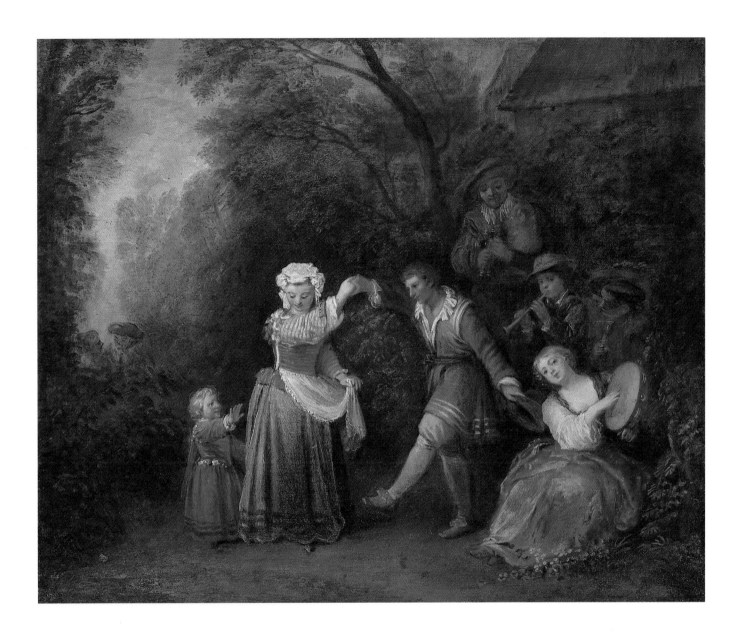

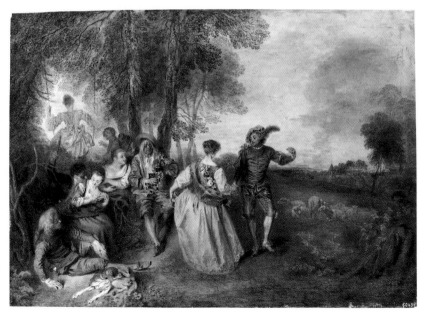

38. Antoine Watteau, *The Shepherds*, c. 1716–17, oil on canvas, Schloss Charlottenburg, Berlin.

The Country Dance contains many of the elements and characteristics for which Watteau would shortly earn his reputation. The theme of dancing, with its allusions to love and courtship, played an important role in many of Watteau's *fêtes galantes*. Although Watteau's paintings invariably merge reality and fantasy, JoLynn Edwards has demonstrated that Watteau was particularly accurate in his portrayal of contemporary dance. She has tentatively identified the peasants in this painting as performing an allemande, a turning dance in which the arms are raised as the participants circle each other (cat. P8, see fig. 81).[3] *The Country Dance* anticipates such mature masterpieces as *The Shepherds* (fig. 38), where a couple dances to the tunes of a bagpiper while lovers cavort under the shade of trees. *The Country Dance*—painted less than a decade before *The Shepherds*—is less sophisticated, with its dynamically asymmetrical composition, its brilliant coloring and light-

ing and the exquisite sense of balance and poise of the figures. Moreover, in his *fêtes galantes* Watteau wanted to find a pictorial equivalent to the highly sophisticated and self-referential social rituals of an urban elite, rather than to portray a slice of life of the peasantry. Nevertheless, in *The Country Dance* he depicted common folk with a dignity and self-possession that was altogether new to lowlife genre.[4]

1. See Janson and Fraser, 1980, 124–27; Posner, 1984, 15, 18, 20–21. Roland Michel, 1984b (211–12), suggests a later date, just after 1710.
2. Posner, 1984, 15; for a good summary of the influence of northern genre on Watteau's early works, see Banks, 1977, 106–50.
3. JoLynn Edwards, "Watteau and Dance," in Moureau and Grasselli, 1987, 219–25, fig. 3.
4. On Watteau's tendency to give these seemingly insignificant subjects a certain nobility and profundity, see Vidal, 1992, 121–30.

2. *The Conversation*

c. 1712–14
Oil on canvas, 19 3/4 × 24 in. (50.2 × 61.0 cm)
The Toledo Museum of Art, gift of Edward Dummond Libbey

Provenance: Jean de Jullienne, Paris, by 1733, until before 1756; (?) Sir Thomas Baring, London, by 1837; Sir Francis Baring, London, by 1857; Edouard Kann, Paris; his sale, Hôtel Drouot, Paris, June 8, 1895, lot 10; Sedelmeyer, Paris; Henry Heugel, Paris, before 1921; Jacques Heugel, Paris, until 1970; Heim, Paris; purchased in 1971.

Selected Exhibitions: Paris, 1925, no. P352; Amsterdam, 1926, no. 116; Paris, 1956, no. 92; Washington, Paris, and Berlin, 1984–85, 295–98, no. 23.

Selected References: Dacier and Vuaflart, 1922, no. 151; Adhémar, 1950, no. 110, pl. 55; Camesasca, 1968, no. 105, ill.; Ferré, 1972, no. B53; The Toledo Museum of Art, 1976, 166–67, pl. 194; Roland Michel, 1984b, 111, 186, 215, 266, fig. 186; Posner, 1984, 111, 145–8, 150, 239, fig. 102; Vidal, 1992, 1, 20–24, 32, 43, 46, 62, 134, 173, fig. 5, figs. 24, 25.

With its representation of aristocratic men and women gathered together in the open air, *The Conversation* stands at the beginning of Watteau's career-long fascination with the subject he invented, the *fête galante*. The far reaches of a verdant parkland provide the setting for this scene of flirtation and intimate conversation; a stone abutment topped by a large urn frames the composition at the left, while a river winds its way into the right distance. The company has come together in a clearing under an arch of trees. Two couples have already taken seats in the shade of a grove, while another has apparently just arrived at the left; they

are greeted by one of the seated couples. In the center of the clearing, a man encourages his partner to join the others. At the right, deep in shadow, two servants ready some refreshments.

As Donald Posner has observed, *The Conversation* is less a poetic combination of reality and fantasy that typifies the fully developed *fête galante* than it is a relatively accurate depiction of aristocratic manners, dress, and leisure activities.[1] This is presented in a straightforward way that conveys convincingly the pleasures of a promenade and a picnic in the country. Already in this early painting—dated by most scholars to the years 1712–14—the artist demonstrates his keen observation of pose, gesture, and bodily attitude in a marked advance from the somewhat stilted and awkward figures in *The Country Dance* (cat. 1). The landscape setting, which in mature works such as *The Perspective* (cat. 3) plays a more dynamic role in the composition, here remains merely a scenic backdrop, although Watteau has obviously taken care to paint the foliage in picturesque masses that shelter and highlight the figures in the foreground. As its title implies, the Toledo painting is in essence a representation of the art of conversation, with its gracefully linked figures shown whispering intimately, greeting each other, or—as suggested by the standing woman in the center, who gazes placidly out of the picture—encouraging the viewer to join in.[2]

It has been argued that the figures in *The Conversation* are actually portraits of the artist's friends and associates.

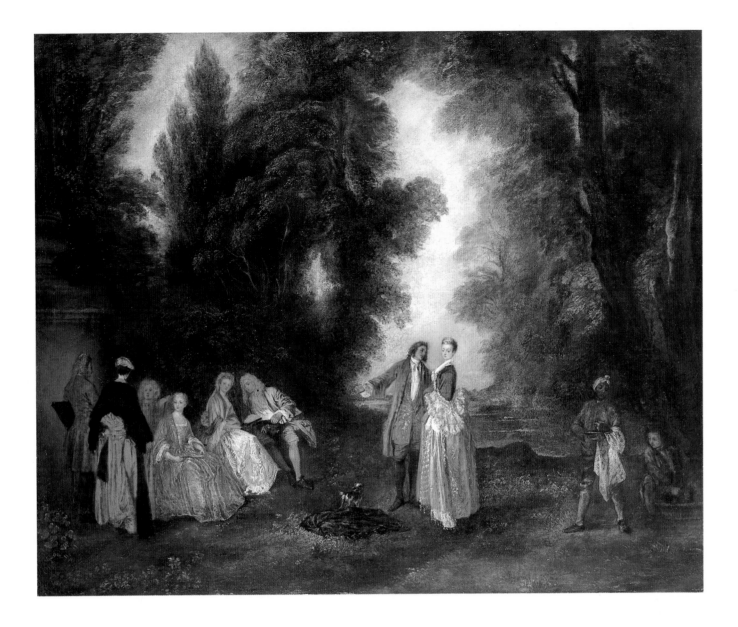

The Goncourts believed they saw Jean de Jullienne and his circle depicted here; others have claimed that the seated man inclining toward his partner is not Jullienne but the great connoisseur and patron of Watteau, Pierre Crozat; the man leaning on a crutch is perhaps Antoine de La Roque, an important collector who was wounded in battle; and the features of Watteau himself have been recognized in the man standing in the center.[3] Such identifications typify the tendency of earlier scholars to read Watteau's paintings in terms of his biography, but most recent art historians have discredited such attempts.[4] Although it is true that in *The Conversation* the figures are clearly Watteau's contemporaries, the characterizations of the faces—some of which are obscured in shadow or turned completely from the viewer—do not seem like portraits, and in fact Watteau apparently used the same model in drawings for the standing man and the seated gentleman leaning over.[5] As Mary Vidal has noted, with its interlaced groupings engaged in intimate discourse, the

picture "is about sociability and not about individual identities."[6]

The earliest provenance of *The Conversation* is uncertain. Adhémar claimed that it belonged to Crozat, but this supposition appears to be based not on documentary evidence but on her belief that, like the Boston *Perspective* (cat. 3), the scene takes place in the gardens of Crozat's estate at Montmorency.[7] In any case, by 1733 the picture, like so many of Watteau's works, was in the possession of Jean de Jullienne, at which time it was engraved by Jean-Marie Liotard for Jullienne's grand compendium of prints.

1. Posner, 1984, 145–48.
2. See the discussion by Vidal, 1992, 22–24.
3. The various scholars' identifications are usefully summarized in Ferré, 1972, 1002.
4. For recent opinion, see Rosenberg in Washington, Paris, and Berlin, 1984–85, 296–97; Posner, 1984, 145; Vidal, 1992, 21–22.
5. See Washington, Paris, and Berlin, 1984–85, 296, fig. 2.
6. Vidal, 1992, 22.
7. Adhémar, 1950, 140.

3. The Perspective

c. 1715–17
Oil on canvas, 18 3/8 × 21 3/4 in. (46.7 × 55.3 cm)
Museum of Fine Arts, Boston, Maria Antoinette Evans Fund

Provenance: M. Guenon, cabinetmaker to the king, Paris, 1729;
Daniel Saint; his sale, Paris, May 4, 1846, lot 56; bought by
Richard, fourth marquis of Hertford; given to his son, Sir
Richard Wallace; Lady Wallace; bequeathed by Lady Wallace to
Sir John Murray Scott, secretary to Sir Richard Wallace, 1903; his
sale, Christie's, London, June 27, 1913, lot 138; bought by Thomas
Agnew and Sons, London; sold to Walker Burns in 1919;
Durlacher Brothers, New York and London; purchased in 1923.

Selected Exhibitions: Toledo, Chicago, and Ottawa 1975–76, no.
119; Washington, Paris, and Berlin, 1984–85, no. 25; New York,
1990, no. 20.

Selected References: Dacier and Vuaflart, 1922, no. 172; Lindblom,
1948, 57–58, fig. 18; Adhémar, 1950, no. 111, pl. 56; Brookner, 1967,
colorplate 10; Camesasca, 1968, no. 117, colorplates IV–V; Ferré,
1972, no. B52; Roland Michel, 1984b, 160, 165, fig. 149; Posner,
1984, 40, 111, 121, 148, 150, 173, 176, fig. 105, colorplate 21; Crow,
1985, 55, fig. 16; Murphy, 1985, 298, ill.; Vidal, 1992, 27–28, 151,
fig. 34; Wine, 1992, 31–33, fig. 19; Scott, 1995, 157, 159, fig. 162.

One of the few Watteaus owned by the fourth marquis of Hertford that did not become part of Lady Wallace's bequest to England in 1897,[1] Watteau's *The Perspective* is among the artist's most intriguing paintings, a unique mix of reality and fantasy. It is the only picture in his oeuvre for which the setting may be positively identified; according to Pierre-Jean Mariette, "the background of the picture represents a view of M. Crozat's garden at Montmorency."[2] This estate, built in the late seventeenth century for the First Painter to the King, Charles Le Brun, with gardens designed by André Le Nôtre, had become the property of the banker Pierre Crozat in 1709. One of the most influential collectors and amateurs of the period, Crozat played an important role in Watteau's aesthetic development, primarily by making available to him his celebrated collection, with its masterpieces by Flemish and Venetian artists.[3]

The Boston painting ostensibly shows the view (the "perspective" of the title) from the gardens back across a reflecting pond—just visible in the middle ground—to the arched façade of Le Brun's château in the center distance. The masses of trees on either side lead the eye to this vanishing point, but Watteau modulated the strict symmetry of the composition by including a group of figures in the lower left. Dressed in elaborate costumes, they engage in conversation and music making in the shade of a bower. The sense of theatricality is enhanced by the distant façade, through which clouds and sky are visible. This detail has led some commentators to believe that the setting was Watteau's invention, possibly influenced by stage de-

sign.[4] Yet it has been demonstrated that the artist was accurate in his depiction, not only in the arrangement of the trees but also in the details of the building: the alterations made at Montmorency by Jean-Silvain Cartaud, Crozat's architect, resulted in the gutting of Le Brun's building, leaving only a freestanding façade that served as a kind of garden pavilion, just as Watteau shows us.[5]

Watteau is known to have frequented Montmorency on numerous occasions, attending the salons and concerts organized by Crozat and drawing in the extensive grounds.[6] As Alan Wintermute has recognized, the representation of nature in *The Perspective* owes much to the writings of Roger de Piles, the great theorist who was promoted by Crozat and whose ideas were certainly absorbed by Watteau.[7] De Piles advocated painting and sketching in the open air as an essential component of artistic training, and his categorization of landscape into ideal and pastoral types had a transforming effect on the development of landscape painting in France. While *The Perspective* undoubtedly was made in the studio, it bears the imprint of Watteau's open-air studies. Compared to earlier garden scenes such as *The Conversation* (cat. 2), here we see the artist handling the landscape with greater confidence and fluency, aspects that are particularly evident in the sensitive appreciation for the character of foliage, the nuances of natural light, and a more convincing integration of figures into their setting.

Yet for all its basis in reality, *The Perspective* is a fantasy, an ideal image of aristocratic leisure, here taking place in the confines of a luxuriant garden. The painting marks a turning point in Watteau's career, representing his development from a more straightforward depiction of intimate sociability—exemplified in the Toledo *Conversation* (cat. 2)—to a metaphorical representation of the Progress of Love that is at the heart of all his *fêtes galantes*. Even if, as has recently been asserted,[8] the costumes worn by the participants are indeed contemporary, and not a mixture of seventeenth- and eighteenth-century clothing, as is often claimed, the misty, dreamlike view to the distant façade and the suggestive groupings of the figures inform the viewer that the scene takes place in the realm of fantasy. According to this interpretation, most convincingly put forth by Donald Posner,[9] the three couples that have come together in the lower left of the painting enact a subtle narrative of love: the man with a beret leaning against the stone wall engages the seated woman in conversation, initiating a relationship that develops further in the couple engaged in music making; their harmony culminates in the

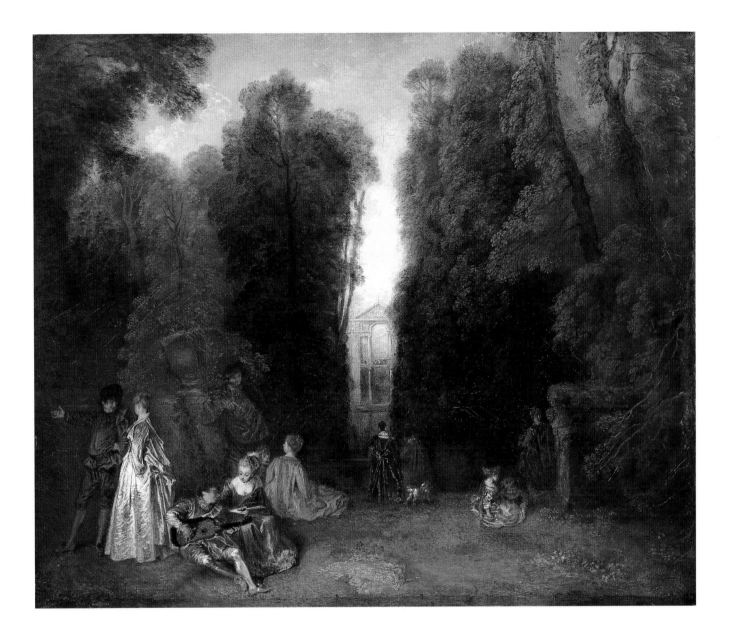

pair at the left edge, who are about to venture together into the shady grove. The intense absorption of these three couples and their quiet, measured activities are accentuated by the figures gazing across the water in the center of the composition and the two children playing innocently at the right. In this, his only "topographical" landscape, Watteau transformed Crozat's estate into an enchanted garden of love, one that mirrored—both metaphorically and in reality—the forms of leisure activity practiced by Crozat and his circle.

1. The picture was one of a group left to Sir Richard Wallace's secretary, Sir John Murray Scott (1843–1912), whose collection was sold in 1913; see Ingamells, 1989, 9, 13, 14, 389.
2. "Le fond de ce tableau représente une veue du jardin de M. Crozat à Montmorency" (P. J. Mariette, *Abécédario* [Paris, 1851–53], 6:110).
3. On Crozat, see Scott, 1973b; Posner, 1984, 118–20.
4. Roland Michel, 1984b, 160–65.
5. For a good summary of the relationship of Watteau's painting to the actual estate at Montmorency, see the discussion by Alan Wintermute in New York, 1990, 131–32.
6. Two drawings by Watteau (one known from an etching made of it by the comte de Caylus) have been identified as representing the grounds of Montmorency; see Washington, Paris, and Berlin, 1984–85, 301–2, figs. 1 and 2.
7. New York, 1990, 134–35.
8. Ibid., 135–36.
9. Posner, 1984, 150.

Nicolas Lancret *(Paris 1690–1743 Paris)*

Lancret studied first under the history painter Pierre Dulin (1669–1748) and then under Claude Gillot (1673–1722), with whom Watteau also worked. Having failed to win the Grand Prix, Lancret turned from history painting to fêtes galantes, *gaining acceptance into the Royal Academy in 1719 with a* Conversation Galante *(probably the version in the Wallace Collection, London). Lancret began exhibiting in the Salon of 1737, and gained a certain amount of fame as an imitator of Gillot and Watteau. Although he is often considered a mere follower of Watteau, Lancret developed a distinct style of* fêtes galantes *that was more grounded in reality and painted in a more naturalistic idiom. He also innovatively combined his pictures into symbolic groupings such as the times of the day, the seasons, and the elements, and drew much of his imagery from seventeenth-century French prints. Later in Lancret's career his work gained its own validity, and it was avidly collected throughout Europe. He enjoyed the patronage of important aristocratic collectors, and was the favorite genre artist of Louis XV (1721–74), for whom he painted* Luncheon Party in the Park *(Musée Condé, Chantilly). A prolific artist, Lancret produced more than seven hundred pictures in his career, many of which were popularized in reproductive engravings by Nicolas IV de Larmessin (1684–1755) and Jacques-Philippe Le Bas (1707–1783).*

4. The Declaration of Love

c. 1720
Oil on canvas, 32 1/2 × 25 1/4 in. (80.1 × 64.3 cm)
The Cleveland Museum of Art, The Elisabeth Severance Prentiss Collection, 1944.86

Provenance: William Sharp Ogden, Finchley; his sale, Christie's, London, December 6, 1927, lot 50; Wildenstein and Co., New York; Elisabeth Severance Prentiss, Cleveland, 1928; bequeathed by Elisabeth Severance Prentiss in 1944.

Selected Exhibitions: Cleveland, 1944, 25, no. 8; Baltimore, 1959, no. 18.

Selected References: The Cleveland Museum of Art, 1982, 79–81, no. 34; Chong, 1993, 124.

Uncatalogued by Wildenstein, *The Declaration of Love* is clearly an early work by Lancret very much in the style of Watteau.[1] The composition, focused on a pair of lovers seated beneath a towering tree, with subsidiary figures half hidden in the background, recalls in particular Watteau's *Harlequin and Columbine* (Wallace Collection, London) of about 1716–19.[2] As with Watteau's painting, in *The Declaration of Love* the ill-defined setting—it appears to be the edge of a grove overlooking a steep hill (one sees a low horizon and cloud-filled sky on the right)—isolates the scene, giving it the quality of a decorative vignette. Lancret, like Claude Gillot, Watteau, and other contemporary artists, enjoyed a lucrative career as a painter of decorative wall panels, which in the early eighteenth century often featured figurative subjects in a vignette surrounded by elaborate arabesques. The landscapes in Lancret's *fêtes galantes* (as opposed to his decorations) are usually more naturalistic, with a careful articulation of texture, color, and

39. Jacques-Philippe Le Bas after Lancret, *Gallant Conversation,* 1743, engraving and etching, cat. P18.

light (for example, see the landscape in *The Bourbon-Conti Family* [cat. 6]). In the Cleveland painting, however, the landscape elements are employed less to create a convincing sense of place than to emphasize the central encounter between the young suitor and his lady-love.[3]

Most scholars have noted the similarity between this couple and the one in Lancret's *Gallant Conversation* (Wallace Collection, London), the painting he submitted as his reception piece to the Royal Academy in 1718 and which was engraved in 1743 by Le Bas (cat. P18, fig. 39).[4] An amorous couple is the focus of both paintings and, although the print reverses the composition of Lancret's original, one can still appreciate the similarities of pose and gesture between them. In the Cleveland painting the man's entreaties are perhaps more forcefully resisted, but one gets the impression that it is all in good fun (despite the worried backward glances of the second couple in *The Declaration of Love*): the woman still smiles sweetly at her suitor, although she draws away, much like her counterpart in de Troy's interior scene with the same title (cat. 9). Lancret repeated this couple, virtually exactly, in a more elaborate composition representing *Autumn* (the Homeland Foundation, New York), one of a series of *Four Seasons* painted in the early 1720s.[5] *The Declaration of Love* probably dates shortly after the *Gallant Conversation* and before *Autumn*—that is, around 1720.

The major difference between the Cleveland painting and these related works is that in the latter the figures are all drawn from or mingling with members of the Italian commedia dell'arte. The grappling couple in the *Gallant Conversation* are actually Pierrot and Columbine, two of the most popular characters of the commedia and among the most frequently depicted in the *fêtes galantes* of Wat-

teau, Lancret, and Jean-Baptiste Pater. In *Autumn* this couple is dressed in contemporary clothes, but they are surrounded by members of the troupe, including Pierrot, Columbine, and Harlequin. Lancret included none of these characters in the Cleveland painting, however, giving the scene a greater immediacy and sense of reality. Nevertheless, with its magical landscape, illuminated by an ethereal light—the setting in the *Gallant Conversation* seems more believable—*The Declaration of Love* retains a sense of theatricality and courtly refinement that is still fully characteristic of the *fête galante*.

1. The present picture may be identical to the one catalogued by Wildenstein (1924, 96, no. 385), last seen at the Duval sale, Versailles, June 13, 1803, lot 14: "*Scène champêtre*. Toile.—H. 0.81; L. 0.62 [cm]. Groupe de personnages dont deux vus en face et deux à mi-corps." However, the description is too vague to make the association certain.
2. See Ingamells, 1989, 352–54, P387.
3. The sense of a vignette is perhaps enhanced because *The Declaration of Love* was painted over a portrait—presumably one by Lancret himself—in a fictive oval. The curved corners of this portrait are still slightly visible, adding to the decorative quality of the final composition. An x-radiograph of this portrait is reproduced in The Cleveland Museum of Art, 1982, 79, fig. 34a.
4. See the discussion by William S. Talbot in The Cleveland Museum of Art, 1982, 81; for the Wallace Collection painting, see Ingamells, 1989, 228–30, P422. Le Bas's engraving served as the printmaker's own reception piece in 1743.
5. For a discussion and illustration of this work, see New York and Fort Worth, 1991–92, 70–71, cat. no. 6.

5. *Young Woman on a Sofa*

c. 1735–40
Oil on panel, 9 1/16 × 12 3/16 in. (23.0 × 31.0 cm)
Collection of Mr. and Mrs. Stewart Resnick

Provenance: Sale, Sotheby's, Monte Carlo, December 5, 1991, lot 189.

Exhibited in Toledo and Houston only

Exhibited here for the first time, this little panel represents a relatively unusual departure for Lancret, whose oeuvre is in the main composed of *fêtes galantes* in the open air. Nevertheless, he did sometimes leave the out-of-doors to focus on an interior, although rarely with the bawdy charm displayed in the present example. Lancret's *fêtes galantes* are often ambiguous in meaning (though rarely so mysterious and enigmatic as those of Watteau), but this engaging scene is wittily anecdotal: a fashionable coquette, seated on her sofa in a richly furnished salon, admires her exposed breasts in the mirror of her compact; she evidently spots

the reflection of a prelate, lurking behind a curtain at the left, who has been spying on her. A bass cello leaning against an arm of the sofa and an empty stool suggest that the woman's companion, perhaps a suitor, has recently left the room. The erotic intrigue of the scene, and the symbolic associations of music, are elaborated by the framed painting hanging on the wall above the sofa: although difficult to make out, it appears to represent a *fête galante*—perhaps one by Lancret himself—in which we can discern a man and woman dancing before a gathering of onlookers.

Lancret's delicate cabinet painting bears the unmistakable influence of de Troy's *tableaux de mode* of the mid-1720s, such as *The Declaration of Love* (cat. 9), in which a beautifully dressed woman similarly reclines on a sofa in a meticulously rendered interior. Both works use fictive paintings to comment on the scene. Yet *Young Woman on*

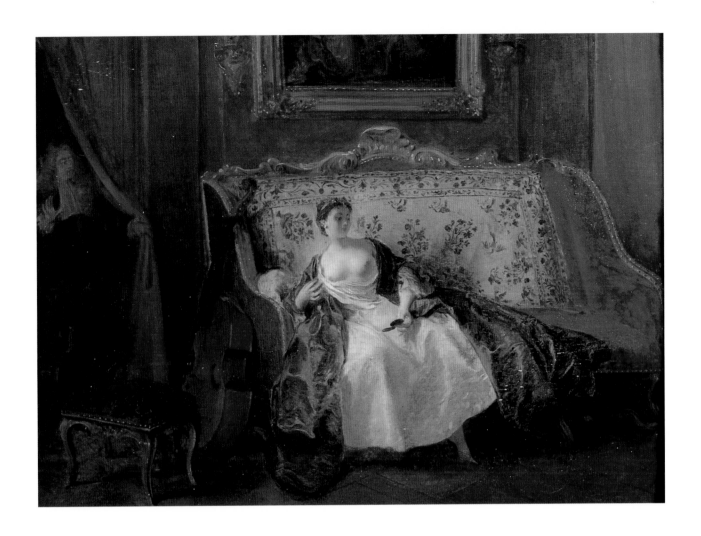

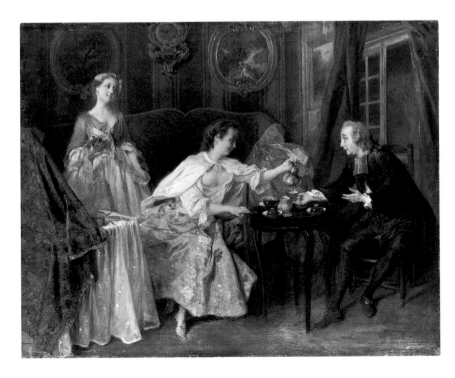

40. Nicolas Lancret, *Morning*, Salon of
1739, oil on canvas, reproduced by cour-
tesy of the Trustees, the National
Gallery, London.

a Sofa undoubtedly dates from a later period (although de Troy continued to paint his fashionable genre scenes well into the 1730s). The style of some of the furnishings, such as the elegantly turned legs of the stool, suggest a date in the middle to late 1730s, although the broad sofa itself appears to be from an earlier period; indeed, it is similar to the one in the de Troy, although—significantly—in Lancret's panel it is not integral with the wall paneling, but seems to have been brought into a room that has been redecorated in an up-to-date style. As Mary Tavener Holmes has discussed, in the late 1730s Lancret's compositions took on a greater simplicity and monumentality so that, even in small-scale works such as the present one, there are generally only a few figures filling a large amount of the pictorial space.[1] Confirming a date in the middle to late 1730s is the close relationship between *Young Woman on a Sofa* and Lancret's *Morning*, a small copper from a series of the four times of day that he exhibited at the Salon of 1739 (fig. 40).[2] In this composition, a woman, her chemise open at the breast, turns from her vanity to pour coffee for a visiting abbé. Her wide skirt, delicately pointed slipper, and shadowy face are all of a piece with the woman in the present painting, and in both scenes Lancret employs works of art hanging on the walls to convey mean-

ing. The idea of a prelate being charmed by a young woman's beauty is the theme of both pictures.

Wildenstein apparently was unaware of Lancret's panel, as none of the works in his catalogue raisonné can be convincingly associated with it; nor is anything known of its provenance. With its intimate scale and mildly erotic subject it was without doubt intended to be viewed in the private cabinet of a connoisseur, perhaps in the kind of room depicted in the picture itself. Its amusing storytelling aspect may have been derived from contemporary literature, although the specific source is unclear. In its general tone the subject is close to tales by such writers as Montesquieu, Pierre Marivaux, and Jean de La Fontaine, an author after whom Lancret painted a number of small pictures in the late 1730s.[3]

1. See New York and Fort Worth, 1991–92, 13; Dr. Holmes has confirmed the attribution of the present panel to Lancret as well as the date of c. 1735–40 (verbal communication).
2. See New York and Fort Worth, 1991–92, 90–91, no. 16. The painting is also similar in size, style, and anecdotal subject matter to Lancret's paintings drawn from the *Contes* of La Fontaine, datable to 1737–38 (see Ingamells, 1989, 226–27).
3. For example, the copper in the Wallace Collection, London (see Ingamells, 1989, 226–27, P409), one of twelve works by Lancret after La Fontaine's *Contes*.

6. *The Bourbon-Conti Family*

c. 1737
Oil on canvas, 19 3/8 × 26 1/4 in. (49.2 × 66.7 cm)
Krannert Art Museum and Kinkead Pavilion, University of Illinois at Urbana-Champaign, Champaign (67.3-5)

Provenance: Comtesse d'Hautpoul (descendant of the Bourbon-Conti family, according to Duveen Brothers), Paris; her sale, Hôtel Drouot, Paris, June 29, 1905, lot 44; purchased by Mme Jonas; Duveen Brothers, London, 1906; Galerie Cailleux, Paris, by 1930; Timary de Binkum; sale, Palais Galliera, Paris, March 16, 1967, lot 28; Galerie Cailleux, Paris; Newhouse Galleries, New York; Ellnora D. Krannert; acquired in 1967.

Selected Exhibitions: Paris, 1930 (1), no. 59; London, 1968, no. 380; New York et al., 1973–75, no. 14; Atlanta, 1983, no. 24; New York, 1990, 150–55, no. 24; New York and Fort Worth, 1991–92, 82–84, no. 12.

Selected References: Wildenstein, 1924, no. 562, fig. 145; Roland Michel, 1984a, 77 and 234.

Lancret's strikingly beautiful, though strangely disquieting, painting is difficult to categorize. It conforms to a type of picture infrequently produced by the artist, one that combines portraiture and genre painting with landscape; Alan Wintermute has aptly described this kind of work as

"a witty union between the *fête galante* and the conversation piece."[1] Conversation pieces—generally small-scale paintings portraying identifiable sitters engaged in informal and intimate groupings, often in the open air—were more popular in England than in France, but Lancret seems to have been attracted to this type of portraiture, perhaps, as Mary Tavener Holmes has observed, because of its clear relationship to the *fête galante*.[2] The traditional identification of the figures in the Krannert painting as members of the prominent Bourbon-Conti family has recently been rejected,[3] and whether the picture is a portrait at all is open to debate: although the group of women at the left, three of whom directly engage us, are rendered with the specificity of actual people, the two central figures, whose faces are hidden from the viewer, engage in an amorous encounter totally unexpected in portraiture. This odd juxtaposition has suggested to Holmes that Lancret intended to illuminate the role and relationships of the identifiable sitters at the left by including the grappling couple in the center "as a reference to the awakening of de-

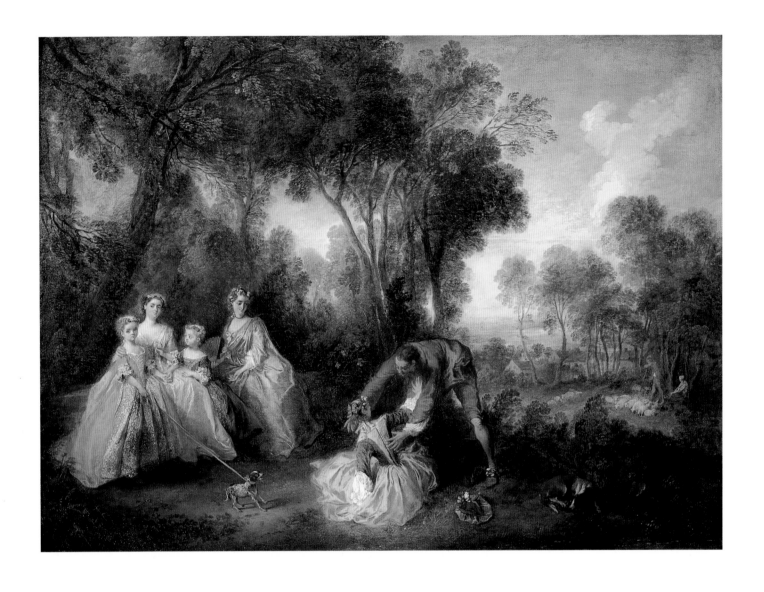

sire in the older of the two girls to the left, to characterize her quickly approaching puberty," a notion also symbolized by the yapping dog, a common symbol of carnality. By contrast, the innocence and purity of the younger girl is manifest in the flower she holds up to her sister.[4] In this way the painting becomes a kind of historicized portrait that was not uncommon in French art of the period.

The elaborate and extensive landscape background is one of the most attractive features of the Krannert painting. Lancret followed Watteau's example (such as is seen in the latter's *The Shepherds* in Berlin—see fig. 38) by juxtaposing a mass of trees, before which he sets a group of figures, with a panoramic view into the distance. The similarity ends there, however: Lancret was less successful than his great mentor at integrating his figures into the setting, but he was much more concerned than Watteau with translating a sense of the immediacy and reality of the natural world into his landscape backgrounds. In this ex-

ample, the rich coloring, the careful attention to detail—especially revealed in the treatment of the leaves on the trees—and the artful massing of foliage and cloud banks demonstrate the painter's absorption of seventeenth-century northern art, particularly the work of Peter Paul Rubens. More to the point, however, is the inclusion of a shepherd and his flock in the right distance. This passage, while undoubtedly a scene that could have been witnessed by the artist, nevertheless places the painting within the context of the pastoral poetry tradition that was avidly studied and enjoyed in the cultured intellectual circle of Lancret's patrons.

1. New York, 1990, 152.
2. New York and Fort Worth, 1991–92, 82.
3. By Alan Wintermute in New York, 1990, 154; Mary Tavener Holmes in New York and Fort Worth, 1991–92, 82. Wintermute (154, 155 n. 10) has also demonstrated that the frequently repeated assertion that the painting was exhibited at the Salon of 1737 is equally unfounded.
4. New York and Fort Worth, 1991–92, 84.

Jean-Baptiste Pater *(Valenciennes 1695–1736 Paris)*

ike Watteau, Pater was born in Valenciennes, the son of a sculptor-dealer named Antoine-Joseph Pater. Jean-Baptiste Pater moved to Paris sometime around 1710, where he spent a brief period as a pupil of Watteau around 1713 before returning to his native city. By 1718 he was back in Paris and making paintings in the style of Watteau. Agréé in 1725, in 1728 he was received into the Royal Academy as a painter of sujets modernes *with* Country Park *(Musée du Louvre, Paris). Although relations between Watteau and Pater had been strained for many years, upon his death Watteau left Pater many influential clients, among them Jean de Jullienne. Criticized at first for overtly copy-ing the style of his mentor, Pater enjoyed a greater reputation in the late eighteenth century. He took many of his subjects from the theater and the military, including* Village Orchestra *(Frick Collection, New York) and* The Vivandières of Brest *(Wallace Collection, London). To the* fête galante *tradition Pater introduced a delicate, feathery touch and a brilliant, light color scheme. His most innovative works are his crowded and lively scenes of country festivals, such as the large* Fair at Bezons *(The Metropolitan Museum of Art, New York) and paintings of women bathing. An indefatigable worker, Pater is said to have neglected his health; he died in Paris at the age of forty-one.*

7. The Picnic

c. 1725–30
Oil on canvas, 22 1/2 × 25 3/4 in. (57.2 × 65.4 cm)

8. The Bathers

c. 1725–30
Oil on canvas, 22 1/2 × 25 3/4 in. (57.2 × 65.4 cm)
The Nelson-Atkins Museum of Art, Kansas City, Missouri (Purchase: acquired through the bequest of Helen Foresman Spencer), F82-35/1–2

Provenance: E. Secrétan, Paris; his sale, Christie's, London, July 13, 1889, lots 3 and 4, ill.; purchased by Boussod, Valadon et Cie., Paris; Henri Bernstein, Paris; Gimpel, Paris; Wildenstein, Paris; John W. Simpson, New York, purchased in 1906; Wildenstein and Co., New York; purchased in 1982.

Selected Exhibitions: Paris, 1892, nos. 31–32; Nishinomiya, 1978, no. 4; Kansas City, 1987, no. 51 (The Picnic *only).*

Selected References: Ingersoll-Smouse, 1928, no. 51, fig. 40, no. 318, fig. 42; Robiquet, 1938, 82 (ill.) (The Bathers*).*

Among the emulators of Watteau, Pater perhaps has been the least well appreciated; he is still often thought of as a mere pasticheur of his master, and his work is generally considered to be unoriginal and merely derivative. Yet in the best examples of his paintings—and the Kansas City pendants certainly would count among them—Pater was able to reach a high standard indeed. His distinctive feathery brushwork and pale, misty landscape backgrounds—

sharply offset by the richly colored figures—distinguish his oeuvre from that of Watteau and, especially, Lancret, whose own *fêtes galantes* (see cats. 4 and 6) are much more naturalistic and keenly observed. Yet like those of Lancret, Pater's paintings are often grouped together in pairs and series. The Kansas City paintings have been together since they were first recorded in 1889; except for their nearly identical size and the similar scale and types of the figures, however, there is nothing inherent in the subjects, or even the compositions, that links the works.[1] Yet the two paintings together demonstrate perfectly the range of Pater's oeuvre, and his interests as a painter.

The Picnic—a loose translation of the French title, *Le Goûter*—is something of a compendium of *fête galante* motifs drawn from the work of Watteau. The setting is the edge of a garden or park in which a group of men and women have gathered to enjoy each other's company and to take refreshments. The verdant landscape, the suggestive sculpture nestled in the foliage, and the complex grouping of amorous couples all recall countless works by Watteau. Indeed, several motifs are drawn specifically from his works: the African servant (one makes an appearance in Watteau's *The Conversation*, cat. 2); the seated man with his knees apart; the aggressive suitor whose advances are resisted by his lover; the children seated on the ground, one seen from behind; and the man at the left edge, who encourages his companion to take a stroll.[2] Despite its appropriations, Pater's painting nevertheless sum-

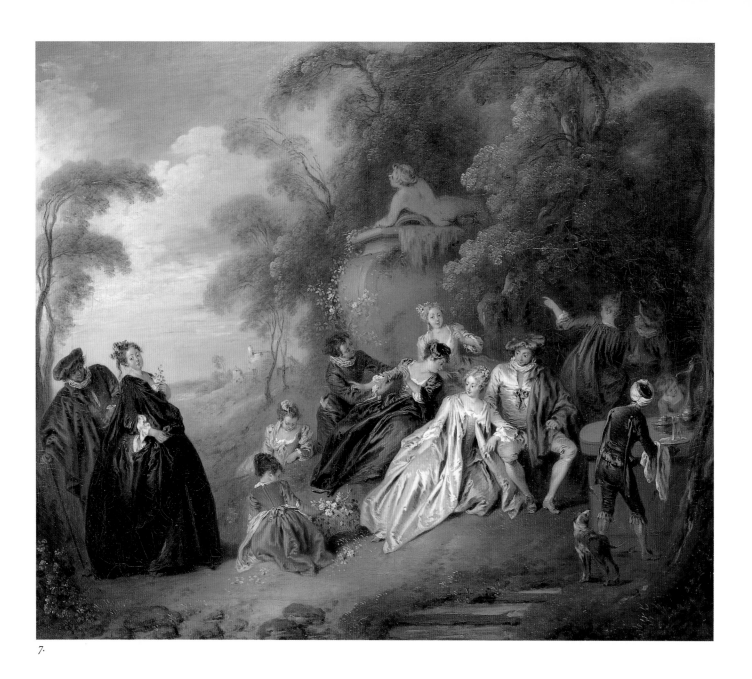

7.

mons up its own distinct spirit, one that is less subtle, enig-matic, and wistful than Watteau's inimitable art.

If *The Picnic* is fairly well representative of the type of *fête galante* made famous by Watteau, *The Bathers* intro-duces a new theme to the genre, one that Pater would make his own. As Ingersoll-Smouse noted in her early monograph (which remains the only full-scale treatment of the artist's oeuvre), "[Women bathing] perhaps con-stitutes the most personal side of his art, in which he is most free of the influence of his master."[3] Aside from his few mythological subjects (and the famous *Lady at Her Toilet* [Wallace Collection, London]), Watteau rarely de-picted nude women, and never in his *fêtes galantes*.[4] Pater, by contrast, fully exploited the bathers theme (he painted some fifty examples), which offered him an opportunity to display the female form in a variety of states of undress and

in an endless combination of poses and groupings. Even so, he relied on a standard format that appears in almost every bathers picture: a clearing in a park is framed on one side by the elegant façade of a garden pavilion, balanced at the opposite side by an appropriately eroticized sculpted fountain, in this case a pair of cupids atop a dolphin, sym-bol of Venus. Around the pond various women lounge about, chatting to one another, shedding their clothing, and entering or leaving the water. Despite the nature of the subject, Pater is ordinarily discreet in his display of female nudity; usually only a few of the women can properly be described as naked, while others display their legs, a breast, or the contours of their figures through the wet drapery that clings to their bodies. Nearly always Pater gives us a figure seen from behind, such as the woman in the center of the Kansas City painting, who climbs out of the water

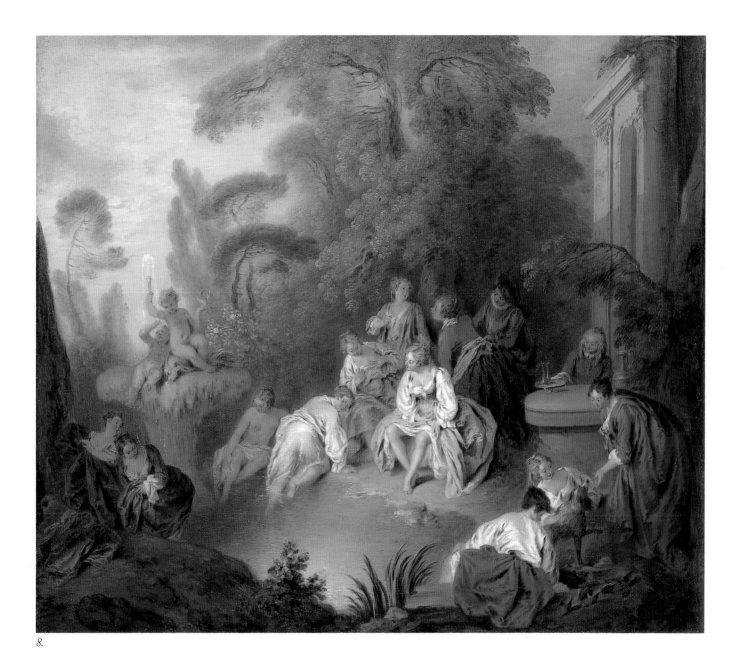

8.

in her wet underclothes while casting a backward glance at the viewer (a pose Pater repeated many times). The voyeuristic nature of the subject is often enhanced by the inclusion of a surrogate for the (presumably male) viewers of these works; in many such pictures one or more men spy on the bathers from behind a mass of foliage, in a kind of modern take on the mythological tale of Diana and Actaeon. In this example, the private and exclusively female gathering has been interrupted by a man in costume in the right background, whose appearance has apparently provoked a maid to seek assistance from the woman standing in the center.[5] The licentious aspect of many of Pater's works—particularly his images of bathers—suggested to Ingersoll-Smouse that some of them might have been commissioned, or at least inspired, by members of the *cénacles galants* and other libertine societies that proliferated

among the aristocracy in the 1720s and 1730s.[6] Unfortunately, the Kansas City pendants can only be traced back to the late nineteenth century.

1. The two compositions do not really balance each other, and the repetition of certain motifs—such as the round stone table that appears in the right foreground of each picture—might argue against them being pendants.
2. As Roger Ward has pointed out (Kansas City, 1987, 122), this couple, dressed in seventeenth-century costume, bears the influence of Rubens.
3. "[*Les Femmes au bain*] . . . constituent peut-être le côté le plus personnel de son art, et celui où il se dégage le plus de l'influence de son maître" (Ingersoll-Smouse, 1928, 12).
4. See the discussion by Pierre Rosenberg in Washington, Paris, and Berlin, 1984–85, 333–36.
5. The other man—visible at the right near the façade—is a servant, and thus cannot be seen as an intruder into the gathering of women.
6. Ingersoll-Smouse, 1928, 14.

Jean-François de Troy *(Paris 1679–1752 Rome)*

The son and student of the portraitist François de Troy (1645–1730), Jean-François de Troy was one of the most prolific painters in the first half of the eighteenth century. Although he did not win the Grand Prix, he traveled to Rome at his own expense, where he studied at the French Academy from 1698 to 1704. He returned to Paris in 1706, and was made both agréé *and* reçu *(made a full member) at the Royal Academy on the same day in 1708 with* Niobe and Her Children Pierced by Apollo's Arrows *(Musée Fabre, Montpellier). De Troy painted a great variety of subjects, particularly mythological themes, and he ex-*

hibited at the Salon from 1737 to 1750. In 1727 he participated in a competition organized by the duc d'Antin, the directeur-général des bâtiments, submitting The Rest of Diana *(Musée des Beaux-Arts, Nancy), for which he shared first prize with his rival François Lemoyne. Among his most innovative works are his* tableaux de mode, *small cabinet pictures that depict intimate groupings of men and women in conversation and at leisure in sumptuously decorated parlors or verdant gardens. De Troy returned to Italy in 1738 as director of the French Academy, after his aspirations to work for Louis XV (1721–74) at Versailles were not realized.*

9. The Declaration of Love

c. 1724–25
Oil on canvas, 25 9/16 × 21 7/16 in. (64.8 × 54.5 cm)

10. The Garter

c. 1724–25
Oil on canvas, 25 9/16 × 21 5/16 in. (64.8 × 54.0 cm)
Williams College Museum of Art, Williamstown, gift of C. A. Wimpfheimer, Class of 1949, 80.17.1–2

Provenance: Count Edmond Blanc, Paris; Madame Evain, Paris; Wildenstein and Co., New York; Charles A. Wimpfheimer, New York, 1925; by descent to his grandson, Charles A. Wimpfheimer; given in 1980.

Selected Exhibitions: Pittsburgh, 1936, nos. 1 and 5; Paris, 1937, nos. 148–49.

Selected Reference: Fahy and Watson, 1973, 295–96.

Although de Troy was most prominent as a history painter—second only to François Lemoyne, in the estimation of his contemporaries—his lasting contribution to French art in the eighteenth century was his invention of a new category of genre picture, the *tableau de mode*. Translated loosely as "fashionable picture," such works focus on intimate moments in the lives of the Parisian haute monde, offering a glimpse of their social rituals and interactions while re-creating with great fidelity the look and feel of contemporary costumes and interior decor. In addition to merely chronicling the life of the aristocracy and the monied classes, these works often convey an undercurrent of sexual intrigue. In this sense they are secular complements to the artist's mythological subjects—espe-

cially his smaller cabinet pictures intended for private display—which frequently draw their imagery from the loves of the classical gods.

The Declaration of Love and *The Garter* typify the genre, representing two gallant scenes acted out in scrupulously articulated interior settings. These compositions repeat two of de Troy's most celebrated *tableaux de mode*, now in a private collection in New York (figs. 41 and 42).[1] Those paintings, signed and one dated 1724, were shown at the Salon of 1725, only the second official exhibition of works by the Royal Academy's members. (The exhibitions would not become a regular feature of Parisian artistic life until 1737.) Although unsigned, the versions presented here are of high quality, exhibiting de Troy's characteristic attention to detail and exquisite brushwork, although—as is typical with the artist's repetitions—they lack the ravishing surfaces and sheer resplendent beauty of the primary versions. Nevertheless, there is little reason to doubt their autograph status; it was not unusual for de Troy to make replicas of his *tableaux de mode* and history paintings, sometimes altering passages, sometimes reproducing his original compositions more or less precisely, as here.[2]

De Troy frequently conceived of his *tableaux de mode* as pendants with complementary subjects, as he did with his small history paintings.[3] The present pictures, for instance, offer contrasting examples of seduction. In *The Declaration of Love*, the suitor appeals to the heart and emotions of the lady as he pleads his case on bended knee; his entreaties are apparently met with some encouragement by the relaxed young woman, who reclines on the

sofa. In *The Garter*, graceful though the paramour may be, his more aggressive approach—he has risen from his chair to assist the woman in attaching her garter—meets with a willful rebuke. In each scene the little dramas are eloquently acted out in a wonderful array of poses, gestures, and facial expressions that epitomize the highly refined and intimate social intercourse of the regency period. Despite their theatrical air—the compositions have been compared to the contemporary *comédies de moeurs* of Pierre Marivaux[4]—the pictures assume a sense of quotidian reality in the exactitude with which the painter has rendered the mise-en-scène. The costumes, the décor, and the furniture are all appropriate to the subjects and the tastes of contemporary fashion. One gets the sense that de Troy took great pleasure in presenting the opulence and sheer variety of French interior design and decorative art, for the interiors, with their different floors, wall treatments, furniture, and works of art, serve as a catalogue of regency style. Some of the objects carry symbolic meaning as well: the opulent clock in *The Garter* reads eleven-thirty, the traditional time for women of leisure to accept visitors (both women are shown dressed in informal, if extravagant, morning dresses suitable for the occasion); the clock is decorated with figures of Cupid and Father Time, recalling the traditional aphorism that Love Conquers Time.

Moreover, each painting employs works of art to comment on the meaning of the scenes. In *The Declaration*, the landscape painting on the wall—based on a now lost work by de Troy himself—includes the figures of Mars and Venus embracing, a clear reference to the thoughts of the flirting cavalier and the woman on the sofa. The nude statuette on the console table in *The Garter*—its back is reflected in the mirror—underscores the lascivious intentions of the bold suitor, but, like the resisting woman, the nude turns away from his gaze.

The sophistication of de Troy's genre scenes, both in their technical brilliance and in their subtle iconographic allusions, was well appreciated by the painter's urbane clientele. As Pierre-Jean Mariette remarked in 1762, "He pleased many in Paris with his little *tableaux de mode*, which are in effect more carefully finished than his history paintings."[5] De Troy's clients during the 1720s and 1730s—the period in which he apparently painted these genre scenes—were drawn from the highest echelon of French society, from Louis XV himself to such well-placed financiers as the prominent banker Samuel Bernard. (Like Charles-Joseph Natoire [see cat. 15], de Troy produced paintings for the king's private apartments at Fontainebleau, among other projects for the *bâtiments*.)[6] There are few cases in which the original owners of the *tableaux de*

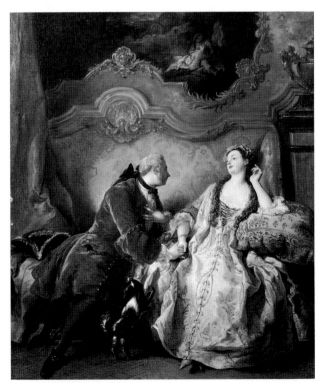

41. Jean-François de Troy, *The Declaration of Love*, Salon of 1725, oil on canvas, private collection, New York.

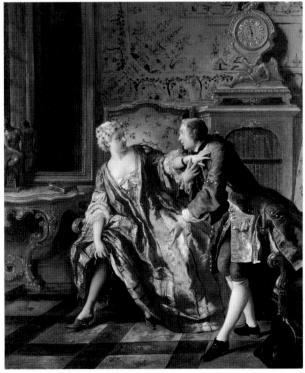

42. Jean-François de Troy, *The Garter*, Salon of 1725, oil on canvas, private collection, New York.

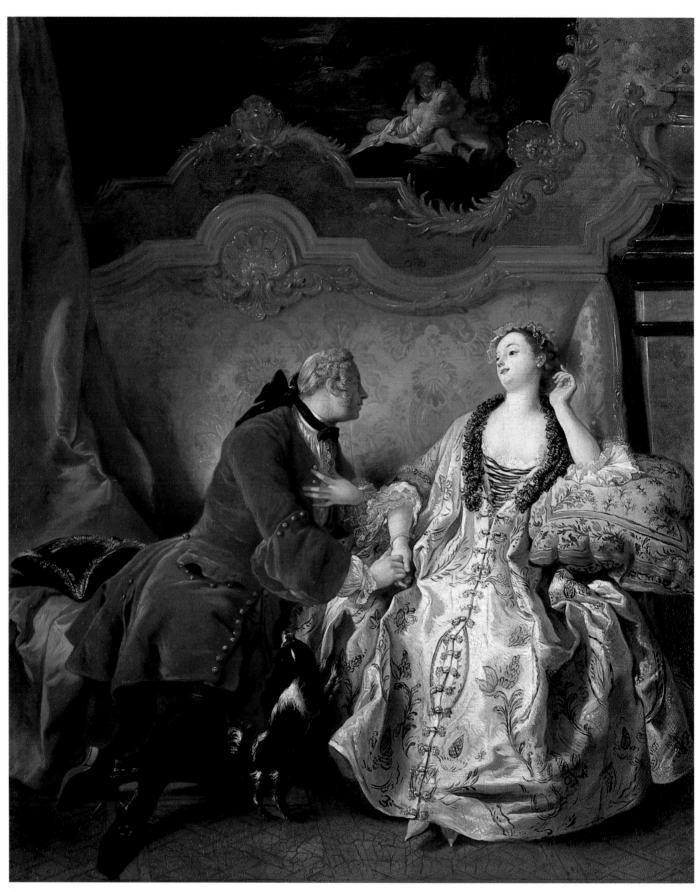

9.

JEAN-FRANÇOIS DE TROY

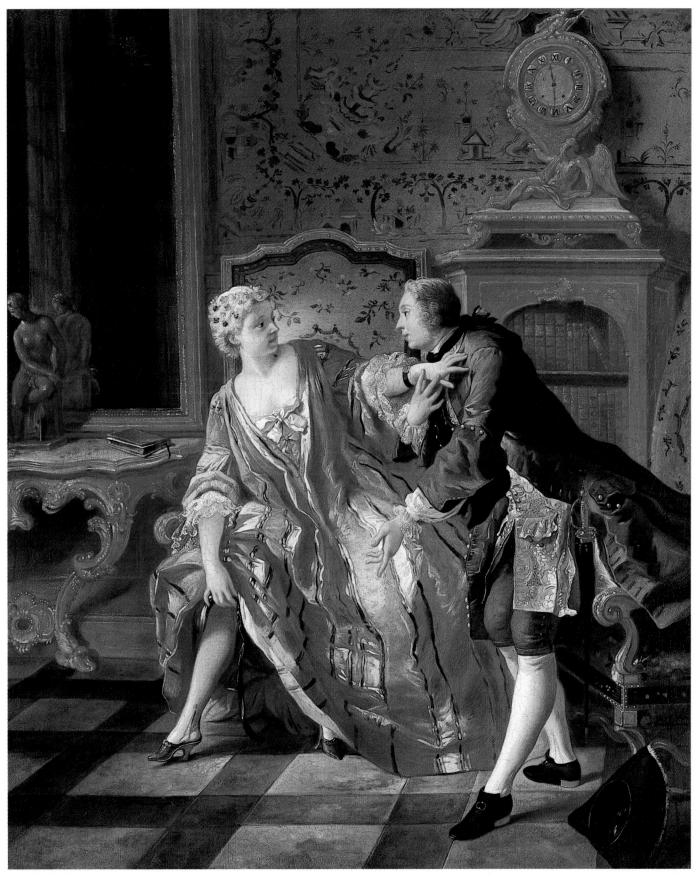

mode have been identified, but it is not too much to claim that in such paintings de Troy's patrons enjoyed both a reflection of the opulence in which they lived and an expression of the intimacy and exclusivity of the life of the leisure classes during the regency. The fascination of such subjects was to remain potent throughout the eighteenth century, finding new expression in the work of artists as diverse as François Boucher (cat. 13), Michel Garnier (cats. 44 and 45), and Marguerite Gérard (cat. 43).

1. Fahy and Watson, 1973, 279–96, nos. 29–30.
2. See, for example, the variants of the Rothschild *tableaux de mode* in The Nelson-Atkins Museum of Art (Ross E. Taggart in Kansas City, 1983, no. 16; Roger Ward in Kansas City, 1987). Unfortunately, the early provenance of the Williams College variants is unknown; thus the circumstances of their creation remain a mystery.
3. Besides the pair exhibited here, the Wrightsman versions, and the pendants mentioned in note 2 above, other pendants include *The Preparation for the Ball* (J. Paul Getty Museum, Los Angeles; see fig. 73) and *After the Ball* (lost, but known through Jacques Firmin Beauvarlet's engraving; see Dacier, 1925, no. 53), and the *Reading of Molière* (private collection) and its supposed pendant, *The Declaration of Love* (Sans Souci, Potsdam).
4. First suggested by Fahy and Watson, 1973, 293.
5. "Il a beaucoup plu à Paris pour ses petits tableaux de modes, qui sont en effet plus soignés que ses grands tableaux d'histoire" (P. J. Mariette, *Abécédario* [Paris, 1853–54], 4:101). This bias in favor of the genre scenes has only recently begun to be reevaluated, as de Troy's mythological and religious pictures have been studied more seriously: see in particular Bordeaux, 1989, 143–69; Paris, Philadelphia, and Fort Worth, 1991–92, 203–41.
6. See Cuzin, 1991.

François Boucher *(Paris 1703–1770 Paris)*

A native of Paris, Boucher learned the rudiments of painting from his father, Nicolas. He studied with François Lemoyne from 1721 until 1723, the year he won the Grand Prix. Boucher's trip to Italy was delayed for several years, however, during which time he produced numerous etchings after compositions by Watteau for Jean de Jullienne's compendium of prints. He traveled to Italy in 1728 at his own expense, although there is little evidence that the trip profoundly affected his art; he was back in Paris by 1731. That same year he was admitted into the Royal Academy, gaining full membership three years later with his painting Rinaldo and Armida *(Musée du Louvre, Paris)*. From that followed an exceptionally successful career; Boucher won commissions from the French crown and aristocracy, and he soon earned an international reputation. With Charles-Joseph Natoire and Carle Van Loo he was one of the principal exponents of rococo, the style of art associated with the reign of Louis XV *(1721–74)*. Perhaps best known for his mythological and pastoral subjects, Boucher also produced religious paintings, genre scenes, landscapes, and portraits. In addition to his many painted decorations and cabinet pictures, he contributed designs for the Beauvais and Gobelins tapestry works, the Sèvres porcelain factory, and sets and costumes for the theater. He was the favorite artist of Louis XV's mistress, Madame de Pompadour, for whom he painted some of his most impressive works, such as The Rising of the Sun *and* The Setting of the Sun *(1753; Wallace Collection, London)*. His career was capped in 1765 when he was appointed First Painter to the King and elected director of the academy.

11. The Surprise

c. 1723–25
Oil on canvas, 32 × 25 3/4 in. (81.5 × 65.6 cm)
New Orleans Museum of Art, Women's Volunteer Committee Fund, 84.58

Provenance: Sorbet (?) sale, Paris, April 1, 1776, lot 46; Contant d'Ivry, Paris; his sale, Paris, November 27, 1777, lot 6; duc des Deux Ponts, Paris; his sale, Paris, April 6, 1778, lot 71; Noyer; sale, Paris, April 3, 1783, lot 9; comte de Pourtalès-Gorgier, Paris; his sale, Paris, February 6, 1865, lot 252 (as Deshays); Prince Paul Demidoff; his sale, Paris, February 3, 1868, lot 21 (as Deshays); (?) marquess of Hertford; Bloomingdale sale, Parke-Bernet, New York, October 30, 1942, lot 23 (as Deshays); Paul Drey, New York; Georg Schäfer, Schweinfurt; sale, Christie's, London, July 14, 1978, lot 150; Galerie Cailleux, Paris; purchased in 1984.

Selected Exhibitions: New York, Detroit, and Paris, 1986–87, 92–94, no. 2; Koriyama, Yokohama, Nara, and Kitakyushu, 1993, no. 5.

Selected References: Ananoff and Wildenstein, 1976, vol. 1, no. 79, fig. 348.

Although the cataloguer of the Contant d'Ivry sale in 1777 asserted that Boucher's *The Surprise* was painted shortly after the artist's return from Rome (that is, sometime during or after 1731), Alastair Laing has recently argued convincingly that the painting should be dated around 1723, during the brief period in which Boucher was working in the studio of François Lemoyne.[1] Laing noted in particular the strong similarities—in the features of the woman as well as in the broken handling of the brushwork—between the present work and Lemoyne's *Cleopatra* (Minneapolis Institute of Arts), which was by all accounts produced in the early 1720s.[2] In further support of this dating is the detailed attention to fabrics in Boucher's painting—most evident in the exquisitely observed embroidery of the pillow—and the erotically charged encounter between the man and woman, which were both perhaps responses to the *tableaux de mode* that had been exhibited by de Troy as recently as 1725. (See cat. 9, which includes a similar pillow.) *The Surprise* is thus an important document of Boucher's early development as an artist (a period, as Pierre Rosenberg has observed, that is frustratingly obscure),[3] and it should not seem illogical that the young artist—barely twenty years old at the time—sought the example of diverse contemporary masters, even those as distinct as Lemoyne and de Troy.

The subject of the painting is enigmatic, although thoroughly in keeping with the eroticized undercurrent that characterizes much genre painting during the regency and early reign of Louis XV and is well represented in this exhibition by de Troy and Lancret (for example, cat. 5), among others. A woman, dressed only in her shift, reclines on a daybed in a stone room overlooking a garden; she is apparently startled by a man who pulls back a curtain to reveal his presence. She seems less concerned with being observed in a state of partial undress, however, than with the young girl at the foot of the bed, who reaches toward

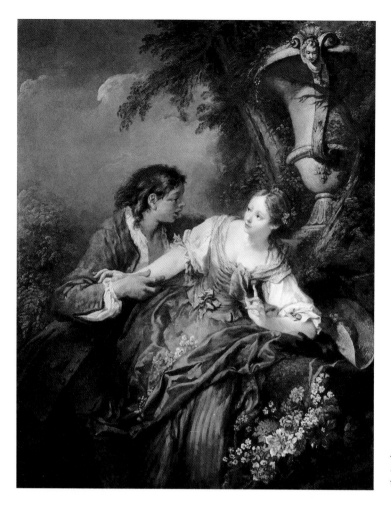

43. François Boucher, *The Gardener Surprised,* oil on canvas, private collection, France.

her imploringly, as if seeking to pet the cat that she holds in her lap. This cat, particularly in the way it is held by the woman, is very close to one that appears in an etching after Boucher entitled *Les Caresses dangereuses.* The quatrain included in the lower margin of this print warns of the natural treachery of all cats, who—like lovers—can turn in an instant on the object of their affections, an idea that is perhaps part of the meaning intended by *The Surprise.*[4] Indeed, there is an underlying sense of danger in the painting, if only because the identities of the protagonists (parents with their child? a courtesan and her client?) and their actions are so mystifying. It is possible that the subject is drawn from a work of literature, perhaps one of the *Contes* of La Fontaine that were sometimes depicted by painters such as Lancret, Pater, and Boucher himself.[5] Arguing against this notion is the existence of a purported pendant to the New Orleans picture, *The Gardener Surprised* (fig. 43).[6] Although no documentation exists to prove the connection between the two works, the latter painting elaborates on the theme of a sudden encounter between a man and woman, this time outdoors and with a composition that balances nicely with the interior view. In the pendant the suitor appears boyish and less sinister than the satyrlike man in *The Surprise,* just as the sweet-faced

gardener appears more innocent than her sophisticated counterpart. Perhaps in this pair of paintings Boucher intended to comment on the classic distinction between the city, with its cultivated, urbane pleasures, and the country, home to simple desires and honest sentiments.

1. Laing in New York, Detroit, and Paris, 1986–87, 92–94; the cataloguer of the d'Ivry sale is quoted in this reference as well.
2. Ibid., 93–94; for the Lemoyne see Rosenberg, 1971–73 and Atlanta, 1983, 33–34, no. 2.
3. Pierre Rosenberg, "The Mysterious Beginnings of the Young Boucher," in New York, Detroit, and Paris, 1986–87, 41–55.
4. For the print, see Jean-Richard, 1978, 336, no. 1402; the verses, by M. Moraine, are cited in Ananoff and Wildenstein, 1976, 1:213: "Quoique ce chat, belle Iris, vous caresse, / Défiez-vous toujours de sa patte traitresse: / Il ressemble fort à l'Amour, / Qui flatte, et dans l'instant vous joue d'un mauvais tour."
5. For example, Pater painted two works, identified by Ingersoll-Smouse (1928, nos. 481–82 [figs. 145–46]) as "tiré des Contes de La Fontaine," which show a man suddenly revealing himself to a woman reclining on a daybed—in one he pulls back a curtain (see Ingamells, 1989, 292–93, P405; according to Ingersoll-Smouse, this painting represents either the tale "La Confidente sans le savoir" or "Le Remède"); in the other there is a rambunctious cat. The subject of *La Courtisane amoureuse* (cat. P14), engraved after Boucher, is taken from the *Contes.*
6. Ananoff and Wildenstein, 1976, vol. 1, no. 91, fig. 376.

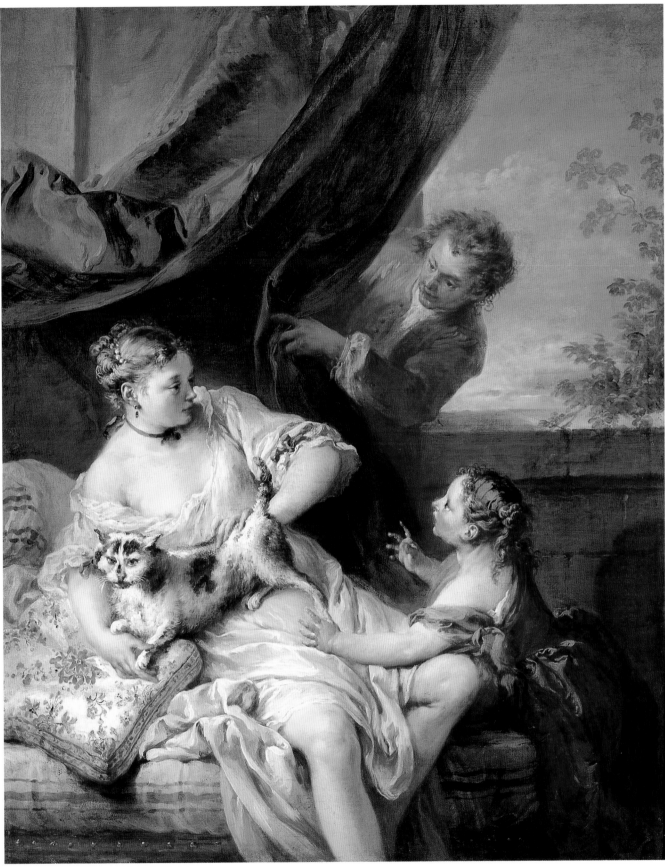

11.

12. La Toilette (A Lady Fastening Her Garter)

1742
Oil on canvas, 20 3/4 × 26 1/4 in. (52.5 × 66.5 cm)
Signed and dated lower left: f. Boucher / 1742
Fundación Colección Thyssen-Bornemisza, Madrid

Exhibited in Houston only

Provenance: Purchased from the artist by Count Karl Gustav Tessin, Swedish ambassador to France; shipped to Stockholm, June 1742; Tessin's posthumous sale, Åkerö, Sweden, February 4–16, 1771; L. Masreliez, Stockholm; Baron E. Cederström, Löfsta; Baron Nathaniel de Rothschild, Vienna, by 1903; Baron Alphonse de Rothschild, Vienna; Rosenberg and Stiebel, New York; acquired in 1967.

Selected Exhibitions: London, 1968, no. 38; Washington, D.C. et al., 1979–81, no. 46; Tokyo and Kumamoto, 1982, no. 23; New York, Detroit, and Paris, 1986–87, 195–97, no. 38.

Selected References: Rothschild, 1903, no. 249, 109; Ananoff and Wildenstein, 1976, vol. 1, no. 208, fig. 643; Brunel, 1986, 116–17, fig. 79; Sammlung Thyssen-Bornemisza, 1986, no. 39, 46, colorplate.

Boucher's *La Toilette,* with its meticulously described interior and motif of a young woman exposing her garter, immediately brings to mind de Troy's fashionable interior scenes, such as *The Garter* (cat. 10). Yet the stylish coquette in the present work is far removed in spirit from the indignant woman who fends off her suitor in that picture. Here the painter presents the viewer with a voyeuristic peek (as suggested by the head in the portrait on the wall, which seems to peer over the Chinese folding screen) at an elegant lady's toilette. Still wearing her peignoir around her shoulders, she has turned from her vanity to tie a pink garter around her stocking; her attention is distracted by her maid, who holds up a bonnet for inspection. The role of the maid recalls that of the one in Lancret's *Morning* (see fig. 40), which Boucher must have seen at the Salon of 1737. Boucher's scene, however, appears to take place in the evening, to judge by the burning candle on the mantelpiece.

The early history of *La Toilette* is well documented: the picture was acquired from the artist by Count Gustav Tessin, the envoy of Crown Princess Louisa Ulrica of Sweden.[1] Tessin was an avid collector, acquiring, for example, one of Boucher's masterpieces of mythological painting, *The Triumph of Venus* (1740, Nationalmuseum, Stockholm), as well as important pictures by Lemoyne, Lancret, and Chardin (see figs. 2 and 68), among others. Moreover, he was instrumental in building the prince and princess's own exceptional collection of eighteenth-century French painting, directing purchases and commissions from Chardin, Alexandre François Desportes, and

Jean-Baptiste Oudry, as well as Boucher. Indeed, Tessin sold many of his pictures to Louisa Ulrica in 1749, although he retained *La Toilette* until his death. Three years after he acquired it, he ordered on Louisa Ulrica's behalf a series of four interior scenes from Boucher, showing a fashionable lady in characteristic activities representing different times of the day. For reasons that are unclear (although Boucher's "libertinage" was claimed to be one),[2] only one of the set was ever completed, the marvelous *The Milliner (Morning),* also exhibited here (cat. 13).

The success of *La Toilette* may in fact have inspired Tessin to commission the Times of Day series for his benefactor. With its attentive maid, fur-lined wrap thrown casually over the chair, and open letter resting on the mantelpiece, it bears some resemblance to the proposed depiction of *Evening* (described in the following entry). It thus would have formed a striking contrast to *The Milliner (Morning).* While the general subjects of *La Toilette* and *The Milliner* are remarkably alike—each shows a fashionable young woman at her vanity, assisted by a maid or milliner—they could not be more different in spirit and mood. Compared to the calm and measured atmosphere of the princess's picture, the present scene is marked by frenetic activity and a general disarray suggesting a woman of a decidedly more impetuous nature. This effect is accentuated by the rich, saturated colors, the brilliantly articulated bibelots and furnishings, and the unstable poses of both the woman and her maid: the viewer's eye is kept in continuous motion, traveling in and around the scene as it explores the myriad details and sheer profusion of accoutrements.

The proposal by Charles Sterling that *La Toilette* may represent an episode in the life of a courtesan, similar to Hogarth's *The Harlot's Progress,* engraved in 1731 and surely known to Boucher, should be reconsidered, although there is no evidence that Boucher's painting, like *The Milliner,* was intended as one of a series.[3] The provocative pose and action of Boucher's young lady is similar to the figure of a harlot at the right in Hogarth's scene at Bridewell prison, and the disorder of the interior in which she is placed might be interpreted as a general comment on her moral character, much as in the second plate of *The Harlot's Progress.*[4] The mysteriously half-open French door, the portrait on the wall that partly appears behind the screen, the fire tongs poking into the glowing fire, even the playful cat that catches the eye of the viewer, all add to an atmosphere of sexual intrigue. Yet, as Sterling recognized,

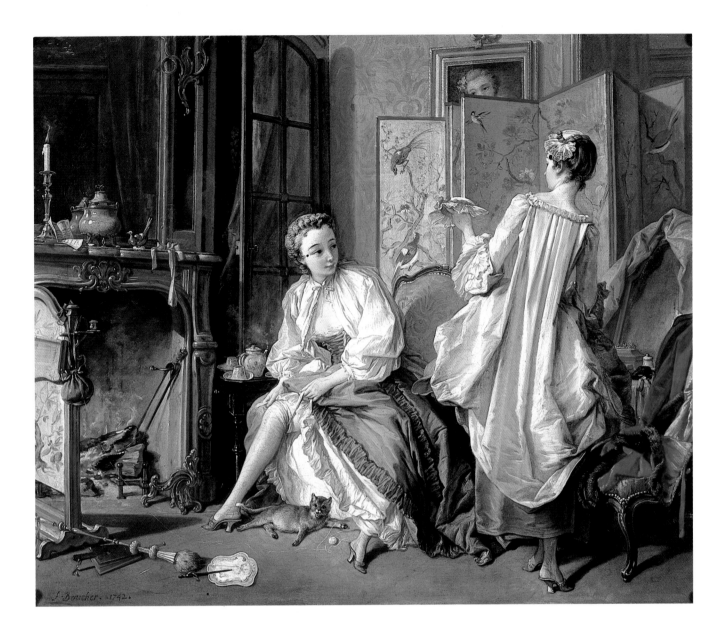

Boucher's painting carries none of the moralizing tone of Hogarth's series, and we are left with a lively image of a cheerful coquette, eagerly anticipating the evening's activities. In light of this, it may be less surprising that *La Toilette* was one painting that Tessin did not sell to Princess Louisa Ulrica, but kept for himself.

1. On Tessin's activities, see J. Patrice Marandel, "Boucher and Europe," in New York, Detroit, and Paris, 1986–87, 74–77; Grate, 1994, 7–8.
2. Laing in New York, Detroit, and Paris, 1986–87, 226.
3. See Heinemann, 1971, 49–51.
4. In this scene, the harlot topples over the tea table to distract her rich patron as her young lover sneaks out the door (see Bindman, 1981, 57, fig. 43).

13. The Milliner (Morning)

1746
Oil on canvas, 25 × 21 in. (64.0 × 53.0 cm)
Signed on the box, lower right: f. Boucher 1746
Nationalmuseum, Stockholm

Exhibited in Hanover and Toledo only

Provenance: Commissioned for Crown Princess Louisa Ulrica of Sweden, October 1745; delivered to the Swedish envoy in Paris, October 1746; Drottningholm Castle until 1865, when it was transferred to the Nationalmuseum.

Selected Exhibitions: New York, Detroit, and Paris, 1986–87, 224–29, no. 51; Stockholm and Paris, 1993–94, 408–9, no. 742.

Selected References: Michel, 1889, 56–57; Kahn, 1904, 59; Nolhac, 1925, 80–82, colorplate facing 80; Ananoff and Wildenstein, 1976, vol. 1, no. 297, fig. 866; Brunel, 1986, 240, fig. 78; Boime, 1987, 12, fig. 1.9; Grate, 1994, no. 89, colorplate 12.

Along with *La Toilette* (cat. 12) and *Le Déjeuner* (see fig. 3), this engaging picture is one of Boucher's few forays into the category of the *tableau de mode* first popularized by de Troy (see cats. 9 and 10). In this case it is literally one, for the scene shows a woman at her vanity examining a selection of ribbons offered her by a young milliner, a measuring rod at her side. Boucher was scrupulous in his representation of all the accoutrements of a fashionable lady, rendered with a finish and attention to detail that he reserved for his cabinet pictures. The light streaming in the window, the snuffed-out candle, and the rumpled bedclothes tell us it is morning, while the letter on the floor perhaps suggests that the woman is preparing for an intimate rendezvous. René Gaillard's engraving after the composition, issued in 1746, includes a poem that gently admonishes the woman for her vanity: "The gods took pleasure in making you perfect, / and these vain ornaments that you wrongly assume / do nothing but hide your real beauty; / therefore quit your dressing table forever, Phyllis," and so on.[1] The poem—which goes on to claim that to win a lover's heart one must remain simple and natural, "without makeup and finery"—reflects a more general critique of aristocratic women, one that was gaining strength during this period, which warned of their increasing power and hold over men, often achieved, so it was argued, through clever deception and seduction.[2]

That the verses reflect Boucher's intention for the painting is difficult to believe, given the destination of the picture. *The Milliner* was to be part of a suite of four scenes representing the times of day commissioned for Louisa Ulrica, Crown Princess of Sweden, through her agent in Paris, Count Tessin.[3] Much to the dismay of Tessin, Boucher ultimately completed only the present picture, depicting Morning, although an idea of how the entire se-

ries would have looked is preserved in a letter of 1745 from Carl Reinhold Berch, secretary to the Swedish embassy in Paris, to Tessin:

> *Morning will be a woman who has finished with her hairdresser, but is still in her peignoir, enjoying examining knickknacks displayed by a milliner. Midday, an encounter in the Palais Royal between a lady and a wit reading her some dreadful poem calculated to bore her, so that she indicates the time by her watch; the sundial showing noon in the background. After dinner, or the Evening, gives us the most difficulty: either notes brought to arrange a rendezvous, or mantles, gloves, etc., being given by the lady's maid to her mistress wishing to pay calls. Night can be shown by some giddy things [des folles] in ball gowns, making fun of someone who is already asleep.[4]*

The theme of the times of day was not particularly new, not even when portrayed as genre scenes representing various occupations of the day; as Anne Schroder points out in her essay, the subject often appears in seventeenth-century prints, although Boucher could have turned to an even closer source, as suggested by Mary Tavener Holmes: Lancret's series (National Gallery, London) of about 1739–40, in which *Morning* shows a fashionable young woman dressed similarly to Boucher's lady, with a loose-

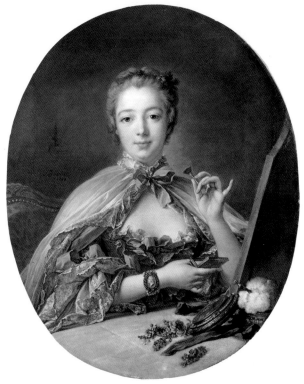

44. François Boucher, *Madame de Pompadour*, 1758, oil on canvas, Harvard University Art Museums, bequest of Charles E. Dunlap.

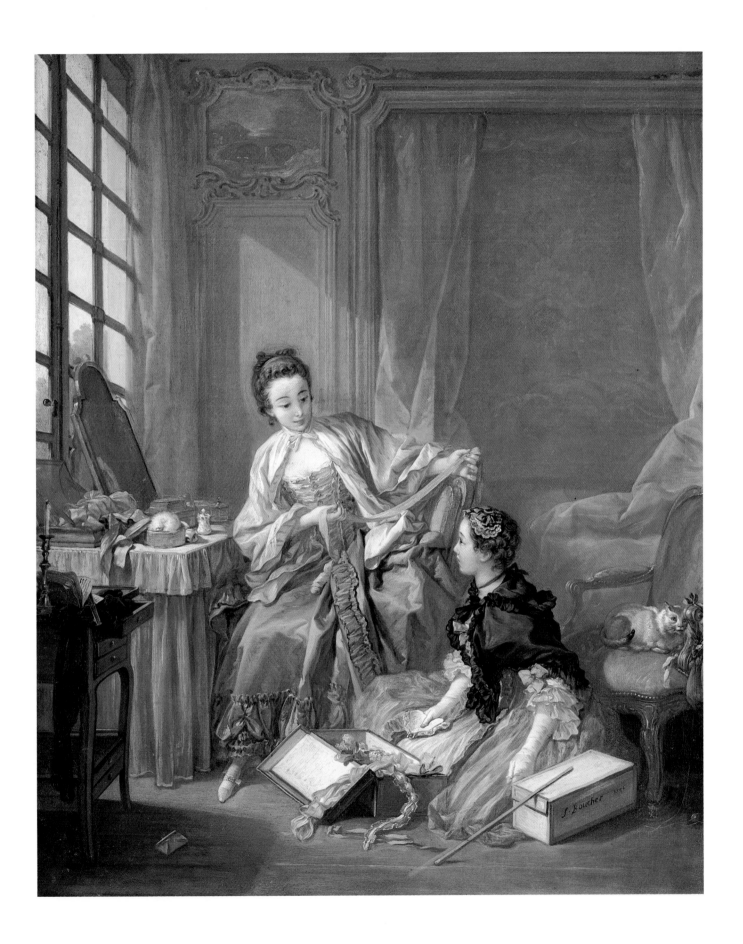

fitting dressing gown tied at the neck and an open bodice (see fig. 40).[5] Like Boucher, Lancret also includes a maid displaying a beautiful piece of fabric, this time some delicate lacework attached to a bonnet, but here the lady's attentions are directed at a prelate, who seems unable to take his eyes off her exposed breast. Boucher—no doubt remembering for whom he was painting the picture—avoids any such scandal, depicting an upright and levelheaded lady of the house, one who assesses the milliner's wares with a discerning eye. Even the cat, which in Boucher's *La Toilette* (cat. 12) assumes an expression and pose appropriate to the nefarious goings-on, here presents a perfect model of decorum and propriety. The picture—notwithstanding the interpretation given in Gaillard's engraving—would have been in pointed contrast to the others in the series, as described in Berch's letter, with their ribald images of an encounter at the Palais Royal, an intimate rendezvous, and a festive night at the ball. Significantly, all these later scenes take place in the public realm where, it is implied, women are most exposed to intrigue and danger. The woman in *The Milliner* is at home, in her own domestic sphere, and Boucher's painting seems to suggest that it is in this environment that she is able—like her

counterparts in *Le Déjeuner* (see fig. 3)—most appropriately to express her authority and will. Twelve years later the artist would paint Madame de Pompadour, the king's *maitresse en titre,* in a similar guise (fig. 44), underscoring the degree to which such ostensibly intimate subjects could be given public expression.[6]

1. "Les Dieux ont prix plaisir à vous rendre parfaite, / Et ces vains ornemens qu'à tort vous empruntez, / Ne servent qu'à cacher de réelles beautés; / Quitez donc pour toujours, Philis, votre toilette, / Voulez-vous exciter les plus vives ardeurs, / A vos aimables loix soumettre tous les coeurs, / Ainsi qu'en l'âge d'Or sans fard et sans paurure, / Montrez-vous dans l'état de la simple nature." The print (Jean-Richard, 1978, 258, no. 1024) was actually made after a replica of the Stockholm painting, now in the Wallace Collection, London (see Ingamells, 1989, 83–85, P390).
2. See Lichtenstein, 1987, 77–87.
3. The circumstances of the commission and Boucher's problem in fulfilling it are fully discussed by Alastair Laing in New York, Detroit, and Paris, 1986–87, 224–29.
4. The letter, written in October 27, 1745, is quoted in ibid., 226.
5. The influence of Lancret's *Morning* on Boucher's picture is discussed by Mary Tavener Holmes in New York and Fort Worth, 1991–92, 51–52, 90–91. Holmes points out that Boucher would have access to Lancret's image through the engraving issued in 1741.
6. Ananoff and Wildenstein, 1976, vol. 2, no. 497, fig. 1386; Goodman-Soellner, 1987.

14. Les Sabots

1768
Oil on canvas, 25 3/16 × 21 1/8 in. (64.0 × 53.7 cm)
Signed and dated: f. Boucher / 1768
Art Gallery of Ontario, Toronto, purchase, Frank P. Wood Endowment, 1978

Provenance: Madame Bertin, by 1773; de Lafontaine de Savigny; his sale, Paris, April 5–6, 1880, lot 4; private collection, London; Wildenstein and Co., New York; purchased in 1978.

Selected Exhibitions: New York, 1980, no. 35; Tokyo and Kumamoto, 1982, no. 68.

Selected References: Ananoff and Wildenstein, 1976, vol. 2, no. 653, fig. 1704; Hyde, 1996, 35, 41–42, 54, 56–57, fig. 5.

Of the many categories of subject matter that Boucher explored, the pastoral is the one with which he is inevitably associated, and the one that, late in his life, would condemn him in the eyes of some contemporary critics ("Will I never be done with these cursed pastorals?" Diderot lamented in his review of the Salon of 1765).[1] The precise brushwork and meticulous rendering of objects in Boucher's earlier interior scenes such as *The Milliner* (cat. 13) gave way in many of these works to a much broader handling that eschewed details and carefully worked surfaces. This development may have been in part compensation for the artist's failing eyesight, but it nevertheless exposed Boucher to the charge that his works were painted too quickly and lacked finish. Yet even if by this late date Boucher was at the summit of his official career—in 1765 he had been named First Painter to the King and elected director of the academy—he had ceased to be a major presence at the Salons. In 1769, the year after he painted *Les Sabots,* he exhibited only one, albeit grand, work, *The Return from Market* (Museum of Fine Arts, Boston).

Nevertheless, *Les Sabots* is an exceptional example of the artist's late pastoral mode in a relatively small format. It is a quintessential rococo painting, marked by rich, fluid passages of paint, resonant color combinations, and curving and serpentine lines that echo the oval format, itself a hallmark of the style. Moreover, the subject of the painting reminds us of an important aspect of Boucher's career, for, as has recently been recognized, *Les Sabots* was based on a scene from an opéra comique of the same title by Jacques Cazotte and Michel-Jean Sedaine that was first performed by the Italian Comedians in Paris on October 26, 1768.[2]

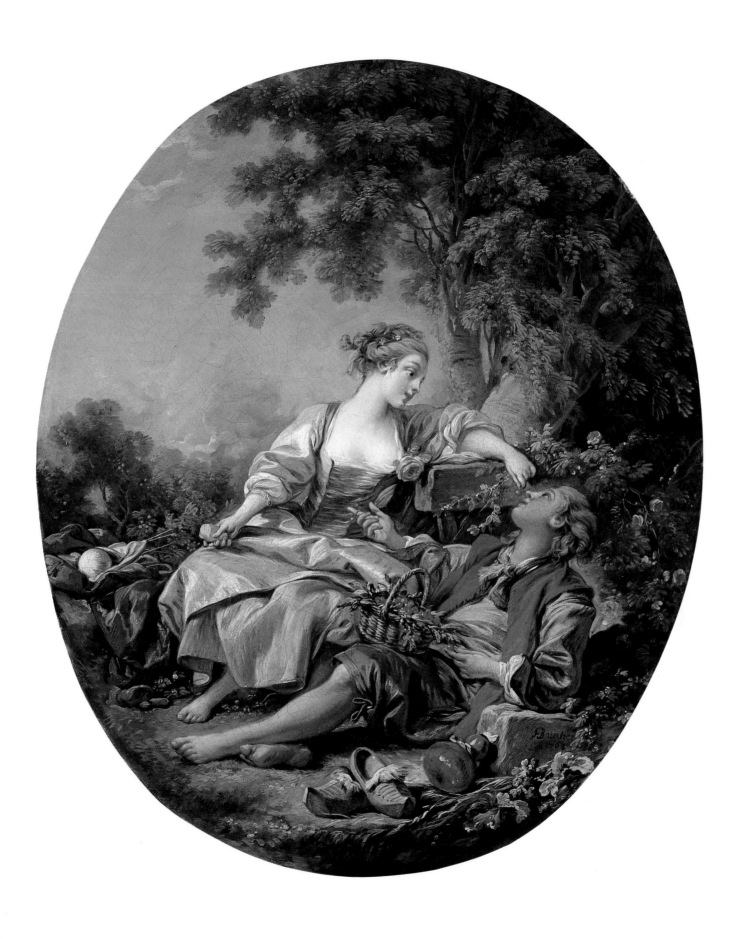

Thus the picture, signed and dated 1768, must have been completed with some haste in the final weeks of the year—testimony to the painter's fluency and speed of execution.

The convoluted story of the play concerns Babet and her love for the shepherd Colin. Babet has been caught by an elderly farmer, Lucas, eating cherries from his tree. When Babet refuses a kiss in exchange for the stolen fruit, Lucas takes her wooden clogs (*sabots*), basket, and brioche. Colin joins Babet and the two play a lovers' game, alternately feeding each other cherries. This is the moment depicted in Boucher's painting, with Colin reclining at Babet's feet. Eventually Babet borrows Colin's clogs (we see them in the lower center of the painting) so that she may recover her own. Because it has begun to rain, she leaves Colin her cap, collar, and apron, which he promptly dons. The old farmer Lucas returns and—mistaking the cross-dressing Colin for Babet—tells him that he knows that Babet loves Colin. The exchange of clothes and resulting role reversal between Colin and Babet—recalling the mythological subject of Hercules and Omphale, which Boucher had treated early in his career—is subtly alluded to in the present painting in the placement and attitudes of the figures: Babet is seated upright in the center of the composition while Colin reclines at her feet: he is in an "unnaturally" subservient, "female" position. At the end of the play the young lovers marry. As the reviewer in the *Mercure de France* noted, the operetta presented "a dramatic tableau . . . in the taste of those that M. Boucher gives us in his ingenious compositions,"[3] while another observer called it "nothing but a trifle, but a very pretty trifle."[4] Both the play and the painting represent the last breath of traditions that would soon be usurped: the opéra comique by a new, more serious type of alternative theater, the *drame bourgeois* (a form practiced with equally great success by Sedaine), and Boucher's pastorals by an artist representing a dramatically new direction in genre painting, one who also drew inspiration from the theater: Jean-Baptiste Greuze.

When it was engraved by René Gaillard in 1773, *Les Sabots* belonged to a Madame Bertin, possibly the wife of Henri-Léonard-Jean-Baptiste Bertin (1720–92), a minister and secretary of state for Louis XV and Louis XVI, as McAllister Johnson has proposed. Gaillard's engraving was issued with a pendant, reproducing another Boucher painting belonging to Madame Bertin, called *L'Heureuse fécondité* (Happy Fertility), showing a young woman seated in a landscape with a cupid on her lap.[5] Although this picture is also oval and of similar dimensions to the Toronto canvas—and both were copied in gouache by Pierre-Antoine Baudouin, Boucher's son-in-law—it is unlikely that the pictures themselves were intended by Boucher to be pendants. Not only is *L'Heureuse fécondité* incompatible in theme, compositional structure, and facture, it is dated 1764, four years earlier than *Les Sabots*. Nor in its curious blending of genre and mythology does it appear to illustrate any known play. The engravings were no doubt issued together simply because at that time both paintings belonged to Madame Bertin.

1. Diderot, *Diderot on Art*, 1:29.
2. The connection between the painting and play was noted in the memoirs of one of Boucher's students, J. Christian Mannlich (cited in Jean-Richard, *L'Oeuvre gravé de François Boucher*, 264). McAllister Johnson has discovered that a second performance was given four days later for King Christian VII of Denmark, who so enjoyed the choreography (but apparently not the music by the Neapolitan composer Egide-Romuald Duni) that the opera was performed again the following year in Copenhagen. My discussion is indebted to the research of Professor Johnson, contained in the files of the gallery and incorporated in *Masterpieces in the Collection of the Art Gallery of Ontario: Masterworks Series no. 9*, Toronto, 1982. The connection between Boucher's painting and Sedaine's play has also been made by Daniel Heartz, 1985, 73, and Hyde, 1996, esp. 56 n. 66, 57.
3. "Elle offre un tableau dramatique . . . dans le goût de ceux que M. Boucher nous présente dans ses compositions ingénieuses" (*Mercure de France* [December 1768]: 183; cited in Hyde, 1996, 56 n. 66).
4. "Cette pièce n'est qu'une bagatelle, mais c'est une très-jolie bagatelle" (letter of November 1, 1768, in Maurice Tourneux, ed., *Correspondance . . . par Grimm, Diderot, etc.* [Paris, 1870], 8:200).
5. For the print, see Jean-Richard, *L'Oeuvre gravé de François Boucher*, nos. 1043–44; the painting, recently on the art market (Sotheby's, New York, May 20, 1993), is reproduced in Ananoff and Wildenstein, 1976, vol. 2, no. 583, fig. 1571.

Charles-Joseph Natoire *(Nîmes 1700–1777 Castel Gandolfo)*

*N*atoire's artistic career probably began under his father, the architect and sculptor Florent Natoire *(c. 1667–1751)*, but he subsequently studied in Paris under Louis Galloche *(1670–1761)* and François Lemoyne *(1688–1737)*. Winner of the Grand Prix in 1721, he worked in Italy from 1723 to 1729 and was received into the Royal Academy in Paris in 1734 with Venus Requesting Vulcan to Make Arms for Aeneas *(Musée Fabre, Montpellier)*. Natoire subsequently secured many commissions for historical and mythological subjects; two series, The History of Clovis *(1737; Musée de Beaux-Arts, Troyes)* and The History of Psyche *(1737–39; Hôtel de Soubise, Paris)*, are among the most important contributions to French painting of the rococo period. He also painted many religious subjects, most notably the spectacular decoration of the Chapelle de l'Hospice des Enfants-trouvés in Paris *(1746–50, destroyed)*. A frequent contributor to the biennial Salon exhibitions, he became director of the French Academy in Rome *(1751–77)*, where he oversaw the training of such great painters as Jean-Honoré Fragonard and Hubert Robert. His principal Italian work, a ceiling decoration for the French national church, San Luigi dei Francesi, painted in 1754–56, was harshly criticized, but his refined landscape drawings and watercolors, many made en plein air in and around Rome, would play an important role in the revival of landscape in French art. Although he was much admired by the young pensionnaires in Rome, his administrative skills were criticized, and he resigned from his directorship in 1775. He spent the remaining two years of his life in Italy.

15. The Rest by a Fountain

c. 1737
Oil on canvas, 27 1/4 × 35 7/8 in. (69.0 × 91.0 cm)
Signed, center left: [C] Natoire./.f.
Hood Museum of Art, Dartmouth College, Hanover, N.H.,
purchased through the Mrs. Harvey Hood W'18 Fund and the
Miriam and Sydney Stoneham Acquisition Fund

Provenance: Jean-François de Canchy; sale, Christie's, Monte Carlo, December 4, 1992, lot 49; Didier Aaron, Paris and New York; purchased in 1995.

This unpublished painting relates to an important commission given to Natoire in 1737 to decorate the private apartments of Louis XV at the Château de Fontainebleau. Overseen by Philippe Orry, *directeur-général des bâtiments,* the project was part of a complex renovation that included works by Lancret, de Troy, Boucher, and Carle Van Loo (fig. 45). Natoire completed six canvases—he exhibited several at the Salon of 1737—representing scenes of hunting and fishing, which were installed as overdoors in the large dining room and in the *petit salle à manger;* they remained in place until 1793.[1] Lost since the Revolution, four have recently resurfaced and have been published by Patrice Marandel.[2]

The Hood painting is an autograph version of one of the Fontainebleau canvases, now in a private collection in Italy (fig. 46). Like many decorative pictures, it has been cut down and was probably also originally vertical in format. Its genesis is unclear: too highly finished to have served as a preparatory study, it may be a replica—it is the same scale as the vertical canvas—perhaps kept by the artist as a record of his prestigious commission. The presence of numerous *pentimenti,*[3] and the sheer brio of the brushwork, however, suggest that it predates the canvas now in Italy. Further complicating the matter, the latter version is signed and dated 1749 rather than 1737. Marandel suggests that Natoire applied this date—twelve years

45. Carle Van Loo, *Halte de Chasse,* Salon of 1737, oil on canvas, Musée du Louvre, Paris, photo R.M.N.

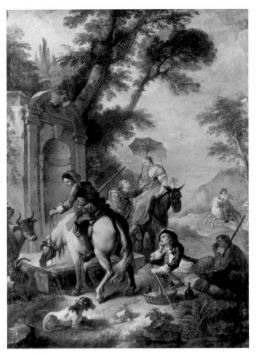

46. Charles-Joseph Natoire, *The Rest by a Fountain*, 1749, oil on canvas, private collection.

47. Charles-Joseph Natoire, *detail* of cat. 15 before cleaning.

after he completed the painting—when the king's rooms underwent renovations that year, necessitating a repositioning of the overdoors in the paneling. The appearance of the present horizontal version suggests another possibility: that it is Natoire's original, installed at Fontainebleau in 1737, and was perhaps damaged during the reinstallation of the *boiseries* in 1749. Natoire was thus compelled to paint a second version (fig. 46), which he signed and dated "Natoire f[ecit] 1749" (Natoire made it in 1749). He retained the present picture, salvaging it by cutting away the damaged areas and repainting the dog's head—awkwardly cropped at the bottom left—as a rock, a detail that was still visible until a recent cleaning removed it (fig. 47).[4]

Whatever its origins, *The Rest by a Fountain* is testament to the sophistication and elegance of decorative painting during the reign of Louis XV. The subject, such as it is, is an idealized melding of social and class types, all brought together in a rugged landscape setting. A hunting party has stopped to rest at an elaborate and overgrown fountain. One hunter waters his horse, to the apparent consternation of a young herdsman, while two others sit on the ground, picnic basket and wine bottles close at hand; two riders gallop into the scene in the right background. In the center a fastidious young man in a green velvet suit helps his lovely companion—sporting a milkmaid's outfit and holding a parasol—alight from her mount. The subject, if not the style, has its origins in Flemish painting, but also in the *fêtes galantes* of Watteau, in particular the lat-

ter's late *Halt During the Hunt* (fig. 48) in which we see such similar motifs as the reclining figure and the gentleman assisting a lady off a horse.[5]

The theme of the hunt—the focus of most of the paintings commissioned by Orry for Fontainebleau—was especially popular in art during the reign of Louis XV. The king's interest in the sport resulted in a series of commissions on the subject from a number of artists.[6] Famous for its vast hunting grounds, Fontainebleau was a particularly appropriate setting for such scenes. Yet *The Rest by a Fountain* is also a paean to the pleasures of being outdoors. Using landscape as a setting for social interaction and flirtation, it continues the tradition of the *fête galante* invented by Watteau in the previous generation. A variety of social types has converged on the site to hunt, tend their herds, or simply take in the sun. Contrasting elements underscore the traditional dichotomy between city and country: the architecture of the fountain is set against the mountainous landscape; the rugged hunters and rustic herdsman are distinguished from the fashionable couple, clearly city folk slightly out of place in the countryside; the intermediary figure is the reclining gentleman who, dressed in city clothes, assumes the pose of an ancient river god, representing an ideal merging of nature and culture. This figure, seemingly in a state of reverie before nature, anticipates the commentaries of Jean-Jacques Rousseau later in the century. The magic of Natoire's painting lies in its synthesis of these disparate elements into convincing and beautiful unity.

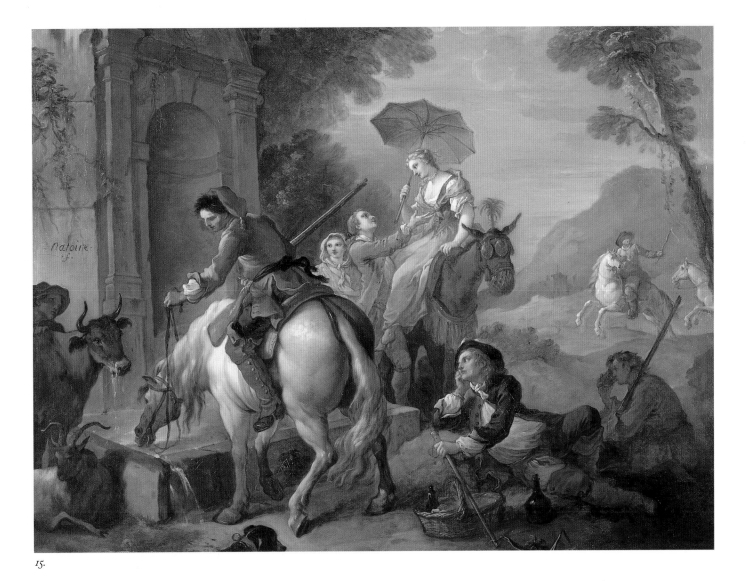

15.

48. Antoine Watteau, *Halt During the Hunt*, c. 1720, oil on canvas, reproduced by permission of the Trustees of the Wallace Collection, London.

1. Boyer, 1949, 70–71, nos. 294–99. See also Engerand, 1900, 312–13. Natoire exhibited five of the paintings in 1737: "M. Natoire exposa aussi trois tableaux faits pour le roi, représentant un repos de chasse, un embarquement et une fête marine, avec deux autres en rond, dont un sujet tiré du pastor fido" ("Exposition de tableaux et nomination de nouveaux officiers à l'Académie royale de peinture et de sculpture, 6 juillet 1737"; Del. 1202; McW. 0005).

2. Marandel, 1992, 129–34; two are in a private collection in Italy and two recently appeared at auction (Christie's, New York, January 16, 1992, lots 125–26).

3. Most prominent in the front legs of the horse galloping in the background and in the positioning of the rifle held by the central hunter, but there are also adjustments in the contours of the reclining man and the dog's head.

4. The other canvas now in Italy, *Fishing* (Marandel, 1992, fig. 3), is also signed and dated 1749 and may likewise be a second version. As part of the same sequence of paneling, the original version of this composition may similarly have been damaged. On the basis of photographs, the two paintings dated 1749 appear rather stiff and mechanical, lacking Natoire's usual fluency, which is so readily visible in the other surviving Fontainebleau canvases (not dated, Marandel, 1992, figs. 1–2) and in the Hood version. Admittedly no documentation has surfaced to suggest that Natoire had to repaint the two works. It is worth pointing out, however, that in 1748 Natoire was commissioned to paint a seventh picture, representing a group of young people at the foot of a staircase in a garden, for the dining room at Fontainebleau (see Engerand, 1900, 313).

5. Ingamells, 1989, 366–70, no. P416; in 1731 the painting was engraved in reverse by Michel Aubert (cat. P1; see fig. 79).

6. See Conisbee, 1981, 157–59.

Jean-Siméon Chardin *(Paris 1699–1779 Paris)*

The son of a Parisian cabinetmaker, Chardin studied art with Pierre-Jean Cazes (1676–1754) and Noël-Nicolas Coypel (1661–1722). He was never formally trained at the Royal Academy, having become in 1724 a member of the Académie de Saint-Luc, the artists' guild. Nevertheless, his remarkable talent at still-life painting—first made evident in two compositions, The Skate *and* The Luncheon *of 1728 (both Musée du Louvre, Paris)—convinced the officials of the academy to accept him as a member. In the early 1730s, perhaps seeking to elevate his art, Chardin turned to painting scenes of everyday life. These sober and carefully composed pictures, usually focused on one or two figures attentively engaged in work or at play, were greatly admired, for example by Diderot, who marveled as much at the artist's technique as at his choice of subject. Chardin's genre scenes celebrate the domestic world of the middle-class household, with its meditative servants, attentive governesses and mothers, and playful children. Chardin participated in every Salon from 1737 to 1779 and served as* tapissier *(the person in charge of the installation of the Salon exhibitions) from 1755 onward. He also was elected treasurer of the academy. With the emergence of Greuze and other genre artists in the mid-1750s, Chardin returned to still-life painting as well as portraiture, succeeding at the latter with a series of brilliant pastels. His works were collected by the most elevated connoisseurs of the day, including Luisa Ulrica of Sweden and Catherine the Great of Russia, while the many prints after his paintings reached a much wider audience. Plagued by illness for more than eight years, Chardin died in his quarters at the Louvre in 1779.*

16. The Kitchen Maid

1738
Oil on canvas, 18 1/8 × 14 3/4 in. (46.2 × 37.5 cm)
Inscribed at upper left of chopping block: Chardin / 1738
National Gallery of Art, Washington, D.C., Samuel H. Kress Collection

Provenance: Probably acquired by Prince Joseph Wenzel von Liechtenstein (d. 1772) when ambassador to France [1737–41]; by descent to the princes of Liechtenstein, Vienna, and Vaduz, until at least 1948; Frederick Mont, Inc., New York; sold in 1951 to the Samuel H. Kress Foundation, New York; given to the National Gallery of Art in 1952.

Selected Exhibitions: Probably Paris, Salon of 1739; Paris, 1907, no. 22; Lucerne, 1948, no. 8.

Selected References: Schéfer, 1904, 59; Wildenstein, 1933, no. 46, fig. 45; Wildenstein, 1969, no. 168, fig. 75; Eisler, 1977, 311–13, fig. 278; Rosenberg, 1983, no. 116, colorplate XXVIII; Conisbee, 1985, 128–32, fig. 120; Roland Michel, 1996, 41, 122, 160, 209, 213, 249, 258, colorplate 42.

The Washington *Kitchen Maid*—sometimes called *The Turnip Scraper* or *Woman Peeling Vegetables*—is in all likelihood the prime version of a composition the artist treated several times, and the one that he exhibited at the Salon of 1739. There it formed part of a remarkable suite of genre pictures that included such masterpieces as *The Governess* (cat. 17) and *The Return from Market* (see fig. 49). All three paintings, along with a fourth, *Meal for a Convalescent* (National Gallery of Art, Washington, D.C.), were acquired by the Prince of Liechtenstein, who was ambassador to France from 1737 to 1741.[1] Together the four paintings represent the full range of Chardin's genre repertoire, including both "upstairs" governesses and nurses and "downstairs" servants such as *The Kitchen Maid*. If at the Salon the present painting did not generate the enthusiastic responses enjoyed by the other works—especially *The Governess*—it may be because the pensive quietude of the servant, who pauses in her humble chore, so thoroughly resists easy interpretation.[2] Indeed, of all Chardin's genre scenes, *The Kitchen Maid* is the least anecdotal, and the one that arguably most closely resembles his still lifes. In Chardin's hands all the elements in the painting—particularly the maid—are constructed as solid, immobile forms, lovingly observed, and rendered with a consistently rich and impasted technique, almost as if they were carved rather than painted with the brush. The dense bulk of the servant, set so solidly on her chair, echoes the palpable shapes of the chopping block, the bowls and pots, and the vegetables that surround her; she becomes one more series of volumes to be given convincing form. In this regard the verses appended to Lépicié's 1742 engraving of the composition, focusing as they do on the foodstuffs, seem less bizarre than they otherwise might: "When our ancestor took from Nature's hands / These vegetables, proof of their simple way, / The art of making food into poison / Had not yet seen the light of day."[3] While in *The Governess* Chardin represented the modest elegance and understated refinement of an *haute bourgeois* household, in *The Kitchen Maid* he shows the bottom of the food chain, as it were, with its raw, earthy vegetables, bloodstained chopping block, and slumped servant.

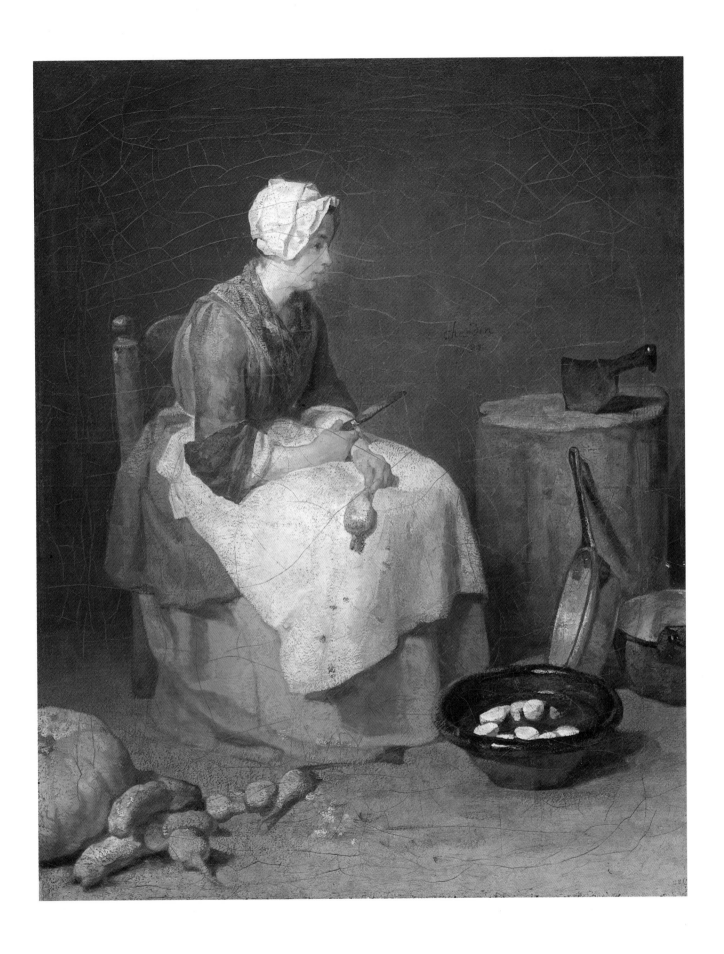

Despite the differences in attitude and dress between the governess and the kitchen maid, Chardin apparently employed the same model for both, a young woman recognizable by her turned-up nose, red lips, and slight overbite; she appears, in various guises, in a good number of Chardin's genre scenes. As Marianne Roland Michel has recently suggested, this maid may have been a member of the artist's own household; Chardin was said to insist on having the subject he was painting directly before him, and many of the everyday objects depicted in his paintings are known to have belonged to him.[4] In the case of the young model, Chardin seems to have cajoled her into dressing the parts of various domestic servants, for she appears in his paintings not only as a kitchen maid and governess, but also as a laundress, a scullery maid, a girl returning from the market, and perhaps even as the mother in *Saying Grace* (cat. 18).[5]

Whether the artist intended any profound meaning in *The Kitchen Maid* is speculative. For once the verses on the engraving avoid an erotic or overtly moralizing interpretation. Many scholars have noted the relationship between this kitchen maid and the idle or lazy servants that are common to seventeenth-century Dutch painting and that were given new life in Chardin's time by Jean-Baptiste Greuze, but the connection is probably more a casual correspondence of type than a shared meaning.[6] In Greuze's *Indolence* (cat. 26), for example, the admonitory message is obvious in the servant's disheveled state and in the objects that surround her. Lépicié's verses for the engraving of *The Kitchen Maid* may be understood as a general plea for tem-

perance and a modest lifestyle,[7] but the ultimate meaning of Chardin's image is more illusory. We can only speculate about the thoughts that run through the servant's head as she pauses, self-absorbed, in her task. It is this very elusiveness, its open-ended meaning, that is at the center of Chardin's appeal, and that keeps his work firmly within the rococo tradition.

1. The Liechtenstein Chardins are now divided between the National Gallery of Art, Washington, D.C., and the National Gallery of Canada, Ottawa. As Pierre Rosenberg has noted, *Meal for a Convalescent* (Washington) was not exhibited until 1747 and was probably acquired by the prince at that time; see Paris, Cleveland, and Boston, 1979, 285.
2. An exception was the Abbé Desfontaines, who felt that *The Kitchen Maid* was the equal of *The Governess* ("Exposition de peintures, sculptures et gravures," *Observations sur les écrits modernes* 19 [September 26, 1739]; Del. 1210; McW. 0016).
3. "Quand nos ayeux tenoient des mains de la nature, / Ces légumes, garants de leur simplicité, / L'art de faire un poison de notre nourriture / N'étoit point encore inventé" (Roland Michel, 1996, 276).
4. Ibid., 213–14. According to P. J. Mariette (1749), "M. Chardin is obliged to have the object he wishes to imitate continually before his eyes, from the first sketch right up until he has applied the final brushstrokes" (M. Chardin est obligé d'avoir continuellement sous les yeux l'objet qu'il se propose d'imiter, depuis la première ébauche jusqu'à ce qu'il ait donné les derniers coups de pinceau [*Abécédario* (Paris, 1851–53), 1:360]). For the relationship of the objects represented in Chardin's paintings to the objects in his household, see Paris, Cleveland, and Boston, 1979, 67–71.
5. See Rosenberg, 1983, nos. 81, 114, 115, among others.
6. Eisler, 1977, 312; Conisbee, 1985, 128–31, fig. 121, compares Chardin's *The Kitchen Maid* to Nicolaes Maes's *Woman Scraping Parsnips* (National Gallery, London) and Gabriel Metsu's *Apple Peeler* (Musée du Louvre, Paris). See also Snoep-Reitsma, 1973, 183–85.
7. Snoep-Reitsma, 1973, 182–83.

17. The Governess

1739
Oil on canvas, 18 3/8 × 14 3/4 in. (46.7 × 37.5 cm)
Signed and dated left of center: chardin / 1739
National Gallery of Canada, Ottawa

Exhibited in Toledo only

Provenance: Chevalier Despuechs, Paris, 1739; acquired in Paris by Prince Joseph Wenzel von Liechtenstein, ambassador to France, by 1741; by descent to the princes of Liechtenstein, Vienna, and Vaduz; purchased through Thomas Agnew's, London, in 1956.

Selected Exhibitions: Salon of 1739, Paris; Lucerne, 1948, no. 6; Seattle, 1962, no. 35; London, 1968, no. 134; Toledo, Chicago, and Ottawa, 1975–76, no. 14; Paris, Cleveland, and Boston, 1979, no. 83, 260–62; Vancouver, 1983, 44.

Selected References: Schéfer, 1904, 59, 70, ill. opposite 40; Wildenstein, 1933, no. 87, fig. 19; Wildenstein, 1969, no. 191, pl. 29; Rosenberg, 1983, no. 117, colorplate XXIX; Conisbee, 1985, 162, colorplate 145; Laskin and Pantazzi, 1987, 1:74–79, fig. 176; Roland Michel, 1996, 41, 44, 67, 110, 121, 160, 192, 209, 213, 240, colorplates 36, 43, 54.

Of the six genre paintings Chardin exhibited at the Salon of 1739, *The Governess* was singled out as his greatest accomplishment—"the work that attracted the most applause," wrote the critic in the *Mercure de France*.[1] According to Mariette (1749) it was the picture that secured Chardin's reputation,[2] and it has remained his most enchanting depiction of an adult instructing a child, a theme that occupied him throughout his career as a genre painter (see cats. 18 and 20). If observers in 1739 universally admired the picture's warm tones, viscous brushwork, and luminosity—one critic compared it to the works of Rembrandt and Teniers—they were less certain about the nature of the exchange between the two figures: whether "the young schoolboy [is] reprimanded by his governess

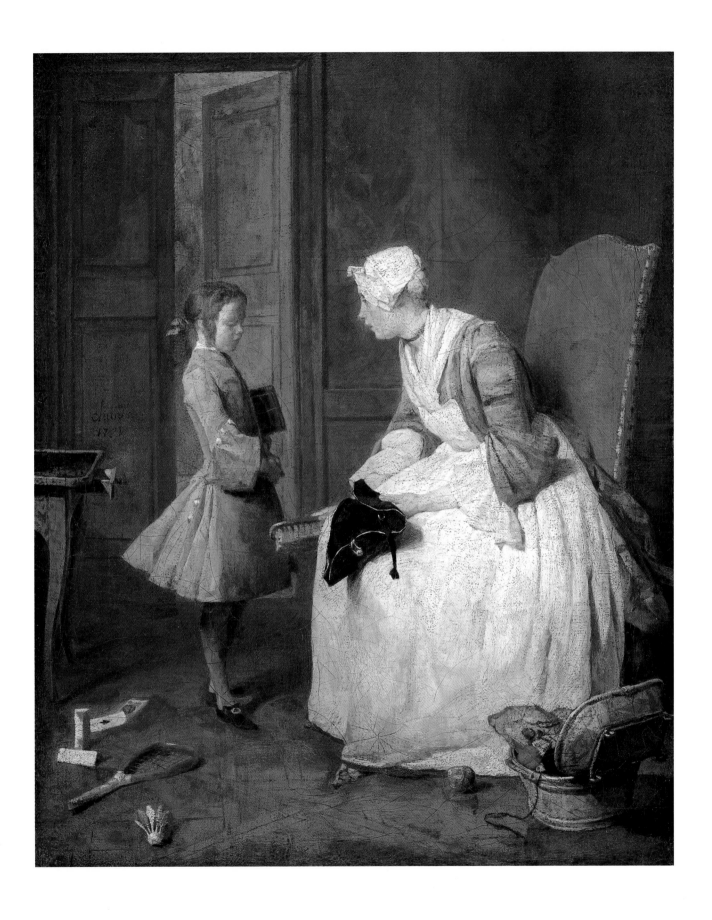

49. Jean-Siméon Chardin, *The Return from Market*, 1738, oil on canvas, National Gallery of Canada, Ottawa.

of the adult and the child, a theme reinforced by the juxtaposition of her open sewing basket and his discarded toys, Chardin reminded his audience that childhood was a distinct stage in life; the boy may be dressed like a little man, ready to venture out into society, but he still has his childish needs and wants.

According to Mariette, *The Governess* was intended for Jean de Jullienne, the great friend and collector of Watteau, but it was purchased instead by "a banker named Despuechs." Sometime after the Salon, however, it was acquired, along with *The Kitchen Maid* (cat. 16) and *The Return from Market* (fig. 49), by Prince Joseph Wenzel von Liechtenstein, ambassador to France between 1737 and 1741, with whose heirs it remained until the 1950s.[6] At the Salon *The Governess* was hung above *The Return from Market*, with a landscape by Oudry in between.[7] Together the works form a dynamic and complementary pair, evidently meant to contrast two aspects of household service. The downstairs maid, returning from her marketing, pauses as she sets down her loaves of bread, as if listening to the exchange between a young girl and a man at the door, just visible in the next room. Her monumental form is posed with a languid elegance that is altogether distinct from the concentrated attention of the governess. At the Liechtenstein gallery, however, *The Governess* was evidently paired with *The Kitchen Maid* (cat. 16).[8] Although in this combination the number of figures is different, the pairing repeats the contrast between upstairs and downstairs servants. Moreover, both maids are seated, leaning toward each other in similar voluminous dresses, and there is an engaging sequence of visual and iconographic relationships that come into dynamic play: the earthy pumpkin and turnips mirroring the child's toys, a ceramic bowl echoing the round forms of the sewing basket, the solid chopping block set against the elegance of a side table. Even if, as has already been suggested (see cat. 16), Chardin used the same model for both kitchen maid and governess, he nevertheless clearly separates their worlds, distinguishing between one of monotonous labor in a dank cellar kitchen and one, demanding more patience and wit, in the refined interiors of the living quarters.

for soiling his hat," or she "is hearing the lesson of a little boy, while brushing his hat, before sending him off to class."[3] Both descriptions have merit, for while the presence of books and the open door indicate that the boy is about to leave for school, he appears not to be speaking but rather to be listening to the governess's words. Lépicié's beautiful engraving (cat. P19; see fig. 28), however, includes verses suggesting that, appearances notwithstanding, his thoughts are wandering: "Despite this child's submissive air, / And his hypocritical little look, / I'll bet his mind's already there / Back to playing with his shuttlecock."[4]

Though rather inelegant, these verses do manage to capture something of the essence of Chardin's image, which contrasts the worlds of adults and children with a naturalism and charm still familiar to modern viewers. As Cochin put it in his obituary of 1780, "[Chardin's] paintings had an extremely rare quality, that of truth and naiveté, both in his expressions and in his compositions. . . . It is truth and nature which most people seek out— this is why M. Chardin had so much success at all of his exhibitions."[5] The little boy, his mouth firmly set as he gazes sidelong at his hat, strikes a mischievous, even petulant note, but Chardin does not appear to condemn; his purpose seems rather to have been to convey a commonplace "truth" about childhood behavior and the obligation of adults to guide it and shape it. By contrasting the worlds

1. "Le morceau qui attire le plus de suffrages" (Del. 1209).
2. P. J. Mariette, *Abécédario* (Paris, 1851–53), 1:358. A second, apparently autograph, version has recently been exhibited and published by Alastair Laing (see London, 1995, 192–93, 222–23, no. 71).
3. "Le jeune écolier grondé par sa gouvernante, pour avoir sali son chapeau" ("Exposition des tableaux . . . de l'Académie royale," *Mercure de France* [September 1739]; Del. 1209; McW. 0014); "Une gouvernante qui fait dire la leçon à un petit garçon, pendant qu'elle lui vergete son chapeau pour l'envoyer en classe, est aussi d'un naturel étonnant" ([Neufville de Brunhaubois-Montador], *Description raisonnée des tableaux exposés au Salon du Louvre* [1739]; Del. 11; McW. 0018).

4. "Malgré le Minois hippocrite / Et l'air soumis de cet Enfant, / Je gagerois qu'il prémédite / De retourner à son volant" (quoted in London, 1995, 223; translation by Alastair Laing).
5. Quoted in Roland Michel, 1996, 269.
6. Mariette, *Abécédario*, 1:358; Pierre Rosenberg (Paris, Cleveland, and Boston, 1979, 260) has tentatively identified this early owner as a member of the Delpuech de la Loubière family.
7. *Explications des peintures . . . de l'Académie Royale* (Paris, 1739), 8 (Del. 9).
8. Laskin and Pantazzi, 1987, 77.

18. Saying Grace

c. 1740–42
Oil on canvas, 19 1/2 × 16 1/8 in. (49.5 × 41.0 cm)
Musée du Louvre, Paris, M.I. 1031

Provenance: Possibly the painting in the December 18, 1779, inventory of Chardin's estate; Madame Chardin; her estate inventory, June 6, 1791; Baron Vivant Denon (1747–1825); his sale, Paris, May 1, 1826, lot 145; Daniel Saint (1778–1847); his sale, Paris, May 4, 1846, lot 48; acquired by Dr. Louis La Caze; bequeathed by La Caze to the Louvre in 1869.

Selected Exhibitions: New York, 1935–36, no. 22; Paris, Cleveland, and Boston, 1979, no. 87.

Selected References: Schéfer, 1904, 53 (ill.); Wildenstein, 1933, no. 75, 162; Wildenstein, 1969, no. 199, fig. 91; Duncan, 1973, 570, fig. 2; Rosenberg, 1983, no. 120A, ill.; Compin and Roquebert, 1986, 3:124, ill.; Roland Michel, 1996, 54, 214, colorplate 215.

One of the most familiar images in French painting, *Saying Grace* epitomizes Chardin's view of domestic life in mid-eighteenth-century Paris. In a modest middle-class interior, enlivened only by the colorful upholstery of the chairs, a young mother (or governess) waits patiently while a little boy says grace before his meal. The boy's sister watches from across the table as her brother recites his prayer. Like so many of Chardin's genre scenes from the 1730s and 1740s (see cat. 17), *Saying Grace* focuses on an adult instructing a child, thus preparing the next generation to be dutiful and responsible members of society. Here the mute intimacy of the scene is enhanced by the figures' complete absorption in their private communion, which is played out without awareness of the viewer's potentially intrusive presence.

The theme itself was not unusual in art and would undoubtedly have been familiar to Chardin's public through its representation in seventeenth-century Dutch painting, but also by earlier French artists such as Antoine Le Nain (fig. 50).[1] The subject continued to enjoy popularity later in the eighteenth century, being treated, for example, by Greuze in a finished drawing that was engraved by Pierre Laurent (cat. P16; see fig. 83).[2] Both of these works emphasize the role of the mother in leading the children in prayer, although each in its own way—the broadly handled characterization of the grinning boy in the Le Nain and the sloppy household and grumpy children in Greuze's image—undermines the pious nature of the theme.

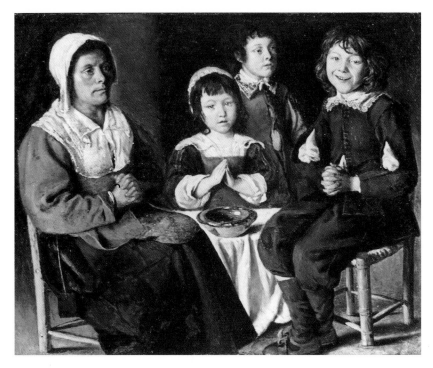

50. Antoine Le Nain, *Saying Grace,* oil on copper, © The Collection of the Frick Art Museum, Pittsburgh, Pennsylvania.

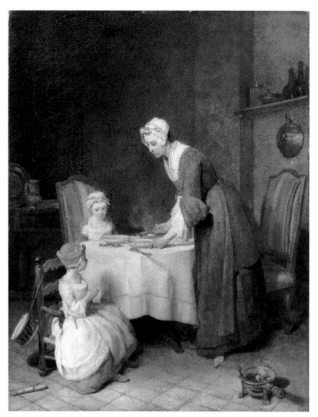

51. Jean-Siméon Chardin, *Saying Grace,* Salon of 1740, oil on canvas, Musée du Louvre, Paris, photo R.M.N.

Chardin's serene image, by comparison, maintains an appropriate dignity: the room is spic-and-span, the table is neatly set, the children are well behaved, and a reverential hush pervades the scene. More than a simple lesson in religious niceties, Chardin's painting as a whole presents an image of middle-class virtue, from warm familial sentiment to modesty and cleanliness. The verses appended by Lépicié to his engraving of the composition, issued in 1744, thus strike us as unnecessarily anecdotal: "The sister slyly laughs at her little brother / Who stammers out his grace. / He hurries through his prayer without troubling himself, / His appetite is the reason."[3] If Chardin does not reveal much in his characterizations of the figures, typically keeping their expressions reticent and their gestures modest, there seems little reason to believe that he intended such a mundane reading of his painting; one is more apt to agree with a contemporary commentator, who, when faced with a version of the picture in 1740, exclaimed: "How elegant, how natural, and true! The viewer feels more than he can put into words."[4]

Chardin painted several variants of *Saying Grace,* which he exhibited at the Salons of 1740, 1746, and 1761. The painting included here—one kept by the artist throughout his life and included in the celebrated La Caze bequest to the Louvre in 1869[5]—is an autograph repetition based on a painting, also in the Louvre, which he had exhibited in 1740 (fig. 51). That work, together with a second, *The Diligent Mother*—showing a woman instructing her daughter in embroidery (see fig. 26)—were given to Louis XV after Chardin was presented to the king following the close of the Salon. Along with *The Bird-Song Organ* (see cat. 19), a version of which was purchased for the royal collection in 1751, these were the only genre pictures acquired by the French crown during Chardin's lifetime. It is uncertain whether Chardin painted the first version of *Saying Grace* specifically for the king or, as Mariette intimated, Louis XV himself chose the picture from Chardin's stock,[6] but in any case, the royal provenance indicates the degree to which the picture was admired in Chardin's lifetime. Indeed, Chardin took unusual care with his composition, scrupulously organizing the elements into a delicate balance and creating a stable and compact central grouping of figures that enhances the overall restraint of the image. The changes he made between the king's picture and the present variant are subtle but telling. In the first version the expressions of the sister and mother are stern and the overall tone is more solemn, whereas in this variant the mother smiles sweetly while the sister's demeanor is better described as impish. The resulting impression is one of an increased sentimentality, in which a mother listens to her child's prayer less with strict rectitude than with loving devotion. The remarks of the critic writing in the *Journal encyclopédique*—in regard to another, horizontal, version (now lost) shown at the Salon of 1761—are appropriate in the present context: "We have already seen a *Saying Grace* by Monsieur Chardin. Today this excellent artist gives us a new one. It's the same background of naiveté, the same truthfulness of expression, but differently conveyed. No doubt he wanted to show that a great master knows to vary that which he repeats."[7]

1. Paris, 1978–79, 149; Snoep-Reitsma, 1973, 190.
2. For the drawing (present whereabouts unknown, datable to c. 1760–65), see *Old Master Drawings,* New York, Paul Rosenberg and Co., 1981, 14, no. 11, ill.
3. "La Soeur en tapinois, se rit du petit frère, / Qui bégaie son oraison; / Lui, sans s'inquiéter, dépêche sa prière / Son apétit fait sa raison" (quoted in Roland Michel, 1996, 278).
4. Quoted in Paris, Cleveland, and Boston, 1979, 270.
5. On La Caze (1797–1869), see Béguin, 1969.
6. P. J. Mariette, *Abécédario* (Paris, 1851–53), 1:358.
7. "On a vu deja un bénédicité de monsieur Chardin. Cet excellent artiste en donne un nouveau aujourd'hui. C'est le même fond de naiveté, la même fidelité d'expressions, mais differemment exprimés. Il a sans doute voulu montrer qu'un grand maître sait varier les choses même qu'il repète" ("Les Tableaux de l'Académie de peinture, exposés dans le Sallon du Louvre. A Paris 1761," *Journal encyclopédique* 6 [1761] [Del. 1273; McW. 0132]).

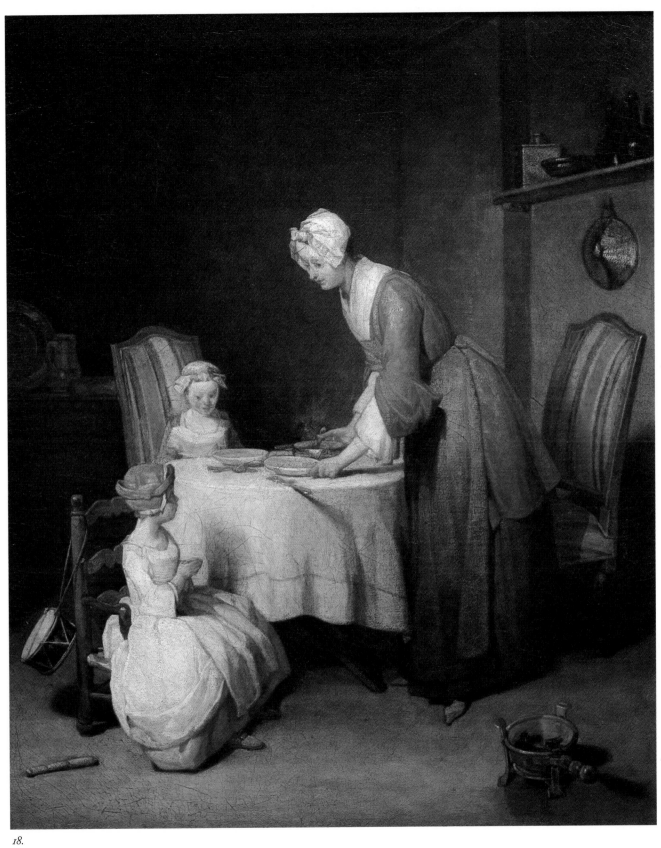

18.

19. The Bird-Song Organ

c. 1751
Oil on canvas, 19 5/8 × 16 3/4 in. (50.0 × 42.5 cm)
Ball State University Museum of Art, Muncie, Indiana,
E. Arthur Ball Collection, partial gift and promised gift of the
Ball Brothers Foundation

Provenance: Etienne-François, comte de Stainville, duc de
Choiseul, Château de Chanteloup, Indre-et-Loire; duc de
Choiseul estate, May 8, 1785; probably Louis-Jean-Marie
de Bourbon, duc de Penthièvre, Château de Chanteloup, Indre-
et-Loire; probably Penthièvre estate, March 4, 1793; acquired by
Charles-Antoine Rougeot, Tours, 1794; Jean-Jacques Raverôt
(son-in-law of Rougeot), Tours; M. Raverôt, Jr., Loches;
M. Augéard (grandson of Raverôt Jr.), Châtellerault, 1932;
Wildenstein and Co., New York; E. Arthur Ball, Muncie; Ball
Brothers Foundation, Muncie; Ball State University Museum of
Art, since 1951.

Selected Exhibition: Notre Dame, 1972, no. 18.

Selected References: Wildenstein, 1933, no. 264; Wildenstein, 1969,
no. 228, fig. 110; Rosenberg, 1983, no. 133B, ill.; Huth and Joyaux,
1994, 91–94, ill. 92.

Remarking on the numerous versions of Chardin's genre paintings, Diderot observed, "Chardin copies himself frequently, which makes me think that his works cost him dearly."[1] For an artist who had made his name as a still-life painter and who had never studied at the academy, Chardin lacked the training to invent and carry out figural subjects easily and, when he had found a composition that was particularly successful, his tendency was to repeat it several times, as long as there was a market for it. *The Bird-Song Organ* is a case in point; Chardin repeated this scene in three versions with hardly any alterations between them. The prime canvas (Musée du Louvre, Paris), exhibited at the Salon of 1751, was actually something of a watershed in the artist's career, representing his first commission from Louis XV. Although he had presented two genre pictures, including a version of *Saying Grace* (see cat. 18), to the king in 1740, for *The Bird-Song Organ* Chardin was paid the substantial sum of fifteen hundred *livres* and was given a second commission, which, for unknown reasons, was never carried out.[2] More elevated in its subject than such "downstairs" scenes as *The Kitchen Maid* (cat. 16), it also included a flattering reference to Antoine Coypel, the First Painter to the King, who was instrumental in Chardin's receiving the commission, by depicting a print of one of Coypel's history paintings, *Thalia Pursued by Painting,* hanging on the wall.[3] Thus the present composition represents an important moment in the history of genre in eighteenth-century France, and Chardin may have wished to replicate his success by returning to the subject several times. The attribution of the Muncie version has sometimes been questioned, but it has tradition-

ally been given a distinguished provenance, first having been owned by the duc de Choiseul and, later, the duc de Penthièvre, although neither has been confirmed.[4]

The subject, as is common with Chardin, is the domestic life of women, in this case an upper-bourgeois lady of the house, who turns from her embroidery (we can make out the frame at the right edge) to play a hand organ; she eyes a canary in its cage, which sings along with the music. Although the caged bird and the harmonies of the music have obvious connotations of love, these aspects of the painting are understated in Chardin's conception. The demure woman—Chardin used his wife as the model[5]—chastely clothed, is whiling away the day with an amusing diversion: indeed, the title given the picture in the Salon *livret* was "Dame variant ses amusements" (A Lady Varying Her Amusements). Critics of the painting and Laurent Cars's engraving after it—issued in 1753—admired the composition, the rapt attention of the woman, and the appropriateness of her activities: "The model whom M. Chardin chose on this occasion portrays a person who is devoted to her honest work, who is full of gentleness, who knows how to occupy herself."[6]

Chardin gave considerable thought to the arrangement of his picture.[7] Unlike in earlier works such as *The Kitchen Maid* (cat. 16) and *The Governess* (cat. 17), in which one or two figures fill the foreground space, here he placed the protagonist deep in the room, where she enters into a visual dialogue with the birdcage placed in dynamic relation to her in the left foreground. The woman and her elegant setting are beautifully illuminated by light falling through a prominent French window—a detail rarely seen in Chardin's oeuvre—recalling seventeenth-century Dutch paintings by such artists as Vermeer and Metsu, while anticipating such later *tableaux de mode* as Garnier's *The Poorly Defended Rose* (cat. 44), a painting whose iconography is decidedly less subtle than Chardin's understated masterpiece.

1. "Chardin se copie volontiers, ce qui me ferait penser que ses ouvrages lui coûtent beaucoup" (Seznec and Adhémar, 1967, 4:83).
2. For a full discussion of the various versions and their provenances, see Paris, Cleveland, and Boston, 1979, 286–90, no. 93. The Louvre version differs from the Muncie variant and the one in the Frick Collection, New York, chiefly in the embroidery workbag, which is red rather than green and is tied to the frame with a big knot.
3. Turner, 1957, 300–301. The king's version later entered the collection of the marquis de Vandières (later Marigny), Madame de Pompadour's brother, who was appointed *directeur-général des bâtiments* in 1752.
4. See Huth and Joyaux, 1994, 93–94.
5. Turner debunked the tradition that the woman is a portrait of Madame Geoffrin (ibid., 303–6).
6. Quoted in Roland Michel, 1996, 59–60.
7. See the rich analysis of the composition of the Frick version by Sheriff, 1988.

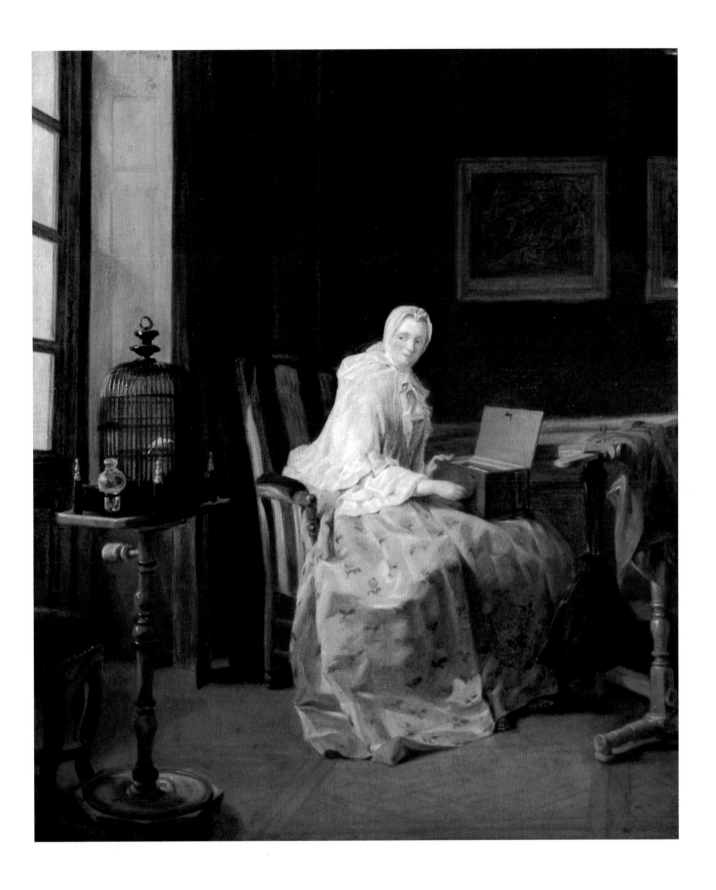

20. The Good Education

c. 1753

Oil on canvas, 16 5/16 × 18 5/8 in. (41.5 × 47.3 cm)
The Museum of Fine Arts, Houston, gift in memory of George R.
Brown by his wife and children, 85.18

Provenance: Ange Laurent de La Live de Jully, Paris, by 1753; his sale, Paris, March 5/May 2–14, 1770, lot 97; Boileau; Count Gustave-Adolphe Sparre, Kulla Gunnarstorp, Sweden, by 1794; by inheritance to Count C. de Geer, Wånas, Sweden, 1837; by inheritance to his niece, Elisabeth Wachtmeister, Wånas, 1855; by descent until 1983; Marlborough Gallery, London; acquired by the museum in 1983.

Selected Exhibitions: Salon of 1753, no. 59; Stockholm, 1926, no. 27; Stockholm, 1958, no. 74; Paris, Cleveland, and Boston, 1979, no. 95.

Selected References: Wildenstein, 1933, 163, no. 85; Wildenstein, 1969, 195, no. 223, pl. 36; Rosenberg, 1983, 102, no. 127A; Hallam, 1985; Museum of Fine Arts, Houston, 1989, 156–57; Roland Michel, 1996, 53, 68, 117, 190, 214, 227, 245, pl. 216.

The early provenance of *The Good Education* has been the subject of some debate, but Pierre Rosenberg convincingly demonstrated that it should be associated with the canvas exhibited at the Salon of 1753.[1] Along with its pendant, *The Drawing Lesson* (fig. 52), it belonged at that time to Ange Laurent de La Live de Jully, one of the most innovative collectors of the day. As the Salon *livret* stated, La Live de Jully's paintings were repetitions after two pictures belonging to the Swedish crown. These prime versions (whose present locations are unknown) had been given by the painter in 1749 to Louisa Ulrica of Sweden, the patron of Boucher's *The Milliner* (cat. 13) and a devoted collector

of Chardin's works. The repetitions shown in 1753 were probably commissioned by La Live de Jully himself; "made for [his] cabinet" were the words in the catalogue of the sale of his collection in 1770. It was in all likelihood at that sale that the pictures were acquired by Count Sparre of Sweden, along with the prime version of Greuze's *The Laundress* (see fig. 64).[2] *The Good Education*, like *The Laundress*, still has La Live de Jully's original frame, with the artist's name prominently displayed in a cartouche.

The Good Education is among the last of Chardin's domestic genre scenes. A modest though well-appointed salon is the setting for an adult instructing a young child, in this case a mother and daughter. Viewers at the time understood the girl to be reciting from the gospels as her elder follows along with the text.[3] The mother has set aside her needlework to give full attention to her daughter, who seems to have stumbled in her recitation. Chardin beautifully captures the tender rapport between them by placing their heads on precisely the same level and leaving an open—but resonant—space in the center of the composition. The soft light pouring through the window illuminates the face of the girl, as if to evoke her dawning spiritual enlightenment. Scholars have pointed out the relationship of *The Good Education* to a passage in Fénelon's *De l'Education des filles* (1693), still an influential educational tract in Chardin's day: "It is necessary to prevail upon young ladies to read the Gospel. Accordingly, select for them a good time of day to read the word of God, just

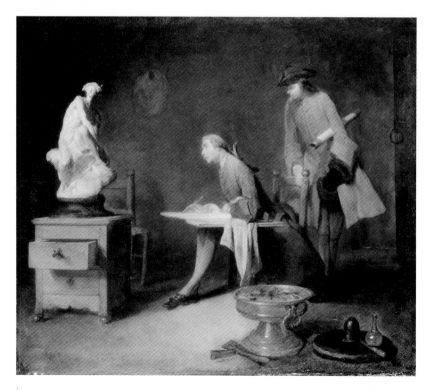

52. Jean-Siméon Chardin, *The Drawing Lesson*, Salon of 1753, oil on canvas, the Tokyo Fuji Art Museum Collection, Tokyo, Japan.

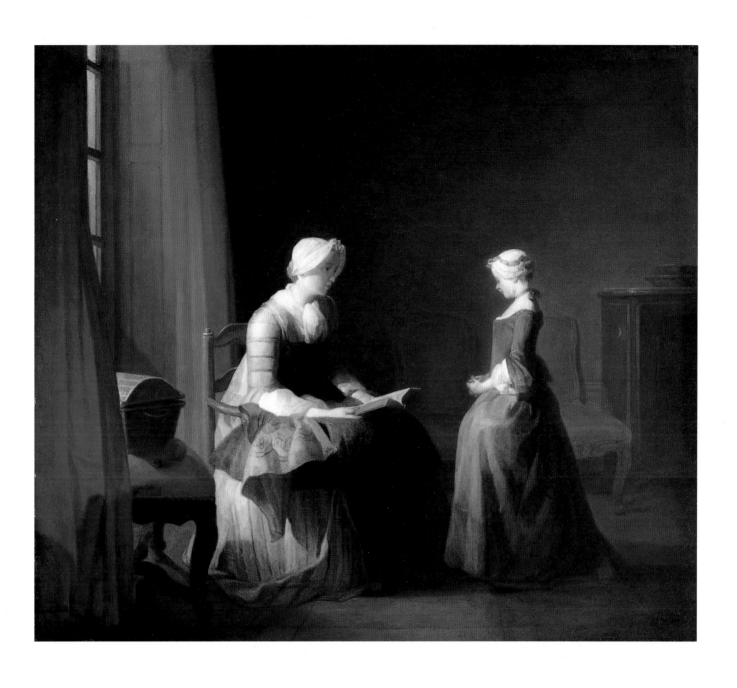

as one prepares them to receive through communion the flesh of Jesus Christ. Above all, inspire young girls with that sober and restrained wisdom which Saint Paul commends."[4] The piety of Chardin's image undoubtedly appealed to its first owner, La Live de Jully, a man known for his sincere and heartfelt religious beliefs.[5] Two years later, he would acquire Greuze's *A Father Reading the Bible to His Family* (see fig. 14), a work of similar theme, although rendered with more picturesque detail.

Education is also the subject of *The Good Education*'s pendant (fig. 52), wherein a young artist sits absorbed before a plaster cast of Pigalle's famous *Mercury*, which he sketches on a drawing pad; his concentration echoes that of the girl in *The Good Education*, and his efforts are also evaluated by a second person, this time a fellow artist or instructor who looks over his shoulder. Like the girl reciting from the Bible, the draftsman learns from a distinguished paradigm, although his study takes place in a studio—possibly even in the Royal Academy's school[6]—while hers is confined to the home, as Fénelon's treatise prescribed.

Though similar in theme to *The Governess* (cat. 17), *The Good Education* marks a distinct change in Chardin's approach to his genre subjects. The format is now horizontal, and the figures are placed farther back from the picture plane, giving them a doll-like appearance. Chardin's brushwork, which in earlier paintings assumed a rich, physical presence of its own, here was delicately applied in much smoother, blended strokes, giving the overall image a blurred, almost foggy appearance, which Rosenberg has insightfully compared to pastel. This was a development noticed by several critics at the Salon of 1753, such as Jacques Lacombe: "It is a handling that produces its total effect only at a certain distance; at close range the painting presents only a kind of haze that seems to envelop all the objects." The Abbé Garrigues de Froment—who wrote of this effect as a "mist that does not dissipate"—was more forthright: "Nowadays he labors over his work, he polishes it. Do we benefit from this change in manner and way of working? Informed connoisseurs maintain that we do not."[7] Of the nine paintings Chardin exhibited that year, the one that was most often singled out for praise was a portrait of the painter Joseph Aved, known as *The Philosopher* (Musée du Louvre, Paris), which had been painted nearly twenty years before.[8] Such criticism of his recent work was probably one of the reasons Chardin returned shortly thereafter almost exclusively to painting still lifes. Yet the distinguished provenance of *The Good Education* is eloquent testimony to Chardin's reputation, the critics' response to the painting notwithstanding.

1. This provenance was offered tentatively in Paris, Cleveland, and Boston, 1979, 292, then with more conviction in Rosenberg, 1983, 102, and clarified further by Hallam, 1985, 10–13. Recently, Roland Michel, 1996, 245 n. 7, has argued that the Houston and Tokyo pictures are indeed the prime versions sent to Louisa Ulrica in 1749; she suggests that Le Bas's engravings, issued only in 1757, which show differences from the extant paintings, were based on La Live de Jully's repetitions, but that the collector allowed the engraver to inscribe them as belonging to the queen of Sweden in order to make them more marketable. Hallam, however, proposed that Le Bas (who never visited Sweden and thus did not have access to Luisa Ulrica's paintings) might have based his prints on drawings provided by his student, J.-E. Rehn, who was in Stockholm working as the surveyor of the royal household; Rehn had in fact provided Le Bas with a drawing of Chardin's *Household Accounts*, also in the queen's collection, for the latter's engraving of 1754 (10–12).
2. See the discussion by Bailey, 1988, xx–xxii; the paintings ("Ces deux morceaux ont été faits pour le Possesseur de ce Cabinet") were lot 97 in the 1770 sale catalogue.
3. Mariette, discussing the first version in 1749, described the scene as "a mother or a governess making a little girl recite a portion of the Gospel" (quoted in Paris, Cleveland, and Boston, 1979, 292).
4. Snoep-Reitsma, 1973, 191–95; Hallam, 1985, 14–16. Hallam suggests the influence of Jansenist doctrine on the picture. On Chardin and the theme of education, see Johnson, 1990.
5. As discussed by Bailey, 1988, xx–xxii.
6. Some critics, however, complained that the setting was a "wretched attic" (see Paris, Cleveland, and Boston, 1979, 293).
7. "C'est un travail qui ne produit tout son effet qu'à une certaine distance; de près le tableau n'offre qu'une sorte de vapeur qui semble envelopper tous les objets" (*Le Salon, en vers et en prose ou jugement des ouvrages exposées au Louvre en 1753*, 24; Del. 55; McW. 0082); "Il regne d'ailleurs partout un brouillard qui ne se dissipe;" "il léche, il finit à présent ces ouvrages. Gagnons-nous à ce changement de manière ou de façon de faire? Les bons connoisseurs prétendent que non" (*Sentimens d'un amateur sur l'exposition des tableaux du Louvre*, letter 3, 35–36; Del. 58; McW.0083).
8. *Mercure de France* (October 1753): 4–5 (Del. 54; McW. 0078). See the discussion by Roland Michel, 1996, 116–17.

Jean-Honoré Fragonard *(Grasse 1732–1806 Paris)*

*B*orn in Grasse, Fragonard moved to Paris at an early age. There he studied briefly with Jean-Siméon Chardin before entering the studio of François Boucher. Under Boucher's sponsorship, Fragonard won the coveted Grand Prix in 1752 with Jeroboam Sacrificing to the Idols *(Ecole des Beaux-Arts, Paris). Before leaving for Italy, however, he studied for several years at the* Ecole des élèves protégés, *a school established to train the Royal Academy's most promising students. From 1756 to 1761 Fragonard was in Italy where, under the guidance of the academy's director, Charles-Joseph Natoire, and the abbé de Saint-Non, an accomplished amateur, he developed an interest in landscape painting and drawing. Back in Paris, he made his public debut at the Salon of 1765 with the monumental* Coresus and Callirhoë *(Musée du Louvre, Paris), which won him probationary acceptance into the academy and was admired by the critic Denis Diderot. Despite his*

success, Fragonard declined to pursue a public career as a history painter, preferring to work for a private clientele of financiers and courtiers. Over the course of four decades he produced many brilliantly realized easel paintings, such as the Portraits de fantaisie *(Musée du Louvre, Paris, and elsewhere), and large-scale decorative works, such as* The Progress of Love *(Frick Collection, New York), commissioned by Madame Du Barry for her retreat at Louveciennes. A second trip to Italy in 1773–74 in the company of the financier Bergeret de Grancourt rekindled Fragonard's interest in landscape and garden imagery, leading to such late masterpieces as the* Fête at Saint-Cloud *(Banque de France, Paris). During the Revolution, Fragonard fled to his native Grasse, returning to Paris in 1793, where Jacques-Louis David appointed him a curator at the new National Museum.*

21. *Blindman's Buff*

c. 1753–56
Oil on canvas, 46 × 36 in. (116.8 × 91.4 cm)
The Toledo Museum of Art, Edward Drummond Libbey Gift, 54.43

Provenance: (?) Baron Baillet de Saint-Julien sale, Paris, June 21, 1784, lot 75, with pendant; M(orel) (and others) sale, Paris, May 3, 1786, lot 177, with pendant; Ferlet sale, Paris, April 18, 1792, lot 25, with pendant; comte de Sinéty, Paris, 1889; Baron Nathaniel de Rothschild, Vienna, probably before 1902; Baron Maurice de Rothschild, Château de Prégny, Switzerland; Rosenberg and Stiebel, New York; acquired by The Toledo Museum of Art in 1954.

Selected Exhibitions: San Francisco, 1965, no. 180; London, 1968, no. 229; Toledo, Chicago, and Ottawa, 1975–76, no. 36; Paris and New York, 1987–88, no. 5.

Selected References: Rothschild, 1903, no. 253; Réau, 1927, 147–50; Réau, 1956, 39, 158; Wildenstein, 1960, no. 47, fig. 31; Watson, 1971, 80, ill.; Wildenstein and Mandel, 1972, no. 53, ill.; The Toledo Museum of Art, 1976, 59–60, pl. 203, colorplate IX; Posner, 1982, 81–82, fig. 10; Cuzin, 1988, 34–36, no. 44, pl. 34; Rosenberg, 1989, no. 41, colorplate IV; The Toledo Museum of Art, 1995, 105, ill.

This glorious picture and its pendant, *The Seesaw* (fig. 53), now in Madrid, are two masterpieces of Fragonard's early career, produced during a period when he painted in a style still in the spirit of his master, François Boucher. Indeed, an early state of Beauvarlet's engravings after the compositions credits Boucher as the painter, although the correct

identification appeared in the second state. These engravings were made in 1760—four years after Fragonard had left for study in Rome but before he had returned to Paris—thus reinforcing a date in the early to mid-1750s.[1] Although many of the hallmarks of Boucher's decorative pastoral style are present—a highly keyed color scheme, oval compositions revolving around a central figure, and (not least) frivolously amorous subjects—it is possible that they were painted after Fragonard had left the studio of his master and was studying at the *Ecole des élèves protégés*.[2] Instituted in 1748 by Lenormant de Tournehem, the *directeur-général des bâtiments*, to prepare the academy's most promising students, this school was governed during Fragonard's tenure (1753–56) by Carle Van Loo. Van Loo's impact on the young painter during this period is well established, and *Blindman's Buff* bears some of the characteristics of Van Loo's art during this period.[3] In conceiving the Toledo painting, particularly the repoussoir foreground elements and the background glimpse of sky and trees, Fragonard may have remembered Van Loo's *Sculpture* (fig. 54), one of four allegories of the arts painted for Madame de Pompadour's estate at Bellevue and exhibited to much acclaim at the Salon of 1753.[4]

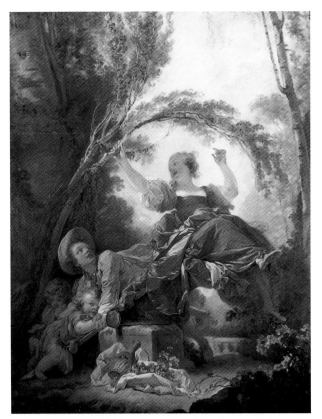

53. Jean-Honoré Fragonard, *The Seesaw*, c. 1753–55, oil on canvas, © Fundación Colección Thyssen-Bornemisza, Madrid.

Unlike Van Loo's well-documented group, however, the origin and intended destination of Fragonard's paintings are not precisely known. The pendants have always been associated with the collection of the baron de Saint-Julien (1713–c. 1789), *receveur général du clergé*, in whose 1784 sale similar paintings appeared. This traditional provenance has recently been questioned by Pierre Rosenberg, who notes that Saint-Julien's paintings were considerably taller, some 78 inches high.[5] Although it is evident that the Toledo and Madrid pictures have been cut down at the top—in Beauvarlet's engravings the uppermost branches, now cropped, are visible—judging from the prints, the paintings were probably only a few inches taller, and thus conform more precisely to the pictures that appeared in the Morel sale in 1786. Yet if the original patron of *Blindman's Buff* and *The Seesaw* cannot be firmly established, it is nevertheless certain that they belong together. The compositions play off each other brilliantly, juxtaposing two games enjoyed by a pair of young companions.

The amorous amusements, appropriately enjoyed in a fecund garden setting, lush with flowers and fruit, reinforce each other as well. As Donald Posner has demonstrated, in the eighteenth century such games would have been readily understood as symbolizing the pursuit of love, with blindman's buff allegorizing courtship and the rhythmic rocking of the seesaw, like the swing—another of Fragonard's favored subjects—serving as a metaphor for

the act of lovemaking.[6] The point is clearly made in Fragonard's pair through an array of signs that announce the theme of love: blooming flowers, ripe fruit, even the children ("cupid-like infants" is Posner's phrase) who participate in the activities. The frankly sexual aspect is understated, however: the couple in *The Seesaw* are not actually rocking back and forth but are using the plank—weighted down with the help of two little boys—to lift the girl up into the air, where she grasps a tree branch to steady herself. In the Toledo painting, mischievous subterfuge also plays a role, for the viewer can plainly see what the boyfriend cannot: that the young woman is peeking from under her blindfold. Thus we are reassured that she is not really in danger of stumbling down the stairs, and also reminded of the pleasures of courtship itself, since—if she can actually see where her potential mate is—she must be extending the game for its own sheer enjoyment.

1. Paris and New York, 1987–88, 46, 48. Réau, 1927 (ill. 148), illustrates a small version of *Blindman's Buff* that he claims served as the model for Beauvarlet's engraving; to judge from the reproduction, however, this painting is of poor quality and, moreover, shows the composition already trimmed at the top, confirming that it is a later copy.
2. It has been suggested that Fragonard's pendants were part of a series of four compositions, the other two—also depicting young lovers in the open air—made by Boucher in 1748 (Ananoff and Wildenstein, 1976, 2:9–10, nos. 313–16); however, the surviving evidence is confusing and incomplete, and most scholars (e.g., Posner, 1982, 82 n. 20; Rosenberg, in Paris and New York, 1987–88, 48) have rightly rejected the idea.
3. Paris and New York, 1987–88, 54–56.
4. For this series, see Rosenberg and Stewart, 1987, 292–306.
5. Rosenberg, 1989, 75.
6. Posner, 1982, 81–82.

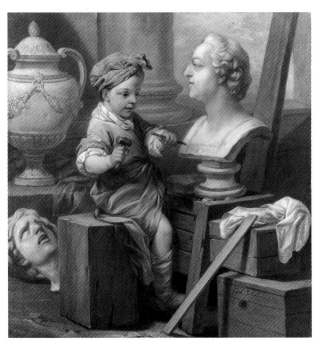

54. Carle Van Loo, *Sculpture*, Salon of 1753, oil on canvas, The Fine Arts Museums of San Francisco, Mildred Anna Williams Collection, 1950.

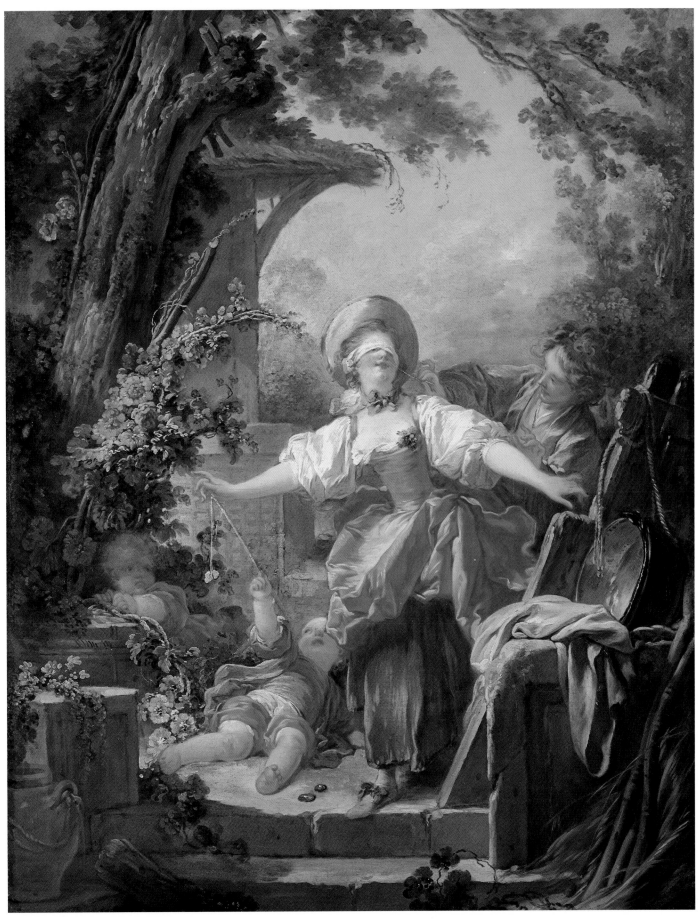

21.

22. The Stolen Kiss

c. 1759–60
Oil on canvas, 19 × 25 in. (48.3 × 63.5 cm)
The Metropolitan Museum of Art, New York, gift of Jessie
Woolworth Donahue, 1956

Provenance: Jacques-Laure Le Tonnelier, Bailli de Breteuil; his
sale, Paris, January 16, 1786, lot 49; acquired by Guérin; Marquis
de Chamgrand, Paris; [Chamgrand, de Proth, Saint Maurice,
Bouilliac] sale, Paris, March 20–24, 1787, lot 224; Dr. Aussant,
Rennes; his sale, Paris, December 28–30, 1863, lot 31; acquired by
Laneuville; Comte Duchâtel, 1863–89; Mrs. William Hayward,
New York, 1933–44; M. Knoedler and Co., New York, 1944; Mrs.
James P. (Jessie Woolworth) Donahue, New York; given to the
museum in 1956.

Selected Exhibitions: Tokyo and Kyoto, 1980, no. 28; Paris and
New York, 1987–88, no. 18; Rome, 1990–91, no. 34.

Selected References: Réau, 1956, 65, 157; Wildenstein, 1960, no.
119, fig. 31; Wildenstein and Mandel, 1972, no. 127, ill.; Cuzin,
1988, no. 76, 49–50, 274, fig. 56; Rosenberg, 1989, no. 63, pl. VI.

The Stolen Kiss is one of a group of small genre scenes
painted by Fragonard during his first trip to Italy, from 1756
to 1761, while he was a pensioner at the French Academy
in Rome. Like his friend Hubert Robert (cat. 32), with
whom he sometimes worked, Fragonard was apparently
fascinated by the picturesque life to be seen in and around
Rome, and he produced a series of paintings as well as in-
numerable drawings inspired by what he saw. Some of
these—women laundering clothes at public fountains,
rustic kitchens, barn interiors, and landscapes—were un-
doubtedly based on reality, while others were clearly the
product of his imagination.[1] Highly finished and mar-
velously anecdotal, The Stolen Kiss may be counted among
the latter. The setting is a rustic interior where a provoca-
tive card game has reached its denouement. A young shep-
herd (he is a close relative of the teasing protagonist in
Blindman's Buff [cat. 21]) has won the game and now takes
his prize, a kiss from a pretty shepherdess who shyly turns
from his embrace. She cannot escape, however, for a com-
panion pins her hands, crumpling the tablecloth and
spilling the cards to the floor. The scene is brilliantly
spotlit, giving the painting a sense of drama somewhat out
of proportion to the nature of its subject matter. (Frago-
nard would use the technique to greater effect in his late
masterpiece on a similar theme of sexual coercion, The Bolt
[see fig. 67].)

The highly finished surface, careful modeling, and re-
fined color scheme that characterize The Stolen Kiss are un-
usual departures for Fragonard at this stage in his career.
The other Italian genre subjects are all painted with a more
typically fluid and broadly handled technique, and each
was probably completed in a relatively short period of
time. Natoire, the director of the French academy during

Fragonard's tenure in Rome, had already remarked in 1758
that the artist "has an astonishing ability to change his
manner from one moment to the next."[2] In conceiving The
Stolen Kiss, with its nervous energy, exquisite draperies,
and sensitively painted hands, Fragonard may have re-
membered the works that Greuze had produced in Rome,
such as The Neapolitan Gesture (cat. 27). The unusual care
he gave to the picture is also a function of its probably hav-
ing been a commissioned work, painted for Jacques-Laure
Le Tonnelier (1723–85), Bailli de Breteuil, ambassador of
the Order of Malta and thus a most prestigious client. An-
other version of The Stolen Kiss (Hermitage, St. Peters-
burg), much more sketchily painted than is usual even for
Fragonard, should probably be considered a preliminary
study for the present picture, further evidence of the
thought and planning that went into it.[3] The circum-
stances of this commission are unknown (the other genre
scenes and landscapes that Fragonard produced in Italy
were in all likelihood painted on speculation, or for the
artist's own purposes), but it is clear that while in Italy
Fragonard continued to attract the interest of private col-
lectors, much as he had already done while a young painter
in Paris, working in the shadow of Boucher.

Genre scenes such as The Stolen Kiss were not part of the
curriculum established at the French academy. The official
course of study had traditionally been strict, and pension-
ers were supposed to spend their time copying ancient
sculpture and the paintings of esteemed Old Masters,
drawing and painting the live model, and attending lec-
tures on artistic theory. Under the directorship of Natoire,
however, the young artists were given greater latitude than
the administration back in Paris would have liked (for ex-
ample, Natoire encouraged his students to paint and draw
the Roman landscape), and Fragonard appears to have
taken full advantage of this.[4] Indeed, he was notoriously
slow in completing his official exercises, and his superiors
became concerned at his seeming obstinacy. Natoire and
Marigny both felt that, early in his tenure in Rome, Frag-
onard was suffering a kind of crisis of confidence.[5]

Yet it is difficult to agree with this assessment when
looking at a picture as accomplished as The Stolen Kiss. The
picture is evidence that Fragonard's difficulties in Rome
perhaps had less to do with his own failings as a painter
than with a simple unwillingness to fulfill the duties that
were expected of him. Having been the prize student of
Boucher, who was rapidly ascending the academic hierar-
chy in Paris, having studied for four years with Carle Van
Loo, the First Painter to the King, and having already

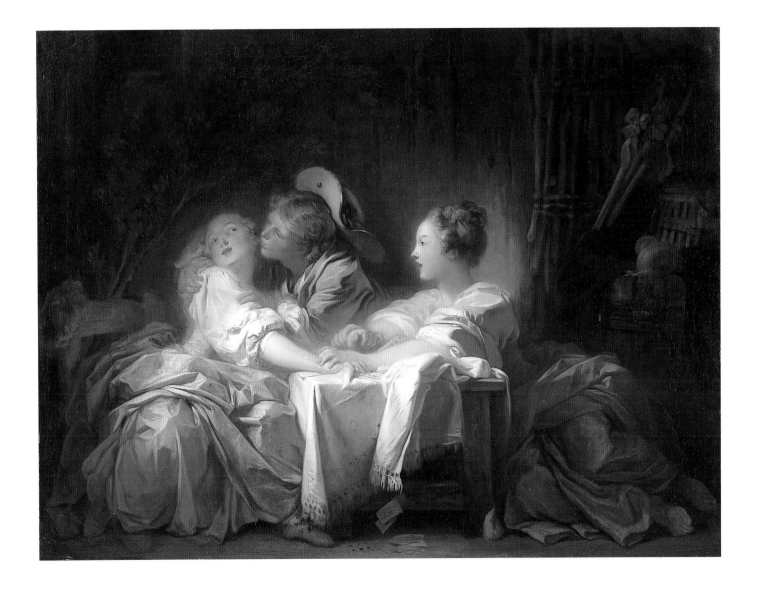

painted numerous works for a variety of clients (see cat. 21), Fragonard must have felt a certain frustration with the rote tasks now expected of him. Perhaps sensing the relatively free environment of Rome, he took the opportunity to paint and draw the subjects in which he was interested. He likely envied the position of Hubert Robert, whose association with the comte de Stainville gave him an independence from the French Academy's routines. Fragonard did indeed find such a patron in the abbé de Saint-Non, a dilettante priest, amateur artist, and influential collector who arrived in Italy in 1759. While in Rome the abbé was the guest of the Bailli de Breteuil,[6] and it is possible that it was he who negotiated the commission for *The Stolen Kiss*. If so, Saint-Non must have been impressed with Fragonard from the start, and this early transaction would have marked an auspicious beginning to an extremely productive friendship.[7]

1. See, for example, Rosenberg, 1989, nos. 51, 60–84; Rome, 1990–91, nos, 14, 32–38.
2. "Flagonard [*sic*] . . . est d'une facilité éthonante à changer de party d'un moment à l'autre, ce qui le fait oppérer d'un manière inégalle" (letter of August 30, 1758, to the marquis de Marigny; quoted in Paris and New York, 1987–88, 67).
3. Rosenberg, 1989, no. 62, pl. VII, however, argues that the sketchier version, which is the same size as the Metropolitan's picture, was an independent work that may have inspired Breteuil to commission a more finished variant for himself. (See also Rome, 1990–91, 80.) On Breteuil, see Ergman, 1960.
4. On Natoire's career as director of the French academy, see Lapauze, 1924, 248–312.
5. The correspondence between Natoire and Marigny is usefully summarized in Paris and New York, 1987–88, 66–70.
6. Guimbaud, 1928, 65 n. 1.
7. Saint-Non's patronage of Fragonard is surveyed by Wildenstein, 1959.

23. The Good Mother

c. 1760–65
Oil on canvas, 18 1/2 × 22 1/4 in. (47.0 × 56.5 cm)
The Fine Arts Museums of San Francisco, gift of Mrs. Herbert Fleishhacker, 54.2

Provenance: Probably in the Le Dart de Caen sale, Hôtel Drouot, Paris, April 24–May 4, 1912, lot 111; M. Cordonnier; Wildenstein and Co., Paris; sale, Hôtel Drouot, Paris, December 12, 1925, lot 95, repr.; Mr. and Mrs. Herbert Fleishhacker, San Francisco, by 1934; given to the de Young Museum in 1954.

Selected Exhibitions: Cincinnati, 1977; Tokyo and Kyoto, 1980, no. 1.

Selected References: Réau, 1956, 187; Wildenstein, 1960, no. 8, fig. 3; Wildenstein and Mandel, 1972, no. 8, ill.; Rosenberg and Stewart, 1987, 169–70, colorplate 168; Cuzin, 1988, no. 59; Rosenberg, 1989, no. 91, ill.

Fragonard's touching representation of a mother cautiously checking on her sleeping child effectively secularizes the artist's ultimate model, *The Holy Family with Angels* by Rembrandt (fig. 55). Although the biblical context is not entirely lost—a heavenly light illuminates the scene from above and Joseph's carpentry tools are visible hanging on the wall in the right background—it is not a large step from the hushed piety of *The Good Mother* to such wholly contemporary, if still reverential, family scenes as *The Visit to the Nursery* (cat. 25). The various titles under which the San Francisco painting and its variants have been known—*The Cradle, The Young Mother, Mother and Child*—are indicative of how thoroughly the artist metamorphosed the most common of Christian subjects into a secular image of up-to-date appeal and meaning.

In the eighteenth century Rembrandt's original belonged to Baron Crozat de Thiers, whose celebrated collection was probably made available to Fragonard through the intermediary of the artist's master, François Boucher. Fragonard copied several of Crozat's Rembrandts, including *Woman Holding a Broom* and the famous *Danaë*, but the *Holy Family* apparently held special fascination; Wildenstein catalogued no fewer than four variations on the theme, although judging from reproductions, these works vary in quality and may not all be by the same hand.[1] The copies—interpretations is a better term—are usually dated to Fragonard's apprenticeship with Boucher, around 1750–53, and those after the *Holy Family* are often compared to the large *Rest on the Flight into Egypt*, formerly in the Chrysler collection, which is undoubtedly datable to those early years.[2] Even if Fragonard's only known complete version of the Rembrandt *Holy Family* (private collection) can be dated to this early period, the reduced versions—so different in technique from that of the Dutch master—could conceivably have been painted long after his encounter with the original itself.[3] The San Francisco version is painted in the warm tones and rich brushstrokes that characterize Fragonard's genre scenes painted during and shortly after his first trip to Italy, from 1756 to 1761. Yet the motif of a woman lifting a drapery to reveal a sleeping child is one that he repeated numerous times throughout his career.[4] For example, there are similarities of treatment, if not of style, between *The Good Mother* and *The Cradle* (fig. 56), a drawing dating from around 1780. The spontaneity of this delightful sketch suggests it was drawn from life, and it has been proposed that it represents the artist's wife, Marie-Anne, gazing at their son Alexandre-Evariste, who would himself become a significant painter.[5] If nothing else, Rembrandt's masterpiece inspired in Fragonard a lifelong devotion to the theme of motherhood and childhood.

55. Rembrandt, *The Holy Family with Angels,* oil on canvas, Hermitage, St. Petersburg.

1. Wildenstein, 1960, nos. 7–11; Cuzin accepts only the copy of Rembrandt's complete composition (formerly in the collection of Boucher) and, with reservations, the San Francisco painting (Cuzin, 1988, nos. 58–59). Rosenberg accepts these two and a third, a variant of the San Francisco composition now in a private collection (Rosenberg, 1989, nos. 90, 91, 91A).

2. For a discussion of this painting, see Paris and New York, 1987–88, no. 10.

3. See Rosenberg, 1989, no. 90, for an illustration of the complete copy (formerly Wildenstein Collection, Paris); it belonged to Boucher, and was sold in 1771, after the latter's death (see ibid., 124). Rembrandt's original, along with the others belonging to Crozat, now in the State Hermitage Museum, St. Petersburg, were acquired by Catherine the Great of Russia in 1772. On Fragonard's copies after Rembrandt, see Réau, 1932, 100–102.

4. For example, *The Twins* (Rosenberg, 1989, no. 60), datable to 1758–59, and *The Cradle* (ibid., no. 101), painted around 1762–65.

5. See the discussion by Marianne Roland Michel in Paris, 1987, no. 55.

56. Jean-Honoré Fragonard, *The Cradle*, c. 1780, black chalk, private collection.

24. The Useless Resistance

c. 1770
Oil on canvas, 17 3/4 × 23 3/4 in. (45.0 × 60.5 cm)
Nationalmuseum, Stockholm, NM 5414

Exhibited in Hanover and Toledo only

Provenance: (?) duc de La Rochefoucauld-Liancourt sale, Paris, June 20, 1827, lot 55; (?) Brunet-Denon sale, Paris, February 2, 1846, lot 331; sale, Paris, December 22, 1851, lot 36; purchased by Laurent Laperlier; his sale, February 17, 1879, lot 11; Anatole Demidoff, prince of San Donato; his sale, Florence, March 15–May 13, 1880, lot 1448; bought by Stettiner; marquis de Saint-Aubanel, 1921; Paul Gallimard; Wildenstein; Löwenstein, Brussels; Van der Straten, Ponthoz; Wildenstein and Co., New York; purchased in 1958 with aid of a contribution of the Friends of the Museum.

Selected Exhibitions: Paris, 1921, no. 38; Pittsburgh, 1954, no. 60; Stockholm, 1958, no. 94.

Selected References: Réau, 1956, 159, pl. 49; Wildenstein, 1960, no. 276, pl. 46; Wildenstein and Mandel, 1972, no. 294, ill.; Cabanne, 1987, 69–70, ill. 74; Rosenberg and Stewart, 1987, 173, fig. 3; Cuzin, 1988, no. 284, 184–85, fig. 218; Rosenberg, 1989, no. 269, ill.; Grate, 1994, no. 142, 146–47, colorplate 20.

"You have also seen at Louveciennes the *nec plus ultra* of the dashed off, the rolled, the well whipped-up, the smeared. . . . It is the divine Fragonard I am telling you about, the greatest brush according to our masters of painting."[1] If these comments in the *Dialogues sur la peinture* (1773), concerning the ill-fated suite of paintings commissioned for Madame Du Barry's pleasure pavilion, are not without a hint of irony, they nevertheless vividly summon up the remarkable facility and exuberance that characterize Fragonard's style in the early 1770s. Even more so than in the paintings for Du Barry (Frick Collection, New York), which are large in scale and highly finished, *The Useless Resistance* demonstrates the artist's fluent brushwork and *alla prima* confidence that made his small cabinet pictures immensely popular among connoisseurs and private collectors. The author of the *Dialogues* went on to say that Fragonard—who had ceased exhibiting at the Salons in 1767—had made his reputation among the financiers and tax farmers, "all of whose galleries are graced with his works."[2]

Although its origins are unknown, *The Useless Resistance* is just the sort of intimately scaled, fluidly brushed painting that would have appealed to these patrons, a work in which there exists a perfect balance of style and subject. A man and woman grapple in bed amid a profusion of plump pillows and billowing draperies. She fends off, seemingly playfully, his advances, squirming away, her legs treading through waves of bedclothes. Although the man is still fully dressed, the woman's clothes have been partially pulled off, exposing her breasts and portions of her legs to the viewer. The aggressive eroticism of the subject recalls Boucher's *The Surprise* (cat. 11)—in fact, that title has sometimes also been attached to the present picture—but in Fragonard's painting the two figures, fully absorbed in the pursuit of pleasure, meld together in a dynamic interplay of forms that makes little distinction between the genders of the protagonists. Fragonard pressed the action close to the picture plane, giving only the barest suggestion to the setting. All of the elements in the painting respond to the oval format of the composition, spiraling out from the center in a profusion of lemon yellows, pinks, blues, and creamy whites that Jean-Pierre Cuzin memorably likened to a kaleidoscope.[3]

Dating Fragonard's pictures is always a tricky business, but *The Useless Resistance* was likely painted around 1770 or shortly thereafter. It may be grouped with several pictures of equally gallant theme, such as *The Happy Lovers* (private collection) and *The New Model* (Musée Jacquemart-André, Paris), that the artist painted around the time he was completing the cycle of canvases for Louveciennes.[4] The Stockholm canvas shares with these other cabinet paintings a number of pictorial techniques favored by Fragonard during these years, such as allowing the ground layer to remain exposed in several areas to create a foil for the flashing strokes of paint and using the butt-end of the brush to incise lines in the folds of drapery. This latter device the artist employed with great success in his fantasy portraits, usually dated to the late 1760s and early 1770s. The sketchy quality of the brushwork, the physical evidence of the master's hand, and the picture's very lack of resolution—what in French aesthetic theory was called the

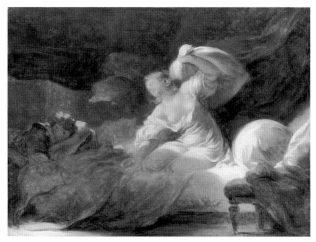

57. Jean-Honoré Fragonard, *The Useless Resistance*, c. 1770, oil on panel, The Fine Arts Museums of San Francisco, Mr. and Mrs. E. John Magnin Gift, 63.33.

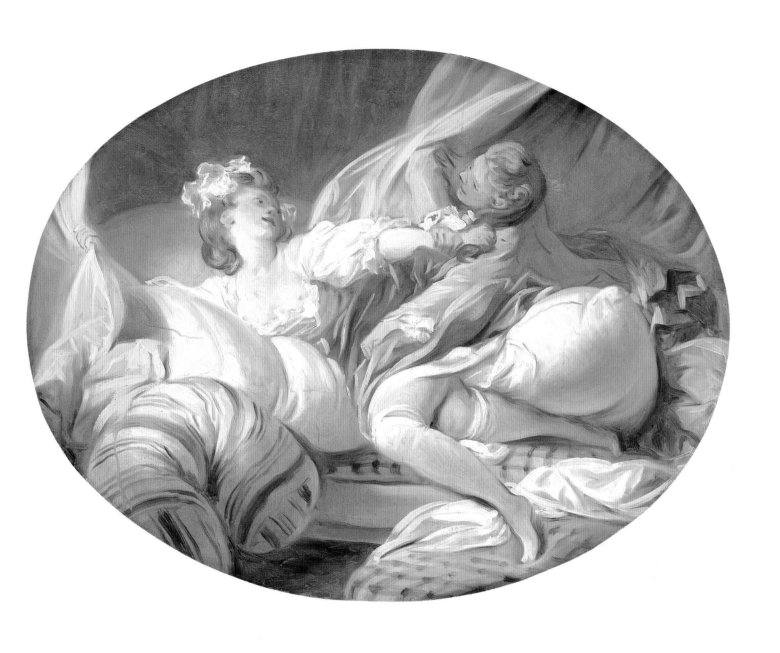

non-fini—were aspects of painting highly prized by connoisseurs. Such an aesthetic was inherently private, even aristocratic, depending on an appreciative viewer with an insider's knowledge of art, one who could engage in a dialogue with the work of art, who understood the mysteries of the creative process, and who could, in his or her own mind, vicariously bring the picture to completion.

The Useless Resistance is often associated with a painting with the same title—taken from Géraud Vidal's engraving—in San Francisco (fig. 57).[5] In this small panel, one of the artist's most stunning works, a young woman on a bed swings a pillow at a boy hiding in the blankets at her feet. Despite the relative similarity in subject and style—the San Francisco picture must date to the same general period as the present work—the two paintings are poles apart in mood and meaning. The child's play depicted in the panel painting has given way in the present work to the

representation of an adult game, one pursued with a drive and single-minded determination far removed from the frivolity and lighthearted spirit that is commonly associated with Fragonard's art.

1. "Vous avez vu à Lussienne [*sic*] encore le *nec plus ultra*, pour le heurté, le roullé, le bien fouetté, le tartouillis. . . . C'est du divin Fragr. dont je vous parle, le peinceau le plus capital selon les chefs de notre peinture" ([Antoine Renou?], *Dialogues sur la peinture* [Paris, 1773; reprint, Geneva, 1973], 20–21).
2. "Tous leurs cabinets sont ornés de ses oeuvres" (ibid., 24).
3. Cuzin, 1988, 184–85.
4. Rosenberg, 1989, nos. 215 and 265 (see Paris and New York, 1987–88, nos. 147 and 150). For a related drawing, although one in which the sexual dynamics of the Stockholm picture are inverted, see Paris and New York, 1987–88, no. 146. A second version of the present painting, although sketchier and more grey in color, is catalogued by Cuzin with reservations (Cuzin, 1988, no. 285) and does appear from reproductions to be inferior in quality.
5. See Rosenberg and Stewart, 1987, 171–73.

25. *The Visit to the Nursery*

c. 1770–75
Oil on canvas, 28 3/4 × 36 1/4 in. (73.0 × 92.1 cm)
National Gallery of Art, Washington, D.C., Samuel H. Kress Collection

Provenance: Leroy de Senneville, Paris; his sale, Paris, April 5–11, 1780, lot 50, bought in; Senneville sale, Paris, April 26, 1784, lot 26; purchased by Basan; Madame Goman, Paris; her sale, Paris, February 6, 1792, lot 100; Amédée Constantin, Paris; his sale, November 18, 1816, lot 365; bought in or purchased by Pérignon; possibly purchased in 1851 by the father of Jules Burat; by inheritance to Jules Burat, by 1883; his sale, Paris, April 28, 1885, lot 71, bought in; probably by inheritance to Madame Louis Burat, Paris, by 1907 until at least 1921; Wildenstein and Co., New York and Paris, by 1939; sold to the Samuel H. Kress Foundation, New York, 1942; given to the National Gallery of Art in 1946.

Selected Exhibitions: Paris, 1921, no. 69; New York, 1940, no. 201.

Selected References: Réau, 1956, 171–72; Wildenstein, 1960, no. 459, fig. 101; Watson, 1971, 86; Wildenstein and Mandel, 1972, no. 482, ill.; Eisler, 1977, 333–35, fig. 292; Cuzin, 1988, no. 123, 89–92, colorplate 118; Rosenberg, 1989, no. 304, ill.; Sheriff, 1990, 117, fig. 27; Sheriff, 1991, 14–40, fig. 1.2.

Fragonard is invariably associated in the popular imagination with amusing and mildly erotic works, exquisite culminations of the rococo style such as *Blindman's Buff* (cat. 21) and *The Useless Resistance* (cat. 24), yet he was also an observant and sometimes sincere painter of family life. *The Visit to the Nursery* is one of his more ambitious and successful of such forays, an unusually classical composition of horizontal, vertical, and triangular forms arranged

neatly before the viewer. As is often the case with Fragonard's oeuvre, the date of the painting has proved elusive, and scholars have placed the picture anywhere from the mid-1760s—near the time of the grand *Coresus and Callirhoë*, his most academic production—to the late 1770s, a time when he is considered to have painted several other family pictures.[1] *The Visit to the Nursery* was certainly painted by 1780, when it appeared in a sale of works belonging to Jean-François Leroy de Senneville (1715–84), a tax farmer and secretary to the king who assembled an impressive collection of modern French paintings (including fifteen Fragonards) as well as many seventeenth-century Dutch and Flemish works. He actually owned two versions of *The Visit to the Nursery*; the present, larger, one was described by the dealer A. J. Paillet in glowing terms: "This piece, with its broad and fluent handling, brings together all the spirit and the character suitable to the subject."[2]

The subject has been the matter of some debate. The painting describes a touching scene in which a young husband and wife gaze lovingly upon their sleeping child. The interior is presented as somewhat rustic (the furnishings are simple and what appears to be straw is visible just behind the open door), and the fashionable dress of the young couple suggests that they have come from the outside (the man still wears his riding leggings) to visit their newborn, who is looked after by an elderly woman seated beside the cradle. Three other children seemingly have

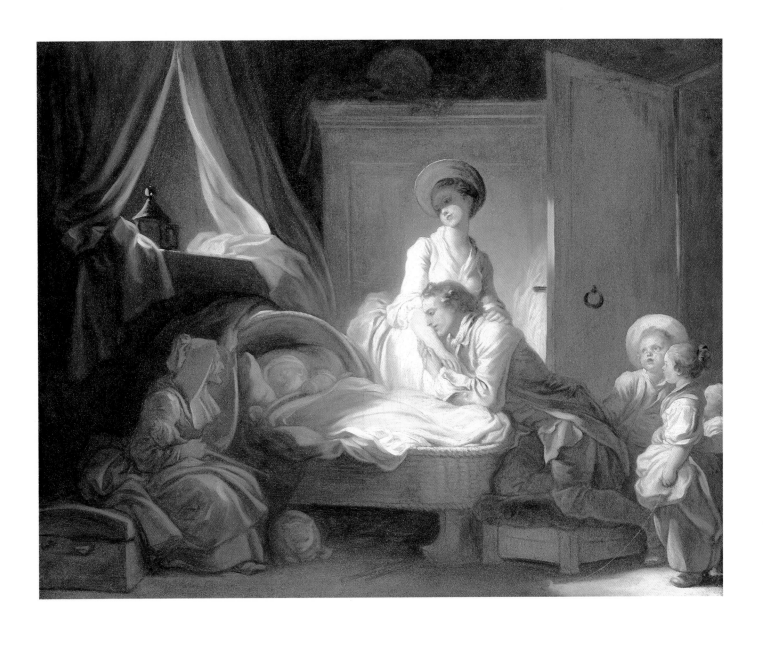

wandered into the room, and they gaze at the proceedings. The scene has been variously interpreted. Wildenstein felt that here, as in all such family pictures, Fragonard was responding to his own presumably happy domestic life; Cuzin saw the influence of Greuze in the painting's subject and its overt appeal to sentiment; recently, Sheriff, whose complex and nuanced analysis of *The Visit* focused on its ambiguous depiction of class identity and gender roles, understood the painting as probably depicting an urban couple visiting their child in the rural home of a wet nurse.[3]

In the 1780 Senneville sale catalogue, however, the painting was specifically identified as a scene from Jean-François de Saint-Lambert's sentimental tale *Sara Th——*[4] First published in 1765, this moralizing romance tells the story of a beautiful, intelligent, and well-bred young English woman who falls in love with a humble but educated Scottish farmer. Forsaking an arranged marriage, Sara weds the farmer, Philips, and the couple lives happily and productively on the farm, their relationship and attitude toward life continually inspired by the extraordinary library that was the gift of her father. (Among its volumes are copies of Richardson's *Pamela* and Rousseau's *Emile*.) The scene depicted in Fragonard's painting is evidently the one witnessed by the story's narrator, a traveler who visits the farm: "I saw them enter a room off the garden, its window open: they went together to a cradle where their fifth child was lying; the two of them knelt by the cradle, by turn looking at their child and at each other, all the while holding hands and smiling."[5] This passage does indeed seem to describe Fragonard's painting, even if the association has not won general acceptance from recent scholars.[6] Fragonard was not averse to painting subjects from popular sentimental literature—such as Marmontel's *Annete and Lubin*—as well as more-elevated classics, and the early identification of the subject of the Washington *Visit* is good evidence in its favor. In any case, the tenor of the painting is certainly similar to that of Saint-Lambert's tale, which is a paean to *sensibilité*, the virtues of honesty and sincerity, and the emotional satisfaction of parenthood. The narrator's response to the episode described above

might have served equally well as the intended effect of *The Visit to the Nursery*: "I was enchanted by this touching scene of conjugal love and parental tenderness."[7] As many writers have observed, to such secular morality of the Enlightenment Fragonard here added a distinct religious flavor, creating a modern reenactment of an Adoration of the Child, a connection underscored by the rusticity of the setting (which brings to mind a stable or manger) and the dramatic yet soft spotlighting, imitating a heavenly aura.

1. See Cuzin, 1988, 90–92; Rosenberg, 1989, 104; for other family scenes from the 1770s, see, for example, ibid., nos. 306–7bis, 334–38, 349, and 351–52.
2. "Ce morceau joint à une touche large et facile tout l'esprit et le caractère convenables au sujet" (Leroy de Senneville sale, Paris, April 5, 1780, lot 49; see Rosenberg, 1989, 126). Nevertheless, the painting failed to sell and was auctioned again in 1784, this time purchased by Basan ([Leroy de Senneville] sale, April 26, 1784, lot 26; see ibid., 128). The smaller version (present location unknown) is ibid., no. 305.
3. Wildenstein, 1960, 26–27; Cuzin, 1988, 89–92; Sheriff, 1991, 22.
4. "Le sujet est tiré du *Roman de Miss Sara* par M. de Saint Lambert. Le moment que représente cette composition intéressante est celui où les deux époux viennent visiter leur enfant" (The subject is taken from the *Roman de Miss Sara* by M. de Saint Lambert. The moment that this interesting composition represents is that when the two spouses go to visit their child [see Rosenberg, 1989, 126]).
5. "Je les vis entrer dans une chambre qui donnoit sur le jardin & dont la fenêtre étoit ouverte: ils allérent ensemble vers un berceau où reposoit leur cinquième enfant, ils se courboient tous deux sur le berceau, & tour-à-tour regardoient l'enfant & se regardoient en se tenant par la main & en souriant" (Jean-François de Saint-Lambert, *Sara Th—— nouvelle traduite de l'anglois* [Lausanne, 1766], 17; the novella was first published in the April 15, 1765, issue of the *Gazette littéraire de l'Europe*).
6. For a survey of various opinions, see the excellent entry by Eisler, 1977, 333–35; Rosenberg, 1989, 104, has given the identification new credence. Sheriff's reading of Fragonard's young parents as "an urban couple from the more privileged classes who have come to visit their nursling, put out in the country" (Sheriff, 1991, 22), is not necessarily inconsistent with Saint-Lambert's novella (a text she does not mention as a possible source for the painting's subject): Sara was, after all, an upper-class woman raised in London, and Philips is described as "very well put out, his face was rather beautiful, and his countenance noble and agreeable" (fort bien fait, son visage étoit assez beau, & sa phisiognomie étoit noble & agréable [Saint-Lambert, *Sara Th——*, 16]).
7. "J'étois enchanté du spectacle touchant de cet amour conjugal & de cette tendresse paternelle" (Saint-Lambert, *Sara Th——*, 17).

Jean-Baptiste Greuze *(Tournus 1725–1805 Paris)*

A brilliant draftsman, portraitist, and genre painter, Greuze was initially trained in Lyons by the painter Charles Grandon (1691–1792). He moved to Paris in 1750, where he studied at the Royal Academy, first drawing public notice at the Salon of 1755 with A Father Reading the Bible to His Family *(private collection, Paris), which gained him probationary acceptance into the academy. Encouraged by important patrons, such as the marquis de Vandières (later Marigny) and the eminent collector La Live de Jully, he traveled in Italy from 1755 to 1757. For the next decade Greuze won the accolades of critics and the public alike with his innovative genre paintings, particularly* The Village Bride *(Musée du Louvre, Paris), exhibited to great acclaim in 1761, and* Filial Piety *(Salon of 1763, Hermitage, St. Petersburg). In 1769, Greuze's ambi-*

tion to be accepted into the academy as a history painter ended in humiliation when his precocious neoclassical painting, Septimius Severus Reproaching Caracalla *(Musée du Louvre, Paris), was roundly criticized; Greuze was accepted only as a genre painter, a slight that caused him to refuse participation in the Salon until 1800. Notwithstanding Greuze's personal setbacks, his dynamic and dramatic compositions, culminating in his late masterworks of moralizing painting,* The Father's Curse: The Ungrateful Son *and* The Punished Son *(1777–78, both Musée du Louvre, Paris), won a new distinction for genre painting. Sympathizing with the Revolution, Greuze painted many portraits of prominent revolutionary figures toward the end of his life, including one of Napoleon as first consul (Musée National, Versailles).*

26. Indolence (The Lazy Italian Girl)

1756–57
Oil on canvas, 25 1/2 × 19 1/4 in. (64.8 × 48.8 cm)
Wadsworth Atheneum, Hartford, Connecticut, The Ella Gallup Sumner and Mary Catlin Sumner Collection Fund

Exhibited in Houston only

Provenance: Jean-Baptiste-Laurent Boyer de Fonscolombe, Aix-en-Provence, 1757; his sale, Paris, January 18, 1790, lot 101; Prince Radziwill Branicki, Rome, Paris, and Warsaw, before 1874; Wildenstein and Co., New York, 1934; acquired by the museum in 1934.

Selected Exhibitions: Salon of 1757, no. 114; London, 1968, no. 302; Toledo, Chicago, and Ottawa, 1975–76, no. 41; Hartford, San Francisco, and Dijon, 1976–77, no. 10; Atlanta, 1983, no. 48.

Selected References: Smith, 1837, vol. 8, no. 96; Martin and Masson, 1908, no. 187; Munhall, 1966, 87; Brookner, 1972, 59, 97, pl. 13; Fried, 1980, 35, 37, fig. 17; Conisbee, 1985, 132, fig. 124.

Along with *The Neapolitan Gesture* (cat. 27), *Indolence* was one of the pictures "in Italian costume" that Greuze painted in Rome and exhibited at the Salon of 1757. At the time it was in the collection of J.-B.-L. Boyer de Fonscolombe, who also owned the painting's pendant, *The Fowler* (Muzeum Narodowe, Warsaw); as Munhall points out, Boyer de Fonscolombe's brother was a French diplomat serving in Rome during Greuze's visit there, and it is likely that he arranged for the sale of the two works.[1] With these two paintings Greuze initiated a series of cabinet-

size pictures representing single figures engaged in various occupations, which would be among his most original achievements.

Unlike *The Fowler*, which shows a man in a dynamic pose tuning the strings of a guitar, in the present work the young woman is immobile, seated heavily on her chair amid a tumbledown household. At the Salon it was called *La Paresseuse italienne* (The Lazy Italian Girl); as this title suggests, she represents the sin of indolence, and is so lethargic that one of her shoes has fallen off (she is literally "slipshod"),[2] crockery litters the floor, a wine jug has toppled, and her own bodice has come loose to expose an ample bosom. The details of the setting have been painted with a nearly mesmerizing attention to surface, texture, and warmth of color, yet one critic at the Salon pointed out that "in truth one finds in each object details that are most satisfying but which, considered in terms of the whole, do not at all achieve harmony and do not at all paint air and light. . . . He proves to us that the least noble style has nobility all the same, but he does not always have the ingenuity of M. Chardin."[3] This final statement is interesting for two reasons. It is testimony to the role Greuze played in raising the status of genre painting and it is also an acknowledgment of the rivalry he shared with Chardin. In

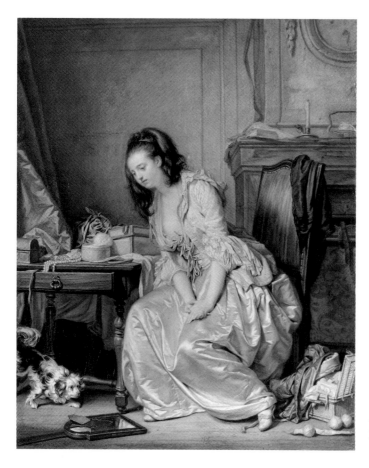

58. Jean-Baptiste Greuze, *The Broken Mirror*, 1763, oil on canvas, reproduced by permission of the Trustees of the Wallace Collection, London.

only his second Salon, Greuze was already emerging as the inheritor of the older artist's mantle; as the critic pointed out, pictures by the two artists were hung in a row, and in *Indolence* Greuze encouraged the comparison by including such objects drawn straight from Chardin's repertoire as the tipped copper pot—a fortuitous inclusion, as it turned out, for a similar one appeared in Chardin's only figure painting exhibited that year, *The Scullery Maid* (Hunterian Art Gallery, Glasgow), a picture he had painted and already exhibited in 1738.[4] Yet in the eyes of this critic Chardin still held his own, even if by 1757 he was content to exhibit genre paintings completed years before or replicas of old compositions.

Seen in proximity to works such as Chardin's *The Kitchen Maid* (cat. 16), Greuze's picture does indeed mark a new direction in genre painting. Superficially the paintings have much in common, yet Greuze has weighted his composition with associations and meanings that must have struck Chardin as painfully literal. The title itself signals to the viewer that the picture is essentially an allegory, which starts one searching for symbols and attributes as well as references to pictorial tradition. Edgar Munhall noted, for example, the close parallel between the pose of the young woman and that of Caravaggio's *Repentant Magdalen* (Palazzo Doria-Pamphili, Rome), a painting the artist undoubtedly saw during his trip to Italy.[5] This connection suggests what in Chardin's case is usually implied

only in the verses appended to reproductive engravings: that Greuze's woman suffers from more than simple laziness, but is also lovesick or even, given her doubled-over pose and hands clutching her stomach, pregnant. In this regard it should be pointed out that there are more than a few parallels between *Indolence* and one of Greuze's most explicit allegories of lost innocence, *The Broken Mirror* of 1763 (fig. 58).[6]

1. See the discussion in Hartford, San Francisco, and Dijon, 1976–77, 42. For *The Fowler*, see ibid., no. 12.
2. The French phrase, "en savate" (in an old shoe, down at the heel), retains the pun.
3. "On trouve à la vérité dans chaque objet des détails les plus satisfaisans, mais qui considérés avec le tout, ne font point d'accord et ne peignent point l'air et la lumière. . . . Il nous prouve que le style le moins noble a pourtant de la noblesse mais il n'a pas toujours l'ingénuité de M. Chardin" ([Renou?], *Observations périodiques sur la physique, l'histoire naturelle, et les arts* [Paris, 1757], 15–16; Del. 83; McW. 0114).
4. For the Chardin, see Paris, Cleveland, and Boston, 1979, 248–52, no. 79; Rosenberg, 1983, 96, no. 114.
5. Hartford, San Francisco, and Dijon, 1976–77, 42.
6. See Ingamells, 1989, 205–7, P442. The woman's discarded shoe may also refer to her condition: it is a motif that frequently appears in Dutch paintings of pregnant or lovesick women. See Michiel van Musscher's *Doctor Taking a Woman's Pulse*, c. 1670–80, private collection (Philadelphia, Berlin, and London, 1984, 266–67, no. 80). If she is indeed pregnant, Greuze avoids any hint of scandal by giving the woman a wedding band.

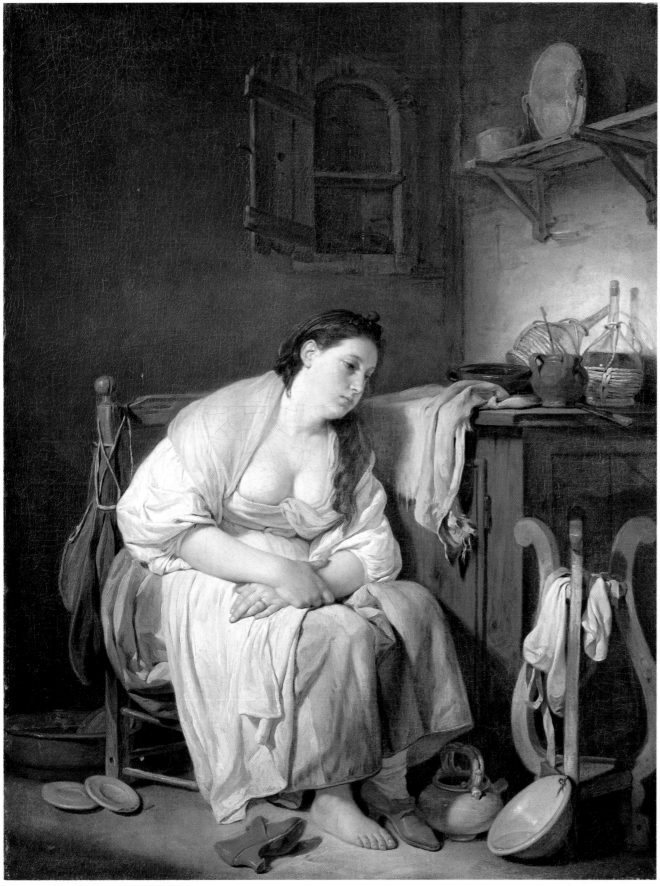

26.

27. The Neapolitan Gesture

1757

Oil on canvas, 28 3/4 × 37 1/8 in. (73.0 × 94.3 cm)
Signed and dated: Greuze f. Roma 1757
Worcester Art Museum, Charlotte E. W. Buffington Fund,
1964.113

Exhibited in Hanover only

Provenance: Louis Gougenot, abbé de Chezal-Benoit, Paris;
Prince Nicolas Nikitich Demidoff (d. 1828); his son Prince
Anatole Demidoff, San Donato Palace near Florence; his sale,
Paris, February 26, 1870, lot 108; purchased at the sale by
Phillips, probably for William, first earl of Dudley (d. 1885);
acquired by Agnew's, London, in the 1890s for Lord Marsham (d.
1924); Viscountess Swinton; David Koetser, New York, 1956;
Acquavella Galleries, New York; Alberto Reyna, Caracas; French
and Co., New York; purchased by the museum in 1964.

Selected Exhibitions: Salon of 1757, no. 113; New York, 1963, no.
28; London, 1968, no. 303; Toledo, Chicago, and Ottawa, 1975–76,
no. 42; Hartford, San Francisco, and Dijon, 1976–77, no. 14.

Selected References: Smith, 1837, vol. 8, no. 150; Maugras, 1902,
65 n. 1; Martin and Masson, 1908, no. 152; Mauclair, 1926, 81;
Brookner, 1972, 59, 97, pl. 14; Worcester Art Museum, 1974,
254–56, fig. 590; Worcester Art Museum, 1994, 132.

Greuze painted *The Neapolitan Gesture* and its pendant, *The Broken Eggs* (fig. 59), for the Abbé Gougenot during their trip in Italy in 1755–57. The artist's Italian sojourn had been arranged by the marquis de Marigny—the king's arts administrator—to validate the training of the up-and-coming painter, who was largely self-taught and had never won the Grand Prix. What impact this trip actually had on the young painter's art has been the topic of some debate,[1] although in the present case, it was more a matter of absorbing local custom than the consequence of a pro-found meditation on ancient or Renaissance art. A letter written on February 22, 1757 by the Abbé Barthélémy to the comte de Caylus underscored the anecdotal aspect of *The Neapolitan Gesture*: "It is a Portuguese, disguised as a match-seller, who wishes to make his way into a house in order to see a young lady. The servant suspects some imposture, pulls his cloak and exposes the Order of Christ (which Greuze calls his dignity). The Portuguese is abashed, and the girl, who is present, mocks him in the Neapolitan manner, that is to say by placing her fingers under her chin. It was to emphasize this gesture, which is very pretty, that Greuze made the picture."[2] The pendant, *The Broken Eggs*, shows a complementary subject with similar if not identical characters: in a rustic interior a haggard crone chastises a young man for causing a pretty girl to overturn her basket of eggs; in the lower right a little boy—his bow and arrow are an allusion to Cupid—innocently tries to reassemble a broken shell. If the implication in this subject is that a greater offense than merely breaking eggs has been committed, in *The Neapolitan Gesture* any designs the "peddler" had on the young woman have been effectively thwarted by the old servant, who pulls at his disguise with one hand while guarding the sanctity of the young maiden with the other. The latter's dismissive gesture is placed at the top of a triangle of hands that form the expressive center of the painting. As in *The Broken Eggs*, Greuze again placed in the margins of the scene wide-eyed children who respond uncomprehendingly to the actions of their elders.

The Neapolitan Gesture and its pendant were the prin-

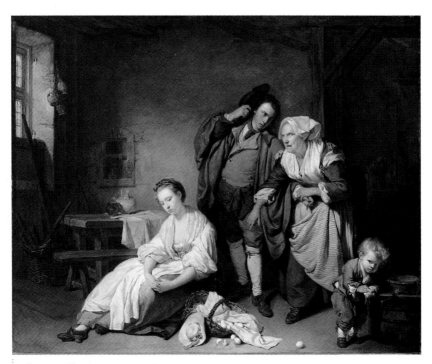

59. Jean-Baptiste Greuze, *The Broken Eggs*, Salon of 1757, oil on canvas, The Metropolitan Museum of Art, New York, William K. Vanderbilt Bequest.

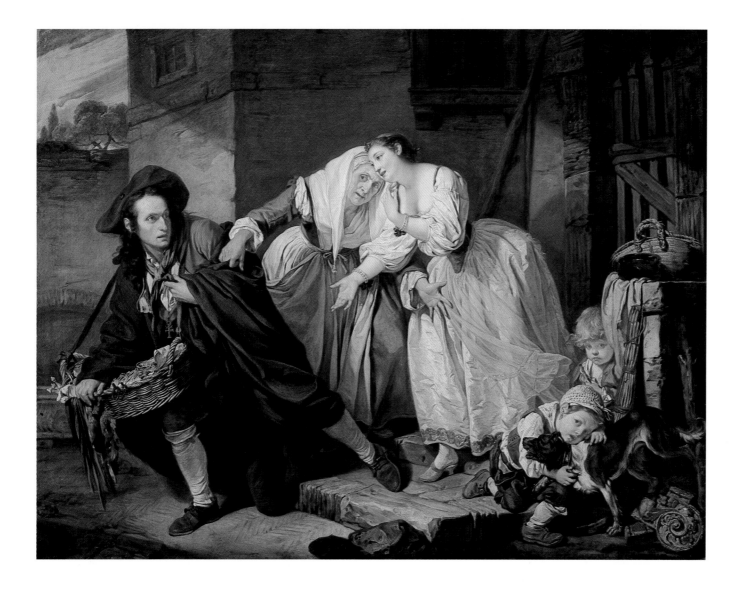

cipal entries at the Salon of 1757 by the young painter "who had made such a noise at the preceding salon [of 1755]."[3] In that debut he had shown two small-scale, multifigure genre pictures similar in style but vastly divergent in theme: the pious *Father Reading the Bible to His Family* (private collection, Paris; see fig. 14) and the irreverent *The Blind Man Deceived* (Pushkin Museum, Moscow; see fig. 15). Greuze continued this narrative strategy—what Brookner has aptly referred to as his "mania for plotting"[4]—in 1757 with two paintings that are treated almost as burlesques, with their grandiloquent gestures and impassioned expressions in the service of ribald anecdotes. The multifigure genre scenes that he would come to paint in his full maturity—for example, *The Father's Curse* (see figs. 18 and 19) or *The Drunken Cobbler* (cat. 31)—are usually read as sincere and serious meditations on family life, moral dilemmas, or personal vice, but *The Neapolitan Gesture* and its pendant are played for broad humor and even satire (see the discussion in Mark Ledbury's essay). Nevertheless, even if the experience of Italy and its art did little to change Greuze's narrative interests at this stage of

his career, one does find in *The Neapolitan Gesture* a clarity of composition and a greater monumentality of form in the figures (there is an echo of the Borghese *Warrior* in the pose of the peddler)[5] that indicate that the trip was not entirely for naught. The critic in the official journal, *Mercure de France,* recognized the dichotomy of the painting and its pendant: "Mr. Greuze is an artist distinguished in the amiable genre in which he indulges himself. His pictures are at once ingenious and naive and are beautifully painted and colored."[6]

1. See Sauerländer, 1965; McPherson, 1985.
2. Quoted by Edgar Munhall in Hartford, San Francisco, and Dijon, 1976–77, 50.
3. "M. Greuze, qui a tant fait de bruit le salon précédent" ([Renou?], *Observations périodiques sur la physique, l'histoire naturelle, et les arts* [Paris, 1757], 15; Del. 83; McW. 0114).
4. Brookner, 1972, 97.
5. Sauerländer, 1965, 149–50.
6. "Mr. Greuze est un artiste distingué dans le genre aimable auquel il s'est livré. Ses tableaux spirituels et naifs a la fois sont d'une belle execution et d'un beau coloris" ("Observations sur les tableaux exposés au Louvre . . . ," *Mercure de France* [October 1757]; Del. 1250; McW. 0110).

28. Simplicity

c. 1759
Oil on canvas, 28 × 23 1/2 in. (71.1 × 59.7 cm)
Kimbell Art Museum, Fort Worth

*Provenance: Marquise de Pompadour, Versailles; marquis de
Marigny; his sale, Paris, March 18, 1782, lot 43; sold "to Robit for
the King of France"; Compte Hyacinthe François Joseph
d'Espinoy, Paris; his sale, Paris, January 14–19 and February
4–9, 1850, lot 935; purchased by Ward; Baron Edouard de
Rothschild, Paris; Baronne Edmond de Rothschild, Château de
Prégny, Switzerland; acquired by the museum in 1985.*

Selected Exhibition: Salon of 1759, no. 104.

*Selected References: Smith,1837, vol. 8, no. 24; Martin and
Masson, 1908, no. 480; Brookner, 1972, 59; Kimbell Art Museum,
1987, 228, colorplate.*

As Edgar Munhall has discussed, *Simplicity* and its pen-
dant, *The Young Shepherd* (fig. 60), were painted for the
Versailles residence of Madame de Pompadour, the mis-
tress of Louis XV. Greuze received the commission in 1756
from Pompadour's brother, the marquis de Marigny, while
traveling in Italy. Marigny expressed the hope that the two
pictures "will be seen by all the court, and great advantages
could come of it for him, if they are found good." Despite
the prestige of the commission and its generous terms—
Greuze was allowed to choose the subjects himself—the
artist failed to finish the paintings until well after his re-
turn to Paris in 1757, exhibiting *Simplicity* at the Salon of
1759 and its pendant only in 1761.[1]

Simplicity is one of the earliest manifestations of
Greuze's interest in emotional or psychological states, as
embodied in a bust-length depiction of a young girl.
Greuze's theme is one of youthful love: in the Kimbell pic-
ture a girl pulls the petals from a daisy in the traditional
game of "he loves me, he loves me not"; in a complemen-
tary gesture, the boy in the pendant makes a wish before
blowing on a dandelion. Greuze took care to balance the
two compositions, turning the figures toward each other,
giving each a bouquet of flowers, and placing a single tree
in each background landscape. Yet in their mutual self-
absorption the girl and boy are essentially isolated, left
alone to ponder the possibilities of their love. The focus of
the paintings is the marvelously painted hands that form
the center of each composition. In *Simplicity* they are par-
ticularly brilliantly realized, emphasizing the tenderness
with which the girl plucks the petals from the daisy; a re-
cently discovered preliminary drawing (fig. 61)[2] shows the
attention Greuze lavished on this key part of the picture.
The drawing also demonstrates that originally the artist
conceived the girl as turned to the left. Although he aban-
doned this formula for the Kimbell picture, he reused it
when he painted *The Young Shepherd*, repeating the pose
and gestures but changing the girl into a boy.

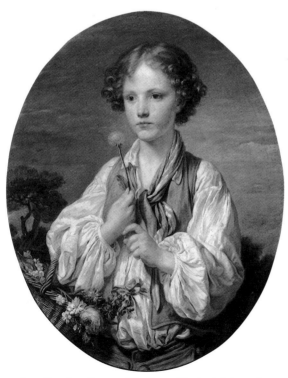

60. Jean-Baptiste Greuze, *The Young Shepherd*, Salon of 1761, oil
on canvas, Photothèque des Musées de la Ville de Paris by
SPADEM, Musée du Petit Palais, Paris.

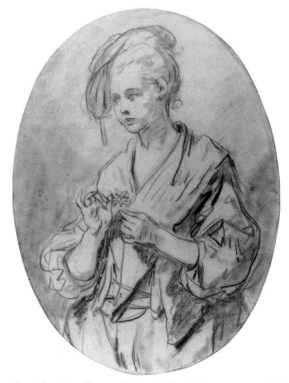

61. Jean-Baptiste Greuze, *Study for Simplicity*, c. 1756–57, black,
red, and white chalk, private collection, Paris.

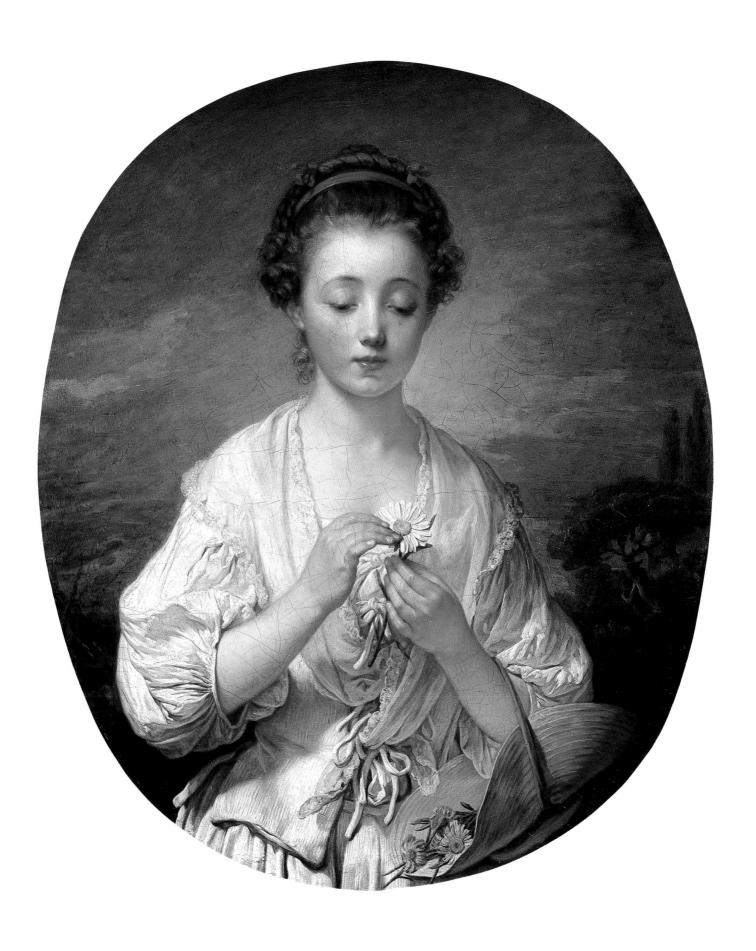

In his paintings of children Greuze frequently combined a sense of youthful innocence with awakening sexual awareness. Yet, perhaps in deference to his prestigious client (despite Pompadour's notorious reputation) Greuze softened the erotic dimension in *Simplicity* and *The Young Shepherd,* representing the children as more naive than knowing. At the Salon of 1759 the Kimbell painting was listed as "Simplicity, represented by a young girl."[3] This association between femininity and ingenuousness (*ingenuité* was another term used to describe the picture) was reiterated by a critic in 1761: "[*The Young Shepherd*] yields not at all to the first by the merits of its art but perhaps by the graces of the character of simplicity, more touching in one sex than in another."[4] Diderot, however, passed *Simplicity* without comment—"The Greuzes aren't marvelous this year"—while claiming that the subject of *The Young Shepherd* "does not mean a great deal." Moreover, he recognized the influence of Boucher in *The Young Shepherd,* an allusion that was not intended as a compliment even if it probably would have been welcomed by Madame de Pompadour.[5]

Indeed, most critics had little to say about either painting, preferring to focus on Greuze's more innovative pictures. *Simplicity* was one of twenty works exhibited by the artist at the Salon of 1759, and the majority of critical attention fell on his portraits and the painting called *Silence* (Royal Collection, London), a small genre scene showing a young woman disciplining a child. Nevertheless, the general remarks of one commentator could be taken as a positive response to the present work, with its creamy passages of fluid paint and subtle tonal nuances: "M. Greuze seems to prefer dressing his figures in white; it is one of the greatest difficulties in painting, worthy of the efforts of a distinguished artist."[6]

1. Hartford, San Francisco, and Dijon, 1976–77, 68; Paris 1984–85, 227–30. Marigny's comment—"Il seront veus de toutte le cour, et il pourroit en naistre de gros avantages pour luy, s'ils sont trouvés bons"—is recorded in a letter of November 28, 1756, to Natoire, the director of the French Academy in Rome. As Posner pointed out in his article on Pompadour's patronage of the arts (1990, esp. 92–100), the intervention of Marigny is another indication of his sister's basically passive approach to commissioning paintings.
2. Red, black, and white chalk, 10 × 8 in. (27.5 × 21.0 cm), Segoura, Paris.
3. "104. La Simplicité représentée par une jeune Fille." *Explication des peintures . . . pour l'année 1759,* Paris, 1759, 22.
4. "Il ne céde point au premier par le mérite de l'art mais peut-être par les graces du caractère de simplicité, plus touchantes dans un sexe que dans un autre" ([Bridard de la Garde?], "Observations d'une société d'amateurs sur les tableaux exposés au Salon cette année 1761," *L'Observateur littéraire* [1761], 52, quoted in Paris, 1984–85, 228; McW. 0133).
5. "Les Greuze ne sont pas merveilleux cette année" (Diderot, "Salon de 1759," in Seznec and Adhémar, 1967, 1:68). "Ce *Berger,* qui tient un chardon à la main, et qui tente le sort pour savoir s'il est aimé de sa bergère, ne signifie pas grand chose. A l'élégance du vétement, à l'éclat des couleurs, on le prendrait presque pour un morceau de Boucher" (ibid., 1:143).
6. "M. Greuze parait preferer de revetir ses figures de blanc; c'est une des plus grandes difficultés en peinture; elle est digne des efforts d'un artiste distingué" ("Exposition des peintures, sculptures, et gravures," *L'Année littéraire* 5 [1759], letter 10; Del. 1257; McW. 0117).

29. A Lady Reading the Letters of Heloise and Abelard

1758–59
Oil on canvas, 32 × 25 1/2 in. (81.3 × 64.8 cm)
Inscribed, on the leaves of the open book: HELOISE, ABEL; *on the spine of the closed book:* LART/DAIME/DE/BERNA
The Art Institute of Chicago, Mrs. Harold T. Martin Fund, Lacy Armour Endowment, Charles H. and Mary F. S. Worcester Collection, 1994.430

Exhibited in Toledo and Houston only

Provenance: David David-Weill, Neuilly-sur-Seine, 1919; Wildenstein, Paris and New York, 1919–24; Albert J. Kobler (d. 1937), New York, thence by descent; sale, Parke-Bernet, New York, April 22, 1948, lot 16; private collection, South America, until 1994; Simon Dickinson, Inc., New York; purchased by the Art Institute in 1994.

Selected Exhibition: Chicago, 1995.

Selected References: Wolff, 1996; Wise et al., 1996, 70–74.

Greuze's *Lady Reading the Letters of Heloise and Abelard,* recently acquired by The Art Institute of Chicago, is a major addition to the artist's oeuvre. Painted during a period when Greuze was one of the most celebrated young artists in Paris, it epitomizes the cult of *sensibilité,* one of the defining characteristics of French culture in the mid-eighteenth century.[1] A young woman is depicted three-quarter length seated against a plush and voluminous cushion. Her head thrown back and her mouth half open, she gazes abstractly into space, no doubt in a daydream inspired by the open book that has fallen from her limp grasp: it is an illustrated verse edition of the story of the ill-fated medieval lovers Heloise and Abelard, popular throughout the eighteenth century; the publication depicted by Greuze

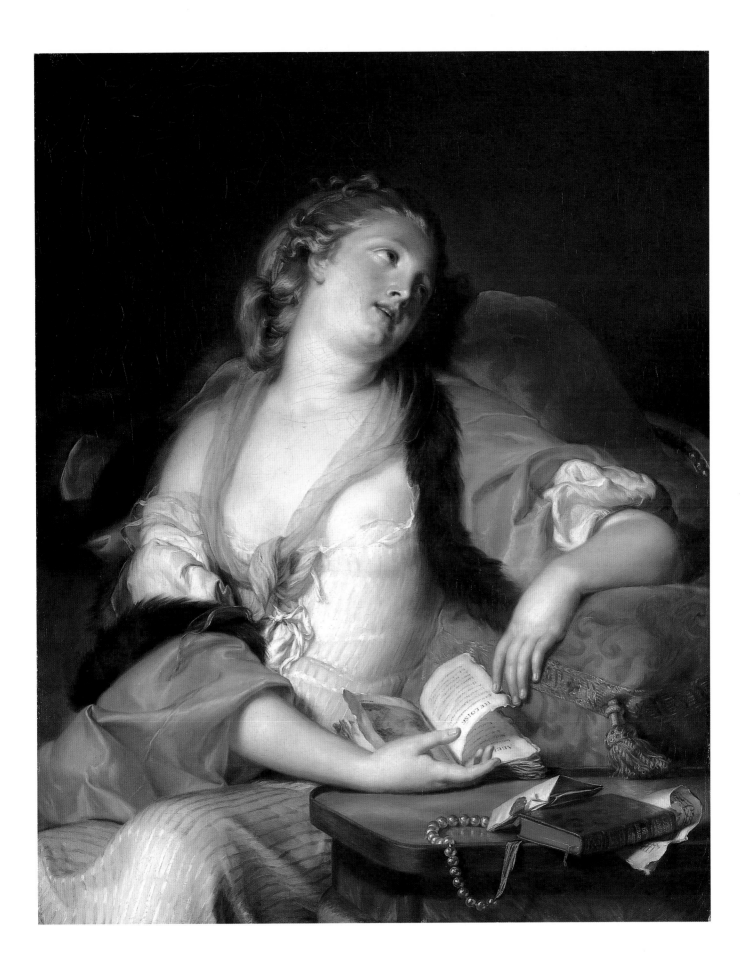

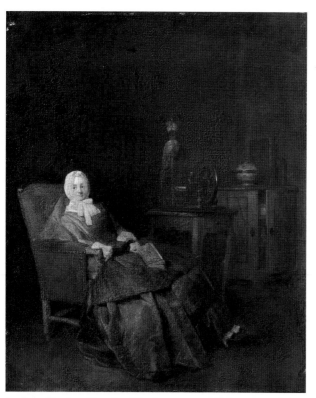

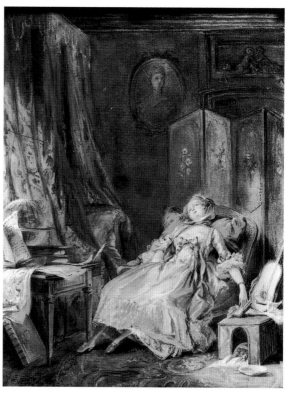

62. Jean-Siméon Chardin, *The Amusements of Private Life,* Salon of 1746, oil on canvas, Nationalmuseum, SKM, Stockholm.

63. Pierre-Antoine Baudouin, *Reading,* c. 1765, gouache, Musée des Arts Décoratifs, Paris.

may be Charles-Pierre Colardeau's *Lettre d'Héloïse à Abélard,* a French translation of Alexander Pope's *Eloisa to Abelard* first published in Paris in 1758.[2] Lying nearby on the side table are several objects placed close to the picture plane so that they appear to jut into the viewer's space: a string of pearls, an open letter, a musical score, and a second book, this one Pierre-Joseph Bernard's erotic poem *L'Art d'aimer* (The Art of Love). These attributes underscore the erotic charge that pervades Greuze's composition, an atmosphere that perhaps is most obviously revealed in the woman's provocative dishabille. The painting epitomizes Greuze's ability to capture strong emotional states—rapture, perhaps, in this case—in his genre paintings, giving them a significance and appeal beyond their vealed in the woman's provocative dishabille. The painting epitomizes Greuze's ability to capture strong emotional states—rapture, perhaps, in this case—in his genre paintings, giving them a significance and appeal beyond their keen observation of daily life.

The theme of women reading—whether novels or letters—was a popular one in eighteenth-century French painting, and Greuze undoubtedly was familiar with earlier examples, such as Chardin's *The Amusements of Private Life,* exhibited at the Salon of 1746 (fig. 62). Despite this woman's modesty of dress and the signs of her proper domestic pursuits that are visible in the background, it was suggested by at least one contemporary critic that her thoughts are elsewhere: "[The picture] has a sort of lan-

guid air which comes from the woman's eyes . . . ; we can tell that she is reading a novel and the tender feelings which this has aroused are making her daydream about some person whom she would like to see arrive soon."[3] Nevertheless, the amorous allusions are typically understated by Chardin, who moreover paired the painting with one showing a woman dutifully tending to her household accounts (Nationalmuseum, Stockholm). For his part Greuze showed no such reticence, endowing his *Lady Reading* with a fluid and sensuous application of paint that brilliantly complements the young woman's rapturous absorption. As Virginia Swain notes in her essay above, the picture captures the spirit of Jean-Jacques Rousseau's admonition at the beginning of *La Nouvelle Héloïse*—the wildly successful novel, published in 1761, intended in part as an update of the Heloise and Abelard story—that "no chaste girl has ever read novels." Inspired by her reading, she has fallen into reverie, apparently oblivious to her seminude state or to the presence of the viewer. Unlike Greuze's *The Laundress* (cat. 30), who adroitly returns one's gaze, here the woman is passive, her pliant and languorous form presented for the delectation of the beholder. A lack of commentary on the painting does not allow us to reconstruct the reaction of Greuze's contemporaries, but one can imagine that the picture would not have inspired the slight unease and wariness with which critics greeted *The Laundress.* Despite the originality in its use of sources and its literary allusions, as a depiction of feminine beauty and

sexual allure *Lady Reading* is entirely conventional. Indeed, it is only a short step from the Chicago painting to such more obvious and overtly erotic conceptions as Baudouin's intimate gouache, *Reading* (fig. 63), a composition that betrays a clear knowledge of Greuze's painting.

Unfortunately the early provenance of the Chicago *Lady Reading* is unknown, so the circumstances of its creation are open to speculation. At the time it was probably painted, 1758–59, Greuze was particularly drawn to the art of Rubens, and Martha Wolff has astutely pointed out that the woman's pose was based on the figure of Marie de' Medici in Rubens's *Birth of Louis XIII,* which Greuze had studied in the Luxembourg Palace. During this period he enjoyed the patronage and friendship of many prominent collectors and critics, including La Live de Jully, the marquis de Marigny, and Diderot. As Wolff notes, these men were associated with members of Rousseau's circle who had access to the manuscript of *La Nouvelle Héloïse* in the years before its publication in 1761, but whether the idea for *Lady Reading* was directly inspired by Rousseau's novel is impossible to determine.[4]

1. Brookner, 1972, 37–53.
2. Wise et al., 1996 (entry by Martha Wolff).
3. Quoted in Roland Michel, 1996, 220.
4. Wolff, 582, 584–85.

30. The Laundress

c. 1761
Oil on canvas, 15 3/4 × 12 3/4 in. (40.0 × 32.4 cm)
Harvard University Art Museums, Cambridge, gift of Charles E. Dunlap, 1957.181

Provenance: M. Gibert, Paris, 1837; comtesse de la Ferronaye, Paris; her sale, April 12, 1897, lot 10; Charles E. Dunlap; given to the Fogg Art Museum in 1957.

Selected References: Smith, 1837, vol. 8, no. 27; Bowron, 1990, 110, fig. 242.

Greuze's *Laundress* is an autograph replica of a painting exhibited to considerable acclaim at the Salon of 1761. That picture (fig. 64), now in the J. Paul Getty Museum, was owned by Greuze's early champion and patron, La Live de Jully, one of the most advanced collectors of his day.[1] The early provenance of the Harvard version is not known, the painting having made its first appearance only in 1837, when it was recorded in the collection of a M. Gibert in Paris. When or why Greuze painted it remains a mystery. The artist did not usually rework his compositions, as did other genre painters such as Chardin. La Live de Jully's *Laundress* was greatly admired at the Salon of 1761—indeed, it was considered Greuze's best work in the show until the late installation, shortly before the end of the exhibition, of the more ambitious *The Village Bride* (see fig. 5)—and it could well be that an admiring visitor to the Salon commissioned a replica for himself or herself. The present example, of high quality, repeats nearly exactly the composition and details of the Getty version.[2]

The Laundress—both the original and this fine repetition—projects a visual power out of proportion to its inti-

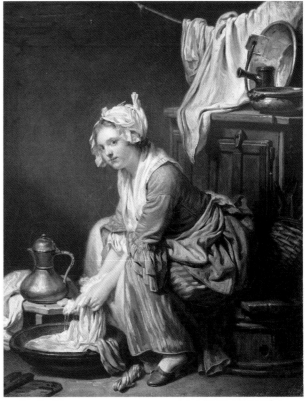

64. Jean-Baptiste Greuze, *The Laundress,* Salon of 1761, oil on canvas, Collection of the J. Paul Getty Museum, Los Angeles.

mate size, and it is not surprising that the picture attracted notice amid the jumble of works that filled the walls of the Salon Carré in the Louvre. As was recognized by an anonymous critic writing in the popular journal *L'Année*

littéraire, "[Greuze] is no less successful with those works he treats on a small scale; one would never tire of contemplating the picture of a young laundress. The head of that girl is the epitome of charm, the color is truthful, brilliant, and rich and altogether pleasing."[3] The young woman, a model employed by Greuze on other occasions, engages the eye of the beholder with a startling directness that excited the imaginations of several commentators. As one expressed it, "Since the opening of the Salon people have admired the young laundress . . . who, while leaning over her washing, throws a glance that is at once coquettish and mischievous."[4] According to Diderot, "That *Little Washerwoman* . . . is charming; but she's a rascal I wouldn't trust a bit."[5]

Such reactions suggest that Greuze's laundress confounded critics' expectations; her bold stare challenged viewers who were used to more objectified representations of women, especially lower-class working girls, such as they found in *Indolence,* exhibited in 1757 (cat. 26). No allegory of the virtues of cleanliness in the Dutch tradition,[6] Greuze's *Laundress* carries a clear erotic dimension—embodied in the wet folds of cloth that she wrings out between her legs and in the general disheveled state of her setting, lovingly rendered with keen attention to texture and color. Indeed, her forthrightness and unbalanced posture apparently perplexed some viewers, provoking Diderot to want to place her more firmly on her seat.[7] In this regard the tenor of the painting is far indeed from the pensive dignity of Chardin's servants in such paintings as *The Kitchen Maid* (cat. 16); that maid seems perfectly settled and at ease. As the Salon's *tapissier*—the man in charge of hanging the pictures—Chardin included several of his own genre works in later Salons, perhaps to orchestrate deliberate comparisons with his up-and-coming rival, a challenge that, by 1761, Greuze had already won in the minds of the public.

1. On La Live de Jully's activities as a collector, see Bailey, 1988, and Scott, 1973a. The Salon version was first recorded in La Live de Jully's collection in 1761 (*Mercure de France* [October 1761]: 160); it was then purchased from the La Live de Jully sale, Paris, March 5, 1770, by Langlier, acting as agent for Count G. A. Sparre of Kulla Gunnarstorp, Sweden; it remained with his heirs in Wånas, Sweden, until its acquisition by the Getty in 1983 (information from the museum's curatorial file).

2. In the Cambridge example, Greuze mixed sand into the ground or paint layers to give the surface a grainy, rough texture quite different from the polished finish of the Getty painting. Fragonard used a similar technique in *The Visit to the Nursery* (cat. 25). It should be noted that Greuze also painted a second version, with minor changes, of *Simplicity* (cat. 28); see Paris 1984–85, 228–30.

3. "Il n'a pas moins de sucées dans les sujets qu'il traite en petit; on ne se lasse point de contempler le tableau d'une jeune blanchisseuse. La tête de cette fille est un modèle d'agrément, le coloris est vrai, brillant et riche des tous les plus agréables" ("Exposition des peintures . . . dans le grand Salon du Louvre," *L'Année littéraire* 6 [1761]; Del. 1272; McW. 0129).

4. "Monsieur Greuse [*sic*] est le favori du public et il merite toute sa faveur. . . . Dès les premiers jours que le Salon fut ouvert, on admira une jeune blanchisseuse de la figure la plus interessante, qui, pendant qu'elle se baisse pour laver son linge, lance un coup d'oeil aussi coquet que malin" (["Les Tableaux de l'Académie de peinture, exposés dans le Sallon du Louvre: A Paris 1761," *Journal encyclopédique* 6 [1761]; Del. 1273; McW. 0132).

5. "Cette *Petite Blanchisseuse* . . . est charmante; mais c'est une coquine à laquelle je ne me fierais pas" (Diderot, "Salon of 1761," in Seznec and Adhémar, 1967, 1:134).

6. See, for example, Schama, 1987, 375–97.

7. "I would only be tempted to push her bench a little closer, so she has a better seat" ("Je serais seulement tenté d'avancer son tréteau un peu plus sous elle, afin qu'elle fût mieux assise"); Diderot, "Salon of 1761," in Seznec and Adhémar, 1967, 1:134.

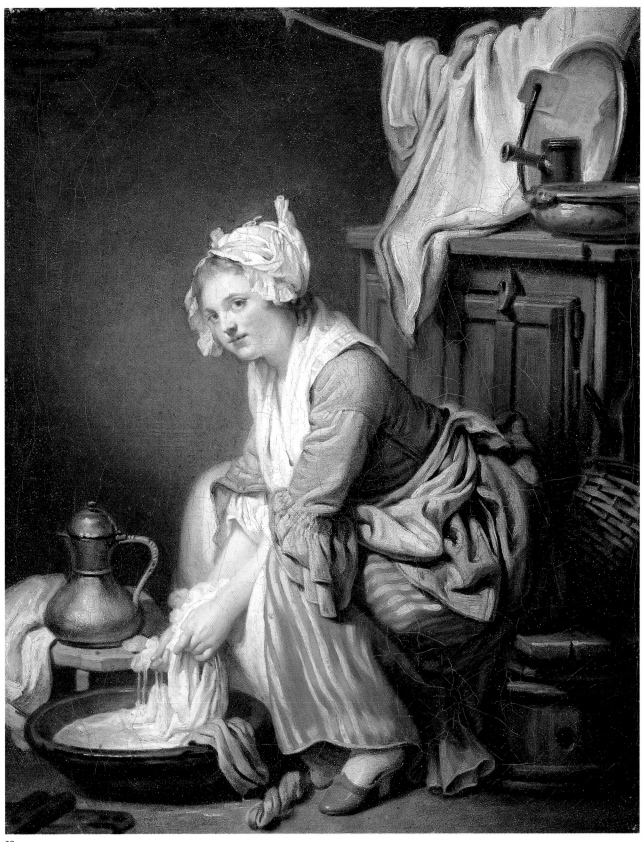

30.

31. *The Drunken Cobbler*

c. 1775–80
Oil on canvas, 29 5/8 × 36 3/8 in. (75.2 × 92.4 cm)
Portland Art Museum, Oregon, gift of Marion Bowles Hollis

Provenance: Marquis de Véri, Paris; his sale, Paris, December 12, 1785, lot 22; purchased by Paillet; Grimod de la Reynière, Paris; his sale, Paris, April 3, 1793 (in catalogue as November 1792), lot 27; purchased by Lebrun; Huard, Paris; his widow's sale, Paris, April 6–11, 1835, lot 245; Duval, Geneva; his sale, London, May 12–13, 1846, lot 109; comte d'Arzujon, Paris; his sale, Paris, March 2–4, 1852, lot 10; Pillot, Paris; his sale, Paris, December 6–8, 1858, lot 48; Baron James de Rothschild, Paris, 1860; Réne Gimpel and Wildenstein and Co., 1920; purchased by Mrs. Bowles, Portland, 1923; Mrs. Marion Bowles Hollis, Portland; given to the museum in 1959.

Selected Exhibitions: Pittsburgh, 1954, no. 59; Los Angeles, 1961, 27; San Francisco, 1965, no. 189; Paris, Detroit, and New York, 1974–75, no. 85; Hartford, San Francisco, and Dijon, 1976–77, no. 94.

Selected References: Martin and Masson, 1908, no. 158; Haverkamp-Begemann and Logan, 1970, 1:31, fig. 4; Brookner, 1972, 116, 120, 124, 127, pl. 65; Boime, 1987, 42, ill. 1.40.

Edgar Munhall was the first to recognize the relationship of this painting to a popular expression, "Les cordonniers sont les plus mal chaussés," usually rendered in English as "The shoemaker's children are always the worst shod."[1] The prominent bare feet of the boy and girl and the general barrenness of the setting are ample testimony to the effects of alcoholism. As Munhall points out, it was not unusual for Greuze to rely on such popular wisdom in ren-

dering a specific vice or state of mind; this was one reason for the artist's great appeal across a wide spectrum of the public. In the present example, as in others, Greuze complicated the situation by also making reference to artistic traditions that would likely have been available only to a learned and culturally aware audience: the pose of the drunken man echoes Michelangelo's *Drunken Bacchus* (Museo Nazionale, Florence), which Greuze would have admired during his visit to Italy in 1755–56. Such classical allusions—one of the strategies used by Greuze to elevate his genre scenes closer to the level of history painting— probably would have appealed to the picture's first recorded owner, the immensely well bred and cultivated marquis de Véri.[2]

In *The Drunken Cobbler* we see the devastation the inebriated patriarch brings on his family. The bemused father, his clothes in disarray, is oblivious to the concern of his children and the anger of his wife. The results of his profligacy are manifest in the humble setting and the tattered clothing of his children. The sadness and sense of betrayal are clearly written on the sensitively painted faces of the children, who gaze questioningly at their father. Although the wife has been described as "passive," even "simpering,"[3] one could just as easily see in her aggressive posture and piercing gaze a forceful and demanding personality who confronts her wayward husband rather than ignores his

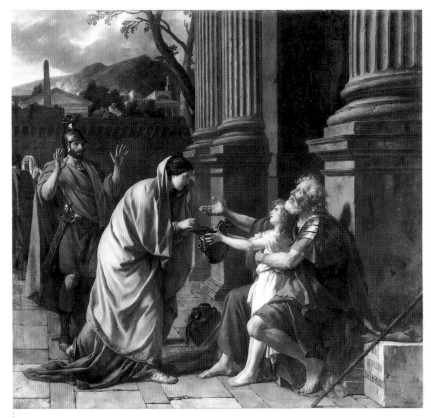

65. Jacques-Louis David, *Belisarius Receiving Alms,* Salon of 1781, oil on canvas, Musée des Beaux-Arts, Lille, photo R.M.N.

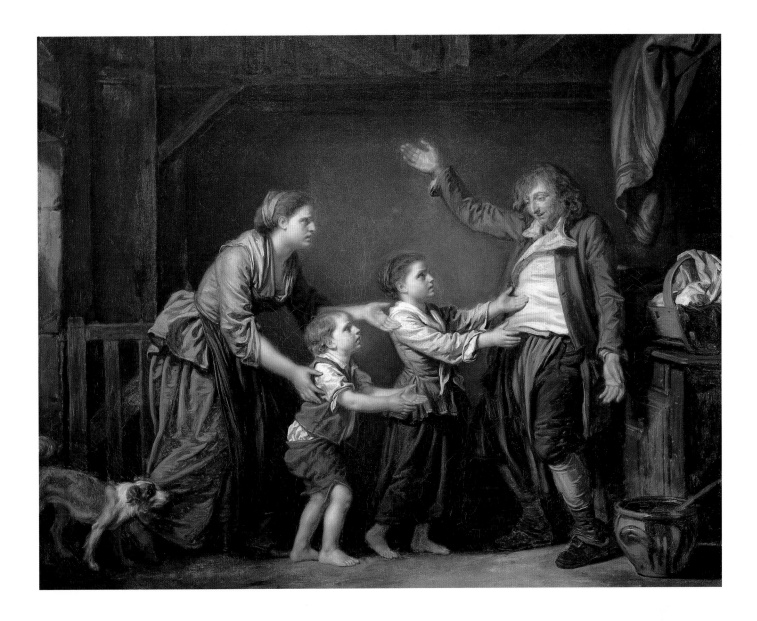

vice. She presents their worried offspring as evidence of the harm he has brought to his family. Greuze's message is that domestic harmony—the seed of social concord—collapses when the patriarch fails to meet his familial responsibility.

One of the artist's late masterpieces, *The Drunken Cobbler* probably dates to around 1780, several years after his other great domestic dramas, *The Ungrateful Son* (see fig. 18)—which the present work resembles in many ways—and *The Punished Son* (see fig. 19). These two paintings also belonged to the marquis de Véri. The marquis apparently stopped collecting around 1779,[4] which could provide a terminus ad quem for Greuze's picture; the painting was evidently admired by Jacques-Louis David, who clearly remembered it when he came to paint his *pièce d'agrément*, *Belisarius Receiving Alms*, exhibited at the Salon of 1781 (fig. 65). Despite Greuze's humiliating failure a decade ear-

lier to win acceptance as a history painter with *Septimius Severus Reproaching Caracalla* (see fig. 17), he was able to recapture something of his high ambitions in such genre paintings as *The Drunken Cobbler*. These moralizing subjects—which he apparently intended in all earnestness—and the rigorously classicizing means through which he presented them, are compelling evidence of the important part the artist played in the revival of history painting and the evolution of the neoclassical style, a role he would have been pleased to claim.

1. Hartford, San Francisco, and Dijon, 1976–77, 188. For the proverb, see Henry G. Bohn, *A Polyglot of Foreign Proverbs* (London, 1867), 34.
2. Bailey, 1985, 67–83.
3. Boime, 1987, 42.
4. Bailey, 1985, 70.

Hubert Robert *(Paris 1733–1808 Paris)*

orn the son of a valet de chambre *to the marquis de Stainville, Robert studied with the sculptor Michel-Ange Slodtz (1705–1764) before taking up painting. Although he did not win the Grand Prix, Robert traveled to Rome in 1754 with the retinue of the French ambassador, the comte de Stainville. Through his important patron the young artist was given accommodations at the French Academy, where he lived for eleven years. Robert's career as a painter was to a large measure determined by his experience in Italy; his study of ancient ruins was greatly enhanced by his friendships with the Italian artists Giovanni Battista Piranesi (1720–1778) and Giovanni Paolo Pannini (1691–1765), while his close association with Jean-Honoré Fragonard stimulated his already active interest in the overgrown gardens in and around Rome. Soon after his return to*

France, he was agréé *in 1766 and was then received into the Royal Academy with* Port de Ripetta *(Ecole des Beaux-Arts, Paris), a fantastic view of one of the principal sites in Rome. One of the most prolific artists of the day, Robert painted garden scenes, the urban topography of Paris, and numerous images of dilapidated ancient architecture, which earned him the nickname "Robert des ruines." Robert pursued a busy second career as a landscape architect, earning the title of* dessinateur des jardins du roi *in 1778 for his renovations of the gardens at Versailles. After a brief imprisonment in 1793–94 during the Revolution, Robert resumed his position as curator of the Musée des Arts, to which he had been appointed in 1784. Near the end of his life, he was chosen to assist in the planning of the new national museum.*

32. *Laundress and Child*

1761
Oil on canvas, 13 13/16 × 12 7/16 in. (35.1 × 31.6 cm)
Signed, dated, and inscribed, center left: H ROBERTI ROM/1761;
signed, dated, and inscribed, center right on drapery:
Roberti/Roma/1761
Sterling and Francine Clark Art Institute, Williamstown,
Massachusetts

Provenance: Adrien Fauchier-Magnan, Neuilly-sur-Seine; his sale, Sotheby's, London, December 4, 1935, lot 90, ill.; purchased by M. Knoedler and Co., London; purchased by Robert Sterling Clark, December 18, 1935; acquired by the Clark Art Institute in 1955.

Selected Exhibitions: Williamstown, 1958, pl. 54; Atlanta, 1983, no. 50; New York, 1988, 4, 82.

Selected References: Rome, 1990, 42, 44, fig. 9; Sterling and Francine Clark Art Institute, 1992, 946, ill.

Painted in Rome, this little picture exemplifies the small-scale genre works produced by Robert and his close friend Fragonard (see cat. 22) during their sojourn in Italy in the late 1750s and early 1760s.[1] Although Robert was primarily fascinated with Rome's incomparable architectural grandeur—an interest that would form a central component of his art throughout his career—he also was drawn to the daily activities of the local population that he witnessed during his frequent promenades through the city. These he described, with varying degrees of keen observation and pure invention, in a series of vivid drawings, watercolors, and paintings that he produced both in Italy and upon his return to France in 1765.

Laundress and Child, dated 1761, is one of the most delightful of those genre scenes painted in Rome, an amusing juxtaposition of the old and the modern city, exuberantly painted with an unusually fluid and deft technique that closely recalls contemporary works by Fragonard.[2] In an overgrown corner of a piazza or courtyard, a young laundress hangs sheets on a clothesline strung across an ancient fountain. Above the fountain, a looming sculpture disappears into the darkness of a niche, its stone draperies offering a contrast with the soft folds of the bedsheets and the laundress's own billowing skirts, caught in raking sunlight. Although the scene is undoubtedly imaginary, the subject was often recorded by the artist, as is evident from one of his surviving Roman sketchbooks.[3] In the Clark *Laundress*, the artist cleverly combined several motifs that would have appealed to the sophisticated tastes of his patrons during these years, such as the abbé de Saint-Non and the duc de Choiseul. For example, he signed and dated the painting twice, using an Italianate version of his name, "H. Roberti," once as if carved into the marble of the sculptural base and again, incised with the butt-end of the brush, in the still-wet paint of the folds of the sheet at the right. In another typically witty combination, he placed near the spitting lion's head a little boy who lifts his shirt to relieve himself at the edge of the fountain. The reaction of the laundress—no doubt concerned for the safety of her freshly cleaned sheets—cannot be read, and the

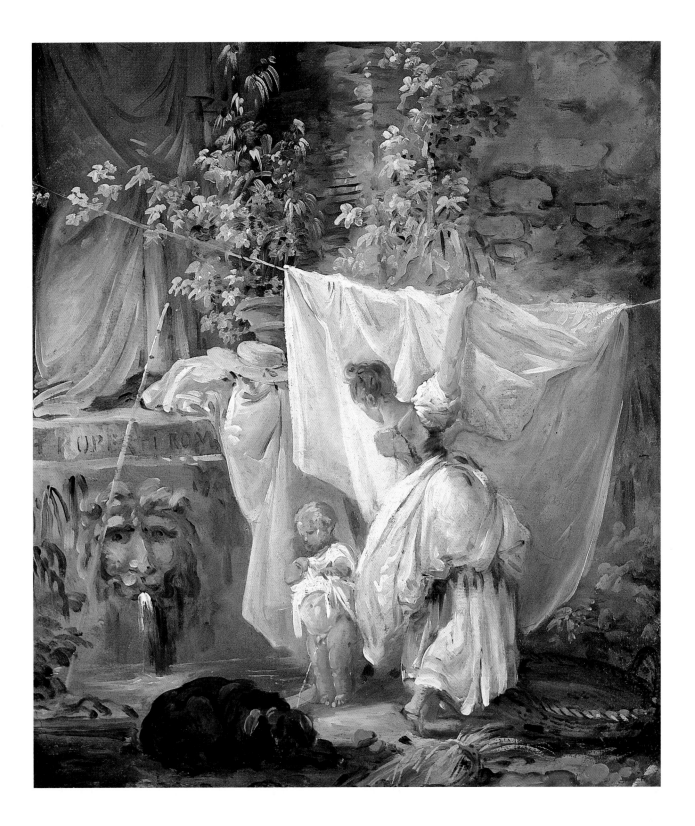

dog, lying perilously close to the offending action, sleeps unaware. Yet the innocent act of the child, mirroring the unceasing flow of the sculpted fountain, offers a sardonic gloss on the ancient-versus-modern debate that prevailed in intellectual circles in Rome, a dispute that the artist usually addressed in his works in more serious terms.

1. Related pictures by both artists are included in Rome, 1990, nos. 30, 36, 51, and 55; Robert's career in Rome is surveyed by Cayeux, 1987, 21–47; and Washington, D.C., 1978, 17–26.
2. It is particularly close in theme, style, and such details as the foreground dog to Fragonard's *Laundresses* (Musée des Beaux-Arts, Rouen), datable to 1759–60; see Rome, 1990, 89, no. 35 (ill.).
3. For example, the sketchbook formerly belonging to Ernest May; see Paris, 1978–79, no. 54; Paris, 1983, nos. 50–51.

Louis-Michel Van Loo *(Toulon 1707–1771 Paris)*

*A*longside his only slightly older uncle Carle Van Loo *(1705–65), Louis-Michel received his early training from his father, the artist Jean-Baptiste Van Loo (1684–1745) in Turin, Rome, and finally Paris. He won the Grand Prix in 1725, just one year after his uncle, with a now lost painting,* Moses with Pharoah's Crown. *He returned to Rome in 1728 with his uncle, brother, and François Boucher for his sojourn at the French Academy. Back in Paris, he was received into the Royal Academy as a history painter in 1733 with* Apollo and Daphne *(Ecole des Beaux-Arts, Paris). Van Loo moved to Madrid in 1737; there he enjoyed great success for fifteen years, and was*

named First Painter to Philip V and Ferdinand VI. He returned to Paris in 1752, and exhibited at the Salon from 1753 to 1767. An extremely skillful portrait painter, Van Loo recorded the likenesses of Louis XV, members of the royal family and court, and a number of contemporary artists and intellectuals. Among the most admired were the group portrait, Carle Van Loo and His Family *(1757; Ecole des Arts Décoratifs, Paris) and his famous portrait of* Denis Diderot, *exhibited in 1767 (Musée du Louvre, Paris). Upon the death of his uncle in 1765, Louis-Michel was made the* gouverneur *of the Ecole royale des eléves protégés.*

33. *Portrait of the Devin Family*

1767
Oil on canvas, 43 5/16 × 59 1/16 in. (110.0 × 150.0 cm)
Signed and dated above the ink stand: L. M. Van Loo 1767
Los Angeles County Museum of Art, purchased with funds provided by Mr. and Mrs. David E. Bright, Mr. and Mrs. William Preston Harrison, William Randolph Hearst, Mrs. Sidney Alcott, Mr. and Mrs. Jack Benny, the Jones Foundation, Mrs. Samuel M. Haskins, B. Gerald Cantor, Dr. and Mrs. Robert Carroll, and the European Painting Acquisition Fund

Provenance: J. J. Devin, Paris; remained in the Devin residence, Hotel de Chenizot, Paris, until 1882; Annel collection, Longueil-Annel, near Compiègne, until 1940; hidden in Brittany with a consignment of furniture from the Chateau d'Annel, 1940–45; returned to Paris, 1945; by descent until 1987; sale, Sotheby's, Monaco, June 20, 1987, lot 396; Heim Gallery, London; purchased by the museum in 1989.

This unpublished family portrait is one of Louis-Michel Van Loo's most engaging productions, painted at a time when the artist was enjoying considerable public acclaim. It represents the family of Jean-Jacques Julien, Comte Devin (1731–1817), a president of the Paris Parlement who had also accumulated the title *sécretaire du Roi* and was appointed a director of the *Caisse d'escompte* in 1767, the year of this portrait.[1] The young family—members of an arriviste class of bureaucrats who had purchased their nobility—is displayed across the width of the canvas in barely restrained opulence, their wealth and status conveyed in a sequence of lavish furnishings and shimmering garments. The artist has clearly taken delight in rendering the contrasting colors and textures of the fabrics, the wood grain of

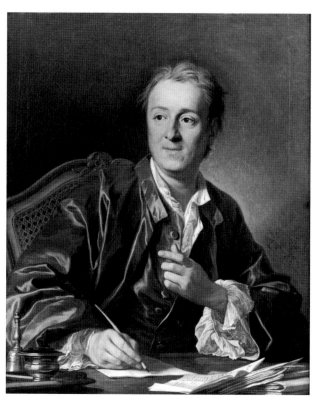

66. Louis-Michel Van Loo, *Denis Diderot*, Salon of 1767, oil on canvas, Musée du Louvre, Paris, photo R.M.N.

the writing desk, and the stiffness of the leather portfolio.

Van Loo was greatly admired for the incomparable sense of likeness he could achieve in his portraiture—"[his sitters'] features, soul, character, and spirit, all are trans-

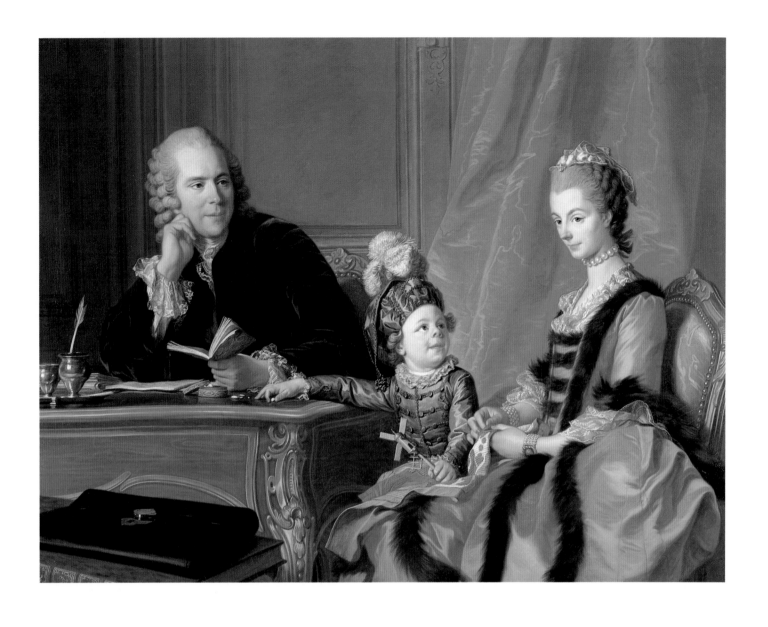

ported to the canvas"[2]—an ability fully in evidence here. Yet the *Devin Family* is as much an idealized representation of familial bonds as it is an objective transcription of real people. Van Loo portrayed the members as acting out roles that would have been considered natural to each of them. The father, dressed in a somber yet elegant velvet jacket, sits at his desk, attributes of his position and occupation—portfolio, books, documents, and writing equipment—close to hand; he assumes the pose of a *philosophe*, his head resting on his crooked elbow as he looks up from his reading to admire his beautiful young wife. The demure Comtesse Devin (1743–70)—herself dazzlingly resplendent in a silk dress lined in fox fur, the elegant column of her neck accented with enormous pearls—occupies herself with embroidery, a pastime appropriate to a woman of her station who wished to avoid idleness while conversing or visiting with intimates.[3] Linking the husband and wife is their offspring, the five-year-old Jean-Jacques Devin, marquis de Fontenay (1762–1817), dressed in an outlandish blue satin *costume à l'espagnol*; he holds a toy windmill—perhaps a reference to the whimsical nature of children—and sneaks a mint from his father's candy box while casting his own loving glance at his mother.

Diderot, himself portrayed by the artist in 1767 (fig. 66), thought that Van Loo was at his best when representing family groups rather than individuals: "Michel Van Loo is truly an artist: he understands the grand production; witness some of his family pictures, where the figures are as large as life, and which are laudable in all aspects of painting."[4] Although presented with the showy accoutrements of their extravagant lifestyle, the members of the Devin family interact among themselves, seemingly oblivious to the gaze of the spectator.[5] And however true to life their actual portraits may be—an issue that would have been irrelevant to anyone but the family's intimates and heirs—the painting is above all a demonstration piece of contemporary family values, representing the Devins as a harmonious and loving ensemble, psychologically and emotionally attached, and secure in their roles and relationships. One needs only contrast it to Lancret's *The Bourbon-Conti Family* (cat. 6) to appreciate the change in taste and meaning. As the Los Angeles painting amply demonstrates, by the late 1760s the boundaries between portraiture and genre could be fluid (compare this work to, for example, Fragonard's *The Visit to the Nursery* [cat. 25]), both articulating a view of marriage and parenting that was fashionably new, drawn from the moral ideology of Jean-Jacques Rousseau. Indeed, the *Portrait of the Devin Family* fairly illustrates sentiments expressed in *Emile*, Rousseau's education treatise of 1762: "The attraction of domestic life is the best counterpoison for bad morals. The bother of children, which is believed to be an importunity, becomes pleasant. It makes the father and mother more necessary, dearer to one another; it tightens the conjugal bond between them. When the family is lively and animated, the domestic cares constitute the dearest occupation of the wife and the sweetest enjoyment of the husband."[6]

1. See Anatole, 1902–6, 2:217.
2. "Leurs traits, leur âme, leur caractère, leur génie, tout a été transporté sur la toile" ([Mathon de la Cour], *Lettres sur les peintures, les sculptures, et les gravures exposées au Salon du Louvre en 1767*, Del. 1302, 236; McW. 0180).
3. The occupation is similar to that of "knotting," a kind of lace making that was often engaged in by well-to-do women. Edgar Munhall has discussed the iconography of knotting and its encouragement by Madame de Genlis in Hartford, San Francisco, and Dijon, 1976–77, 56.
4. "Michel Van Loo est vraiment un artiste: il entend la grande machine; témoins quelques tableaux de famille où les figures sont grandes comme nature et louables par toutes les parties de la peinture" (Diderot, "Salon de 1767," in Seznec and Adhémar, 1967, 3:69).
5. Michael Fried has discussed Van Loo's tendency, in some of his family portraits, to depict his sitters engaged in activities that cause them to disregard the presence of the viewer (Fried, 1980, 109–11).
6. Jean-Jacques Rousseau, *Emile; or, On Education*, trans. Allan Bloom (New York, 1979), 46.

Jean-Baptiste Le Prince *(Metz 1734–1781 Saint-Denis-du-Port)*

orn into a family of sculptors, Le Prince studied with François Boucher. He traveled to Russia by way of Amsterdam in 1758. He worked at the Imperial Palace in St. Petersburg and was able to journey throughout Russia, Siberia, and Finland, observing the customs and costumes of these locales. Returning to Paris in 1763, he was agréé in 1764, and the next year was accepted into the Royal Academy with his greatly admired Russian Baptism *(Musée du Louvre, Paris). Le Prince exhibited at the Salons from 1765 to 1781, gaining a measure of acclaim with*

exotic images of daily life in Russia. His Russian subjects were also popularized by way of no less than thirteen separate suites of prints, and he was eventually criticized for his repetition of ideas. He did, however, continue to paint other subjects, including landscapes and genre scenes, often in a style reminiscent of Boucher. Afflicted with illness for many years, he retired to the countryside outside Lagny after having finished a number of cartoons for the Beauvais tapestry works.

34. Fear

1769
Oil on canvas, 19 3/4 × 25 1/4 in. (50.0 × 64.0 cm)
Signed and dated, lower left: J. B. Le Prince / 1769
The Toledo Museum of Art, gift of Edward Drummond Libbey,
70.44

Provenance: Duc de Liancourt, c. 1782–92; Sénateur Boittelle, Paris; his sale, Pillet, Paris, April 24–25, 1866, lot 89; baroness d'Erlanger, London, 1932; Dr. Ernest L. Tross; sale, Sotheby's, London, May 14, 1958, lot 144; Count Guillaume de Belleroche, 1958–62; sale, Christie's, London, June 29, 1962, lot 48; Tooth Galleries, London; Madame Gomey; her sale, Versailles, February 22, 1970; Galerie Cailleux, Paris; acquired by the museum in 1970.

Selected Exhibitions: Salon of 1777, no. 55; London, 1968, no. 434; Toledo, Chicago, and Ottawa, 1975–76, no. 66.

Selected References: Chiego, 1974, 11–14, figs. 6, 7; Cailleux, 1975, 300; Wildenstein, 1975, 18, fig. 7; The Toledo Museum of Art, 1976, 96, pl. 204.

Le Prince's intriguing picture, delicately painted in a beautiful range of blues, mauves, and creamy whites, typifies an enduring tradition in eighteenth-century French genre painting that focuses on the life of the boudoir (see, for example, cats. 11 and 24). In this intimate scene a young woman, in concert with her little dog, reacts in alarm to something off to the left of the composition. The rumpled bedsheets, the woman's partial state of undress, and—most damning—the two cups and *chocolatière* on the side table and the pair of armchairs (one of which has been knocked over) suggest the interruption of a tryst. The woman's outstretched left hand, reaching toward the cascading curtains at the right of the composition, might be understood as a gesture of warning to an unseen lover. Indeed, the second state of Noël Le Mire's engraving after the painting, issued

in 1784, included the head of a young man hiding among the draperies.[1]

Although Le Prince painted *Fear* in 1769, he did not exhibit it until the Salon of 1777, adding it to a number of more recently completed landscapes. The reason for the delay is unknown, but it is possible that its first owner—perhaps the duc de Liancourt, who possessed the work in the eighteenth century—thought the subject was too risqué. The writer in the *Mémoires secrets* (September 15, 1777) hinted as much: after observing that the painting's title did not really fit the scene depicted, he went on, "Is this thus an enigma that [Le Prince] has submitted to the public? It is easier to believe that, fearful of scandal should he identify his subject with its true title, he has masked it under another for which he could not be rejected by the Salon."[2] Despite its small size and provocative subject—which indeed must have seemed rather licentious in the company of respectable moralizing genre works such as Aubry's *Farewell to the Nurse* (cat. 37)—the painting attracted considerable notice at the Salon. Unlike the cynical critic in the *Mémoires secrets*, other commentators tried gamely to understand Le Prince's title by considering the picture a noble attempt at evoking a generalized state of fear: "A pallor permeates her entire person and her blood seems to have withdrawn into her heart. Her gaze is fixed, her ear attentive, her mouth begins to open: the thrown covers and an armchair next to the bed that we see overturned, these also indicate the first traces of this young person's agitation."[3] Indeed, her expression mirrors almost exactly the model for *La Crainte* (Fear), in Charles Le Brun's canonical *Conférence sur l'expression* (1698).[4]

The relationship between *Fear* and Fragonard's cele-brated *The Bolt* (fig. 67)—apparent especially in the tum-bledown bedclothes, the capsized chair, and the dramatic spotlighting that are features common to both works—has often been observed. The belated appearance of Le Prince's jewel-like cabinet painting at the Salon of 1777 even may have inspired Fragonard to paint his late mas-terpiece, which is dated by most scholars to this same pe-riod.[5] As Daniel Wildenstein notes, the reproductive en-gravings after the two works were associated with each other as early as the mid-1780s.[6] Compared to Fragonard's masterpiece, however, Le Prince's painting is less innova-tive stylistically, and—its title notwithstanding—the sense of imminent danger in *Fear* is nothing compared to the fright expressed by the woman in Fragonard's scene of co-erced sex. By contrast, with its lighthearted tone and anec-dotal quality, focused on the fear of discovery, Le Prince's subject is more in keeping with another, less disturbing work by Fragonard, the amusing 1778 etching *The Armoire* (cat. P11; see fig. 32).[7]

1. Hédou, 1879, 55, who notes that the addition of the lover's head must have been Le Mire's decision, since the second state was issued after Le Prince's death.

2. "Seroit-ce donc une énigme qu'il a proposée au Public? Il est plutôt à présumer que, craignant de scandalisier s'il eut indiqué son sujet sous le vrai titre, il l'a masqué sous un autre, pour qu'il ne fût point rejetté au Sallon" (*Mémoires secrets pour servir à l'histoire de la République des lettres en France* [London, 1780], 11:28).

3. "La paleur est repandue sur toute sa personne et son sang semble s'etre retiré autour de son coeur. Ses regards sont fixes, son oreille attentive, sa bouche entre ouverte: ses couvertures jettées et un fau-teuil placé a coté du lit et que l'on voit renversé, ses veut encore a designer les premiers mouvements d'agitation de cette jeune per-sonne" ("Exposition au Salon du Louvre des peintures . . . en 1777," *Mercure de France* 1 [October, 1777]: 1089; Del. 191, McW. 0270).

4. See Martin, 1977, 89, fig. 638, Walsh, 1996, 527–33.

5. Both Cuzin and Rosenberg date *The Bolt* to around 1777–78; the pic-ture was painted for the marquis de Véri (owner of Greuze's *Drunken Cobbler* [cat. 31] and Aubry's *Farewell to the Nurse* [cat. 37]), who apparently ceased collecting in 1779 (see Bailey, 1985, 70).

6. Wildenstein, 1975, 24 n. 20. For Maurice Blot's engraving after Frag-onard's *The Bolt*, see cat. P4, fig. 33.

7. See Baltimore, Boston, and Minneapolis, 1984–85, 227–29, no. 76.

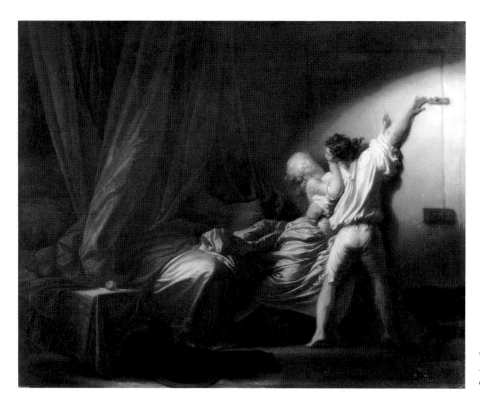

67. Jean-Honoré Fragonard, *The Bolt*, c. 1778, oil on canvas, Musée du Louvre, Paris, photo R.M.N.

34.

Etienne Aubry *(Versailles 1745–1781 Versailles)*

*A*ubry studied first under Jacques-Augustin de Silvestre, the drawing teacher of the French royal children, and then with the history painter Joseph Marie Vien (1716–1809). In 1771, Aubry gained admittance into the Royal Academy as a portraitist, although it was primarily as a genre painter that he would carve out his reputation. He exhibited a series of genre pictures at the Salons of 1775, 1777, and 1779, focusing on images of domestic harmony and homey virtue—often with a moralizing intent—inspired by Greuze and, to a lesser extent, by Chardin. Like the work of many genre painters, Aubry's compositions were collected by many of the leading connoisseurs of the period, including the comte d'Angiviller, the directeur-général des bâtiments *and the painter's principal benefactor; his com-*

positions were disseminated to a wider audience through engravings. Despite his success as a genre painter, Aubry's ambition was to become a history painter; in 1777, at the urging of the comte d'Angiviller, Aubry traveled to Rome, yet his attempts at elevating his art were viewed as beyond his capabilities. He returned to Versailles in 1780, lamenting his failure, and died the following year at the age of thirty-six. His final history painting, Coriolanus Saying Farewell to His Wife, *now lost, was posthumously displayed at the Salon of 1781. Although Aubry's oeuvre remains largely undocumented, his surviving portraits and genre paintings show him to be a keen observer of nature and an adept, if sometimes sentimental, storyteller.*

35. Household Task

c. 1771–72
Oil on canvas, 31 7/8 × 23 3/8 in. (81.0 × 59.3 cm)
Museum of Fine Arts, Springfield, Massachusetts, James Philip Gray Collection, 52.11

Provenance: (?) Barthélemy-Augustin Blondel d'Azincourt, Paris; Mrs. Van Cortland Hawks, Bar Harbor, Maine, by 1925; to her niece, Mrs. Newbold Morris; Childs Gallery, Boston, 1952; purchased by the museum in 1952.

Selected References: Ingersoll-Smouse, 1925, 79–80, 83, ill.; Museum of Fine Arts, Springfield, 1979, no. 284, ill.

Aubry is usually considered a follower of Greuze, but he also was inspired—as were many genre painters of his generation—by the paintings of Chardin. This is nowhere more clear than in the present case, where Aubry based his composition directly on Chardin's *The Washerwoman* of 1737 (fig. 68), one of the latter's first forays into genre painting. Whether Aubry had access to Chardin's original—the two surviving versions (Nationalmuseum, Stockholm, and Hermitage, St. Petersburg) were already out of France by 1772, but Chardin himself owned a third—or whether he relied on Cochin's engraving is answered by the direction of Aubry's composition; it is in the same orientation as the print, that is, in reverse of Chardin's painting.[1]

As in Chardin's image, in *Household Task* a servant leans over a washtub, her sleeves rolled up as she scrubs the laundry, while a little boy uses the soapy water to blow bubbles through a straw. Despite its somewhat abraded condition (evident particularly in the background), Aubry's painting echoes Chardin's style in its warm range of earth tones, reds, and greens, sharply offset by passages of brilliant white in the clothes of the washerwoman. Unlike in his

later, more characteristic paintings, such as *The Shepherdess of the Alps* (cat. 36), here Aubry sought to replicate Chardin's brushwork (an essentially impossible goal) in the textures of cloth and wood, and he also adopted something of the older artist's compositional strategies, placing a brazier in the lower left corner of the picture. Like its counterpart in Chardin's *Saying Grace* (cat. 18), this object establishes the foreground while leading the viewer's eye into the scene. Completely uncharacteristic of Chardin, however, is the direct glance of the young boy, who catches our eye, a conceit that effectively breaks the self-contained spell of the picture.[2]

68. Jean-Siméon Chardin, *The Washerwoman,* Salon of 1737, oil on canvas, Nationalmuseum, SKM, Stockholm.

The ostensible meaning of *Household Task* draws equally on Chardin's example. The motif of a boy blowing bubbles was, according to Mariette, the first genre subject attempted by Chardin, and the artist certainly was aware of the iconographic tradition that it recalled.[3] The all-too-brief life of the soap bubble could allude to the transience and decay of all earthly things, and thus as a warning against worldliness and vanity, or—more positively and appropriately in the present context—as an acknowledgment of the passing pleasures of childhood itself. The boy's idle play contrasts acutely with the drudgery of the washerwoman, who labors amid her tumbledown household. Indeed, unlike Chardin, whose servants are always poised and fully integrated into spotless environments, Aubry draws our attention to the destitute state of this washerwoman and the child—his clothes in tatters—who must use their single ramshackle room as a combination kitchen, laundry, and bedroom. Despite the picturesque appeal of the scene and the pretty features of the woman—a model encountered elsewhere in Aubry's work[4]—we are keenly aware of the difficulty of her task, of the force she must bring to bear in wringing out the wet clothes. The keen observation and insistent verism of Aubry's picture form a striking antidote to the genre scenes of his mentor Greuze, whose own jaunty *Laundress* (cat. 30) performs the same task with a carefree insouciance amid an engaging jumble of beautifully painted objects. Maurice Blot's engraving after *Household Task* is dedicated to the eminent collector Blondel d'Azincourt (1719–94), although whether he owned the picture is not clear. (It did not appear in the 1783 sale of d'Azincourt's collection.) Chevalier of the order of Saint Louis and a lieutenant-colonel in the infantry, d'Azincourt was an honorary member of the Royal Academy who formed an important collection, owning some five hundred drawings by Boucher, as well as paintings by Watteau and, not surprisingly—if indeed he did own *Household Task*—Chardin.[5]

1. On Chardin's *Washerwoman*, see Paris, Cleveland, and Boston, 1979, 195–203.
2. Only rarely in Chardin's pictures that are not portraits (e.g., Rosenberg, 1983, nos. 100 and 106a) do the protagonists look directly at the viewer; in all of his household scenes the figures turn their heads, look to the side, or gaze right past us (for example, *The Bird-Song Organ* [cat. 19]).
3. Snoep-Reitsma, 1973, 176–80; Conisbee, 1985, 133–37. For Chardin's several versions of *Soap Bubbles*, see Los Angeles, 1990.
4. According to Ingersoll-Smouse, 1925, 83, she also appears as the wet nurse in *Farewell to the Nurse* (cat. 37).
5. He owned Watteau's *Champs-Élysées* (Wallace Collection, London), which he had purchased from the collection of his father, Blondel de Gagny (see Ingamells, 1989, 355–58); two Chardin still lifes, pendants of vegetables and kitchen utensils, appeared in his sale on February 10, 1783, lot 52 (see Rosenberg, 1983, 120).

36. *The Shepherdess of the Alps*

1775
Oil on canvas, 20 × 24 1/2 in. (50.8 × 62.2 cm)
Signed and dated, lower left: Aubry 1775
The Detroit Institute of Arts, Founders Society purchase with funds from Mr. and Mrs. Edgar B. Whitcomb

Provenance: Le Chevalier Lambert, Paris; his sale, Paris, March 27, 1787, lot 206; Sir John Foley Grey, Baronet, Malvern, England; his sale, Christie's, London, June 15, 1928, lot 127; Horace Ayers Buttery, London, 1928; A. F. Mondschein Galleries, New York, 1947; acquired by The Detroit Institute of Arts in 1948.

Selected Exhibitions: Paris, Salon of 1775, no. 177; Houston, 1954, no. 152.

Selected References: Ingersoll-Smouse, 1925, 79; Grigaut, 1949, 30–47, ill; Seznec and Adhémar, 1967, 4:261, 291, no. 177; Bukdahl, 1980, 58, 127 (ill.).

The Salon of 1775 was notable for the great number and high quality of genre paintings and landscapes exhibited, prompting one critic to remark that while the history paintings on view "did little to capture the attention of connoisseurs and amateurs, moral genre and that of landscape have attained a degree of perfection that leaves little else to desire."[1] In this context it is significant that Aubry's

The Shepherdess of the Alps was described as "pretty much all that composes moralizing genre painting."[2] Aubry exhibited several other genre pictures and a group of portraits that year, staking his claim as the inheritor of Greuze's mantle after the latter's self-imposed exile from the official exhibitions. Indeed, of all of Aubry's paintings, the present composition is the most indebted to Greuze, being essentially a pared-down version of the latter's earlier masterpiece *The Village Bride* (see fig. 5). Aubry's ambitions as a history painter are reflected in this small but sophisticated work, with its carefully considered arrangement of figures and array of eloquent gestures and expressions.

Unlike Greuze, who invariably invented his own stories, here Aubry drew the subject from a popular work of literature, Jean-François Marmontel's *La Bergère des Alpes*, first published in the *Mercure de France* in 1759. In this regard the picture could be seen as a more elevated form of genre, based on a literary text rather than representing an anonymous happenstance. Aubry's painting depicts the moment early in the story when the wealthy marquis and marquise

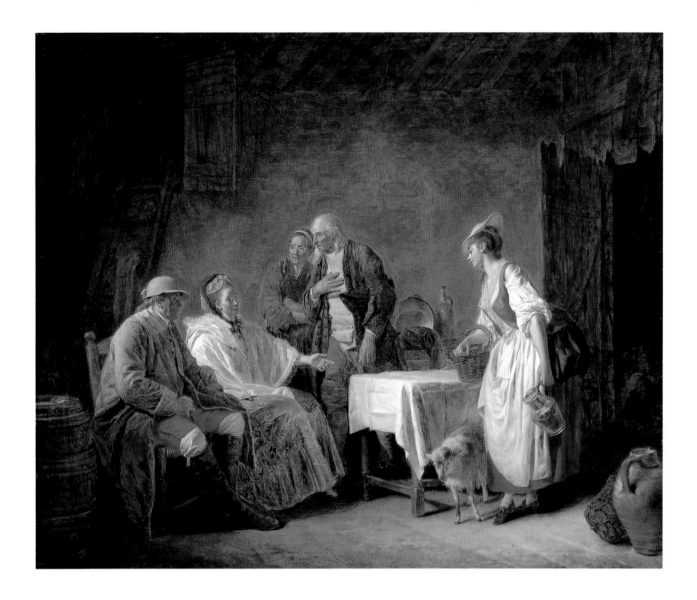

de Fonrose, having sought shelter with a humble peasant couple, recognize the beautiful shepherdess, Adelaide, who had assisted them earlier that evening: "She appeared with a bucket of milk in one hand, and in the other a basket of fruits; and after having saluted them with a charming grace, she began immediately the care of the house, as if nobody busied themselves about her."[3] The twist in the story is that, despite her lowly circumstances, Adelaide is in truth a young noblewoman—a fact intuitively recognized by the marquise—who has withdrawn into the countryside to be near the grave of her beloved husband, a soldier killed in the line of duty. Eventually, the Fonroses' son, beguiled by descriptions of Adelaide's beauty, will himself take the role of a shepherd in order to win her love. Despite her faithfulness to her husband's memory, the faux shepherdess eventually succumbs to the young suitor's charms. Aubry treated the subject of the meeting of Adelaide and the young Fonrose several times, including in a painting that appeared at the Lambert sale in 1787 as a pendant to the Detroit picture.[4]

Aubry's painting gives pictorial expression to the essential conflict of the scene—that Adelaide cannot disguise her birthright from her social equals. The elderly marquis and marquise, seated at the left, look on in wonder at the appearance of the shepherdess, illuminated by a soft light as she enters through the door. Her elegant bearing and beautiful features sharply distinguish her from the old peasants who protect her and from the barren and ramshackle surroundings of the dwelling. The shepherdess's graceful turn of the head, which emphasizes the line of her neck and the profile of her face, reveal her beauty and youth; she conforms to a figural type generally reserved for depictions of aristocratic women (for example, she is repeated closely in the mother on the donkey in *Farewell to the Nurse* [cat. 37]). By contrast, the aged peasants appear rough and ill at ease, more in keeping with the decor. (The obsequious old man is a recognizable Greuzian ancient.)[5] They are placed between the main protagonists, at the center of the composition, but are psychologically excluded from the unspoken dialogue between their social betters.

Aubry's success at rendering such subtleties won the praise of numerous critics, one of whom singled out the artist for his "broad and tasteful brush, his carefully observed details, correct drawing, and that which is still more precious, truthfulness, sentiment, and expression."[6]

1. "Ne captivent point l'attention des connoisseurs & des amateurs, le genre moral & celui du paysage ont atteint ce degré de perfection, qui ne laisse plus rien à desirer" (*Courtes mais véridiques réflexions sur l'exposition des tableaux de l'année 1775,* Geneva, [1775?], 5; Del. 159; McW. 0239). For a useful review of the critical responses to genre at the Salons of the 1770s, see McPherson, 1982, 187–267.
2. "Voilà à-peu-près tout ce qui compose le genre moral" (*Courtes mais véridiques réflexions,* 6–7).
3. *The Shepherdess of the Alps: A Moral Tale,* trans. Evan Thomas (Wilmington, England, 1794), 19.
4. Lot 207 in the Lambert sale (present location unknown); a smaller

version of this picture appeared at the Leonino sale, Galerie Charpentier, Paris, March 18–19, 1937, lot 10 (ill.), signed and dated 1777, oil on canvas, 29 × 38 cm; according to the catalogue, the picture was in the collection of the marquis de Véri. Another depiction of the subject by Aubry, *La Reconnaissance de Fonrose,* was reproduced in the *Gazette des beaux-arts* (February 1909): 169. A finished wash drawing for the Detroit painting is in the Albertina in Vienna. For a general discussion of Marmontel's story and representations of it in art, see Grigaut, 1949.
5. He is similar to the father in *The Village Bride* (see fig. 5). As Hallam (1979, 54–55) pointed out, the figure of the old man was repeated (in reverse, probably based on Leveau's engraving) by Boilly in the background of *Family Scene,* traditionally thought to represent the family of the playwright Beaumarchais (see Marmottan, 1913, pl. XIV).
6. "Un pinceau large et plein de gout, des details etudiés, un dessin correct et ce qui est encore plus precieux, de la verité, du sentiment, de l'expression" ("Exposition des peintures . . . de l'Académie royale," *Mercure de France* [1775]: 739–40; Del. 165; McW. 0246).

37. Farewell to the Nurse

1777
Oil on canvas, 20 7/16 × 24 3/4 in. (51.9 × 62.8 cm)
Sterling and Francine Clark Art Institute, Williamstown, Massachusetts

Provenance: Louis Gabriel, marquis de Véri; his sale, Paris, December 10, 1785, lot 56; purchased by Paillet; Cochu sale, Paris, March 6, 1798; Jacques Augustin de Silvestre; his sale, Paris, February 28–March 25, 1811; Dior Collection, Paris, 1925; Charles d'Heucqueville sale, Galerie Charpentier, Paris, March 24–25, 1936, no. 77; Knoedler, London; purchased by Robert S. Clark in 1936.

Selected Exhibition: Paris, Salon of 1777, no. 126.

Selected References: Ingersoll-Smouse, 1925, 79, 80, 82–84, 85 (ill.); Duncan, 1973, 577, fig. 9; Bailey, 1985, 70, 75, figs. 4, 10; Sheriff, 1991, 19–20, fig. 1.4, 27–28; Sterling and Francine Clark Art Institute, 1992, 15, ill.

Aubry's painting, exhibited to considerable acclaim at the Salon of 1777,[1] preaches a moral that by its date was becoming familiar: an elegant aristocratic couple has gone to the country to retrieve their child from a kindly if humble wet nurse and her husband. The baby, failing to recognize its actual parents, struggles to return to the arms of the nurse, the only mother it has known. As Carol Duncan succinctly put it, "Aubry teaches that environment and social behavior mean more than simple blood ties and that good parents nurse and keep their children at home."[2] Greuze had depicted the same poignant scene in a drawing, datable to the early 1760s (fig. 69), in which the child pushes away from his mother, whom he does not know. As Edgar Munhall pointed out in that context, the subject was a focus of Diderot's article on mothers in the *Encyclopédie* (1765), which warned of the risks—both morally and in terms of their physical health—to children who were farmed out to wet nurses. Diderot's concern was

shared by Rousseau in *Emile* (1762), where he proclaimed, "The first duty of a mother is to nurse her children."[3] These sentiments were echoed by a commentator at the Salon of 1777, who wrote of *Farewell to the Nurse*: "I will say nothing about its subject, because the sentiments that hold to a practice so little seen in nature, that of entrusting one's children to a mercenary woman, must not be very natural and by consequence cannot move a reasonable man."[4] The Enlightenment's advocacy of "natural" breast-feeding was aimed especially at upper-class women—those who were

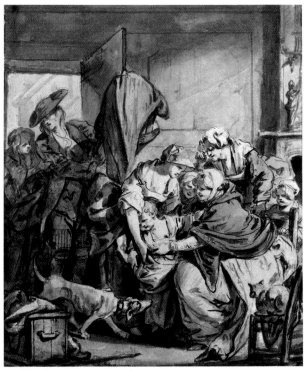

69. Jean-Baptiste Greuze, *The Return from the Wet Nurse,* c. 1763, brush and ink wash on paper, formerly Norton Simon Museum, Pasadena.

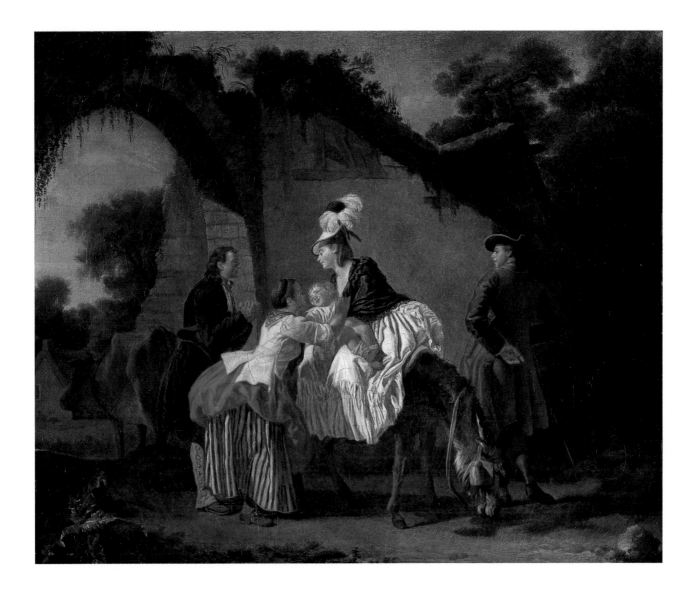

economically more able to devote themselves fully to their offspring—and the growing fashion for the practice emerged occasionally in portraiture, such as the beautiful example by Vincent (cat. 39).

In Aubry's little painting, popularized by Robert De Launay's 1779 engraving, the artist carefully organized the scene according to classical compositional methods for maximum visual effect. The mother, astride a donkey, forms the apex of a central pyramidal scheme; she is linked in her concern for the child to the nurse, who tearfully presses the baby away. This central group is flanked by the two men, a study in contrasts: the ingratiating farmer on the left appears more moved by the pathetic scene than does the haughty father on the right. Aubry may have intended a note of social caricature in this latter figure, who seems to embody all the aloofness and cynicism of a cultured city dweller. Sheriff noted that the scene is a clever play on the traditional subject of the flight into Egypt, in which the holy family flees Herod on a donkey. In this case, the family "escapes only the love of foster parents and the good health of their country life."[5] Such a subtle

and ironic allusion to a biblical story might have appealed to the first recorded owner of the painting, the marquis de Véri, a noted connoisseur who also owned Greuze's *Drunken Cobbler* (cat. 31).[6]

1. "Dans les adieux d'un Villageois et de sa femme, j'aimerois beaucoup la Figure de la mère, qui m'a paru bien dessinée, bien coloriée, bien coëffée, et d'un tour charmant. Les deux époux, allant voir un de leurs enfans en nourrie, forment aussi un Tableau où la vigueur, l'effet et l'expression se sont également admirer" (*Lettres pittoresques à l'occasion des tableaux exposés au Sallon en 1777* [Paris, 1777], 22; Del. 190).

2. Duncan, 1973, 577.

3. Hartford, San Francisco, and Dijon, 1976–77, 100–101, no. 42; "Le premier devoir d'une mère est d'alaiter ses enfans" (Denis Diderot, "Mère," in *Encyclopédie* [Paris, 1765], 10:380).

4. "Quant au sujet, je n'en dirai rien parce que des sentiments qui tiennent à un usage aussi peu dans la nature, que celui de confier ses enfants à une femme mercenaire ne doivent pas être fort naturels et par conséquent ne peuvent toucher un homme raisonnable" (*Les Tableaux du Louvre où il n'y a pas le sens commun, histoire véritable* [Paris, 1777], no. 17; Del. 193; McW. 0275).

5. Sheriff, 1991, 27–28.

6. Véri, it might be remembered, had commissioned Fragonard to paint *The Bolt* (see fig. 67) as a "bizarre contrast" to the same artist's *Adoration of the Shepherds* (see Bailey, 1985, 75).

Nicolas-Bernard Lépicié *(Paris 1735–1784 Paris)*

*S*on of the engraver, *François-Bernard Lépicié (1698–1755), and the artist Renée-Elisabeth Marlié (1714–1773), Nicolas-Bernard was the pupil of Carle Van Loo (1705–1765).* Agréé *in 1764, he was accepted into the academy as a history painter in 1769 with* Chiron Educating Achilles *(Musée des Beaux-Arts et d'Archéologie, Troyes). His first notable commission was for the refectory of a Benedictine abbey in Caen. This was followed by several requests from the crown for decorations at the Petit Trianon at Versailles and at the Ecole militaire, as well as an order for a series of cartoons of historical scenes for the Gobelins tapestry* works. *Lépicié regularly exhibited history and religious paintings at the Salon from 1765 until 1773, when he began painting genre scenes inspired by seventeenth-century Dutch masters. His first and most famous genre painting,* Le Lever de Fanchon *(Musée de l'Hôtel Sandelin, Saint-Omer), was exhibited at the Salon of 1773, where it was highly praised for its naturalism, attention to detail, and brilliant palette. Lépicié devoted the remaining ten years of his life to genre painting, and it is for these intimate compositions that he is now most celebrated. He died of tuberculosis at the age of forty-nine in 1784.*

38. The Carpenter's Family

c. 1775
Oil on canvas, 19 1/4 × 24 3/8 in. (49.0 × 62.0 cm)
Signed, lower right: Lépicié
Private collection

Provenance: Nicolas-Bernard Lépicié; bequeathed to his niece at his death; purchased by M. Boittelle, sénateur and préfet de police, Paris, c. 1850; his sale, Hôtel Drouot, Paris, April 24–25, 1866, lot 77, bought in; acquired after 1866 by baronne d'Erlanger; Wildenstein and Co., New York; private collection.

Selected Exhibitions: Atlanta, 1983, no. 53; New York, 1989 (2), no. 7.

Selected References: Gaston-Dreyfus, 1910; Gaston-Dreyfus, 1923, 77, no. 179; Ingersoll-Smouse, 1926, 294, 295 (ill.).

Lépicié's *Carpenter's Family*—both in the canvas exhibited at the Salon of 1775 and in this smaller version—underscores the changing attitudes toward genre painting during the 1770s and the increasing demand for moralizing themes. Originally, the young carpenter in the center of the picture was shown turning to whisper suggestively in the ear of the pretty girl looking up from her sewing. This detail was admired by at least one contemporary critic, who wrote that "the artist has represented with likable naiveté a young girl who seems to forget the work in her hands as she listens to the words of a young carpenter."[1] Others, perhaps responding to the subtly licentious aspect of the scene, felt that the picture could not be said—as was Aubry's *The Shepherdess of the Alps* (cat. 36), exhibited at the same Salon—to represent "moral genre," "even though all the heads are perfectly characterized and the poses are completely natural."[2] Nevertheless, the picture was popular enough that Lépicié painted the present, smaller, version to serve as a model for the engraver Le Bas (it has the same dimensions as the print). Yet some time later, Lépi-

cié—having suffered a spiritual crisis—repainted both pictures, shifting the carpenter's head so that he looks across at the child reading, as we see it now. As he explained it in his 1783 testament, the alterations were necessary to prevent the encouragement of "ill thoughts" and to avoid scandal; he also demanded "the same changes to be made in the engraved plate of M. [Le Bas], with the most careful precautions that no more impressions be pulled in its present state," and that all existing examples of the print be destroyed, along with his preliminary studies of the girl sewing.[3]

Lépicié's wishes were granted, for no trace of Le Bas's engraving was found until an impression appeared in Paris in 1923, when it was published by Gaston-Dreyfus.[4] It reproduces the original state of the painting, with the head of the carpenter turned to the right and looking down the girl's bodice. Lépicié's "improvement" dramatically changed the nature of the relationships among the principal figures in the composition. Instead of presenting the viewer with a scene of idle flirtation, we now observe a disciplined and harmonious family, very much in the spirit of Greuze. When the repainted Salon version (location unknown) last appeared in the sale of Lépicié's effects after his death in 1785, the figures were described as "the father occupied with his work and the mother who teaches her young daughter to read; near her, an older [daughter] sews."[5] Thus the young woman sewing went from being a potential lover of the carpenter to his dutiful daughter. Despite its obvious allusions to the holy family, the "reformed" *Carpenter's Family* preaches a secular message more in the spirit of the Enlightenment. In book 3 of *Emile*, for example, Rousseau expounds on the virtue of work, especially

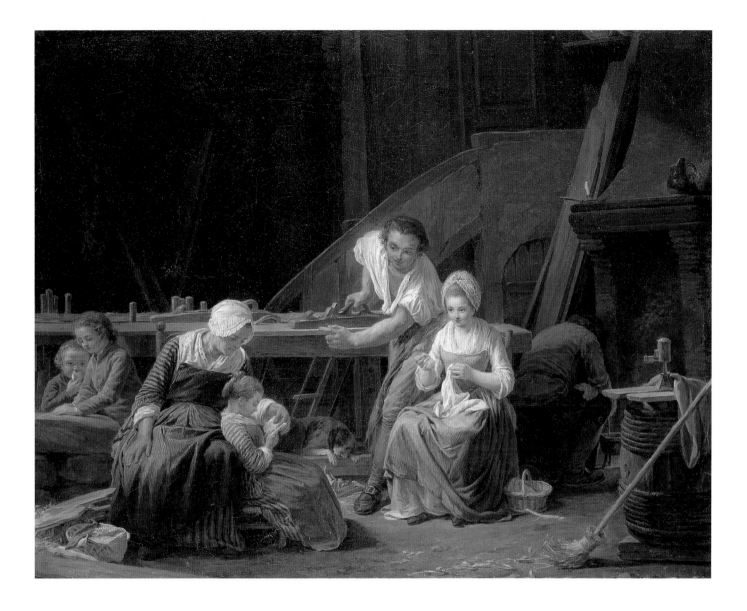

the practical trades that benefit all of society rather than merely embellish the lifestyles of the rich: "I prefer that [Emile] be a shoemaker to a poet, that he pave highways to making porcelain flowers." Although for Rousseau sewing and needlework are tasks suitable only for women (a notion reiterated in Lépicié's painting), "the trade I would most like to be to my pupil's taste is the carpenter's. It is clean; it is useful; it can be practiced at home. It keeps the body sufficiently in shape; it requires skill and industry from the worker; and while the form of the work is determined by utility, elegance and grace are not excluded."[6]

1. "On a egalement remarqué l'atelier d'un menuisier, tableau de chevalet, ou l'artiste avait representé avec une naiveté aimable une jeune fille qui semble oublier l'ouvrage qu'elle tient dans ses mains pour ecouter les discours d'un jeune garçon menusier" ("Exposition des peintures . . . de l'Académie royale," *Mercure de France* I [October 1775]: 727; Del. 165; McW. 0246).

2. "Dont toutes les têtes sont si parfaitement caractérisées, et dont toutes les attitudes sont si naturelles" (*Courtes mais véridiques réflexions sur l'exposition des tableaux de l'année 1775* [Geneva, 1775?]: 7; Del. 159; McW. 0239).

3. "Comme j'ai réformé dans les deux tableaux de l'*Attelier du Menuisier* ce qui pouvoit donner lieu à penser mal, je veux que la même réforme se fasse sur la planche gravée par M. . . . [Le Bas], avec les précautions les plus scrupuleuses pour qu'il ne s'en tire point d'épreuves dans l'état où elle est" (quoted in Gaston-Dreyfus, 1910, 27. A wash drawing (Musée des Beaux-Arts, Orléans, inv. 855) showing the entire "reformed" composition was probably made in preparation for the changes to the paintings (see Paris, 1989, no. 329).

4. Gaston-Dreyfus, 1923, ill. opposite 76.

5. Gaston-Dreyfus, 1910, 29.

6. Jean-Jacques Rousseau, *Emile; or, On Education*, trans. Allan Bloom (1762; New York, 1979), 197–201. The relationship of Lépicié's painting to *Emile* was first discussed in Paris, 1989, 241.

François-André Vincent *(Paris 1746–1816 Paris)*

The son of a Swiss miniaturist, Vincent was a student of the history painter Joseph Marie Vien (1716–1809). He won the Grand Prix in 1768, but before traveling to Rome he spent three years at the Ecole royale des élèves protégés in Paris. He studied in Rome from 1771 to 1775 under Charles-Joseph Natoire (1700–1777). He was received into the academy in 1777, soon after his return to Paris, becoming a full member in 1782 with a grand painting culled from French history, President Molé Stopped by Insurgents during the Fronde *(Chamber of Deputies,*

Paris). His innovative narrative paintings, many drawn from French as well as Roman history, can be seen as part of d'Angiviller's efforts to promote didactic history painting during the last quarter of the eighteenth century. He was also a prolific and successful portraitist. Unlike many artists whose popularity waned during the postrevolutionary years, Vincent's reputation survived into the nineteenth century, as he moved away from a fluid rococo style and embraced a more rigorous neoclassical manner.

39. Portrait of a Mother and Child

1782
Oil on canvas, 32 1/2 × 27 3/4 in. (82.5 × 76.9 cm)
New Orleans Museum of Art, Women's Volunteer Committee Fund, 83.2

Provenance: Dr. Piogey; A. F. sale, Paris, May 10, 1909, lot 652; Coblentz; private collection, Sweden; Stair Sainty Fine Art, Inc., New York, until 1983; purchased by the museum, 1983.

Selected Exhibition: Koriyama, Yokohama, Nara, and Kitakyushu, 1993, no. 10.

Portraits of mothers with their children were part of a long tradition in eighteenth-century French painting—Nicolas de Largilliere was one of the first to exploit the theme[1]— but in the 1770s and 1780s such works often displayed a new intimacy and sense of emotional attachment. Called *maternités*, these portraits eloquently embody the Enlightenment's advocacy of strong familial attachments and natural motherhood. The unidentified woman in this exceptional portrait holds her child tenderly in her arms, supporting her offspring on an elegant white pillow. The intimacy of the portrayal is enhanced by the sitter's dress, an informal costume reserved for home wear.[2]

Probably the most famous example of this kind of portraiture in the late eighteenth century is Elizabeth-Louise Vigée-Lebrun's *Portrait of the Artist with Her Daughter* of 1786 (fig. 70), but Vincent also on occasion employed the theme, as in his presumed portrait of Madame Boyer-Fonfrède and her son (1796; Musée du Louvre, Paris). Unlike in those examples, where the children twist away from their mothers to catch the eye of the spectator, in the present picture the child turns toward the proud parent, who becomes the focus of the composition. The effect undermines somewhat the primary role of portraiture (to capture and present a likeness) in order to emphasize the nurturing role of the mother. Although the woman in the

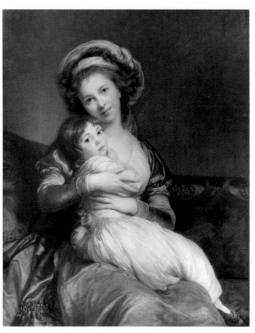

70. Elizabeth-Louise Vigée Lebrun, *Portrait of the Artist with Her Daughter,* 1786, oil on canvas, Musée du Louvre, Paris, photo R.M.N.

New Orleans portrait is not shown nursing, the implication is clear in the position and action of the child, who turns toward the mother and grasps at her bodice. Vincent's painting is a vivid reminder of the tendency during this period for women to be viewed and represented, even in portraiture, as social types rather than unique individuals. During the 1760s and 1770s, the Enlightenment campaign against the practice of wet nursing was at its height, and for Vincent's sitter it would have been considered extremely fashionable and sophisticated to have herself portrayed in such an intimate relationship with her child. For reformers such as Rousseau, it was believed that breastfeeding one's child was the best way to develop the famil-

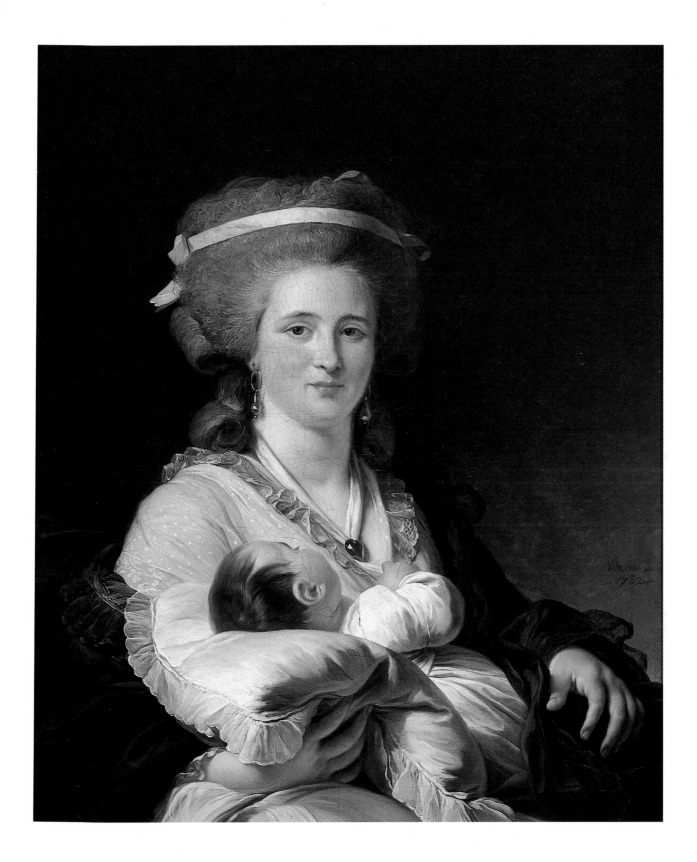

ial bond. As he put it in the first book of *Emile* (1762), "But let mothers deign to nurse their children, morals will reform themselves, nature's sentiments will be awakened in every heart, the state will be repeopled."[3] Vincent's portrait, with its sense of monumentality and strong draftsmanship, recalls the High Renaissance madonnas that the artist admired during his study in Rome in the late 1770s. In the New Orleans portrait several categories of paint-

ing—religious, portraiture, and genre—are blended together to form an image of wide appeal and meaning.

1. See, for example, the *Portrait of Catherine Coustard, Marquise de Castelnau, with Her Son Léonor*, c. 1699–1700 (The Minneapolis Institute of Arts).
2. Koriyama, Yokohama, Nara, and Kitakyushu, 1993, 133.
3. Jean-Jacques Rousseau, *Emile; or, On Education*, trans. Allan Bloom (New York, 1979), 46.

Jean-Frédéric Schall *(Strasbourg 1752–1825 Paris)*

A native of Strasbourg, Schall entered the local Ecole publique de dessin in 1768, studying with the brothers Pierre and Henri Haldenwanger. He was in Paris by 1772, when he is listed as a student at the Royal Academy under the sponsorship of Nicolas-Guy Brenet. He is also documented as working in the studio of Nicolas-René Jollain (1732–1804) in 1775, and with Nicolas-Bernard Lépicié (1698–1784) from 1776 to 1779. Schall's paintings, invariably small in scale and often painted on panels, usually focus on the amorous affairs and erotic intrigues of well-heeled lovers, cavorting in both the boudoir and the garden; he also *specialized in depictions of actresses and dancers. Schall enjoyed a diverse clientele, including the jewelers Godefroy and the princess de Condé, as well as German and English collectors, and his paintings were popularized through engravings. Although Schall continued exhibiting his lighthearted works after the Revolution at the Salons of 1793 and 1798, his republican loyalties are evident in some of his literary and historical subjects, such as* The Heroism of William Tell *(Musée des Beaux-Arts, Strasbourg). During this period he produced prints and book illustrations for such publishers as Didot.*

40. The Beloved Portrait

c. 1783
Oil on panel, 11 5/8 × 9 in. (29.5 × 22.8 cm)
Private collection

Provenance: Madame de Polès, Paris; her sale, Galerie Georges Petit, Paris, June 22–24, 1927, lot 24; private collection.

Selected Exhibition: New York, 1989 (2), no. 18, ill.

Selected Reference: Girodie, 1927, 8, 18, 62.

The subject of Schall's exquisitely finished panel is similar to that of Michel Garnier's *The Letter* (cat. 45), in which a well-to-do young woman admires a portrait miniature of her lover while reading his missive. Unlike in Garnier's painting, where the unspoken dialogue between the mistress and the servant provides the narrative impulse, Schall's woman must carry the message by herself, through pose and gesture as well as through her relationship to the objects that orbit around her form. Characteristically for Schall, this results in an erotic tone that nearly overwhelms the small composition. Here the woman is alone (save for the panting lapdog at her feet) as she swoons on her sofa and places a kiss on the image of her beloved. The torn-open letter rests provocatively in the skirts between her legs and, if this gesture is not enough, the carnal nature of her thoughts is perhaps implied by the explicit mythological subject in the painting hanging on the wall—a conceit that looks back to de Troy's *Declaration of Love* (cat. 9). The panicky resistance of the nude woman in Schall's fictive painting to the assault of the satyrlike man is in striking contrast to the woman on the sofa here, who is represented as available to the viewer, her pliant form turned toward the picture plane and beautifully lit from the left. Like the nude in the painting, placed before a blue sky and surrounded by a curved and beaded gilt frame, she reclines on a blue sofa encased in similar decorative woodwork, yet she breaks from the confines of her frame, stepping off the sofa and into the space of the viewer. That she is lost in reverie only increases the voyeuristic aspect of the image.

Schall's small painting is typical of his production in the mid-1780s, when he was working with the engraver Louis-Martin Bonnet (who made a print after *The Beloved Portrait*).[1] It is similar in many ways—apparently the same female model, the crude gesture between the legs, the lovingly rendered flowers—to *The Broken Fan*, a slightly larger painting that is signed and dated 1785.[2] Such works, characterized by a meticulous technique worthy of manuscript illuminators, show the influence of cabinet paintings by Marguerite Gérard (see cat. 43), although they are even more painstakingly rendered. That Schall continued to paint and exhibit titillating works such as *The Beloved Portrait* during the 1790s suggests that his appeal and market were more widespread than one might have thought, although as one critic remarked, when *The Love Nest* (present location unknown) was exhibited at the Salon of 1793, at the start of the Terror, "It is a shame that . . . the artist has profaned his talent and has forgotten that the arts, rather than inspire vice, should only be directed at promoting good morals and virtue."[3]

1. See Girodie, 1927, 8, 18; New York, 1980, 31.
2. Oil on panel, 16 1/2 × 13 1/4 in. (42.0 × 34.0 cm), Segoura, Paris; see Girodie, 1927, 17, 19, 26, pl. VII.
3. "C'est dommage que . . . l'artiste ait profané son talent, et qu'il ait oublié que les arts, au lieu d'inspirer le vice, ne sont destinées qu'à propager les bonnes moeurs et les vertus" ([Defonds], *Explication par ordre des numéros et Jugement motivé des ouvrages de peintures . . . exposés au Palais national des arts* [Paris, n.d.], no. 22; Del. 458; McW. 0502).

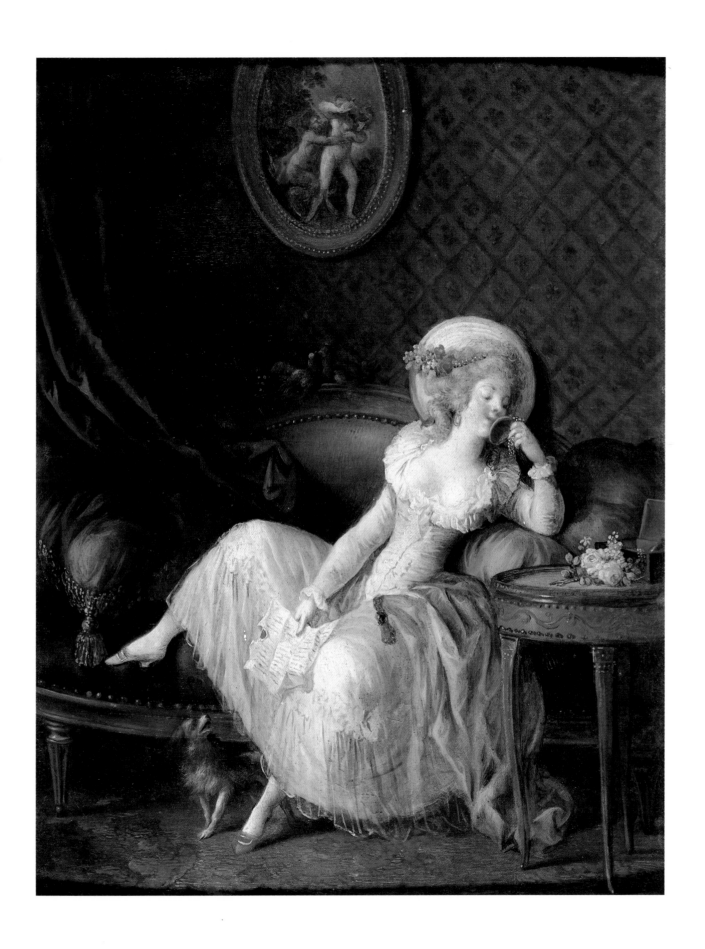

Marguerite Gérard *(Grasse 1761–1837 Paris)*

The daughter of a perfume distiller in southern France, Marguerite Gérard studied with her brother-in-law Jean-Honoré Fragonard, in whose household she lived following her move to Paris in 1775. Her first works, produced in the late 1770s, were a series of etchings and aquatints—exemplified by the innovative allegorical print To the Genius of Franklin—which she made in collaboration with her mentor. Although she was refused entry into the Royal Academy because it had reached its maximum number of women members, her reputation as an artist of intimate genre scenes had grown considerably by the mid-1780s. Along with Adélaïde Labille-Guiard (1749–1803), Elizabeth-Louise Vigée-Lebrun (1775–1842), and Anne Vallayer-Coster (1744–1818), she was among the few widely respected women artists in her time, exhibiting at the Salon from 1799 to 1824. Her anecdotal genre scenes were disseminated through engravings by printmakers such as Géraud Vidal, Antoine de Launay, and her brother Henri Gérard. Gérard's artistic versatility was further proved by the Emperor's purchase in 1808 of her only history painting, The Clemency of Napoleon at Berlin *(present location unknown)*. Her works indicate her absorption of both Enlightenment thought, popularized by Diderot and Rousseau, and the neoclassical trends of the late eighteenth century.

41. The First Step

Possibly painted with the assistance of Jean-Honoré Fragonard
c. 1780–85
Oil on canvas, 17 3/8 × 21 5/8 in. (44.0 × 55.0 cm)
Fogg Art Museum, Harvard University Art Museums, Cambridge, gift of Charles E. Dunlap, 1961.166

Provenance: "O" sale, Paris, December 16–17, 1839, lot 89; de Rigny sale, Paris, June 2, 1857, lot 40; Pillot sale, Paris, December 6–8, 1858, lot 43; Lord Rosebery, Mentmore, England; Wildenstein and Co., New York; Charles E. Dunlap, Saint Louis, 1952; given to the Fogg Art Museum in 1961.

Selected Exhibitions: Paris, Detroit, and New York, 1974–75, no. 71; Paris and New York, 1987–88, no. 303; Cambridge, 1993, no. 22.

Selected References: Doin, 1912, 432, 433 (ill.); Wildenstein, 1960, no. 540, fig. 234; Wells-Robertson, 1978, 732, cat. 6; Cuzin, 1988, 217–18, no. 409, pl. 270; Rosenberg, 1989, no. 427, ill.

The First Step is one of the earliest and most endearing of Gérard's representations of mothers and children. Such subjects established the artist, in the words of Sally Wells-Robertson, "as the preeminent painter of maternal genre scenes from 1785–1825."[1] In *The First Step*, the delights of maternity are the theme: in a quiet corner of a garden we see a group of women enjoy an important event in the life of a small boy, who leaves his crib to take his first tentative steps. The young mother, beautiful in a shimmering satin gown—Gérard's signature motif—waits, seemingly holding her breath, while a young nurse (or aunt) and a withered granny watch from behind; a girl, probably the boy's sister, sits in the shadows. Apart from the baby, the gath-ering is an exclusively female affair, with three generations of women joining in celebrating the progress of life. Gérard paid special attention to the play of gestures—three sets of outstretched hands, each expressing a differ-ent emotion or purpose (surprise, balance, welcome)—and to the expressions, ranging from delight to encouragement to slight fear. The complex dynamics of family relation-ships are underscored by the sister in the middle ground:

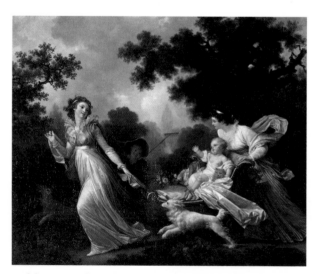

71. Marguerite Gérard and Jean-Honoré Fragonard (?), *The Beloved Child*, c. 1780, oil on canvas, courtesy of the Fogg Art Museum, Harvard University Art Museums, Gift of Charles E. Dunlap.

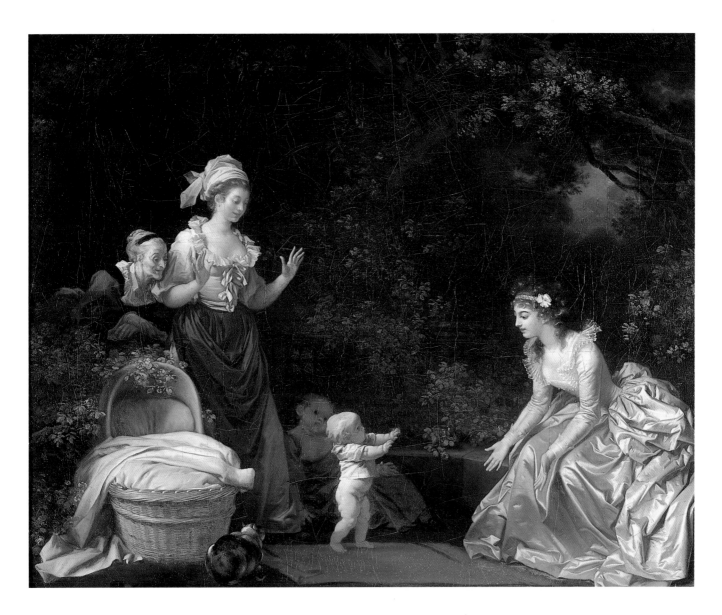

the adults' attention has, for the moment at least, turned from her, and she sits in shadow as her brother, brilliantly lit by the sun, passes her by.

The stable, classical composition, so characteristic of Gérard's paintings, here serves to underscore the nurturing role of women: the figures are placed parallel to the picture plane, forming a right triangle whose points are the elegant young mother at the right, the entranced nurse, and the woven crib, its blankets cascading onto the ground. In contrast to the exquisite balance of *The First Step*, its pendant, *The Beloved Child* (fig. 71), is full of movement and energy, as two young women charge across a landscape with a little boy, who sits like a pasha in an elaborately decorated wagon. The two paintings are very different in spirit: one quiet, still, and anecdotal; the other bustling, dramatic, and allegorical. Wells-Robertson has questioned whether they were originally intended as pen-

72. Jean-Honoré Fragonard, *The First Step*, black and white chalk on paper, courtesy of the Fogg Art Museum, Harvard University Art Museums, Isabella Grandin Fund and Marian H. Phinney Fund.

dants. Nevertheless, the paintings have been together since at least 1839, and the prints reproducing them were issued as a pair in 1792. If, according to the inscription on the engraving, *The First Step* was "dedicated to good mothers,"[2] its supposed pendant epitomizes the eighteenth-century's celebration of childhood.

The question of collaboration between Gérard and Fragonard has been a constant focus in discussions of *The First Step*, as it has with *The Beloved Child* and other early works by Gérard. Citing the engraving by Géraud Vidal and N.-F. Regnault, which attributed the picture to "M. Fragonard et Mlle. Gérard," as well as such quintessentially Fragonardesque elements as the little blond boy and the haggard crone, most scholars have considered the work to have been a joint effort. *The First Step* was probably painted in the early or mid-1780s,[3] several years after the young artist had moved to Paris to take up residence with her sister and brother-in-law, Fragonard, and for many it seems natural that the established master assisted his young student in the design and execution of her first paintings.[4] Wells-Robertson, however, has argued forcefully for Gérard being the sole author. While conceding that certain motifs do indeed reflect Fragonard's repertoire, she maintains that stylistically *The First Step* is wholly of a piece with Gérard's technique, and that there is no scientific evidence to indicate two hands at work. Fragonard's name could have been added to the engraving to enhance its marketability.[5] The debate has been further complicated by the discovery of a drawing—recently acquired by the Fogg—by Fragonard that is by all accounts an early study for the painting (fig. 72).[6] It represents a pre-liminary idea for the composition, although it varies from the painting in details: a third young woman now kneels beside the boy, helping him along; a boy appears at the left; and the granny is missing altogether. On the basis of this drawing it is possible to conclude that Fragonard did indeed assist his sister-in-law in *The First Step*, but only in providing an idea for its design, not in its actual execution. Yet the decidedly Fragonardesque passages do seem different in handling from those, like the figure of the mother, that are unquestionably by Gérard. In any case, either scenario—that Fragonard actually helped paint *The First Step* or that he merely provided the drawing—undermines the traditional claim that Gérard's subject matter was a "natural" function of her status as a woman.[7]

1. Paris, Detroit, and New York, 1974–75, 441.
2. "Dédié aux bonnes mères"; see Paris and New York, 1987–88, 573.
3. Wells-Robertson suggests a date of c. 1780–82, although most scholars place the painting around 1785.
4. For a good summary of this debate, see Paris and New York, 1987–88, 574–75, and the discussion by Eunice Williams in Cambridge, 1993. Cuzin, 1988, 216–19, believes that *The First Step* is largely the work of Fragonard and that Gérard was responsible only for the figure of the mother.
5. Wells-Robertson, 1978, 54–60; and Paris, Detroit, and New York, 1974–75, 441–43; I am grateful to Dr. Wells-Robertson for allowing me to consult a draft of her entry on the painting for her important forthcoming study on Gérard.
6. The drawing was discovered and first published by Eunice Williams; Williams, 1987, 281–84, fig. 3; Cambridge, 1993. Two oil studies, attributed to Fragonard, for *The First Step* and *The Beloved Child* that appeared at auction in 1804 may have served a similar function (see Cuzin, 1988, nos. L201–2).
7. See the discussion in the essay by Rand in this volume.

42. Before the Masked Ball

c. 1785
Oil on canvas, 11 5/8 × 9 3/8 in. (29.5 × 23.7 cm)
Private collection

Provenance: Hippolyte Walferdin, Paris; his sale, Hôtel Drouot, Paris, April 12–16, 1880, lot 119; purchased by M. May; anonymous sale, Paris, November 15, 1882, lot 23; M. Dumont; his sale, Galerie Georges Petit, Paris, May 23–25, 1921, lot 54, ill.; purchased by M. Guiraud; private collection.

Selected Reference: Wells-Robertson, 1978, 760, cat. 20a.

This freely brushed painting, exhibited here for the first time, may be preparatory to a larger and more tightly finished version (present location unknown), although, as Sally Wells-Robertson notes, Gérard's oil sketches were usually executed on panels.[1] In the larger version some of the details, such as the still life on the table, were elaborated, and a crouching boy was added behind the round-back chair. The brushwork of the present painting is more fluid and tactile than Gérard's typically meticulous and detailed manner—brilliantly realized in such works as *The First Step* (cat. 41)—and is clearly influenced by the style of her brother-in-law and artistic mentor, Fragonard. Nevertheless, the central figure, with her high-waisted diaphanous gown and pink undergarment, is typical of Gérard's style, similar, for instance, to the woman at the left in *The Beloved Child* (see fig. 71), a painting usually assigned the same date as the present work.

The precise subject of *Before the Masked Ball* is puzzling; the painting and its variant have been known under vari-

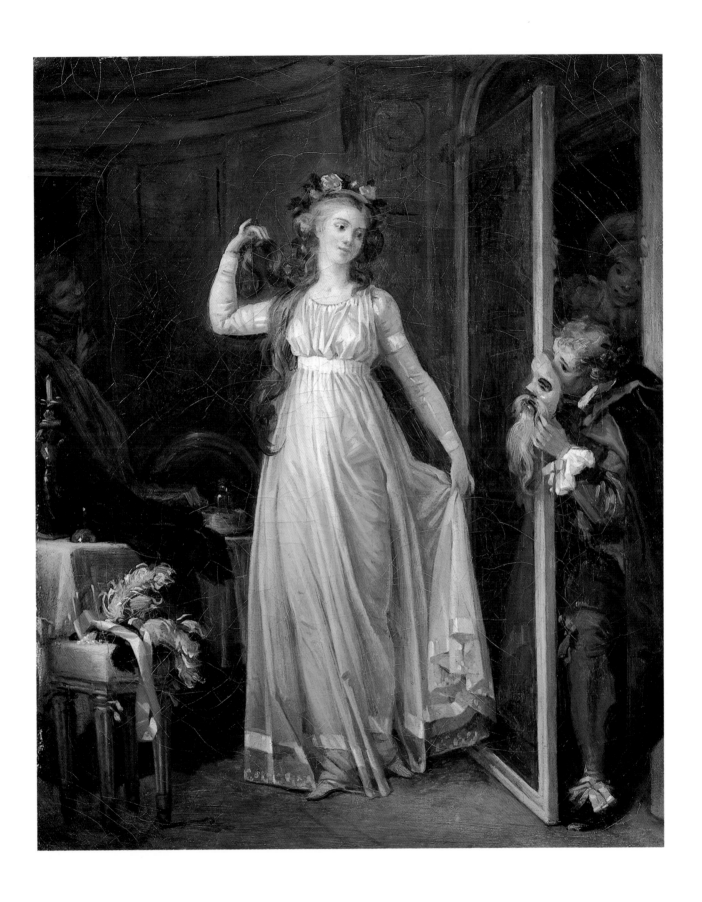

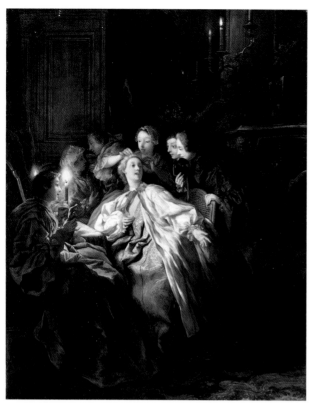

73. Jean-François de Troy, *Preparation for the Ball*, c. 1725, oil on canvas, collection of the J. Paul Getty Museum, Los Angeles.

of her dress. This passage is rendered with exquisite sensitivity and keen observation on the part of the artist, a devoted painter of fabrics of all textures. The length of hair falling on the woman's shoulder, mirroring the pink ribbon that dangles from the vanity stool, adds to the sense of an intimate moment interrupted.

The theme of preparing for the ball, usually showing a woman doted on by maidservants and observed by friends, had a venerable tradition in French painting of the Old Regime. De Troy's painting of around 1725 (fig. 73), popularized through Beauvarlet's engraving, includes fashionable ballgoers holding masks to their faces in a manner similar to that of the figure in Gérard's picture. In the present painting, however, the traditional iconography is complicated by the identities of the observing men, who seem drawn from the company of the Italian commedia dell'arte. The clown Pierrot, in his white hat and costume, is clearly visible in the doorway, behind the young man holding the bearded mask, who may be disguising himself as the lewd character Pantaloon. Could the woman then be understood as representing Colombine, Pierrot's friend who frequently appears in a light-colored dress and wearing flowers in her hair?[2] Such identifications might have inspired the alternative titles that have been attached to the painting and its variant, although Gérard's *sujets galants* are usually open to interpretation, without any specific meaning dictated by the artist. Nevertheless, Gérard, like Fragonard, was known to frequent the world of the theater, and her paintings frequently draw their subject matter from it.[3]

ous titles—*La Loge de l'actrice, Une artiste de la comédie française*—as well as the present one, which appears to conform most closely to the action depicted: a young woman in a long gown stands before a full-length mirror attached to a door. She ties up her hair in order to don an elegant feathered hat that rests on a stool before her dressing table. Her preparations are slyly observed by several figures, including a young man holding a bearded mask before his face, who peeks around the mirrored door. These spying men act as surrogates for the viewer of the painting, who is presented with the best perspective of the young woman's figure, glimpsed through the sheer fabric

1. For the larger version, see Wells-Robertson, 1978, no. 20; a photograph is in the archives of the Service de la documentation du Louvre.
2. A useful survey of the characters in the commedia dell'arte is available in Washington, Paris, and Berlin, 1984–85, 507–26.
3. Wells-Robertson, 1978 (192–97), discusses the influence of the theater on Gérard's art.

43. The Happy Household

c. 1795–1800
Oil on panel, 16 × 12 3/4 in. (41.0 × 32.0 cm)
Signed, center right: M^{te} Gerard
Private collection, courtesy of Rosenberg and Stiebel

Provenance: Duchesse de Raguse sale, Paris, December 14–15, 1857, lot 21; sale, Paris, March 27, 1877, lot 19; M. Gouttenoire de Toury, Paris, 1904; Kathryn Bache Miller; her sale, New York, April 1, 1945, lot 9; Wildenstein and Co., New York; sale, Christie's, New York, June 5, 1980, lot 102; sale, Christie's, New York, January 18, 1983, lot 140; Rosenberg and Stiebel, New York; private collection, New York.

Selected Exhibitions: Paris, 1910, 18, no. 77; Hamburg, 1986, 288, no. 141; New York, 1987, 60–62, 75, no. 31.

Selected References: Bellier de la Chavignerie and Auvray, 1882, 638; Hymans, 1904, 309, ill.; Doin, 1912, 445; Oulmont, 1928, no. 49; Wells-Robertson, 1978, no. 57, 827.

Gérard, like Chardin, usually excluded men from her domestic genre scenes, preferring to represent the nurture and education of children as an exclusively female respon-

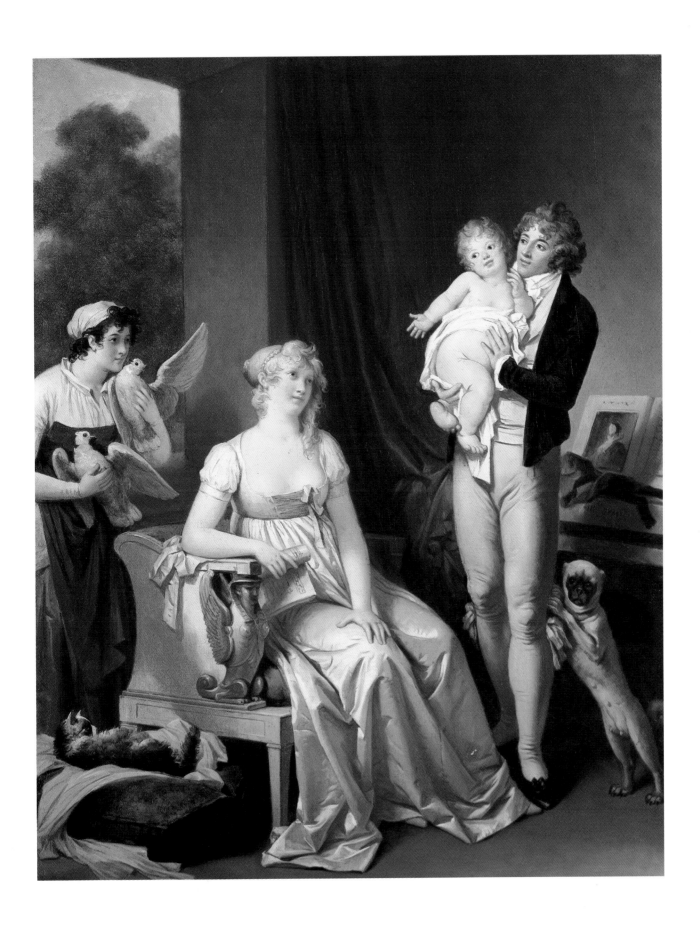

sibility (see, for example, cat. 41).[1] *The Happy Household* is one of the rare exceptions, showing the father not merely present but fully integrated into the family circle, affectionately and proudly holding his young son. The tender rapport between them is admired by the young mother, seated near the center of the scene and assisted by a maidservant. Indeed, despite the prominence of the father, Gérard makes it clear that it is the mother who is the heart of the household and the emotional focus in the life of the child; the eyes of her husband and child are on her, and the infant's gesture signals her importance.

Although affectionate family scenes had for several decades been painted by artists such as Greuze and Fragonard (cat. 25), Gérard's innovation was to place these subjects in the households of the well-to-do, to demonstrate that familial bliss need not be the prerogative of the "uncultivated" (and correspondingly closer to nature) middle and lower classes.[2] The family members represented in *The Happy Household* are glamorous, exquisitely dressed, and surrounded by the trappings of a sophisticated urban elite, including a clavichord, visible against the right wall, and a fashionable armchair complete with sculpted sphinxes. These elements help date the picture to the years 1795–1800, when Gérard painted numerous family subjects.

Sally Wells-Robertson has suggested that *The Happy Household* might be considered a parody of neoclassical composition,[3] with the antique chair and the outstretched arm of the child mimicking elements frequently encountered in Davidian history paintings. The strict division of the composition into female and male zones is also a con-

ceit derived from neoclassical paintings, such as Jacques-Louis David's *Oath of the Horatii* and *Brutus*; in Gérard's picture this results in an unusually emblematic representation of what in her oeuvre are normally more anecdotal scenes. Thus the males on the right, placed before a clavichord and a music book, might be seen to represent civilization, or culture, while the mother and the maid are depicted in front of a verdant landscape that suggests their association with nature. Indeed, any sense that the painting represents a believable family (much less an actual group portrait) is thwarted by the clearly symbolic elements that comment most particularly on the roles of the wife and mother. This is most apparent in the two doves carried in by the maid, with their obvious associations with Venus, but also the two house pets: the sleek sensuality of the reclining cat suggests the appealing beauty of the wife to the husband, while the prominent teats of the dog remind us of the mother's role in nurturing her son. Moreover, the music she holds speaks of the general harmony of this idealized family.[4] By such means Gérard continues in this intimately scaled picture some of the pictorial strategies of Greuze and his followers, in which seemingly straightforward representations of everyday life are invested with greater meaning and significance than are at first apparent.

1. Wells-Robertson, 1978, 168–69.
2. Ibid., 131–32.
3. Ibid., 827.
4. See Hamburg, 1986, 288, and the excellent discussion by Penelope Hunter-Stiebel in New York, 1987, 61–62.

Michel Garnier *(Saint-Cloud 1753–1819 Paris)*

Apart from the tradition that he studied with the history painter Jean-Baptiste-Marie Pierre (1713–1789), next to nothing is known about Garnier. He was primarily a painter of gallant genre subjects, which he exhibited to some notice at the Salon from 1793 to 1814, but he also painted portraits and, later in life, still lifes. He apparently enjoyed the protection of the duc de Chartres (the future Philippe-Égalité), a fellow Mason whose portrait he painted (Musée Condé, Chantilly). Like his contemporaries Louis-Léopold Boilly and Marguerite Gérard, to whose work his is often compared, Garnier frequently represented intimate moments in the life of upper-class Parisians. With their exquisitely finished surfaces, his cabinet-size paintings show an appreciation of such seventeenth-century Dutch artists as Gerard Terborch. Yet in their careful recording of costume, furniture, and interior décor, Garnier's jewel-like pictures also represent a late variant on the* tableaux de mode *made fashionable earlier in the century by Jean-François de Troy.*

44. The Poorly Defended Rose

1789
Oil on canvas, 18 3/16 × 14 13/16 in. (46.2 × 37.62 cm)
Signed, on the back of the lute: Michel Garnier 1789

45. The Letter

1791
Oil on canvas, 18 1/8 × 15 in. (46.03 × 38.1 cm)
Signed, on the back of the chair: Michel Garnier 1791
The Minneapolis Institute of Arts, gift of Mr. and Mrs. Jack Linsky

Provenance: Sale, "H. E." Collection, Paris, March 9, 1951, lots 40–41; M. R. Schweitzer, New York, 1951; Catroux; Max-Kann; Mr. and Mrs. Jack Linsky, New York; given in 1964.

Selected References: Clark, 1965, 52–53, ill.; The Minneapolis Institute of Arts, 1971, no. 92, 176–78, fig. 92a–b; Druce, 1988, 180–81, 185, fig. 1 (The Letter).

Despite their different dates, Garnier's two beautifully preserved cabinet paintings should probably be considered as a pair. The pictures are virtually identical in size and their subjects are complementary, with the woman in each appearing to be the same model. The scenes take place in an identical parlor, recognizable by the common parquet floor and neoclassical wall moldings. In *The Poorly Defended Rose*, a young man embraces his ladylove while reaching to pluck a rose from a potted plant on a windowsill; his action receives the mildest of rebukes from the woman, who struggles slightly against his grasp as she tugs on his outstretched arm. The denouement of this scene is the subject of *The Letter*, where the woman, with a more worldly air to her expression, reads a letter while admiring a portrait miniature, presumably of her absent lover; she shares her confidences with an elderly maidservant, who examines the portrait through a pair of thick pince-nez.

The two paintings thus work well as a narrative in the tradition of the "before and after" theme popular with genre artists in both France and England.[1] Lest the viewer miss the point, Garnier has linked the two compositions with well-established symbols of love easily recognizable to the eighteenth-century viewer. In *The Poorly Defended Rose*, the cage hanging on the wall safely imprisons its bird, although the woman's imminent fall from virtue is anticipated by a version of Pigalle's marble, *Child with a Cage* (serving as a temporary hat-rack) on the pedestal at the right, in which a little boy holds open the door to reveal an empty birdcage,[2] and made explicit by the broken pitcher on the floor at the lower left. *The Letter* continues this strategy of symbolic displacement, drawn from the Dutch tradition popular in Garnier's day: the plucked roses (a reference to more than one tryst?) have been neatly arranged in a vase, the letter and miniature portrait act as stand-ins for the absent lover, while the prominent harpsichord and open music book suggest the perfect harmony of the lovers.[3]

Garnier's genre paintings, with their careful finish, subtly erotic subjects, and precise recreation of setting and costume, continue the tradition of the *tableau de mode* invented in the 1720s by de Troy (cats. 9 and 10). Surprisingly, the *retardetaire* aspects of the genre—its seeming celebration of the sexual intrigues and material possessions of the well-to-do—occasioned little criticism when Garnier exhibited such works at several Salons in the 1790s. In fact, many were greatly admired for their high finish and attention to detail, drawing comparison to works by Martin Drolling. One commentator was particularly taken by a

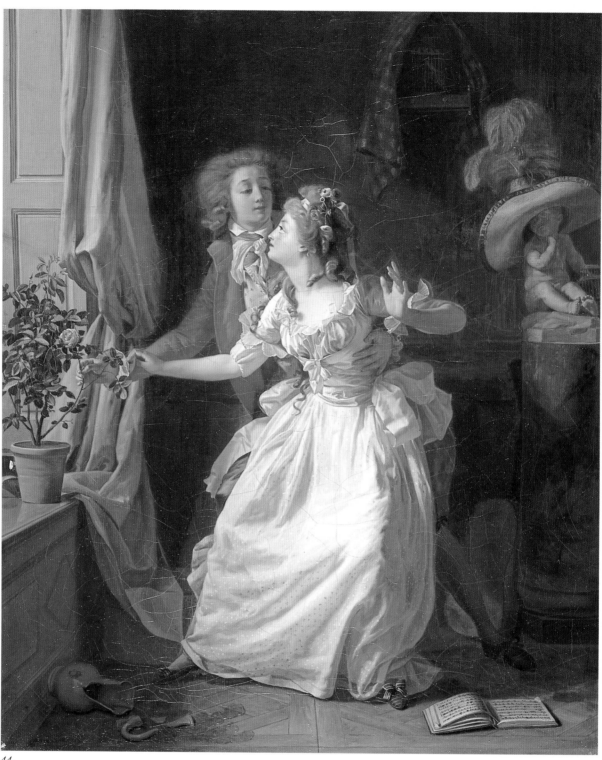

44.

variant of *The Letter* exhibited at the Salon of 1795: "A charming picture . . . where a woman shares a secret with her servant by showing her a letter. The subject is extremely well expressed and the details . . . are excellent in many of the parts, especially in the figure of the servant, in the red velvet drape, in a candle that she extinguishes, and in other objects."[4] Like de Troy's precise and meticulous handling, Garnier's glossy, sparkling technique seemed appropriate to such lighthearted subjects as the Minneapolis pictures, and it could well be that they were viewed as

too unimportant to condemn outright; critics were less enthusiastic when Garnier attempted more serious moralizing works, as suggested by the words of one critic regarding *The Good Mother*, a painting drawn from the tales of Marmontel shown at the Salon of 1793: "There is some interest here in the expression; the color, while seductive, is not natural."[5]

1. Probably the most famous examples are Hogarth's paintings (known in several versions, e.g., Fitzwilliam Museum, Cambridge, and J. Paul Getty Museum, Los Angeles). In France, the theme was

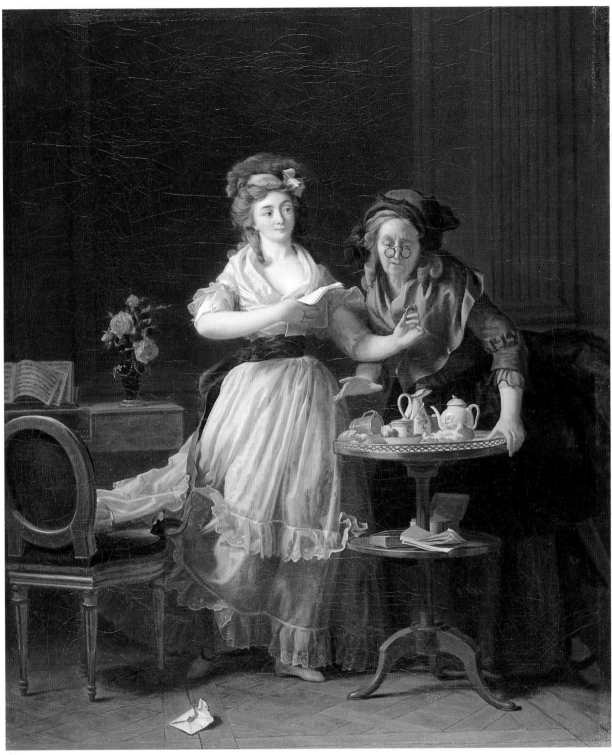

45.

made popular by Greuze (for example, *The Neapolitan Gesture* [cat. 27] and its pendant, *The Broken Eggs* [see fig. 59] and, closer to Garnier's time, by Boilly (*La Dispute de la rose* and *La Rose prise* [engravings, Marmottan, 1913, pls. IX and VIII]).

2. For Pigalle's sculpture, exhibited at the Salon of 1750, see Gaborit, 1985, 48–51.

3. This last theme is made explicit in Garnier's *Ils sont d'accord*, signed and dated 1786 (Paris, Hôtel Drouot, June 22, 1992, lot 18), which shows a man moved by the beauty of his female companion's lute playing.

4. "Le charmant tableau . . . où une Dame remet à son Servante une lettre en lui recommandant le secret. Le sujet y est fort bien exprimé et les détails . . . sont excellens dans beaucoup de parties, telle que dans la figure de la Servante, dans un tapis de velours rouge, dans une bougie qui s'eteint et dans quelques autres objets" ([Rob——], "Beaux-Arts: Expositions publique des ouvrages des artistes vivans, dans le Salon du Louvre, au mois de septembre, année 1795," *Magazin encyclopédique* 4 [1795]: 447; Del. 469; McW. 0508). The painting is listed in the Salon *livret* as follows: "No. 218. Par le C.[itoyen] Garnier, (Michel). Une Femme donnant une lettre à son officieuse, en lui recommandant le secret, et autres Tableaux sous le même numéro."

5. "Il y a de l'interet de l'expression; la couleur, quoique séduisante, n'est pas celle de la nature" (*Explication par ordre des numéros, et jugement motivé des ouvrages de peinture* [Paris, 1793], no. 19; Del. 458; McW. 0502).

Martin Drolling *(Oberhergheim, near Colmar 1752–1817 Paris)*

*L*ittle is known about Drolling's early years. After studying drawing at Schlestadt, he moved to Paris in 1780 and enrolled in the Ecole des beaux arts. His study of the seventeenth-century Dutch masters is evident in his carefully articulated style and the domestic subjects he often represented. Specializing in portraiture and genre painting, Drolling, like Boilly, represented an important current of French art that developed concurrently with Davidian neoclassicism; Boilly included Drolling in his famous Reunion of Artists in Isabey's Studio *(Salon of 1798; Musée du Louvre, Paris),* a group portrait that gathered many up-and-coming genre painters. Between 1793 and 1817, Drolling exhibited continuously at the Salon, and his compositions—sometimes moralizing, often anecdotal—were popularized by many engravers, including F. Noël, Langlumé, Leroy, and L. Debucourt. Little is known of his political sympathies, but much of his production celebrates the lives of the working and middle classes.

46. The Pricked Finger

1795
Oil on canvas, 17 1/4 × 14 1/4 in. (44.5 × 36.0 cm)
Signed and dated, lower left: Drolling f. 1795
Private collection

Provenance: Emile Pereire, Paris; sale, Palais Galliera, Paris, May 26, 1972, lot 10; sale, Sotheby's, London, January 17, 1985, lot 145; Colnaghi USA, Ltd., New York, 1985; private collection.

Selected Exhibition: Salon of 1795, no. 153.

Selected Reference: Heim, Béraud, and Heim, 1989, 189.

Drolling's beautiful little painting is a fin-de-siècle summation of a whole category of subject matter treated by genre painters through much of the eighteenth century. A gentle admonition against the dangers of passion, it depicts a young woman, in slight dishabille, alone in an appropriately lush garden setting; she is depicted lost in reverie, like so many images of lovelorn women painted during the ancien régime, and once again the erotic charge is transferred to a common metaphor, be it a cracked pitcher, broken egg, or, as here, pricked finger. The influence of Dutch painting is evident in the brilliant sheen of the Terborch-like satin gown, although, as the critic at the Salon of 1795, in which Drolling exhibited *The Pricked Finger,* commented, he enlivened the meticulously rendered surfaces with a fluid brushwork: "If our artist does not possess the astonishing art of finishing that has made these foreign painters so famous, in return his touch is fluent and light."[1]

At the Salon of 1795, *The Pricked Finger* and its pendant, now in the Clark Art Institute (fig. 74), were described as follows: "Two pictures making a pair; in one a young woman in an English garden holds a letter and is about to cross a stream; in the other, a young woman near a rosebush has pricked herself while trying to pick a rose."[2] The two works follow a well-established conceit in describing the course of love, in which the awakening of passion is

74. Martin Drolling, *The Letter ("Madame Dugazon"),* Salon of 1795, oil on canvas, Sterling and Francine Clark Art Institute, Williamstown, Massachusetts.

followed by the pang of absence, embodied by a letter, made familiar by such pendants as those by Garnier in this exhibition (cats. 44 and 45). In *The Pricked Finger,* unlike in Garnier's *The Poorly Defended Rose,* the male lover is already missing, leaving the woman to contemplate the consequence of their actions by herself. The red, white, and blue of her garment, no doubt a nod to contemporary patriotic feeling as much as to fashion, nevertheless suggest a new twist to an old tale of fallen virtue: has this woman merely been jilted, or, like many women of the time, has

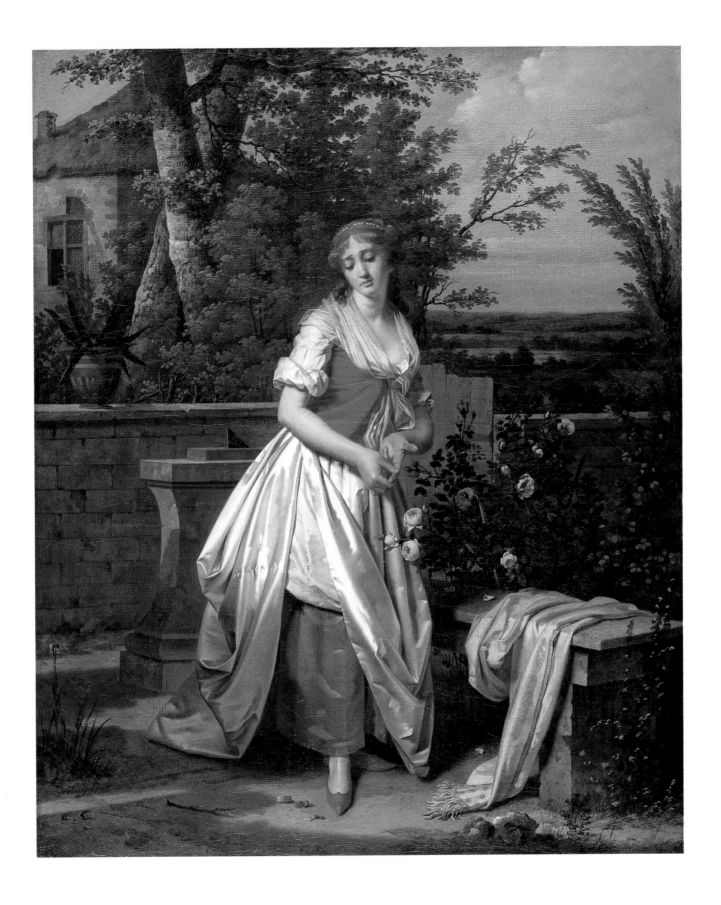

she been left behind as her lover goes off to defend the ideals of the Revolution? The juxtaposition of an open landscape in the right distance with the enclosed garden, its gate firmly shut, in the foreground might imply that, rather than having lost her honor, this is a dutiful, loyal woman who stays behind to tend to the domestic sphere, while the man ventures out to engage with the world. In the Clark painting (fig. 74), the woman turns from her letter to gaze into the distance, as if awaiting the return of her beloved.[3] The setting, identified in the Salon *livret* as an English garden, places Drolling's symbolic women in an environment—with its associations of artlessness, naturalism, and privacy—that would have been considered appropriately feminine; like Rousseau's Julie in her garden Elysium, lovingly described in *Julie, ou La Nouvelle Héloïse*, these imaginary women remain essentially imponderable, cloistered from the male realm of culture and public affairs.[4]

1. "Si notre artiste ne possède pas l'art etonnant de finir qui a rendu si fameux les peintres étrangers, en revanche sa touche est facile et legère" ([Rob——], "Beaux-Arts: Exposition publique des ouvrages artistes vivans, dans le Salon du Louvre," *Magasin encyclopédique* 4 [1795]: Del. 469, McW. 0508).

2. 153. "Deux Tableaux faisant pendans; l'un, une jeune Femme dans un jardin anglais, tenant une lettre & prête à passer un Ruisseau; l'autre, une jeune Femme près d'un Rosier, où elle s'est piquée, voulant cueillier une Rose" (*Explication des ouvrages de peintures . . . exposés dans le Grand Sallon du Museum, au Louvre* [Paris, 1795], 22). It is possible that a second version of *The Pricked Finger* (present whereabouts unknown), also signed and dated 1795 but showing a broken fence in place of the bench and a stone vase in place of the sundial, was the Salon painting (photograph in the archives of the Service de la documentation du Louvre).

3. The woman in the Clark painting has been identified as Madame Dugazon, née Louise-Rosalie Lafèvre (1755–1821), a celebrated actress in the 1770s and 1780s. Best known for her lead role in *Nina*, Madame Dugazon was an ardent royalist who was forced to leave the theater in 1792, gaining readmittance only after the fall of Robespierre in 1794. (See *Nouvelle biographie générale* [Copenhagen, 1965], 15–16:86; *Dictionnaire de biographie française* [Paris, 1967] 11:1490.) Although a portrait by Drolling made for the Salon of 1795, coinciding with her return to the stage, might have been appropriate, the woman in the Clark painting—supposedly shown in the title role of *The Miller's Wife*—bears little resemblance to Madame Dugazon as portrayed by Vigée-Lebrun in 1787 (see Nolhac, 1908, 72) and should be discounted in light of the description in the Salon *livret* cited above. That the Clark painting once belonged to Celestin Gandais, nephew of Madame Dugazon, suggests that the identification was an early invention made to personalize the painting.

4. See Siegfried, 1995, 107–15.

47. Peasants in a Rustic Interior

c. 1800
Oil on canvas, 26 × 36 1/2 in. (66.0 × 93.0 cm)
Colnaghi, London

Provenance: Sale, Sotheby's, Monaco, December 2, 1988, lot 677.

Selected Exhibition: New York, 1989 (1), no. 17.

Peasants in a Rustic Interior well justifies Paul Marmottan's enthusiastic praise for Drolling, whom he described as "the greatest painter of interiors of his time—a strong palette, perfect understanding of light and shade, irreproachable and astonishingly faithful powers of imitation, consummate drawing, and intelligent compositions—these are the qualities of this 'Hollandais Français.'"[1] In the present picture these talents are brought to bear on an unrelentingly grim subject: in a rustic and rugged cabin, a despairing family watches over their younger child, who lies, apparently deathly ill, in his cradle. In subject and mood the painting is the polar opposite of Lépicié's *Carpenter's Family* (cat. 38), in which the working poor are represented as healthy, happy, and properly industrious. The warm family feeling that pervades that painting gives way here to a keen sense of despondency and ineffectualness. Drolling movingly evokes an air of resignation by turning each person to gaze in a different direction, as if tragedy, rather than drawing the members of the family together, has instead forced them apart; even the dog is dejected, seemingly lost in its own thoughts rather than bringing comfort to his master. All this is captured through the lens of Drolling's unremitting naturalism, so that the pathos of the scene is seared in the viewer's consciousness.

The influence of seventeenth-century Dutch and Flemish art is palpable in the insistent realism, the humble figure types, and the domestic setting of the painting. Teniers, Dou, even Rembrandt (in the use of a curtain drawn away from the cradle, which recalls the latter's *Holy Family with a Painted Frame and Curtain* [1646; Gemäldegalerie, Kassel]) are all relevant points of comparison. As Carol Eliel has pointed out, however, the painting owes as much to contemporary French art as it does to those older sources.[2] The strict planar arrangement of the composition, the stagelike setting, even the figures and lighting draw inspiration from the pictorial strategies of neoclassicism, especially those of Jacques-Louis David: as Eliel astutely observes, the pose of the mother, bent over in sorrow, her back brilliantly illuminated, is drawn directly from the weeping women on the right side of David's

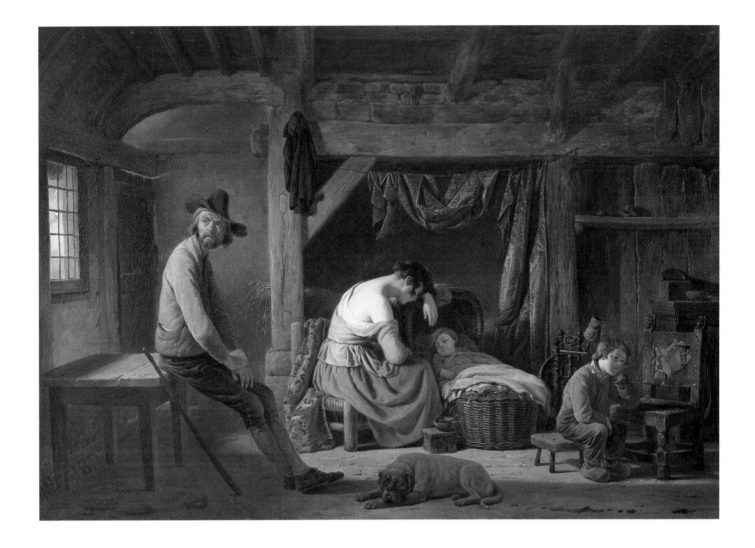

seminal masterpiece, *The Oath of the Horatii* (Salon of 1785; Musée du Louvre, Paris). Such appropriations from history painting could only help elevate Drolling's humble scene, in his attempt to give the subject a sense of tragedy and emotional punch normally reserved for historical paintings.

Nevertheless, Drolling's true thematic source was the moralizing genre painting of Greuze, particularly such dramatic narratives as *The Ungrateful Son* and *The Punished Son* (see figs. 18 and 19), pendants from the late 1770s that are similarly grim and uncompromising in subject and style. Yet the subject of those paintings advanced an obvious and understandable message concerning family loyalty and the wages of selfishness; the death of the patriarch, while tragic, served to emphasize the son's transgression and thus taught an important moral lesson. It is difficult to imagine to what noble ends Drolling's pathetic subject is directed. The possibility exists that it, too, was one of a pair (the absence of a signature being further evidence), its pendant providing a happy ending, or at least a justification for the present scene; such a complementary picture, however, has yet to be identified.[3]

The origins of this painting, unusually large by Drolling's standards, are unfortunately unknown. Given its size and didactic quality, it would have likely been sent to one of the Salons, yet it has proved impossible to link the painting precisely with any exhibited by the artist. In 1807 Drolling showed a *scène familière* (familiar or intimate scene), a description that, while not inconsistent with the present picture, could describe innumerable works by the artist.[4]

1. "La meilleur peintre d'intérieurs de son époque.—Coloris ferme, entente parfaite du clair-obscur, fidélité irréprochable et surprenante de l'imitation, dessin fini, composition bien entendue, telles sont les qualités de ce Hollandais Français" (Marmottan, 1886, 258).
2. In "Genre Painting during the Revolution and the *Goût Hollandais*," in New York, 1989 (1), 54.
3. The possibility of a pendant was raised by Nicholas Hall (New York, 1989 [1], 154).
4. The suggestion, tentatively advanced by Hall (ibid.), that the present work might be identical with the painting called *Le Dieu vous assiste* (*God Will Help You*) exhibited at the Salon of 1802 (no. 86), must be discounted: that painting (present whereabouts unknown) was an exterior scene, showing a woman with her child, accompanied by a little girl, begging at the door of a house. (See the description in "Peinture," *Journal des Arts* [1802]: 141–42; Del. 782; McW. 0732.)

Henri-Nicolas Van Gorp *(Paris 1760–after 1819 Paris)*

*V*an Gorp (sometimes written Vangorp or Van Gopf) has remained an elusive figure in the history of art. He entered the school of the Royal Academy in 1773 under the sponsorship of Etienne Jeaurat (1699–1789). His art must have developed slowly, for he was still there ten years later, and he even reapplied in 1785, this time sponsored by the history painter Antoine-François Callet (1741–1823). He did not begin exhibiting at the Salon until 1793, yet after that belated debut he participated regularly until 1819. Like many of the petits maîtres to whom his work is related (especially Boilly and Schall), Van Gorp painted small, highly finished pictures, often on panel and focused on intimate and sometimes gallant subjects—women playing guitars or reading letters, for example—but also on domestic subjects such as mothers and children. In addition he was a successful portraitist, an aspect of his career to which he increasingly devoted his energies.

48. *The Joy of Motherhood (Polichinelle)*

1796
Oil on panel, 15 1/2 × 12 1/4 in. (39.4 × 31.2 cm)
Signed, at lower left: vangorp x.
Collection of Mr. and Mrs. Stewart Resnick

Exhibited in Toledo and Houston only

Provenance: Masson, 1796; Madame la comtesse d'Hautpoul, Paris; Edouard Jonas, Paris, 1927; Joseph Heine; his sale, Parke Bernet, New York, 1944; Mrs. Charles E. Dunlap; her sale, Sotheby Park Bernet, New York, December 4, 1975, lot 364; Thomas Agnew and Sons, London, 1979.

Selected Exhibition: Salon of 1796, no. 477.

Selected Reference: Heim, Béraud, and Heim, 1989, 117, 368-69.

75. Marguerite Gérard, *M. Fanfan*, c. 1775, etching, private collection.

Although Van Gorp's endearing panel occasioned no written commentaries when it was exhibited at the Salon of 1796, critics must have recognized its profound debt to the cabinet paintings of Boilly. When compared to such works as Boilly's *S'il vous plaît* (cat. 50), the present picture is evidence of the ability of such minor artists to reach a high standard. Van Gorp here responded with exceptional acuity to the example of the seventeenth-century Dutch tradition, although he expended most of his talent in rendering the figures and their brilliantly realized costumes, having found less success in re-creating the neoclassical furniture and decor.

At the Salon the painting was entitled *The Joy of Motherhood (Le Plaisir des mères)*, evoking a contemporary interest in the celebration of maternity and childhood that was particularly apposite during the 1790s. The young mother teases her son by withholding a doll, a brightly colored Polichinelle (Punch or Pulcinello, a character from the commedia dell'arte) that she has apparently just removed from the box on the table. The child's entreaties and the mother's playful resistance evoke a warm familiarity between the parent and her child, an emotional attachment that would have been considered a positive develop-

ment from the detached and aloof attitude that traditionally existed between the generations. Nevertheless, the general subject had a long pedigree, having been treated, for example, by Jean-François de Troy in a black chalk drawing of 1746.[1] In that composition a young mother makes the puppet dance for the amusement of the child, while in the Van Gorp she playfully withholds the toy. Here even the household spaniel has been caught up in the game, and the mother's amused expression suggests that the child's desire will not be long unfulfilled. In con-

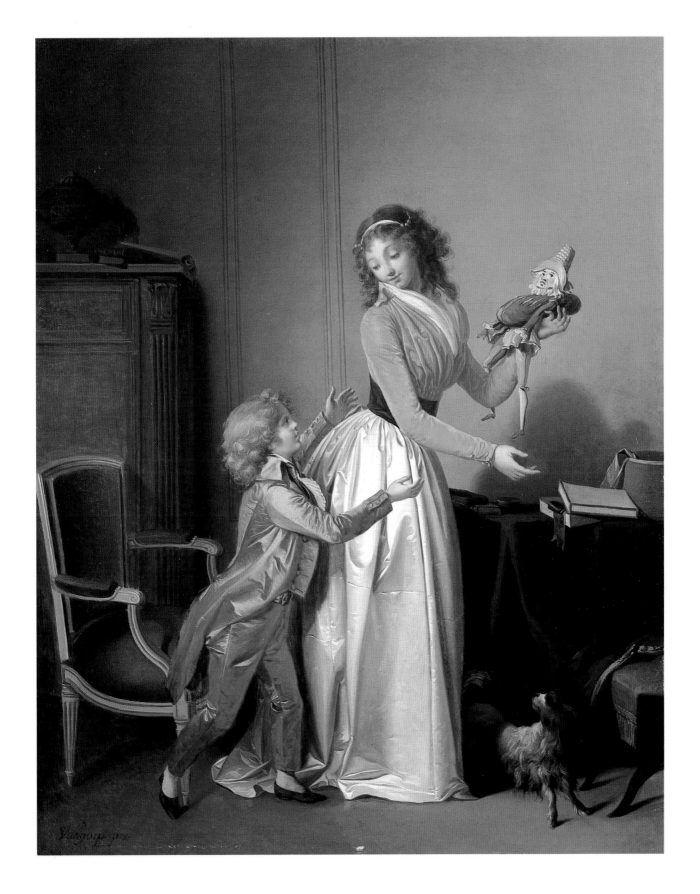

ceiving this scene Van Gorp may have had in mind an impression of the print *M. Fanfan jouant avec Monsieur Polichinelle* by Marguerite Gérard after a painting by Fragonard and dated to the late 1770s, which shows a young boy clutching a pair of dolls while fleeing two yapping lapdogs (fig. 75).[2]

1. Black chalk, 42 × 33 cm; sale, Galerie Charpentier, Paris, December 11, 1933, lot 1 (photograph in the archives of the Service de la documentation du Louvre).
2. See Paris and New York, 1987–88, 493–94, no. 244 (ill.). The painting, now lost, appeared in the Leroy de Senneville sale in 1780 (no. 54).

Louis-Léopold Boilly *(La Bassé, near Lille 1761–1845 Paris)*

After studying in Douai between 1775 and 1779 and then at Arras as a young man, Boilly moved to Paris in 1785, where he spent the remainder of his life. In the 1780s and 1790s he painted modest cabinet pictures, often with erotic undertones, works for which Boilly was threatened with imprisonment during the French Revolution. These pictures, with their smooth, refined surfaces and engaging attention to detail, show his admiration for the seventeenth-century Dutch masters. Boilly could easily adapt his art to the prevailing political climate, however, submitting The Triumph of Marat *(Musée des Beaux-Arts, Lille) to the competition of 1797. His public renown rested primarily on his anecdotal scenes of Parisian boulevard life,* such as L'Arrivée d'une diligence *(Musée du Louvre, Paris) and* L'Entrance du Jardin Turc *(private collection), complex and eye-catching paintings that were intended to attract the attention of Salon-goers. Boilly also enjoyed a successful career as a portraitist, producing hundreds of small bust-length portraits, as well as large-scale works such as* Reunion of Artists in Isabey's Studio *(Salon of 1798; Musée du Louvre, Paris). Boilly's work was also popularized through his prints, the most famous of which is a collection of humorous studies of the human countenance entitled* Les Grimaces *(1823). In 1833, he was awarded the Cross of the Legion of Honor; shortly thereafter he retired from painting.*

49. The Electric Spark

c. 1791
Oil on canvas, 18 1/8 × 21 3/4 in. (46.1 × 55.3 cm)
Signed, on the base of Cupid's pedestal: L Boilly
Virginia Museum of Fine Arts, Richmond, the Arthur and Margaret Glasgow Fund, 1973

Provenance: (?) Lafontaine sale, Paris, January 17, 1810, lot 10; (?) De Livry sale, Paris, April 25, 1810, lot 105, bought in; marquis d'Estampes; Hodgkins, Paris; sale, Hôtel Drouot, Paris, November 28, 1910, lot 17; Lucien Cottreau, Paris; duchesse de Cadore, Paris, 1930; H. Shickman; acquired by the museum in 1973.

Selected Exhibitions: (?) Paris, Exposition de la jeunesse, 1791; Paris, 1930 (2), no. 24.

Selected References: Harrisse, 1898, no. 198 or 199, 102; Marmottan, 1913, 35, 39, pl. XII; Poncheville, 1931, 32–33, 164; Hallam, 1977, 2–11, colorplate 1; New York, 1989 (1), 51–53, fig. 2.

Boilly's most famous and innovative productions focus on the public sphere of Parisian life, with its crowded boulevards, political gatherings, and popular diversions, works that reflect the full emergence of the bourgeoisie in the Napoleonic era. Yet in the first years after his arrival in the capital in 1785 he made a name for himself painting mildly erotic cabinet pictures thoroughly in the spirit of the Old Regime. It was reportedly for producing such works, many of which take their stylistic and thematic cues from the works of Fragonard and Gérard, that Boilly was censured by the revolutionary Committee of Public Safety for corrupting public morals.[1] *The Electric Spark* conforms to this early type of picture while adding an innovative and unexpected element. A fashionable couple participates in an unusual experiment in a dank laboratory. Embracing, they step toward a statue of Cupid drawing his bow, which has been rigged to an electric generator cranked by an old scientist. The woman, encouraged by her lover, touches the tip of Cupid's arrow, which presumably sends a charge coursing through them both. The electric current is wonderfully expressed by the ethereal light—apparently coming from the fire in the neoclassical *athénienne* (brazier) in the middle background—that illuminates the couple as if by a flash of lightning. This sharp light reveals some of the details of the setting: the aged scientist and his wife, the strange equipment and exotic furniture of the laboratory,

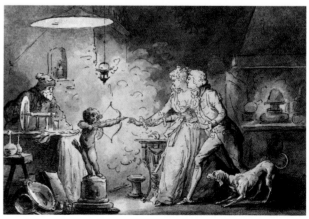

76. Louis-Léopold Boilly, *The Electric Spark,* c. 1791, pen and ink, Virginia Museum of Fine Arts, Richmond, Virginia, the Arthur and Margaret Glasgow Fund; photo: Katherine Wentzel, 1996, Virginia Museum of Fine Arts.

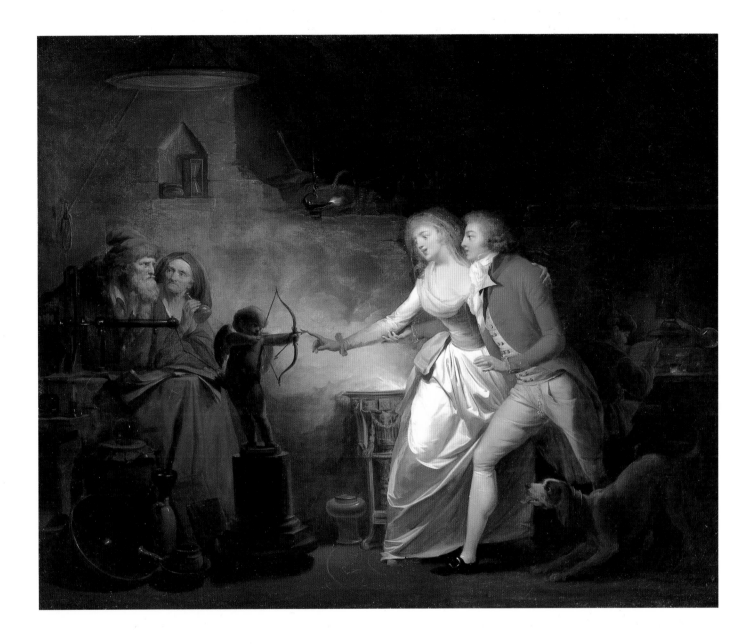

and another figure absorbed in his reading in the right background.

Boilly took special care with this painting, working out the composition in a detailed wash drawing recently acquired by the Virginia Museum of Fine Arts (fig. 76).[2] The painting itself is exquisitely finished, with a porcelainlike surface that enhances Boilly's careful attention to the look and feel of the objects depicted. As recent commentators have pointed out, *The Electric Spark* is a fascinating meld of influences, combining the Dutch high-life genre, as seen in the work of Gerard Metsu, and the Flemish *bambocciade* tradition, with the theme of the alchemist borrowed directly from artists such as Teniers.[3] The picture was evidently a success, for Boilly painted a second version—similar to the present work, although the alchemist's

wife was left out—and exhibited one of them in 1791 at the *Exposition de la jeunesse,* an exhibition space that since 1789 had been held in the gallery of the art dealer J.-B. Lebrun. There it was described as "a painting representing two lovers shocking themselves by a Cupid. Night effect."[4] It was subsequently engraved with the title *L'Expérience d'électricité* (*The Electrical Experiment*).

The theme of electricity is indeed what gives the painting both its stunning visual quality and its topical interest. The plate generator shown in *The Electric Spark* is based on an actual, working instrument—Hallam has pointed out that it is identical to that illustrated in Signaud de la Fond's *Traité de l'électricité,* published in 1771—and the scene itself recalls the electrical experiments performed in the late eighteenth century, some of which were described

in the *Encyclopédie*: "If a person touches the bar [connected to the generator] . . . not only will the bar become electrified, as usual, but the person . . . also receives the charge; . . . and if he gives his hand to another . . . that person will become as electrified as the first."[5] In Boilly's painting, however, the preoccupation is less with science than with furthering the game of love. As we have seen, to include a statue of Cupid or Venus near an amorous encounter between lovers was a common conceit in genre paintings (see, for example, the works by de Troy [cat. 10] and Garnier [cat. 44]); here it serves as a clever comment on the contemporary taste for such pseudoscientific pursuits as alchemy and mesmerism. Carol Eliel has analyzed the relationship of the painting to an engraving by Gravelot called *L'Electrisée,* showing a fashionable couple hooked up to a generator; the verses below this print make explicit the erotic allusions of the electric charge: "I know, where better to find / This almost magic virtue / Wisely called electric; / Young Beauties, it is in your eyes."[6] Gravelot's print reminds us that in the popular imagination of this period, electricity was believed to be possessed of magical curative powers, especially in enhancing fertility. In *The Electric Spark* any interest in expounding on the scientific properties of electricity has been overwhelmed by a playful exposé of a well-heeled but gullible couple who hope to jump-start their love.

1. Much has been made of this episode in Boilly's career, which Susan Siegfried (1995, 29–34) has thoughtfully reconsidered.
2. Pen, ink, and brown wash, 4 5/16 × 6 1/4 in. (11.0 × 16.0 cm); Hallam, 1977, 4–5, fig. 3; Harrisse, 1898, 168, no. 939; see also New York, 1996, no. 33.
3. Hallam, 1977; Carol Eliel, "Genre Painting during the Revolution and the *Goût Hollandais,*" in New York, 1989 (1), 52.
4. "No. 45. Un tableau représentant deux amants se faisant électriser par l'Amour. Effect de nuit" (quoted in Marmottan, 1913, 39). The second version of the painting is reproduced in Hallam, 1977, fig. 2. On the *Expositions de la jeunesse,* see Wrigley, 1993, 29–32.
5. "Electricit (Physique)," in *Encyclopédie* (Paris, 1755), 5:472–73.
6. "Je le sçais, où se trouve mieux / Cette vertu presque magique, / Sçavement nommé électrique; / Jeunes Beautés, c'est dans vos yeux." See Eliel in New York, 1989 (1), 52.

50. *S'il vous plaît*

c. 1793
Oil on panel, 15 7/8 x 12 5/8 in. (40.4 × 32.0 cm)
The Toledo Museum of Art, Edward Drummond Libbey Gift, 75.58

Provenance: Georges Lutz; his sale, Georges Petit, Paris, May 26–27, 1902, lot 9; Agnew, London; Wildenstein, London; Sir Robert Mayer, London; E. V. Thaw, New York; acquired by the museum in 1975.

Selected References: Harrisse, 1898, no. 502, 130; Marmottan, 1913, 251; The Toledo Museum of Art, 1976, 25, pl. 213.

Boilly's exquisite little panel shows a fashionably dressed young woman presenting a piece of fruit to a little girl. Her long gloves and beribboned hat indicate that she is about to venture out of the house. The subject is not altogether clear, and one's reading of it depends on how the expression of the woman and the gesture of the child are understood. The present title, taken from the engraving by Jean Testard, suggests that the woman is admonishing the girl for not politely asking for the fruit; the girl puts her fingers to her lips in a gesture of regret. Conversely, her action has been understood as blowing a kiss in exchange for the gift.[1] An alternative title of the painting, *La Récompense (The Reward)*, would seem to follow this interpretation, although the description in the Lutz sale claims that the older woman is about to go out and is bribing the little girl to stay at home.[2] Given the open composition book

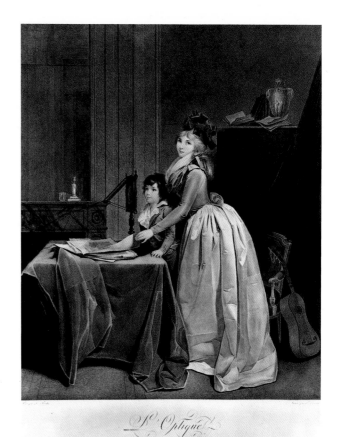

77. Frédéric Cazenave after Boilly, *The Optical Viewer,* c. 1794, color aquatint with etching and engraving, cat. P5.

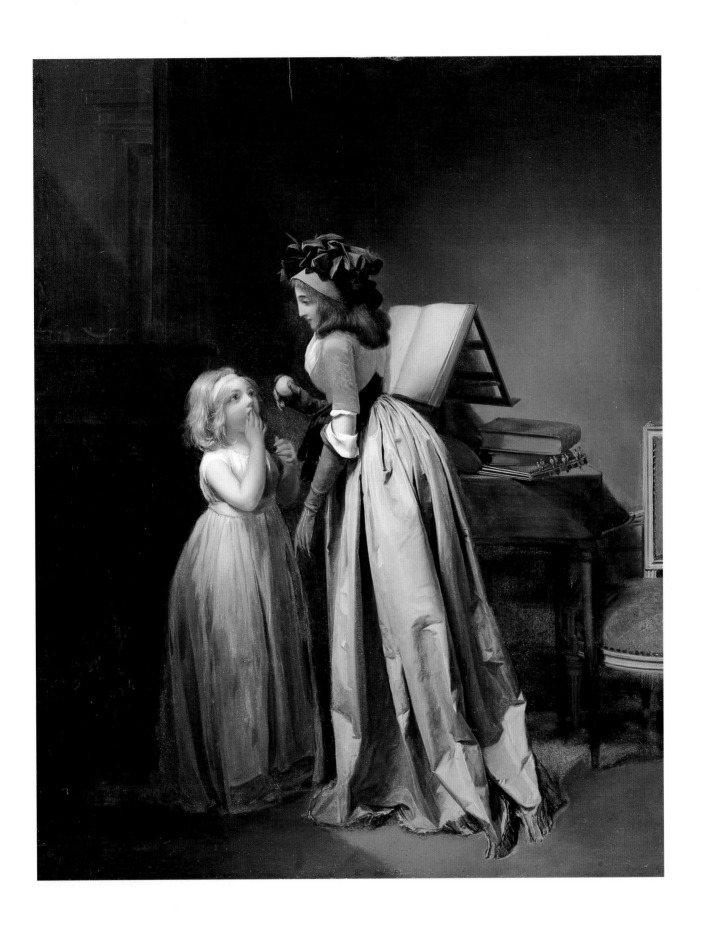

and the lute resting atop the side table, one might just as easily interpret the woman not as the girl's mother or older sister but as a music teacher who is rewarding her young charge for a successfully completed singing lesson.

S'il vous plaît probably dates to the same time as *The Optical Viewer* (private collection), shown at the Salon of 1793 and made famous through Cazenave's color print (cat. P5; fig. 77).[3] The two works share many details—of costume, furnishings, and decor, such as the mirror over the mantle that reflects the room—as well as the overall idea of a woman instructing a child. Unlike *The Optical Viewer*, which is a portrait of the son and second wife of the revolutionary Danton, *S'il vous plaît* appears to be a pure genre scene. Whatever its precise meaning, if indeed Boilly intended one, the Toledo panel presents a snippet of late-eighteenth-century Parisian private life that is a decided

alternative to the risqué subjects the artist painted during the 1780s and 1790s, a type well represented in this exhibition by *The Electric Spark* (cat. 49). In contrast to that hothouse of sexual intrigue, *S'il vous plaît* updates the sort of well-to-do interior popularized earlier in the century by such works as Chardin's *The Good Education* (cat. 20). The image's simple homily—that bourgeois women should tend to the upbringing of their children in an atmosphere of peace and tranquillity—is one that would have been in keeping with the political and moral climate of the mid-1790s.

1. Harrisse, 1898, 130.
2. This was the title given the work in the Lutz sale (1902) and subsequently adopted by Marmottan, 1913, 251.
3. See Paris, 1984, no. 7; for the print, see Baltimore, Boston, and Minneapolis, 1984–85, 304–5, no. 110.

51. The Artist's Wife in His Studio

c. 1795–1800
Oil on canvas, 16 1/16 × 12 3/4 in. (40.8 × 32.5 cm)
Sterling and Francine Clark Art Institute, Williamstown, Massachusetts

Provenance: (?) J. W. G. Davis, London; sale ("Vente D"), Lechat, Paris, February 25, 1869; (?) sale, Escribe, Paris, May 12, 1883, lot 4; Mme. Louise Suzanne Oger de Bréart; sale, Chevallier, Paris, May 17, 1886, lot 3; "Collection de M. X" [M. Lallemand, M. Lecocq Dumesnil] sale, Galerie Georges Petit, Paris, May 2, 1894, lot 1; Felix Doistan collection; his sale, Galerie Georges Petit, Paris, June 9, 1909, lot 5; Alfred de Rothschild, London; bequeathed to the Right Honorable Almina, countess of Carnavon, Highclere Castle, Newbury; her sale, Christie's, London, May 22, 1925, lot 54; M. Knoedler and Co., Paris; purchased by Robert Sterling Clark, December 31, 1925; acquired by the institute in 1955.

Selected Exhibitions: Williamstown and Hartford, 1974, no. 5, 21–23, ill.; Fort Worth and Washington, 1995–96.

Selected References: Harrisse, 1898, no. 340, 114; Marmottan, 1913, 232; Hallam, 1979; 57–59, fig. 64; Sterling and Francine Clark Art Institute, 1992, 19, ill.; Siegfried, 1995, 175, colorplate 150.

The studio interior was one of Boilly's favorite subjects, often allowing him to combine his interests in genre, portraiture, still life, and even trompe l'oeil. His most publicly acclaimed essays on the theme were complex group portraits, such as *A Reunion of Artists in Isabey's Studio* (Musée du Louvre, Paris), exhibited to wide praise at the Salon of 1798, and two versions of *A Sculptor's Studio* (Musée des Arts Décoratifs, Paris [see fig. 7], and Musée des Beaux-Arts, Cherbourg), which show the celebrated sculptor Houdon modeling from life.[1] Yet his more typical productions are small-scale, intimate views of anonymous stu-

dios, of which the Clark picture is one of the most accomplished. In a dark corner of a cluttered atelier, lit by a shaded lamp on the wall and an external light source from the left, a beautiful woman in a white dress leafs through a portfolio of prints and drawings. She is surrounded by

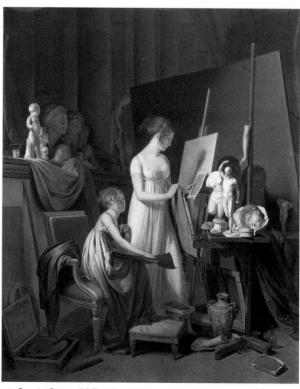

78. Louis-Léopold Boilly, *A Painter's Studio*, c. 1800, oil on canvas, National Gallery of Art, Washington, D.C., Chester Dale Collection, 1943.

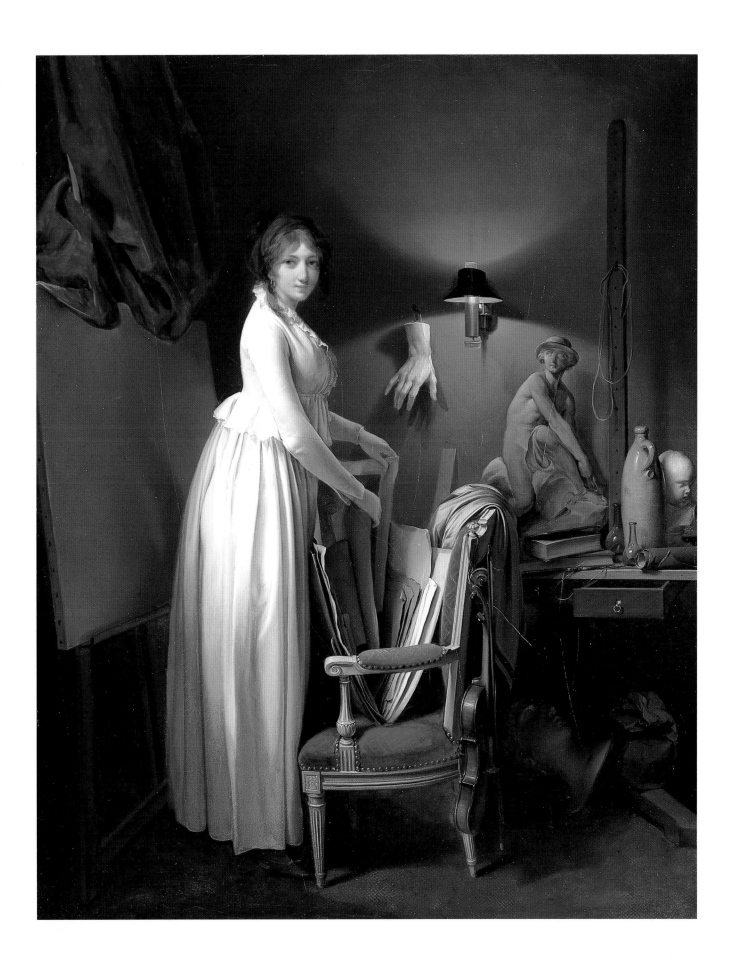

the materials of the painter's profession, their textures, forms, and colors all lovingly rendered: canvases, drawings and prints, brushes, jars of oil, and plaster casts, including a version of Pigalle's celebrated *Mercury Fastening His Heel Wing*. For good measure a violin hangs from an armchair. Boilly's picture suggests that from these diverse elements—which draw equally from artistic tradition, observation of nature, and imaginative faculties—the painter creates original works of art. In this context it is worth noting that Chardin had included Pigalle's *Mercury*, one of the most admired sculptures of the period, in two paintings that are in essence allegories of the arts: *The Drawing Lesson* (see fig. 52) and a monumental still life, *The Attributes of the Arts and Their Rewards* (Hermitage, St. Petersburg), commissioned in 1766 for Catherine the Great of Russia.[2]

In an 1894 sale the Clark painting was titled *La Jeune artiste* (*The Young Artist*), a description that was repeated by Boilly's cataloguers Harrisse and Marmottan. Boilly did on rare occasions depict women artists seriously at work in the studio (for example, the beautiful picture of 1796 in Schwerin).[3] Such images reflect the new measure of respect and status enjoyed by women artists with the opening of the Salon exhibitions in 1791. Yet Boilly's more usual—and conventional—tendency was to portray women as either models or visitors to what was still a paradigmatically male environment. *A Painter's Studio* of around 1800 in the National Gallery of Art, Washington, D.C. (fig. 78) is typical. Again we see the attributes of the artist's craft surrounding a beautiful woman who examines a portfolio of prints. Although Boilly also included a young woman artist, seated in an armchair with sketchbook and chalk in hand, he gave her a dreamy expression and directed her gaze, in a kind of twist on the theme of "feminine vanity,"

toward a voluptuous torso of Venus placed on the easel before her.

In the Clark painting the woman is less an artist than an interloper who has entered the studio to examine a sheath of prints and drawings. The absent male painter is suggestively represented by the aggressive posture of Pigalle's *Mercury*, which glances over at her, or in the slightly menacing plaster cast of a male hand reaching toward her, suspended on the studio wall in the dead center of the painting. The woman, who turns to meet the viewer's gaze, is actually a portrait of Boilly's second wife, Adelaïde-Françoise-Julie Leduc (born 1778), whom he had married in 1795.[4] It was not uncommon for Boilly to include depictions of his friends and family (including himself) in his genre scenes, and—while the similarities between the woman in the present picture and Boilly's own wife are apparent—the painting is less a straightforward portrait than a play on the traditional personification of the artist's muse as a woman. Boilly's wife turns pleasantly to the viewer, as if she has been interrupted; she stands before a blank canvas onto which she casts a shadow. Boilly invites us to imagine her transformed onto that canvas into a work of art—something, of course, that he has already accomplished for us.

1. See Siegfried, 1995, 97, fig. 69; 104, fig. 79; 105, fig. 81.
2. For the still life see Paris, Cleveland, and Boston, 1979, 344–47, no. 125. For Pigalle's sculpture, see Gaborit, 1985, 38–42. On the significance of Pigalle's *Mercury* for French artists, see Conisbee, 1985, 27–30.
3. On the innovative character of this painting, see Siegfried, 1995, 174–80, fig. 149.
4. The woman portrayed in the Clark painting, distinguished by her high cheekbones, widely spaced eyes, and pointed chin, closely resembles a drawing of Madame Boilly dating to around 1795 (Musée des Beaux-Arts, Orléans; reproduced in Lille, 1988–89, 92).

Checklist of Prints

Unless otherwise noted, all prints are lent by David P. Tunick, New York

P1
MICHEL AUBERT (1700/4–1757)
Rendez-vous de chasse (Halt During the Hunt), 1731
After Antoine Watteau
Engraving
14 1/4 × 20 1/2 in. (36.3 × 52.1 cm)
Dacier and Vuaflart, 1921–22, no. 213 ii/ii
fig. 79

P2
PIERRE ALEXANDRE AVELINE (1710–1760)
L'Enseigne de Gersaint (Gersaint's Shop-sign), c. 1732
After Antoine Watteau
Engraving and etching
22 7/8 × 33 1/2 in. (58.0 × 85.0 cm)
Dacier and Vuaflart, 1921–22, no. 115 iii/iii
fig. 29

P3
BERNARD BARON (1696–1762)
L'Accord parfait (Perfect Harmony)
After Antoine Watteau
Engraving
13 2/3 × 11 in. (34.7 × 28.0 cm)
Dacier and Vuaflart, 1921–22, no. 23 ii/ii

P4
MAURICE BLOT (1753–1818)
Le Verrou (The Bolt), 1784
After Jean-Honoré Fragonard
Engraving and etching

15 3/4 × 18 3/16 in. (40.0 × 46.3 cm)
Portalis and Béraldi, 1880–82, no. 4 ii/ii
fig. 33

P5
FRÉDÉRIC CAZENAVE (ACTIVE 1793–1843)
L'Optique (The Optical Viewer), c. 1794
After Louis-Léopold Boilly
Color aquatint with etching and engraving
25 1/2 × 18 1/2 in. (65.0 × 47.2 cm)
Harrisse, 1898, no. 6
fig. 77

P6 a-b
PHILIBERT-LOUIS DEBUCOURT (1755–1832)
Le Compliment, ou La Matinée du Jour de l'An (The Compliment, or New Year's Morning), 1787
Les Bouquets, ou La Fête de la Grand-Maman (The Bouquets), 1788
Color aquatint with etching
14 1/2 × 11 in. (36.8 × 28.0 cm);
14 5/8 × 11 1/16 in. (37.2 × 28.1 cm)
Fenaille, 1899, no. 15 iv/v, no. 16 iii/iv
figs. 35 and 80

P7
PHILIBERT-LOUIS DEBUCOURT (1755–1832)
Le Menuet de la mariée (The Minuet of the Bride), 1786
Color etching and engraving
12 × 9 1/8 in. (30.7 × 23.3 cm)
Fenaille, 1899, no. 8 iii/iii (or no. 8 v/vi)
fig. 34 and colorplate page 68

80. Philibert-Louis Debucourt, *The Bouquets*, 1788, color aquatint and etching, cat. P6b.

81. Gilles Demarteau after Boucher, *The German Dance*, 1769, crayon manner engraving, cat. P8.

P8
GILLES DEMARTEAU (1722–1776)
La Danse allemande (The German Dance), 1769
After François Boucher
Crayon manner engraving
15 13/16 × 10 1/16 in. (38.7 × 25.9 cm)
Jean-Richard, 1978, no. 769 ii/ii
fig. 81

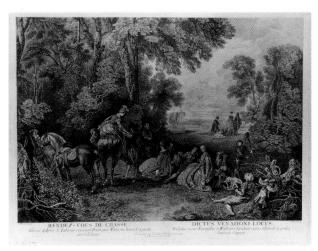

79. Michel Aubert after Watteau, *Halt During the Hunt*, 1731, engraving, cat. P1.

P9
GILLES-ANTOINE DEMARTEAU
(1750–1802)
Mère et enfant (Mother and Child)
After François Boucher
Crayon manner engraving
8 1/3 × 6 in. (21.2 × 15.5 cm)
Jean-Richard, 1978, no. 860

P10
CHARLES-MELCHIOR
DESCOURTIS (1753–1820)
L'Amant surpris (The Surprised Lover)
After Jean-Frédéric Schall
Color aquatint and etching with
roulette
21 5/8 × 16 1/2 in. (54.9 × 41.9 cm)
Portalis and Béraldi, 1880–82, no. 3(a)
ii/ii

P11
JEAN-HONORÉ FRAGONARD
(1732–1806)
L'Armoire (The Armoire), 1778
Etching
16 1/4 × 21 5/8 in. (41.2 × 55.0 cm)
Hood Museum of Art, Dartmouth
College, Hanover, New Hampshire,
purchased through the Phyllis and
Bertram Geller 1937 Memorial Fund
Wildenstein, 1956, no. 23 ii/iv
fig. 32

P12
JEAN-FRANÇOIS JANINET
(1752–1814)
L'Aveu difficile (The Difficult Confession), 1787

After Nicolas Lavreince
Color etching and engraving
19 3/8 × 14 3/8 in. (49.2 × 36.5 cm)
Bocher, 1875, no. 8 ii/iii

P13
JEAN-FRANÇOIS JANINET
(1752–1814)
L'Indiscretion (The Indiscretion), 1788
After Nicolas Lavreince
Color etching and engraving (aquatint
with roulette?)
19 1/2 × 14 3/8 in. (49.0 × 36.5 cm)
Bocher, 1875, no. 30 ii/iii

P14
NICOLAS DE LARMESSIN
(1684–1755)
*La Courtisane amoureuse (The Loving
Courtesan)*, 1736
After François Boucher
Engraving
10 2/3 × 13 13/16 in. (27.0 × 35.0 cm)
Jean-Richard, 1978, no. 1252

P15
NICOLAS DE LAUNAY (1739–1792)
*Les Hazards heureux de l'escarpolette
(The Swing)*, 1782
After Jean-Honoré Fragonard
Etching and engraving
24 5/8 × 17 15/16 in. (62.3 × 45.5 cm)
Lawrence and Dighton, 1910, no. 85
v/vii
fig. 82

P16
PIERRE LAURENT (1739–1809)
Le Bénédicité (Saying Grace), c. 1760–65
After Jean-Baptiste Greuze

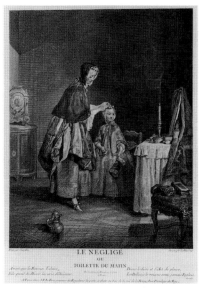

84. Jacques Philippe Le Bas after
Chardin, *The Morning Toilet*, 1741, engraving, cat. P17.

Engraving and etching
19 1/4 × 15 1/4 in. (48.8 × 38.8 cm)
Le Blanc, 1854–56, no. 5
fig. 83

P17
JACQUES PHILIPPE LE BAS
(1707–1783)
La Toilette du matin (The Morning Toilet), 1741
After Jean-Siméon Chardin
Engraving
15 × 10 11/16 in. (38.1 × 27.0 cm)
Bocher, 1876, no. 38 ii/ii
fig. 84

P18
JACQUES PHILIPPE LE BAS
(1707–1783)
Conversation galante (Gallant Conversation), 1743
After Nicolas Lancret
Engraving and etching
13 1/4 × 10 2/3 in. (33.6 × 27.0 cm)
Bocher, 1877, no. 20 iii/iii
fig. 39

P19
FRANÇOIS BERNARD LÉPICIÉ
(1698–1755)
La Gouvernante (The Governess), 1739
After Jean-Siméon Chardin
Engraving
14 5/8 × 10 9/16 in. (37.1 × 26.7 cm)
Bocher, 1876, no. 24a
fig. 28

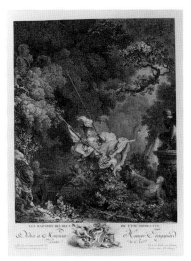

82. Nicolas de Launay after Fragonard,
The Swing, 1782, etching and engraving,
cat. P15.

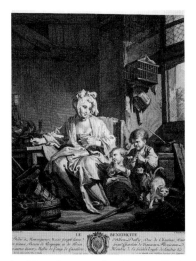

83. Pierre Laurent after Greuze, *Saying
Grace*, c. 1760–65, etching and engraving, cat. P16.

P20
FRANÇOIS BERNARD LÉPICIÉ
(1698–1755)
La Mère laborieuse (The Diligent Mother), 1740
After Jean-Siméon Chardin
Engraving
14 13/16 × 10 9/16 in. (37.7 × 26.7 cm)
Bocher, 1876, no. 35 ii/ii
fig. 27

P21
JEAN-MICHEL MOREAU LE JEUNE (1741–1814)
Le Coucher de la mariée (The Marriage Bed), 1770
After Pierre-Antoine Baudouin
Engraving
15 1/16 × 12 1/8 in. (38.3 × 30.8 cm)
Bocher, 1875, no. 16 v/v
fig. 6

P22
JEAN-MICHEL MOREAU LE JEUNE (1741–1814)
La Paix du ménage (Household Peace), 1766
After Jean-Baptiste Greuze
Engraving
13 1/8 × 9 7/8 in. (33.3 × 25.1 cm)
Bocher, 1882, no. 175 i–ii/ii
fig. 31

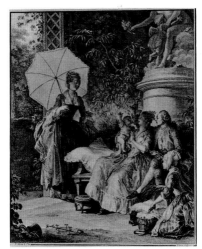

85. After Moreau le Jeune, *The Delights of Motherhood,* etching, cat. P23b.

86. Gabriel de Saint-Aubin, *Scenes in the Tuileries,* 1760–63, etching and drypoint, cat. P25.

P23 a–d
After JEAN-MICHEL MOREAU LE JEUNE (1741–1814)
Monument du costume:

C'est un fils, monsieur (It's a Boy, Sir), 1776
Etching
13 × 10 15/16 in. (32.7 × 26.2 cm)
Bocher, 1882, no. 1352 ii/v

Les Délices de la maternité (The Delights of Motherhood)
Etching
10 5/8 × 8 5/8 in. (27.0 × 21.9 cm)
Bocher, 1882, no. 1354 iii/vi
fig. 85

Les Petits Parrains (The Little Sponsors), 1777
Etching
12 15/16 × 10 5/16 in. (32.7 × 26.2 cm)
Bocher, 1882, no. 1353 iv/vii

N'Ayez pas peur, ma bonne amie (Do Not Be Afraid, My Dear), 1776
Etching

10 3/8 × 8 3/8 in. (26.4 × 21.2 cm)
Bocher, 1882, no. 1351 ii/v

P24
NICOLAS PONCE (1746–1831)
L'Enlèvement nocturne (The Nocturnal Abduction)
After Pierre-Antoine Baudouin
Engraving and etching
18 9/16 × 13 in. (47.1 × 33.0 cm)
Bocher, 1875, no. 20 iii/iv

P25
GABRIEL DE SAINT-AUBIN
(1724–1780)
Scenes des Tuilleries (Scenes in the Tuileries):
Les Chaises (The Chairs) and *Le Tonneau d'arrosage (The Watering Cart)*,
1760–63
Etching and drypoint
8 1/16 × 7 1/8 in. (20.4 × 19.3 cm),
plate
3 11/16 × 7 1/8 in. (9.3 × 19.3 cm), each image
Dacier, 1914, nos. 18–19 ii/ii
fig. 86

Bibliography

Adhémar, Hélène. *Watteau: Sa vie, son oeuvre.* Paris, 1950.

Ananoff, Alexandre, and Daniel Wildenstein. *François Boucher.* 2 vols. Lausanne, 1976.

Anatole, Marquis de Granges de Surgères. *Repertoire historique et biographique de la Gazette de France: Depuis l'origine jusqu'à la Revolution, 1613–1790.* Paris, 1902–6.

Aujaleu, Edouard. "J. B. Greuze: La bonne peinture et les bons sentiments." *Peinture et philosophie: Actes du Colloque, 15 et 16 Mai 1992, Université Paul-Valery, Montpellier* (1993): 9–19.

Bailey, Colin B. "Le Marquis de Véri, collectionneur." *Bulletin de la Société de l'histoire de l'art français, Année 1983* (1985): 67–83.

———, ed. *Ange-Laurent de La Live de Jully: A Facsimile Reprint of the Catalogue historique (1764) and the Catalogue raisonné des tableaux (March 5, 1770).* New York, 1988.

Banks, Oliver. *Watteau and the North: Studies in the Dutch and Flemish Baroque Influence on French Rococo Painting.* New York, 1977.

Béguin, Sylvie. "Exposition hommage à Louis La Caze (1798–1869)." *La Revue du Louvre et des musées de France,* 19 (1969): 115–20.

Bellier de la Chavignerie, Émile, and Louis Auvray. *Dictionnaire général des artistes de l'école française.* Paris, 1882.

Bindman, David. *Hogarth.* New York, 1981.

Bocher, Emmanuel. *Les Graveurs françaises du XVIIIe siècle: Nicolas Lavreince.* Paris, 1875.

———. *Les Graveurs françaises du XVIIIe siècle: Pierre-Antoine Baudouin.* Paris, 1875.

———. *Les Graveurs françaises du XVIIIe siècle: Jean-Baptiste Siméon Chardin.* Paris, 1876.

———. *Les Graveurs françaises du XVIIIe siècle: Nicolas Lancret.* Paris, 1877.

———. *Les Graveurs françaises du XVIIIe sicèle: Jean-Michel Moreau le Jeune.* Paris, 1882.

Boime, Albert. *Art in the Age of Revolution, 1750–1800.* Chicago, 1987.

Bordeaux, Jean-Luc. *François Le Moyne and His Generation.* Neuilly-sur-Seine, France, 1984.

———. "Jean-François de Troy—Still an Artistic Enigma: Some Observations on His Early Work." *Artibus et Historiae* 20 (1989): 143–69.

Bowron, Edgar Peters. *European Paintings before 1900 in the Fogg Art Museum.* Cambridge, Mass., 1990.

Boyer, Ferdinand. "Catalogue raisonné de l'oeuvre de Charles Natoire." *Archives de l'art français,* n.s., 21, (1949): 29–106.

Brookner, Anita. *Watteau.* London, 1967.

———. *Greuze: The Rise and Fall of an Eighteenth-Century Phenomenon.* Greenwich, Conn., 1972.

Brunel, Georges. *Boucher.* New York, 1986.

Bryson, Norman. *Word and Image: French Painting of the Ancien Régime.* Cambridge, 1981.

———. *Looking at the Overlooked.* Cambridge, Mass., 1990.

Bukdahl, Else Marie. *Diderot: Critique d'art, théorie, et pratique dans les "Salons" de Diderot.* Translated by Jean-Paul Faucher. 2 vols. Copenhagen, 1980.

Cabanne, Pierre. *Fragonard.* Paris, 1987.

Cailleux, Jean. "A Rediscovered Painting by Watteau: 'La Partie Quarrée.'" *Burlington Magazine* 104 (April 1962): i–v.

———. "Les Artistes français du dix-huitième siècle et Rembrandt." In *Etudes d'art français offertes à Charles Sterling,* ed. Albert Chatelet and Nicole Reynaud, 287–305. Paris, 1975.

Camesasca, Ettore. *The Complete Paintings of Watteau.* New York, 1968.

Cayeux, Jean de. *Hubert Robert et les jardins.* Paris, 1987.

Chiego, William. "A Boudoir Scene by Le Prince." *The Toledo Museum of Art: Museum News* 17, no. 1 (1974): 11–14.

Chong, Alan. *European and American Painting in The Cleveland Museum of Art.* Cleveland, 1993.

Clark, Anthony M. "Eight Seventeenth- and Eighteenth-Century Paintings." *Minneapolis Institute of Arts Bulletin* 54 (1965): 52–53.

Cleveland Museum of Art. *European Paintings of the Sixteenth, Seventeenth, and Eighteenth Centuries.* Cleveland, 1982.

Compin, Isabelle, and Anne Roquebert. *Catalogue sommaire illustré des peintures du Musée du Louvre et du Musée d'Orsay, Ecole Française.* 3 vols. Paris, 1986.

Conisbee, Philip. *Painting in Eighteenth-Century France.* Ithaca, N.Y., 1981.

———. *Chardin.* Lewisburg, N.J., 1985.

Crow, Thomas E. *Painters and Public Life in Eighteenth-Century Paris.* New Haven, 1985.

Cuzin, Jean-Pierre. *Jean-Honoré Fragonard: Life and Work, Complete Catalogue of the Oil Paintings.* Translated by Anthony Zielonka and Kim-Mai Mooney. New York, 1988.

———. "Le Déjeuner de chasse de Jean-François de Troy (1679–1752) peint pour Fontainebleau." *La Revue du Louvre et des musées de France* 41 (March 1991): 43–48.

Dacier, Emile. *L'Oeuvre gravé de Gabriel de Saint-Aubin, notice*

historique et catalogue raisonné. Paris, 1914.

———. *La Gravure de genre et de moeurs.* Paris, 1925.

Dacier, Emile, and Albert Vuaflart. *Jean de Jullienne et les graveurs de Watteau au XVIIIe siècle.* 4 vols. Paris, 1921–22.

Dargenty, G. *Antoine Watteau.* Paris, 1891.

Diderot, Denis. *Diderot Salons.* Edited by Jean Seznec. 2d ed. 4 vols. Oxford, 1983.

———. *Diderot on Art.* Edited and translated by John Goodman. 2 vols. New Haven, 1995.

Doin, Jeanne. "Marguerite Gérard (1761–1837)." *Gazette des beaux-arts,* 4th ser., 7 (December 1912): 429–52.

Druce, Robert. "The Vanishing Reader: The Changing Role of Letters in Paintings." *Word and Image* 4, no. 1 (1988): 177–85.

Duncan, Carol. "Happy Mothers and Other New Ideas in French Art." *Art Bulletin* 55 (December 1973): 570–83.

———. "Fallen Fathers: Images of Authority in Pre-Revolutionary French Art." *Art History* 4, no. 2 (1981): 186–202.

Ehrard, Antoinette. "L'Utopie du langage naturel: Gestes et objects." In *Diderot et Greuze: Actes du colloque de Clermont-Ferrand,* ed. Antoinette and Jean Ehrard, 33–38. Clermont-Ferrand, 1986.

Eisler, Colin. *Paintings from the Samuel H. Kress Collection: European Schools Excluding Italian.* Oxford, 1977.

Engerand, François. *Inventaire des tableaux commandés et achetés par la directions des bâtiments du roi (1709–1792).* Paris, 1900.

Ergmann, Raoul. "La Collection inédite du Bailli de Breteuil." *Connaissances des Arts* 413/414 (July–August 1986): 70–75.

Fahy, Everett, and Sir Francis Watson. *The Wrightsman Collection.* Vol. 5, *Paintings, Drawings, and Sculpture.* New York, 1973.

Fenaille, Maurice. *L'Oeuvre gravé de P.-L. Debucourt (1755–1832).* Paris, 1899.

Ferré, Jean. *Watteau.* Madrid, 1972.

Fried, Michael. *Absorption and Theatricality: Painting and Beholder in the Age of Diderot.* Berkeley and Los Angeles, 1980.

Furst, Herbert E. A. *Chardin.* London, 1911.

Gaborit, Jean-René. *Jean-Baptiste Pigalle, 1714–1785: Sculptures du musée du Louvre.* Paris, 1985.

Gaston-Dreyfus, Philippe. "Une dernière volonté de Nicolas-Bernard Lépicié." *Bulletin de la Société de l'histoire de l'art français* (1910): 25–32.

———. *Catalogue raisonné de l'oeuvre peint et dessiné de Nicolas-Bernard Lépicié (1735–1784).* Paris, 1923.

Girodie, André. *Jean-Frédéric Schall.* Strasbourg, 1927.

Goodman-Soellner, Elise. "Boucher's *Madame de Pompadour at her Toilette.*" *Simiolus* 17, no. 1 (1987): 41–58.

Grate, Pontus. *French Paintings II: Eighteenth Century.* Stockholm, 1994.

Grigaut, P. "Marmontel's *Shepherdess of the Alps* in Eighteenth-Century Art." *Art Quarterly* 12, no. 1 (1949): 30–47.

Guimbaud, Louis. *Saint-Non et Fragonard d'après des documents inédits.* Paris, 1928.

Hallam, John S. "The Alchemist Transformed: Boilly's *Electric Shock* in Richmond." *Arts in Virginia* (Spring 1977): 2–11.

———. "The Genre Works of Louis-Leopold Boilly." Ph.D. diss., University of Washington, 1979.

———. "Meaning and Manner in Chardin's *The Good Lesson.*" *Bulletin of the Museum of Fine Arts, Houston* 8, no. 4 (1985): 8–18.

Harrisse, Henry. *L.-L. Boilly: Peintre, dessinateur, et lithographe.* Paris, 1898.

Hautecoeur, Louis. *Les Peintres de la vie familiale: Evolution d'un thème.* Paris, 1945.

Havercamp-Begemann, E., and Anne-Marie S. Logan. *European Drawings and Watercolors in the Yale University Art Gallery.* New Haven, 1970.

Heartz, Daniel. "Opéra-Comique and the Théâtre Italien from Watteau to Fragonard." In *Music in the Classic Period,* ed. Allan W. Atlas, 69–84. New York, 1985.

Hédou, Jules. *Jean-Baptiste Le Prince, 1734–1781: Peintre et graveur.* Paris, 1879.

Heim, Jean-François, Claire Béraud, and Philippe Heim. *Les Salons de peinture de la Révolution française, 1789–1799.* Paris, 1989.

Heinemann, Rudolph J., ed. *Sammlung Thyssen-Bornemisza.* Lugano-Castagnola, Switzerland, 1971.

Henriot, Gabriel. *Collection David-Weill: Peintures.* Paris, 1926–28.

Huth, Nancy M., and Alain G. Joyaux. *European and American Paintings and Sculpture: Selected Works.* Muncie, Ind. 1994.

Hyde, Melissa. "Confounding Conventions: Gender Ambiguity and François Boucher's Painted Pastorals." *Eighteenth-Century Studies* 30, no. 1 (1996): 25–57.

Hymans, Henri. "L'Exposition de l'art français du XVIIIe siècle." *Gazette des beaux-arts* (1904): 302–10.

Ingamells, John. *The Wallace Collection, Catalogue of Pictures III: French before 1815.* London, 1989.

Ingersoll-Smouse, Florence. "Quelques tableaux de genre inédits par Etienne Aubry (1745–1781)." *Gazette des beaux-arts* 11 (1925): 77–86.

———. "Nicolas-Bernard Lépicié." *Revue de l'art ancien et moderne* 50 (December 1926): 293–96.

———. *Pater.* Paris, 1928.

Janson, Anthony F., and A. Ian Fraser. *One Hundred Masterpieces of Painting: Indianapolis Museum of Art.* Indianapolis, 1980.

Jean-Richard, Pierrette. *L'Oeuvre gravé de François Boucher dans la Collection Edmond de Rothschild.* Paris, 1978.

Johnson, Dorothy. "Corporality and Communication: The

Gestural Revolution of Diderot, David, and *The Oath of the Horatii.*" *Art Bulletin* 71 (March 1989): 92–113.

———. "Picturing Pedagogy: Education and the Child in the Paintings of Chardin." *Eighteenth-Century Studies* 24, no. 1 (1990): 47–68.

Jourdain, Francis. *Chardin, 1699–1779.* Paris, 1949.

Kahn, Gustave. *Boucher.* Paris, 1904.

Kimbell Art Museum. *In Pursuit of Quality.* New York, 1987.

Lapauze, Henri. *Histoire de l'Académie de France à Rome.* Paris, 1924.

Laskin, Myron, Jr., and Michael Pantazzi, eds. *European and American Painting, Sculpture, and Decorative Arts: Catalogue of the National Gallery of Canada.* Ottawa, 1987.

Lawrence, H. W., and B. L. Dighton. *French Line Engraving of the Late XVIII Century.* London, 1910.

Le Blanc, Charles. *Manuel de l'amateur d'estampes.* 4 vols. Paris, 1854–56.

Lichtenstein, Jacqueline. "Making Up Representation: The Risk of Femininity." *Representations* 20 (Fall 1987): 77–78.

Lindblom, Andreas. *Antoine Watteau.* Stockholm, 1948.

Lipton, Eunice. "Women, Pleasure, and Painting (e.g., Boucher)." *Genders* 7 (March 1990): 69–86.

Locquin, Jean. *La Peinture d'histoire en France de 1747 à 1785.* Paris, 1912.

Marandel, J. Patrice. "Natoire aux appartements de Louis XV à Fontainebleau." *Antologia di belle arti,* n.s., nos. 39–42 (1992): 129–34.

Marmottan, Paul. *L'Ecole française de peinture (1789–1830).* Paris, 1886.

———. *Le Peintre Louis Boilly (1761–1845).* Paris, 1913.

Martin, Jean, and Charles Masson. *Catalogue raisonné de l'oeuvre peint et dessiné de J.-B. Greuze.* Paris, 1908.

Martin, John Rupert. *Baroque.* New York, 1977.

Mauclair, Camille. *Greuze et son temps.* Paris, 1926.

Maugras, Gaston. *Le Duc et la duchesse de Choiseul.* Paris, 1902.

McPherson, Heather Ann. "Some Aspects of Genre Painting and Its Popularity in Eighteenth-Century France." Ph.D. diss., University of Washington, 1982.

———. "Jean-Baptiste Greuze's Italian Sojourn, 1755–1757." *Studies in the Eighteenth Century* 14 (1985): 9–107.

Michel, André. *François Boucher.* Paris, 1889.

Minneapolis Institute of Arts. *European Paintings from The Minneapolis Institute of Arts.* New York, 1971.

Moureau, François, and Margaret Morgan Grasselli, eds. *Antoine Watteau (1684–1721), Le Peintre, son temps, et sa légende.* Paris, 1987.

Munhall, Edgar. "Quelques découvertes sur Greuze." *La Revue du Louvre et des musées de France* 2 (1966): 85–92.

Murphy, Alexandra R. *European Paintings in the Museum of Fine Arts, Boston.* Boston, 1985.

Museum of Fine Arts, Houston. *A Permanent Legacy: One Hundred Fifty Works from the Collection of The Museum of Fine Arts, Houston.* New York, 1989.

Museum of Fine Arts, Springfield. *Museum of Fine Arts: The American and European Collections.* Springfield, Mass., 1979.

Nelson, Robert. "The Development of Intimacy: History of an Emotional State in Art and Literature." *Australian Journal of Art* 4 (1985): 14–35.

Nolhac, Pierre de. *Mme. Vigée-Lebrun.* Paris, 1908.

———. *Boucher, Premier peintre du Roi.* Paris, 1925.

Oulmont, Charles. *Les Femmes peintres du XVIIIe siècle.* Paris, 1928.

Pascal, André, and Roger Gaucheron. *Documents sur la vie et oeuvre de Chardin.* Paris, 1931.

Poncheville, A. Mabille de. *Boilly.* Paris, 1931.

Portalis, Le Baron Roger, and Henri Béraldi. *Les Graveurs du dix-huitième siècle.* 3 vols. Paris, 1880–82.

Posner, Donald. *Watteau: A Lady at Her Toilet.* New York, 1973.

———. "The Swinging Women of Watteau and Fragonard." *Art Bulletin* 64 (March 1982): 75–88.

———. *Antoine Watteau.* Ithaca, N.Y., 1984.

———. "Mme. de Pompadour as a Patron of the Visual Arts." *Art Bulletin* 72 (March 1990): 74–105.

Rand, Richard. "Civil and Natural Contract in Greuze's *L'Accordée de Village.*" *Gazette des beaux-arts* 127 (May–June 1996): 221–34.

Réau, Louis. *Histoire de la peinture française.* Paris, 1926.

———. "Les Colin-Maillard de Fragonard." *Gazette des beaux-arts* 15 (March 1927): 148–52.

———. "Les influences flamandes et hollandaises dans l'oeuvre de Fragonard." *Revue belge d'archéologie et d'histoire de l'art* 2 (April 1932): 97–104.

———. "Carle Vanloo." *Archives de l'art français* 19 (1938): 7–96.

———. *Fragonard: Sa vie et son oeuvre.* Brussels, 1956.

Robiquet, Jean. *La Femme dans la peinture française, XV–XX siècle.* Paris, 1938.

Roland Michel, Marianne. *Lajoüe et l'art rocaille.* Neuilly-sur-Seine, France, 1984a.

———. *Watteau: An Artist of the Eighteenth Century.* New York, 1984b.

———. *Chardin.* New York, 1996.

Rosenberg, Pierre. "A propos de Lemoyne." *Minneapolis Institute of Arts Bulletin* (1971–73): 55.

———. *L'opera completa di Chardin.* Milan, 1983.

———. *Tout l'oeuvre peint de Fragonard.* Paris, 1989.

Rosenberg, Pierre, and Marion C. Stewart. *French Paintings, 1500–1825: The Fine Arts Museums of San Francisco.* San Francisco, 1987.

Rothschild, Nathaniel. *Notizen über einige Meiner Kunstgegenstände.* Vienna, 1903.

Saisselin, Remy. "The Rococo as a Dream of Happiness." *Journal of Aesthetics and Art Criticism* 19 (1960): 145–52.

Sammlung Thyssen-Bornemisza. *Thyssen-Bornemisza Collection: Catalogue Raisonné of the Exhibited Works of Art.* Milan, 1986.

Sauerländer, Willibald. "Pathosfiguren im Oeuvre des Jean-Baptiste Greuze." In *Walter Friedlaender zum 90. Geburtstag,* ed. Georg Kauffmann and Willibald Sauerländer, 146–50. Berlin, 1965.

Schama, Simon. *The Embarrassment of Riches.* New York, 1987.

Schéfer, Gaston. *Chardin.* Paris, 1904.

Scott, Barbara. "La Live de Jully, Pioneer of Neoclassicism." *Apollo* 97 (January 1973): 72–77.

———. "Pierre Crozat, a Maecenas of the Régence." *Apollo* 97 (January 1973): 11–19.

Scott, Katie. *The Rococo Interior: Decoration and Social Spaces in Early Eighteenth-Century France.* New Haven, 1995.

Seznec, Jean, and Jean Adhémar. *Diderot Salons.* 4 vols. Oxford, 1967.

Sheriff, Mary D. "Reflecting on Chardin." *Eighteenth Century: Theory and Interpretation* 29, no. 1 (1988): 19–45.

———. *Fragonard: Art and Eroticism.* Chicago, 1990.

———. "Fragonard's Erotic Mothers and the Politics of Reproduction." In *Eroticism and the Body Politic,* ed. Lynn Hunt, 14–40. Baltimore, 1991.

Siegfried, Susan L. *The Art of Louis-Léopold Boilly: Modern Life in Napoleonic France.* New Haven, 1995.

Smith, John. *A Catalogue Raisonné of the Works of the Most Eminent Dutch, Flemish, and French Painters.* 9 vols. London, 1837.

Snoep-Reitsma, Ella. "Chardin and the Bourgeois Ideals of His Time." *Nederlands Kunsthistorisch Jaarboek* 24 (1973): 147–243.

Stein, Perrin. "Le Prince, Diderot et le débat sur la Russie au temps des Lumières." *Revue de l'art* 112 (1996): 16–27.

Sterling and Francine Clark Art Institute. *List of Paintings in the Sterling and Francine Clark Art Institute.* Williamstown, Mass., 1992.

Sutton, Denys. "Jean-Honoré Fragonard: The World as Illusion." *Apollo* 125 (February 1987): 102–13.

Toledo Museum of Art. *European Paintings.* Toledo, Ohio, 1976.

———. *Toledo Treasures: Selections from the Toledo Museum of Art.* New York, 1995.

Turner, Evan. "*La serinette* by Jean-Baptiste Chardin: A Study in Patronage and Technique." *Gazette des beaux-arts* 69 (May–June 1957): 299–310.

Vidal, Mary. *Watteau's Painted Conversations: Art, Literature, and Talk in Seventeenth- and Eighteenth-Century France.* New Haven, 1992.

Walsh, Linda. "The Expressive Face: Manifestations of Sensibility in Eighteenth-Century French Art." *Art History* 19, no. 4 (December 1996): 523–50.

Watson, Francis. "Fragonard, Painterly and Non-Painterly, in the France of Louis XVI." *Art News Annual* 37 (1971): 75–88.

Wells-Robertson, Sally. "Marguérite Gérard, 1761–1837." Ph.D. diss., New York University, 1978.

Wildenstein, Daniel. "Sur *Le Verrou* de Fragonard." *Gazette des beaux-arts* 85 (January 1975): 13–20.

Wildenstein, Daniel, and Gabriele Mandel. *L'opera completa di Fragonard.* Milan, 1972.

Wildenstein, Georges. *Lancret.* Paris, 1924.

———. *Fragonard aquafortiste.* Paris, 1956.

———. "L'Abbé de Saint-Non: Artiste et mécène." *Gazette des beaux-arts* 54 (November 1959): 225–44.

———. *The Paintings of Fragonard.* New York, 1960.

———. *Chardin.* Paris, 1933; 2d ed. Greenwich, Conn., 1969.

Wilenski, R. H. *French Painting.* London, 1931.

Williams, Eunice. "Drawings for Collaboration." In *Drawings Defined,* ed. Walter Strauss and Tracie Felker, 281–84. New York, 1987.

Wine, Humphrey. *Watteau.* London, 1992.

Wise, Susan, et al. *French and British Paintings from 1600 to 1800 in the Art Institute of Chicago.* Chicago, 1996.

Wolff, Martha. "An Early Painting by Greuze and Its Literary Associations." *Burlington Magazine* 138 (September 1996): 580–85.

Worcester Art Museum. *European Paintings in the Collection of the Worcester Art Museum.* 2 vols. Worcester, Mass., 1974.

———. *Worcester Art Museum: Selected Works.* Worcester, Mass., 1994.

Wrigley, Richard. *The Origins of French Art Criticism from the Ancien Régime to the Restoration.* Oxford, 1993.

Exhibitions

AMSTERDAM 1926. *Exposition rétrospective d'art français.* Rijksmuseum.

ATLANTA 1983. *The Rococo Age: French Masterpieces of the Eighteenth Century.* High Museum of Art. Catalogue by Eric Zafran.

AUCKLAND 1993. *Rembrandt to Renoir: Three Hundred Years of European Masterpieces from the Fine Arts Museums of San Francisco.* Auckland City Art Gallery.

BALTIMORE 1959. *Age of Elegance: The Rococo and Its Effect.* The Baltimore Museum of Art.

BALTIMORE, BOSTON, AND MINNEAPOLIS 1984–85. *Regency to Empire: French Printmaking, 1715–1814.* The Baltimore Museum of Art; Museum of Fine Arts, Boston; The Minneapolis Institute of Arts.

CAMBRIDGE, MASSACHUSETTS 1993. *Gens, Honorez Fragonard! Works from the Collection of Harvard University and Harvard Friends.* Harvard University Art Museums. Brochure by Eunice Williams.

CHICAGO 1995. *A Passion for Virtue: An Eighteenth-Century Masterpiece by Greuze.* The Art Institute of Chicago.

CINCINNATI 1977. *The Best of Fifty.* The Taft Museum.

CLEVELAND 1944. *Catalogue of the Elisabeth Severance Prentiss Collection.* The Cleveland Museum of Art.

FORT WORTH AND WASHINGTON 1995–96. *The Art of Louis-Léopold Boilly: Modern Life in Napoleonic France.* Kimbell Art Museum; National Gallery of Art.

HAMBURG 1986. *Eva und die Zukunft: Das Bild der Frau seit der Franzosichen Revolution.* Hamburger Kunsthalle.

HARTFORD, SAN FRANCISCO, AND DIJON 1976–77. *Jean-Baptiste Greuze, 1725–1805.* Wadsworth Atheneum; California Palace of the Legion of Honor; Musée des Beaux-Arts, Dijon. Catalogue by Edgar Munhall.

HOUSTON 1954. *George Washington's World.* The Museum of Fine Arts, Houston.

KANSAS CITY 1983. *Genre.* The Nelson-Atkins Museum of Art.

KANSAS CITY 1987. *A Bountiful Decade: Selected Acquisitions 1977–1987.* The Nelson-Atkins Museum of Art.

KORIYAMA, YOKOHAMA, NARA, AND KITAKYUSHU 1993. *French Art of Four Centuries from the New Orleans Museum of Art.* Koriyama City Museum of Art; Sogo Museum of Art; Nara Sogo Museum of Art; Kitakyushu Municipal Museum of Art.

LILLE 1988–89. *Boilly 1761–1845: Un Grand Peintre français de la Révolution à la Restauration.* Musée des Beaux-Arts de Lille.

LONDON 1968. *France in the Eighteenth Century.* Royal Academy of Arts. Catalogue by Denys Sutton.

LONDON 1995. *In Trust for the Nation: Paintings from National Trust Houses.* National Gallery. Catalogue by Alastair Lang.

LOS ANGELES 1961. *French Masters: Rococo to Romanticism.* The UCLA Art Galleries.

LOS ANGELES 1990. *Masterpiece in Focus: Soap Bubbles by Chardin.* Los Angeles County Museum of Art. Catalogue by Philip Conisbee.

LUCERNE 1948. *Meisterwerke aus den Sammlungen des Fürsten von Liechtenstein.* Kunstmuseum Luzern.

NEW YORK 1935–36. *French Painting and Sculpture of the XVIII Century.* The Metropolitan Museum of Art.

NEW YORK 1939. *Masterpieces of Art.* World's Fair.

NEW YORK 1940. *Masterpieces of Art.* World's Fair.

NEW YORK 1963. *French Masters of the Eighteenth Century.* Finch College Museum of Art.

NEW YORK ET AL. 1973–75. *Paintings from Midwestern University Collections.* Wildenstein et al.

NEW YORK 1980. *François Boucher: A Loan Exhibition for the Benefit of the New York Botanical Garden.* Wildenstein. Catalogue by Denys Sutton.

NEW YORK, NEW ORLEANS, AND COLUMBUS 1985–86. *The First Painters of the King: French Royal Taste from Louis XIV to the Revolution.* Stair Sainty Matthiesen; New Orleans Museum of Art; Columbus Museum of Art. Catalogue by Colin B. Bailey.

NEW YORK, DETROIT, AND PARIS 1986–87. *Francois Boucher, 1703–1770.* The Metropolitan Museum of Art; The Detroit Institute of Arts; Réunion des Musées Nationaux, Grand Palais.

NEW YORK 1987. *Chez Elle, Chez Lui: At Home in Eighteenth-Century France.* Rosenberg and Stiebel. Catalogue by Penelope Hunter-Stiebel.

NEW YORK 1988. *Hubert Robert: The Pleasure of Ruins.* Wildenstein.

NEW YORK 1989 (1). *1789: French Art during the Revolution.* Colnaghi.

NEW YORK 1989 (2). *The Winds of Revolution.* Wildenstein. Catalogue by Joseph Baillio.

NEW YORK 1990. *Claude to Corot: The Development of Landscape Painting in France.* Colnaghi.

NEW YORK AND FORT WORTH 1991–92. *Nicolas Lancret, 1690–1743.* The Frick Collection; Kimbell Art Museum. Catalogue by Mary Tavener Holmes.

NEW YORK 1996. *Master Drawings, 1996.* Didier Aaron.

NICE, CLERMONT-FERRAND, AND NANCY 1977. *Carle Vanloo, Premier Peintre du Roi.* Musée Chéret; Musée Bargoin; Musée

des Beaux-Arts. Catalogue by Marie-Catherine Sahut.

NISHINOMIYA 1978. *Exposition Rococo: Poésie et rêve de la peinture française au XVIIIe siècle.* Otani Museum.

NOTRE DAME 1972. *Eighteenth-Century France: A Study of Its Art and Civilization.* The Art Gallery, University of Notre Dame.

PARIS 1892. *Cent chefs-d'oeuvre des collections françaises et étrangères.* Musée des Arts Décoratifs.

PARIS 1907. *Exposition Chardin et Fragonard.* Galerie Georges Petit.

PARIS 1910. *Exposition: Les Enfants.* Palais du Domaine de Bagatelle.

PARIS 1921. *Exposition d'oeuvres de J.-H. Fragonard.* Musée des Arts Décoratifs; Pavillon de Marsan; Palais du Louvre. Catalogue by Georges Wildenstein.

PARIS 1925. *Le Paysage français de Poussin à Corot.* Musée du Petit Palais.

PARIS 1929. *Exposition des oeuvres de J. B. S. Chardin.* Galerie Pigalle.

PARIS 1930 (1). *Les Artistes de Salon de 1737.* Grand Palais.

PARIS 1930 (2). *Exposition L.-L. Boilly.* Ancien Hôtel de Sagan.

PARIS 1937. *Chefs d'oeuvre de l'art français.* Palais National des Arts.

PARIS 1946. *Chefs d'oeuvre de la peinture français du Louvre: Des primitifs à Manet.* Musée du Petit Palais.

PARIS 1956. *De Watteau à Prud'hon.* Gazette des Beaux-Arts.

PARIS 1968. *Watteau et sa génération.* Galerie Cailleux.

PARIS, DETROIT, AND NEW YORK 1974–75. *French Painting, 1774–1830: The Age of Revolution.* Reunion des Musées Nationaux; The Detroit Institute of the Arts; The Metropolitan Museum of Art.

PARIS 1978–79. *Sanguines: Dessins français du dix-huitième siècle.* Galerie Cailleux.

PARIS, CLEVELAND, AND BOSTON 1979. *Chardin, 1699–1779.* Galeries Nationales du Grand Palais; The Cleveland Museum of Art; Museum of Fine Arts. Catalogue by Pierre Rosenberg.

PARIS 1983. *Rome, 1760–1770: Fragonard, Hubert Robert, et leurs amis.* Galerie Cailleux.

PARIS 1984. *Louis Boilly, 1761–1845.* Musée Marmottan.

PARIS 1984–85. *Diderot et l'art de Boucher à David.* Hôtel de la Monnaie.

PARIS 1987. *Aspects de Fragonard: Peintures—dessins—estampes.* Galerie Cailleux.

PARIS AND NEW YORK 1987–88. *Fragonard.* Galeries Nationales du Grand Palais; The Metropolitan Museum of Art. Catalogue by Pierre Rosenberg.

PARIS 1989. *La Révolution française et l'Europe, 1789–1799.* Galeries Nationales du Grand Palais.

PARIS, PHILADELPHIA, AND FORT WORTH 1991–92. *The Loves of the Gods: Mythological Painting from Watteau to David.* Galeries Nationales du Grand Palais; Philadelphia Museum of Art; Kimbell Art Museum. Catalogue by Colin B. Bailey.

PHILADELPHIA, BERLIN, AND LONDON 1984. *Masters of Seventeenth-Century Dutch Genre Painting.* Philadelphia Museum of Art; Gemäldegalerie, Staatliche Museen Preussischer Kulturbesitz; Royal Academy of Arts. Catalogue by Peter Sutton.

PITTSBURGH 1936. *A Survey of French Painting.* Carnegie Institute.

PITTSBURGH 1954. *Pictures of Everyday Life: Genre Painting in Europe, 1500–1900.* Carnegie Institute.

ROME 1990. *J. H. Fragonard e H. Robert a Roma.* Villa Medici.

ST. PETERSBURG, FLORIDA 1982–83. *Fragonard and His Friends: Changing Ideals in Eighteenth-Century Art.* Museum of Fine Arts.

SAN FRANCISCO 1965. *Man, Glory, Jest, and Riddle: A Survey of the Human Form through the Ages.* M. H. de Young Memorial Museum, California Palace of the Legion of Honor, The Fine Arts Museums of San Francisco.

SEATTLE 1962. *Masterpieces of Art.* Fine Arts Pavilion.

STOCKHOLM 1926. *Liljevalchs, Fransk Konst i Svensk Privat Ago.* Nationalmuseum.

STOCKHOLM 1958. *Fem Sekler Fransk Konst.* Nationalmuseum.

STOCKHOLM AND PARIS 1993–94. *Solen och Nordstjärnan, Frankrike och Sverige På 1700-Talet.* Nationalmuseum; Grand Palais.

TOLEDO, CHICAGO, AND OTTAWA 1975–76. *The Age of Louis XV: French Painting, 1710–1774.* The Toledo Museum of Art; The Art Institute of Chicago; National Gallery of Canada. Catalogue by Pierre Rosenberg.

TOKYO AND KYOTO 1980. *Fragonard.* The National Museum of Western Art; Kyoto Municipal Museum. Catalogue by Denys Sutton.

TOKYO AND KUMAMOTO 1982. *François Boucher.* Tokyo Metropolitan Art Museum; Kumamoto Prefectural Museum of Art. Catalogue by Denys Sutton.

TROYES, NÎMES, AND ROME 1977. *Charles-Joseph Natoire.* Musée des Beaux-Arts (Troyes); Musées des Beaux-Arts (Nîmes); Villa Medicis.

VANCOUVER 1983. *Masterworks from the Collection of the National Gallery of Canada.* The Vancouver Art Gallery.

WASHINGTON, D.C. 1978. *Drawings by Fragonard in North American Collections.* National Gallery of Art. Catalogue by Eunice Williams.

WASHINGTON, D.C. ET AL. 1979–81. *Old Master Paintings from the Collection of Baron Thyssen-Bornemisza.* National Gallery of Art. Catalogue by Allen Rosenbaum.

WASHINGTON, D.C., PARIS, AND BERLIN 1984–85. *Watteau, 1684–1721.* National Gallery of Art; Galeries Nationales du

Grand Palais; Schloss Charlottenburg. Catalogue by Margaret Morgan Grasselli and Pierre Rosenberg.

WILLIAMSTOWN 1958. *Exhibit Four and Exhibit Seven*. Sterling and Francine Clark Art Institute.

WILLIAMSTOWN AND HARTFORD 1974. *The Elegant Academics: Chroniclers of Nineteenth-Century Parisian Life*. Sterling and Francine Clark Art Institute; Wadsworth Atheneum.

List of Artists

References are to catalogue numbers

Aubert, Michel, P1

Aubry, Etienne, 35–37

Aveline, Pierre Alexandre, P2

Baron, Bernard, P3

Blot, Maurice, P4

Boilly, Louis-Léopold, 49–51

Boucher, François, 11–14

Cazenave, Frédéric, P5

Chardin, Jean-Siméon, 16–20

Debucourt, Philibert-Louis, P6, P7

Demarteau, Gilles, P8

Demarteau, Gilles-Antoine, P9

Descourtis, Charles-Melchior, P10

de Troy, Jean-François, 9–10

Drolling, Martin, 46–47

Fragonard, Jean-Honoré, 21–25, P11

Garnier, Michel, 44–45

Gérard, Marguerite, 41–43

Greuze, Jean-Baptiste, 26–31

Janinet, Jean-François, P12, P13

Lancret, Nicolas, 4–6

Larmessin, Nicolas de, P14

Launay, Nicolas de, P15

Laurent, Pierre, P16

Le Bas, Jacques Philippe, P17–P18

Lépicié, François Bernard, P19–P20

Lépicié, Nicolas-Bernard, 38

Le Prince, Jean-Baptiste, 34

Moreau le Jeune, Jean-Michel, P21–P23

Natoire, Charles-Joseph, 15

Pater, Jean-Baptiste, 7–8

Ponce, Nicolas, P24

Robert, Hubert, 32

Saint-Aubin, Gabriel de, P25

Schall, Jean-Frédéric, 40

Van Gorp, Henri-Nicolas, 48

Van Loo, Louis-Michel, 33

Vincent, François-André, 39

Watteau, Jean-Antoine, 1–3

Index

PHOTO CREDITS

All photography has been provided by the institutions cited, with the exception of the following: figs. 3, 67, cat. 18, Photo RMN-Arnaudet; figs. 8, 14, Frick Collection, New York; fig. 18, Photo RMN-R. G. Ojeda, P. Néri; fig. 38, Jörg Anders, Berlin; figs. 41, 42, The Metropolitan Museum of Art, New York; figs. 43, 56, Cailleux, Paris; figs. 45, 51, Photo RMN-C. Jean; fig. 55, Rijksmuseum, Amsterdam; fig. 61, Segoura, Paris; cats. 7, 8, Mel McLean; cat. 13, Hans Thorwid; cat. 15, Jeffrey Nintzel; cat. 24, Alexis Daflos; cat. 28, Michael Bodycomb; cat. 49, Ann Hutchinson.